P9-DCD-733

Ancient Near Eastern Art

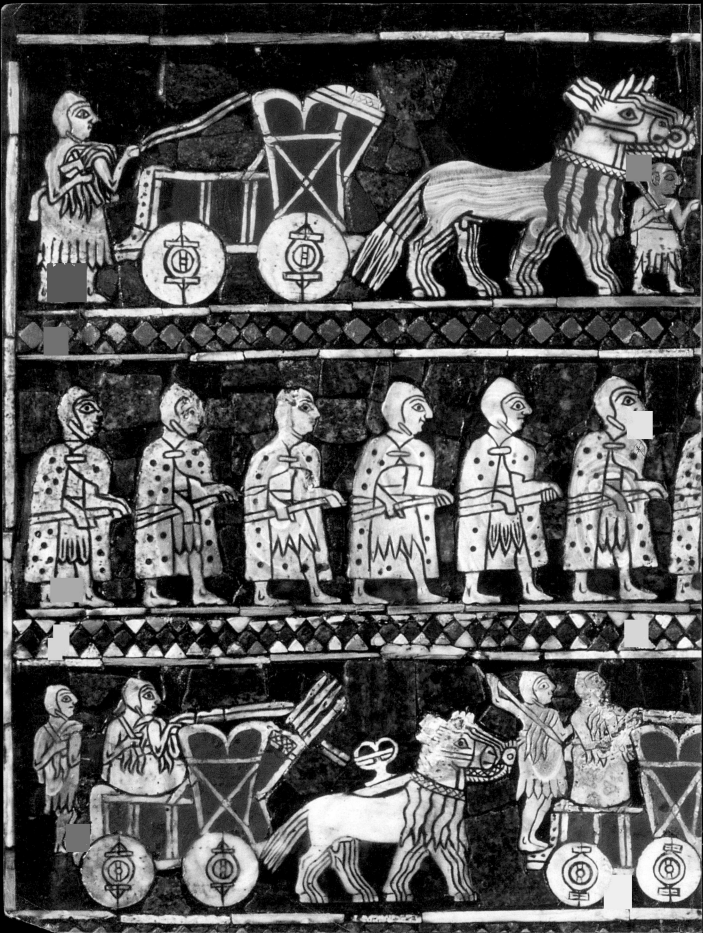

Ancient Near Eastern Art

Dominique Collon

University of California Press
Berkeley Los Angeles

For Gerard

The Trustees of the British Museum
are grateful to the Friends of the
Ancient Near East for their generous
contribution towards the production
of this book.

University of California Press
Berkeley and Los Angeles, California

Published by arrangement with British Museum Press

© 1995 The Trustees of the British Museum

Cataloging-in-Publication Data on file with the Library of Congress

ISBN 0-520-20307-0

Typeset in Linotron Plantin by Rowland Phototypesetting Limited
Bury St Edmunds, Suffolk
Origination by Colourscan, Singapore
Printed and bound in Italy by Grafedit

9 8 7 6 5 4 3 2 1

FRONT COVER Head of one of the lions which flanked the entrance to the temple
of the goddess Ishtar at Nimrud, 9th century BC (see Fig. 186).

BACK COVER Achaemenid silver drinking horn (*rhyton*) said to have been found
near Erzincan in eastern Turkey, 5th–4th century BC. Ht 25 cm (WA 124081;
Sir A. W. Franks bequest).

FRONTISPIECE Detail from the 'Royal Standard of Ur', *c.* 2600 BC (see Fig. 50).

Contents

Acknowledgements *page 6*

Introduction 7

1 From Village to Town *41*
 before 3000 BC

2 Temple, Cemetery and Palace *56*
 the 3rd millennium BC

3 Trade and Diplomacy *90*
 the 2nd millennium BC

4 Great Empires *128*
 the 1st millennium BC

5 Parthians and Sasanians beyond the Euphrates *188*
 c. 238 BC–AD 651

6 Survival and Revival *212*

General Chronology *228*

Mesopotamian Chronology *230*
by C.B.F. Walker

Further Reading *239*

Sources of Illustrations *240*

Index *242*

Acknowledgements

This survey of Ancient Near Eastern Art is based on the collections of the British Museum, and I should like to thank John Curtis, Keeper of the Department of Western Asiatic Antiquities, for asking me to write it. I am most grateful to my colleagues in the Department for their support and helpful comments. Any errors are, according to the time-honoured phrase, my own. Eva Wilson kindly allowed me to use her drawings of a seal in Chapter 3 and Annie Searight drew the maps and two of the figures in Chapter 4. Hero Granger-Taylor supplied me with information on Sasanian textiles discussed in Chapters 5 and 6. Christopher Walker produced the Mesopotamian Chronology. Unless otherwise stated in the captions, all objects illustrated are in the British Museum. Barbara Winter and John Heffron took many photographs specially for this book, and colleagues in the Oriental Institute in Chicago, the Metropolitan Museum of Art in New York, the Ashmolean Museum in Oxford, and the Louvre in Paris helped me to obtain photographs of objects in their collections. Celia Clear and Nina Shandloff of British Museum Press read an early draft, but the onus of editing and seeing this volume through to publication has rested on Teresa Francis, who has coped with my exigencies with efficiency, patience and humour. To all I extend my heartfelt thanks.

Introduction

The Ancient Near East is here understood as consisting of pre-Islamic Turkey east of the Bosphorus, the Caucasus, Syria, Lebanon, Israel, Palestine, Jordan, Iraq, Iran eastwards into Central Asia, and the Arabian peninsula. A large part of this area is linked by two great rivers, the Tigris and the Euphrates. Both have their sources in eastern Turkey. The Euphrates flows westwards and then south into Syria, and south-eastwards through Syria and Iraq to join the Tigris just before entering the Gulf. In Syria it has several left-bank tributaries, of which the most important is the Khabur; these originate in the mountains which form the frontier between Turkey and Syria, and they irrigate a rich area which has always been extensively settled. Most of the course of the Tigris is also south-eastwards,

1 Assyrians offer sacrifices, while scribes and sculptors carve inscriptions and a relief of the king (still visible today) in the caves (note the stalagmites) at the source of the Tigris south of Lake Van in eastern Turkey. Part of one of the bronze bands decorating the gates set up by the Assyrian king Shalmaneser III (r. 858–824 BC) at Balawat in northern Iraq (see p. 140). Ht of band 27 cm.

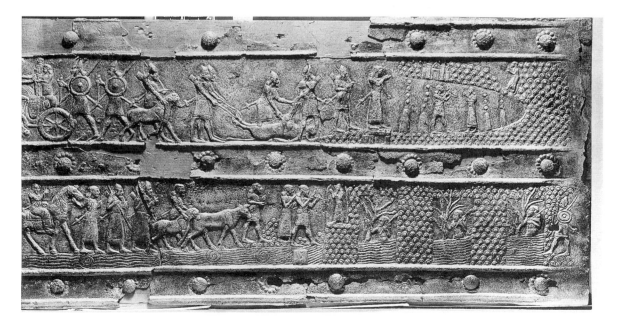

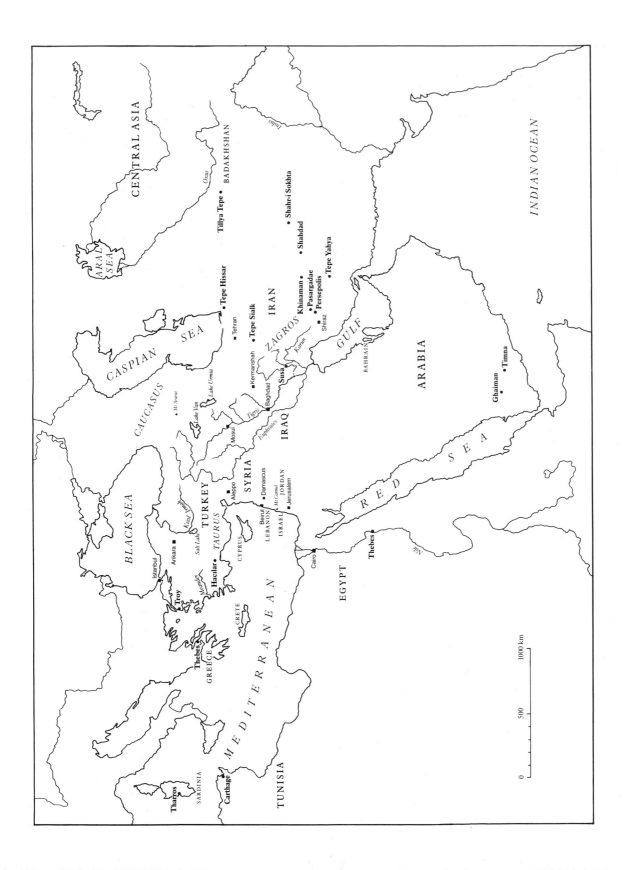

CENTRAL ASIA

Indus

BADAKHSHAN

ARAL SEA

Oxus

• **Tillya Tepe**

• **Shahr-i Sokhta**

• **Shahdad**

• **Tepe Hissar**

CASPIAN SEA

■ Tehran

Tepe Sialk

Khinaman •
Pasargadae •
Persepolis •

IRAN

ZAGROS

■ Kermanshah

Karun

Shiraz ■

• **Tepe Yahya**

CAUCASUS

▲ *Mt. Ararat*

Lake Van

Lake Urmia

GULF

BAHRAIN

ARABIA

■ Mosul

Tigris

Baghdad ■

Euphrates

Susa ■

Ghaiman •

• **Timna**

IRAQ

BLACK SEA

Kızıl Irmak

SYRIA

Aleppo ■

■ Damascus

TURKEY

Salt Lake

TAURUS

Ankara ■

■ Beirut

LEBANON

JORDAN

Mt. Carmel

ISRAEL

Jerusalem ■

RED SEA

Istanbul ■

CYPRUS

Troy ■

Hacılar •

Meander

Cairo ■

EGYPT

Thebes ■

Nile

CRETE

Thebes •

GREECE

M E D I T E R R A N E A N

1000 km

500

SARDINIA

Tharros •

Carthage •

TUNISIA

INDIAN OCEAN

0

from Turkey into Iraq, where it eventually joins the Euphrates and enters the Gulf. It, too, has important left-bank tributaries, but these flow south-westwards from the Zagros mountains which form the natural barrier between Iraq and Iran; the most important, from north to south, are the Greater and Lesser Zab, the Diyala, the Karkheh and the Karun, all of which provide routes into Iran.

The land between the Tigris and the Euphrates is often called Meso-potamia, a Greek word meaning 'between the rivers'. In the south was the land of Sumer, where one of the great civilisations of antiquity originated. Here, where the two rivers unite near modern Basra, was the traditional location of the biblical Garden of Eden (EDEN is a Sumerian word meaning steppe). Further north was the land of Akkad which, between about 2330 and 2190 BC, under a brilliant dynasty, produced magnificent objects which reflect its imperial ambitions. Later, Sumer and Akkad were united under Babylonian rule. Whenever Mesopotamia has been united, its capital cities – Akkad, Babylon, Seleucia, Ctesiphon, Samarra and finally Baghdad – 154 have stood at or near the point where the two rivers flow closest to each other. The so-called Assyrian Triangle, centred on the Tigris north of the Lesser Zab, was the land of Assyria which, from time to time, and most dramatically in the first centuries of the first millennium BC, extended its rule to other areas of the Near East.

Sumer, Akkad/Babylonia and Assyria were linked to each other and to Syria and Turkey by the Tigris and Euphrates, which were major trade routes. Another main trade route ran south of the foothills of northern Iraq and Syria and carried goods, luxuries and ideas to and from the Mediterra-nean on the one hand, and Iran and even Central Asia on the other. Here were the cities of Carchemish and Aleppo. Further to the south-east, the Syrian Desert formed an effective barrier which was only overcome to a limited extent when the domestication of the camel in the early second millennium BC led to the development of caravan trade and the eventual rise to importance of cities such as Tadmor (Palmyra) and Hatra. In the south, 164,158 the Syrian and Arabian Deserts merge. The early settlements and caravan cities of the Arabian peninsula could never have supported a large popula-tion, and throughout the millennia nomads have moved from their oases into the fertile land to the east and west of the Syrian Desert and revitalised the old, sedentary civilisations.

To the west of the Syrian Desert a road south still links a string of major cities situated at points where there are passes through the mountains to the Mediterranean coast: from Aleppo in the north travellers can reach the coast either at al-Mina via ancient Alalakh and Antioch, or at Ugarit; Hama is 2 astride the road to Tartous and the island city of Arvad; Homs, at the western end of the caravan route across the Syrian Desert from Palmyra, guards the Homs Gap where Qadesh once stood, and the Crusader castle of

MOST OF THE MAJOR CITIES WERE UNITED BY TWO RIVERS TIGRIS & EUPHRATES MAJOR TRADE ROUTE

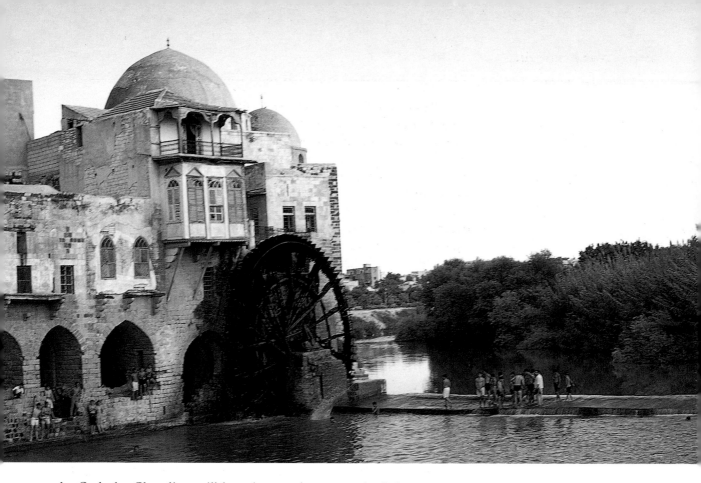

the Crak des Chevaliers still broods over the way to the Lebanese coast, Tripoli and Byblos; Damascus, surrounded by its orchards, lies on the road to Beirut; Megiddo and Beth-Shan guarded the biblical 'Way of the Sea' which led from the River Jordan, through the Jezreel Valley and the fertile Plain of Esdraelon, to the coast near medieval Acre and modern Haifa; and Amman is at one end of a route leading across the River Jordan, past Jericho, up to Jerusalem and on to the coast at Joppa (now Jaffa, part of Tel Aviv).

6

Parallel and to the west is another north–south route along a geological fault which is the extension northwards of the African Great Rift Valley. Along it are the Ghab in Syria with the River Orontes flowing through it, the Bekaa in the Lebanon, the Sea of Galilee, the River Jordan, the deep depression formed by the Dead Sea, the Wadi Araba and the Red Sea. Mountain ranges create an almost unbroken barrier between this fault and a narrow coastal strip along the east Mediterranean coast.

5

Because they were hemmed in by the mountains, the people who lived along this coast – the Canaanites and later, in the first millennium BC, the Phoenicians in the north and the Philistines in the south – had to look westwards across the Mediterranean for their livelihood. They made use of the fine natural harbours: al-Mina at the mouth of the River Orontes; Minet el-Beida, the harbour of ancient Ugarit (now Ras Shamra) near its modern

2 A water-wheel at Hama in Syria in 1972 still raised the waters of the River Orontes to the level of the gardens behind the Gailani mosque.

equivalent Latakiyeh; Arvad, Byblos, Sidon, Tyre, Acco, Dor, Joppa and Ashkelon. Goods from the east reached them through the passes from the great cities of inland Syria and were traded for wares from Egypt, Cyprus, Crete, Greece and beyond. The name Palestine, which derived from Philistine, was used until recently for the whole area south of Syria, and in the present book it will be used in this broader sense. The Phoenicians established harbours and trading centres wherever the Greeks, and later the Romans, were unable to stop them, predominantly along the north coast of Africa, in southern Spain and along the Atlantic seaboard on both sides of the Straits of Gibraltar. The centre of these Punic colonies was Carthage, near modern Tunis, and the Punic state soon became independent of its Phoenician origins and rose to dominate trade in the west Mediterranean basin. It came into conflict with the Roman Republic, and the Punic wars, fought under such generals as Hannibal, culminated in the destruction of Carthage in 146 BC.

Turkey is a land bridge between east and west, north and south, and throughout its history peoples such as the Hittites, Lydians, Lycians, perhaps the Carians, the Phrygians, Ionians and Aeolians, and more recently the Seljuk and Ottoman Turks, have moved into the country, settled and been assimilated by those already there, or have passed through to some other area of Europe, the Near East or beyond. Frequently referred to as Anatolia (from the Greek, meaning 'east'), Turkey consists of a high central plateau embraced by two huge ranges of mountains, the best known of which are the Taurus mountains in the south. These ranges come together in the west, where they are cut by rivers such as the Meander, and extend like fingers out to sea to form the Aegean islands. In eastern Turkey the mountains are gradually being compressed by the tilting of the Arabian peninsula, and the area is subject to earthquakes. The highest mountain, Mount Ararat, lies on the border between Turkey, Iran and the Republic of Armenia; its name is derived from that of the Kingdom of Urartu, which flourished here from the ninth to the seventh century BC, with its capital on Lake Van, and controlled the vast mineral resources of the area. To the 131 north-east, the rich tombs on either side of the Caucasus mountains provide a tantalising glimpse of the cultures which flourished in these areas. South of the Anatolian plateau, major passes cut through the mountains to the coast, the most famous being the strategic Cilician Gates through the Taurus mountains to the rich plains of Cilicia along the Mediterranean.

Finally, to the east lies Iran, also known as Persia. Here, a huge central desert is surrounded on the north, west and south by mountains which are equally rich in mineral resources. To the north-east and east there is no clear natural boundary between Iran, Central Asia and the areas now known as Pakistan and Afghanistan. Lapis lazuli from the mountains of Badakhshan in Afghanistan (and later perhaps tin) was the principal item of trade which

passed through Iran to the countries of the Near East and to Egypt. In south-central Iran a local source of chlorite, a soft green stone, was exploited by the inhabitants of Tepe Yahya, and vessels made from it were traded as far afield as Syria. Bronze-working was a major activity in Luristan in the west. Here, in remote mountain valleys, communities developed their own individual cultures, but it has been suggested that nomads formed a link between them and carried objects made by them southwards to the markets of Elam around Susa. Geographically this latter area, now known as Khuzistan, is an eastward extension of the south Mesopotamian plain, but politically it has always been separate and this tension has led to conflicts between the two areas from time immemorial, culminating most recently in the Iraq–Iran war. The cultural life of the two areas has always reflected this political tension, and Elam shifted its location accordingly, at times controlling an area round a more eastern capital at Anshan (Tall-i Malyan), and at others centred on Susa, which was closer to Mesopotamia. Later, after the arrival of 143 the Indo-Aryan Persians, Susa remained the capital and Persepolis replaced Anshan as the royal city of the Achaemenid Persians.

The climate of the huge area covered by the term Near East is as varied as its geography. What has frequently been referred to as the Fertile Crescent extends in a huge arc south of the mountains forming the natural border between Turkey and Syria, and then curves round along the Zagros mountains which form a similar natural boundary between Iraq and Iran. In this region, which not only has sufficient rainfall but is well watered by the rivers flowing from the mountains, there is abundant vegetation, game and fish. Many of the wild species of both animals and plants which were first domesticated by man occur naturally in this area, and here some of the earliest farming communities developed. It used to be thought that this was the so-called 'cradle of civilisation', but it now appears that similarly favourable conditions existed in many other regions, for instance in an area of caves near Mount Carmel on the borders between Israel and the Lebanon; around Damascus and even further out towards the Syrian Desert; in central and south-eastern Turkey; and in the valleys of western Iran. Numerous other places are constantly being added to the list as surveys and excavations increase our knowledge.

These rural communities may have been responsible for what is sometimes referred to as the 'Neolithic' or 'Agricultural Revolution', but although they produced interesting painted pottery, figurines and sometimes wall-paintings, something more was necessary to create a civilisation. The right conditions for this emerged in the land of Sumer, in the southern reaches of the Tigris and Euphrates rivers. Here there was an area of 3 marshes where wild boar and fish abounded and date-palms grew, and where a specialised way of life developed which has remained virtually unchanged over the millennia. Beyond, however, the country is arid, and in

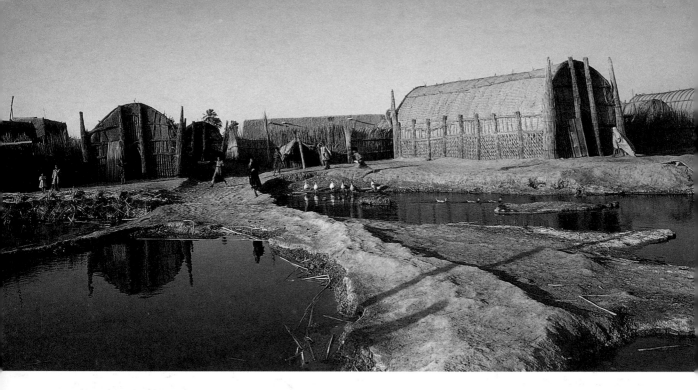

3 The *mudhif* reed huts of the marshes of southern Iraq have not changed over the millennia (see Figs 33 and 37). They are made of bundles of reeds used both as uprights and bent over to form the ribs of an arched roof, which is then covered with reed matting. The walls are made of reed trellises through which the light can filter and air can circulate. The patterns created by the criss-crossing lines of the trellis may have inspired early pottery designs in the region (the so-called Eridu and Hajji Mohammed styles).

order to grow plants and feed their cattle and flocks the inhabitants have to divert the waters of the Tigris and the Euphrates into a network of canals and irrigation ditches. Irrigation agriculture can only be practised successfully if there is co-operation on a large scale between those building, administering and benefiting from the canals. A similar degree of co-operation was needed for the development of agriculture in the Nile Valley in Egypt, the Indus Valley on the borders of Pakistan and India, and the Yellow River in China, and it is no coincidence that all developed early, successful and individual civilisations, accompanied by the elaboration of recording systems and writing (see Chapter 1).

The production of surplus crops, by-products and manufactured goods meant that exchange was possible and this enabled the Sumerians, or their predecessors in the area, to obtain materials which were lacking in their country, such as wood of better quality than the fibrous date-palm, oil, stones and metals. This long-distance trade brought other regions into contact with Sumer, and ideas as well as goods travelled along the waterways and tracks of the Near East. By the fourth millennium BC distinctive cultures were developing in Sumer, south-western Iran and Egypt, and these cultures were in touch with one another. The civilisation developed in Sumer spread up the river valleys and their tributaries into Syria and Turkey, and in each area, under this impetus, further cultures evolved, combining the new ideas with what had been elaborated locally over the millennia.

The increase in wealth led to the development of a hierarchy able to make use of it. At first the economy seems to have been controlled by the temples of the local deities and their priests, but increasingly, during the third

millennium BC, wealth came to be concentrated in the hands of secular powers. In order to enhance the importance of their temples or palaces, priests and rulers stimulated the creation of beautiful objects made of rich materials, often imported over great distances.

The objects produced in this way are not always what we now understand as art. But art is so often a question of personal taste, and what is beautiful to one person or within one culture may not be so to another person or in another context. The taste and financial resources of the person who commissions a work of art are, and always have been, key factors (see page 187 and Fig. 147). The amount of time and technical expertise expended on an artefact have also always been taken into account in assessing its worth. Many of the objects which we consider to be works of art may not have been valued in the same way by the people who created them, because they saw them in the context of a whole culture, while for us only the tip of the iceberg remains.

What has survived from the cultures of the Ancient Near East is to a large extent due to the strange configuration of ancient sites in the region. Until the recent advent of concrete, and even perhaps since, the main building material has been mud brick. The raw materials for this – mud and straw for bonding – are ubiquitous. In areas where stone was available, mud-brick

4 Mud-brick houses at Tell Mahli north of Hama in Syria in 1967. The beehive construction is a wood-saving device already known, it seems, at Arpachiyah in northern Iraq in the 5th millennium BC. Note the new concrete building in the background.

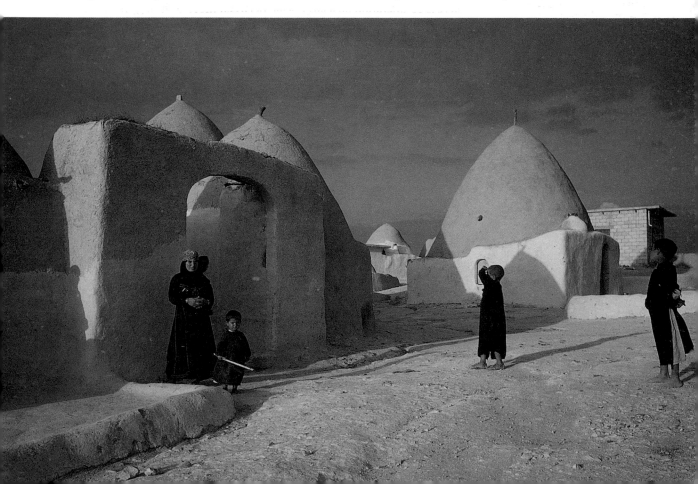

walls were often built on stone foundations or were faced with stone slabs which could be carved with reliefs. Where fuel was available in sufficient quantities, the mud brick could be baked, but baked brick was normally reserved for weather-proofing major buildings, and then only for the outer skin of bricks. In earthquake areas half-timber constructions were common because they gave buildings the necessary elasticity; however, in the event of a fire accompanying the earthquake, such buildings have been shown to be extremely vulnerable. Usually, because suitable wood for roofs, door- and window-frames was generally at a premium, when a building was abandoned the wood would be removed and reused. The mud-brick building would be demolished and the site levelled to provide a platform for the new building. These platforms, therefore, contain the foundations and ground-plans of earlier buildings. As the process repeats itself, so a mound is formed, incorporating a series of superimposed platforms and building remains.

Thus, over the years, the mounds grow, and they are found all over the Near East, extending into Egypt and the Balkans. The secret of a mound's rapid growth lies in the use of perishable materials. To a lesser extent, the same process can be traced in the older European cities, where Roman and medieval levels lie below the surface of modern roads, and steps often lead down into old churches and cathedrals where once they led up to them. However, because in these cities baked brick or stone, both reusable, have been the main building materials, the rate of growth is much slower and the characteristic mound is not perceptible.

The Near Eastern mound is a feature of the landscape; in Arabic it is referred to as *tell*, and in Turkish as *hüyük*, *höyük* or *tepe*, and one of these terms appended or prefixed to a place-name means that somewhere in the vicinity there is an ancient site. Settlements have generally been centred on strategic cross-roads, near fords or ferries across rivers, or near the sources of raw materials. A good water supply has always been an essential prerequisite and, because the presence of water meant the possibility of flooding, a natural elevation would, if possible, be selected for the original settlement; as a result, many ancient mounds are in part natural. As a mound increased in height, so the climb up and down to the water-source became steeper and the area at the top of the mound became smaller. Buildings would be terraced into the sides of the mound, but eventually most of the new houses would be built around its foot, and the old town, sometimes walled, sometimes including the palace or temple of the city, would survive in a fossilised state at the top. Erbil, in northern Iraq, is a huge mound topped by a citadel and an old city, while the new city and market stretch at its feet.

Qalaat el Moudiq, in Syria, is another example. The mound was built on a 5 natural limestone outcrop dominating a ravine which provided access from

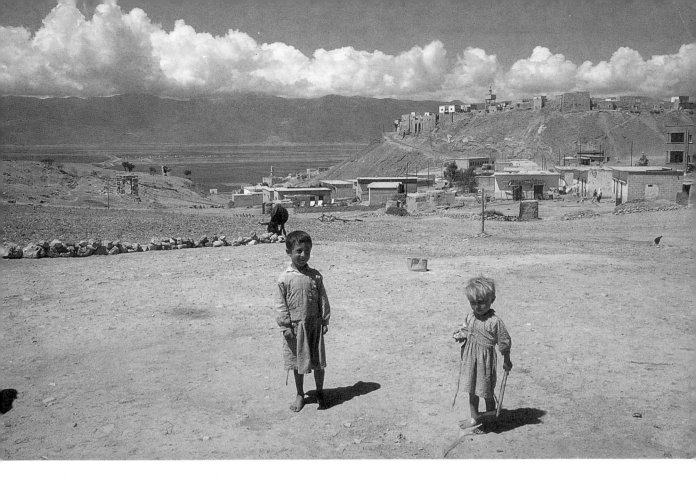

the Ghab depression and the River Orontes onto the plateau north-west of Hama. Excavation into the slopes of the mound has revealed occupation from at least as early as the fifth millennium BC and Palaeolithic flints indicate some activity around the site at a much earlier date. Later the mound served as the acropolis of the Hellenistic and Roman city of Apamea, the ruins of which cover the hills on the opposite side of the ravine. The Ghab had probably already become a malarial marsh during the second millennium BC, but earthquakes, the advent of Islam and the subsequent break in trade with the west from the seventh century AD onwards led to the abandonment of Apamea and only the acropolis was still inhabited. When the Abbasid caliphs were building their capital at Samarra north of Baghdad in the ninth century AD, they obtained some of their building materials and columns from Apamea, 500 miles across the Syrian Desert. The fortifications built by the Crusaders are still visible on the top of the mound. In the sixteenth century a charming little mosque was built into the slopes of the mound and an Ottoman caravanserai – now a museum of Roman mosaics – was built in the valley. The modern village still huddles within the Crusader ramparts but is expanding along the track up the ravine. Drainage of the Ghab is leading to repopulation of the valley.

Changes in water supply or in a road or canal system can lead to the abandonment of a site, and the process of erosion means that the upper

5 Qalaat el Moudiq in Syria. The mound is on the right, crowned by the later fortifications built by the Crusaders (the large number of fair-haired children are reputed to be their descendants). The ravine leads down to the Ghab depression, where a modern canal is visible in the distance. The arch on the left was part of the Roman theatre, and the minaret of the mosque appears just above the donkey.

17

levels are gradually washed down the slopes of the mound. In some cases a river will change its course and part of the mound may be washed away. Or a mound may be buried in alluvial deposits; this has happened to many sites in southern Iraq and some have only been rediscovered during the cutting of an irrigation channel or a new road.

When an archaeologist selects a site for excavation, the task, in the Near East, is made easier for him (or her) because the presence of the mounds indicates the location of habitation sites. However, these need not necessarily be very ancient, and in order to choose one of the period he wishes to investigate, he must carry out a survey in the area of his choice. The clues to the dates of the sites lie all over the mounds and around them in the form of sherds of broken pottery. Pottery, which was first made around 6000 BC, is one of the most enduring of all artefacts and is an extremely good indicator of date – we only have to think of the way fashions in china and in the types of dishes we use in our kitchens have changed over the last few decades to see that this is so. And because pots break and are thrown away, the archaeologist has to look for sherds showing the shape or decoration which are typical of the period in which he is interested.

Pottery sequences have been established for most areas of the Near East and provide relative dates. Certain items, such as oil and wine, were traded in pottery containers and these have allowed links to be made between individual pottery sequences. Sometimes approximate dates can be provided through scientific methods such as thermoluminescence (which indicates when a pot was fired), radioactive Carbon 14 (for organic matter), or dendrochronology (tree-ring dating of wood). In some areas, or at some periods, absolute dates have been established by texts (see page 24 below) recording astronomical observations or sequences of kings, thus providing fixed points within relative chronologies.

The sherds on the top of a mound will be those from the pottery in use immediately prior to its abandonment. Sometimes the sherds at the mouth of an animal's burrow will give some indication of the types of pottery hidden in the heart of the mound. Where an extensive settlement is succeeded by a smaller one, evidence of the larger settlement will survive on parts of the surface and the mound will have an irregular shape. The excavation of a composite mound is difficult because the latest levels at the top of the parent mound will be earlier than, or contemporary with, the settlement at its foot, and the houses terraced into the sides of a mound will be later than other houses at the same level but within the parent mound. It is therefore necessary to keep a close check of which walls cut into which. In the last centuries BC there was a widespread habit of digging deep grain silos, later used as rubbish pits, and the outlines of these have to be carefully plotted since the contents of the pits will be later – and sometimes very considerably later – than the levels into which the pits have been sunk.

POTTERY IS THE BEST FORM OF KNOWING FROM WHAT PERIOD IS A CITY/VILLAGE

THERMOLUMINESCENCE
RADIO ACTIVE 14 CARBON

DENDROCHRONOLOGY
ASTRONOMICAL OBSERVATIONS
SEQUENCES OF KINGS

Graves present a similar problem, but the habit of digging cemeteries into the tops of abandoned mounds persists to this day and often causes difficulties for the would-be excavator who suddenly finds he has a whole community up in arms. In the 1870s Hormuzd Rassam had to excavate the mound of Balawat in northern Iraq through a series of tunnels in order to avoid disturbing the graves on the surface, and in the 1950s Max Mallowan was confronted with the same problem, which he thought he had solved by paying the inhabitants of the modern village of Balawat a sum in compensation, only to discover that the mound served as a cemetery for several different villages. Sometimes the excavator will cut a step trench into the side of a mound in order to establish the whole sequence of occupation. If part of the mound has been washed away by a river, then the section through the mound, once cleaned up, can serve the same purpose. This sequence of layers is known as the stratification of the mound.

The history of the exploration of the ancient sites of the Near East is tied to religion, politics and economics as well as to the growth of interest in antiquarian matters in Europe in the seventeenth and eighteenth centuries AD. Religion has been responsible for interest in the Holy Land throughout the last two thousand years. Pilgrims, and later Crusaders, brought back relics, although the majority of these were of very doubtful authenticity. 179 However, many of them were wrapped in pieces of old silk of Sasanian date (c. AD 224–651) and woven with intricate designs incorporating animals and mythical creatures (see also Chapter 6). One Crusader brought back a small stone from the site of the Crucifixion in Jerusalem and donated it to the Cappella Palatina in Palermo, where it was enclosed in a casket and only rediscovered in 1981: it turned out to be a cylinder seal of about 2300 BC from southern Mesopotamia (now Iraq). The merchants of Venice also returned with treasures from their forays into the Near East, which included the sack of Constantinople in 1203 during the Fourth Crusade; Sasanian vessels and jewels were given Byzantine settings and are now to be found in the Treasury of St Mark's. During the nineteenth century, missions were set up in the Holy Land and interest in the Bible led to research in antiquities relating to the Old and New Testaments. Too often, however, excavations were – and sometimes still are – undertaken to 'prove' the Bible right, leading to selective interpretation of the finds.

Travellers in the nineteenth century showed considerable interest in the topography of the Holy Land and attempted to locate the sites mentioned in the Bible. In 1864–5 Captain Charles Wilson carried out the first accurate survey of Jerusalem. The interest this work aroused led to the establishment of the Palestine Exploration Fund, under whose auspices further surveys in Sinai and Palestine were undertaken, notably by a team led by Lieutenant Charles Warren who mapped the Temple area in Jerusalem (1866–8), often by means of tunnels and at great personal risk. Some antiquities were

acquired during these activities but generally their date remained to be established. In 1890 the Fund selected William Flinders Petrie to direct its first excavations at Tell el-Hesi near Gaza. Petrie was able to establish a pottery sequence for the mound, covering three millennia from the Early Bronze Age to Greek times; absolute dates were provided by finds of closely datable Egyptian objects. His work was continued by Daniel Bliss, who used a grid system to plan the site and then went on to work in Jerusalem and, together with R. A. S. Macalister, at a number of other sites which were published by the Fund. Between 1902 and 1909, Macalister excavated and published the finds from biblical Gezer, but his incomplete grasp of the stratification led to confusion in his attribution of the finds to particular levels. The lack of written documents in Palestine meant that a terminology was needed to divide the finds chronologically. Macalister used the terms Early, Middle and Late Bronze Age; his successor for the Fund, Duncan Mackenzie, working at biblical Beth Shemesh, refined the terminology, and it has since undergone many further changes and interpretations.

After the First World War, work resumed in the Holy Land. Between 1926 and 1934 Petrie excavated at Tell Jemmeh, Tell Fara South and Tell el-Ajjul and built up a substantial body of information which he published with exemplary speed. The famous biblical site of Jericho, which had previously been investigated only briefly, was excavated by Professor John Garstang (1930–6) and Kathleen Kenyon (1950–8). These excavations

6 The prehistoric mound of Tell es-Sultan, the site of biblical Jericho. In the foreground are the remains of part of the camp inhabited by 70,000 Palestinian refugees between 1948 and 1967. In the distance is the River Jordan.

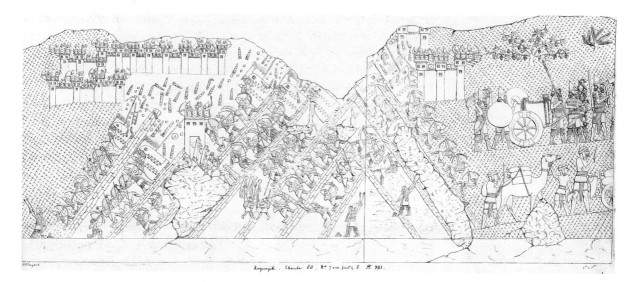

revealed substantial remains dating back to around 7000 BC, and a particularly important sequence of Middle Bronze Age tombs from the early centuries of the second millennium BC (see pages 41 and 97).

The excavations of the site of Lachish between 1932 and 1938 (when the director of the excavations, J. L. Starkey, was murdered by bandits) were sponsored by Sir Henry Wellcome and Sir Charles Marston, whose share of the finds has recently been acquired by the British Museum. These finds have a particular significance because one of the Museum's treasures is a series of Assyrian reliefs from Sennacherib's South-West Palace at Nineveh, depicting that king's capture of Lachish in 701 BC.

It is important to stress that the British Museum's collections of material from the Holy Land come to a large extent from excavated sites. A firm foundation for the reconstruction of biblical history can only be obtained through meticulous excavation; the Museum has therefore contributed to this work and now houses a useful collection of well-stratified and provenanced material from most of the sites mentioned above, acquired on the basis of its scientific importance rather than artistic merit. This policy has continued with the recent excavations by Jonathan Tubb at Tiwal esh-Sharqi and Tell es-Sa'idiyeh in Jordan.

Politics and economics were the impetus for interest in other areas of the Near East. The Portuguese had opened up trade with the Far East, and the British, French and Dutch were determined to break this monopoly. The East India Company was founded in 1600 and the British began acquiring huge territories in India. Then the Russian Tsar Peter the Great (1682–1725) had the ambition to provide his country with a port on the Black Sea and access to the Mediterranean through the Bosphorus. To counter this threat to the balance of power, contacts with the Ottoman Turks were

7 Drawing by A. H. Layard of some of the reliefs he excavated in Room XXXVI of the palace of the Assyrian king Sennacherib (r. 704–681 BC) at Nineveh in northern Iraq. Here the siege of the Judaean town of Lachish is depicted (see pp. 142–5).

8 This stone relief from the North Palace of Ashurbanipal at Nineveh (*c.* 650 BC) depicts gardens on a slope planted with trees and a columned pavilion, with a royal stele to the left, abutting on a turreted wall. Water is brought in on an aqueduct with pointed arches similar to one built about 700 BC by Sennacherib and excavated at Jerwan north of Nineveh. Classical and Roman authors frequently confused Babylon and Nineveh, and Stephanie Dalley has suggested that the 'Hanging Gardens' were actually at Nineveh, where Sennacherib records planting exotic trees and constructing complicated works to water them. Ht of register 95 cm.

9 The 'Bellino Cylinder', once in the collection of C. J. Rich, is inscribed on clay in the cuneiform script with a text describing the first two campaigns of the Assyrian king Sennacherib (r. 704–681 BC). It was copied for publication by Charles Bellino (1791–1820). L. 26.7 cm.

intensified and missions were sent to the Shah of Persia. Later, in response to the Russian threat in Central Asia, the British established bases in Afghanistan and along the north-west frontier of India.

In order to reach India by ship, it was necessary either to circumnavigate Africa, or to sail to Alexandria, travel overland to Suez, and re-embark there for Bombay. When, in 1798, during the Napoleonic wars, the French conquest of Egypt made this shorter journey impossible, the British were forced to find an alternative overland route through the Near East, which was then part of the Ottoman Empire and ruled by the Turks from Constantinople. As a preliminary, they opened a Residency in Baghdad and in 1808 appointed a young man of 21, Claudius James Rich, as Resident. Rich was a brilliant linguist and extremely able. He travelled extensively throughout Mesopotamia and kept records of the sites he visited, including Nineveh. In 1811, and again in 1817, he spent several days examining the ruins of Babylon, and he published accounts of his findings. The walls and 'Hanging Gardens' of Babylon had been one of the 'Seven Wonders' of the ancient world but the city was reduced to a group of impressive mounds along the Euphrates south of Baghdad. In the nineteenth century it became fashionable for adventurous young men to extend their Grand Tour of Europe to include parts of the Near East, while others travelled overland to take up appointments in India. Many of these came to Baghdad, where the Riches welcomed them and arranged for them to see the sites, which they duly recorded. Regrettably, Rich died of cholera in Shiraz in 1821. He had, however, built up a large collection of antiquities, coins and manuscripts and these were sold to the British Museum by his widow in 1825 for £7,000. He seems to have been particularly interested in objects (including seals) inscribed in the cuneiform script and was greatly aided in recording the inscriptions by his secretary, Carl Bellino.

Excavations at Uruk in southern Iraq and at Susa in south-western Iran have produced evidence for the invention of this script some time between 3500 and 3100 BC. At first it was pictographic (that is, simple line drawings representing words, incised on damp clay with a sharp instrument). Gradually the drawings were reduced to signs made up of short straight lines impressed into the clay with a stylus, and as the impression of the stylus formed a wedge, this system of writing has come to be known as cuneiform, from the Latin *cuneus* meaning wedge or nail. Because the system developed from pictographs, each sign represented a whole word of a language which, in southern Iraq, can be recognised as Sumerian. Since most Sumerian words consisted of one syllable, each sign also came to represent that syllable in longer words, words which sounded the same but had different meanings which were less easy to draw, and even similar-sounding words or syllables in other languages. Soon the signs became highly stylised, and any resemblance they might still have retained to the original pictograph vanished

8

9

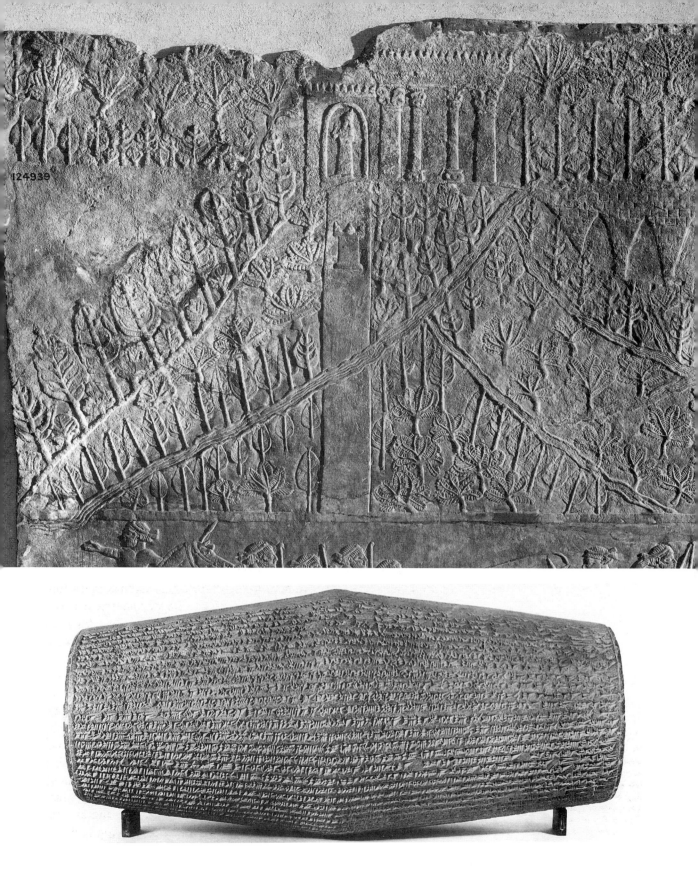

23

when the direction of writing turned through ninety degrees – a phenomenon which has also been detected in other scripts.

Because of its versatility, cuneiform was adapted for writing languages totally unrelated to Sumerian, the principal ones being Akkadian and its Assyrian, Babylonian and West Semitic dialects, Ugaritic, Hurrian, Hittite, Urartian, Elamite and Old Persian. Thanks to the survival of vocabulary lists and dictionaries, it has been possible to decipher most of these languages.

But the lists and dictionaries would not have survived had they not been written predominantly on clay. Already used for buildings and for making pottery, clay was available everywhere. When baked, it is one of the most long-lasting materials used by man. Many archives have been burned accidentally over the millennia, but whereas papyrus, leather, parchment, lead and, more recently, paper, are destroyed, a fire serves to preserve an archive written on clay by baking it. Egyptian funerary papyri have survived in the dry conditions which prevail in Egyptian tombs, but the day-to-day correspondence and records are largely lacking. Not so with cuneiform texts: ration lists, letters, annals, epic poems, myths, legends, school texts, maps, mathematical problems, astronomical records, omens and rituals and many other types of text have survived and have been excavated over the last couple of centuries. At certain periods, cuneiform writing was used all over the Near East and even for diplomatic correspondence with Egypt. It has been said that for no other period are there the same number and variety of surviving texts as for the three thousand years when cuneiform was the main writing system. Our own written culture may be more extensive, but how much of it is likely to survive for up to five thousand years?

The cuneiform script, though devised for writing on clay, was adapted for carving on stone and first came to be known in the West through copies of rock-cut inscriptions still visible in the ruins of Persepolis; these copies had been made by early travellers such as the Italian Pietro della Valle in the early seventeenth century and the Dane Karsten Niebuhr in the late eighteenth century. The German philologist Georg Friedrich Grotefend had already worked on its decipherment when Henry Creswicke Rawlinson travelled to Iran as part of a military mission to the court of the Shah. In 1835 Rawlinson was posted to Kermanshah and over the next twelve years he undertook the copying of a long inscription 120 metres up, on a mountainside at Bisitun, 35 kilometres east of Kermanshah. The inscription accompanies a relief depicting the Achaemenid Persian king Darius I (r. 521– 486 BC) receiving the submission of nine rebel chiefs and trampling underfoot the usurper Bardiya. It was written in three languages: Old Persian, Elamite and Babylonian, and the rock below was cut back so that the inscription would not be defaced. The courage and ingenuity which Rawlinson displayed were finally rewarded when, with the help of a local

Kurdish boy, he obtained squeezes (impressions made on special dampened paper) of all the inscriptions. Armed with these, he worked on the decipherment of the script. His notebooks were kept in the British Museum (they are now in the British Library), as were the squeezes until, some fifty years later, they were partly eaten by mice.

The Old Persian inscription was quasi-alphabetic and Rawlinson began with this, as had Grotefend before him. A royal name, frequently repeated, was written, like those of the Egyptian pharaohs, in a cartouche, or frame. The number of signs gave the length of the name which, through a process of trial and error, it was possible to identify with that of Darius, mentioned by the Greek historians. The repetition of groups of signs following this name could be equated with the title 'king of kings'. And so, gradually, the values of more and more of the signs were established. A further impetus to Rawlinson's cuneiform studies came when, in 1843, he became Resident in Baghdad – the same post once occupied by Rich.

In the meantime, still with the aim of finding a better overland route to India, an attempt had been made to sail down the Euphrates. To achieve this, two paddle-steamers, the *Tigris* and the *Euphrates*, were sent out from England in pieces and brought, with considerable difficulty, from the Mediterranean coast to the River Euphrates at Carchemish, where they were assembled and eventually set sail. On 21 May 1836 the *Tigris* sank during a hurricane and twenty people were drowned. The expedition established that the River Euphrates was not navigable, but that the Tigris below Baghdad was. The benefit for Near Eastern archaeology was the partial mapping of both river valleys, including the ancient sites along them, more especially Nineveh and Nimrud in Assyria and Babylon south of Baghdad. These maps, produced by Captain Felix Jones in 1852, are the most accurate record of what the sites and the areas around them were like before excavation, modern irrigation and roadworks changed them.

Meanwhile, another young Englishman, who was to have a profound influence on Near Eastern archaeology and on the collections in the British Museum, was also getting his first glimpse of the mounds. This was Austen Henry Layard who, with a friend, set out in 1839, at the age of 22, to travel overland to take up an appointment in Ceylon. Layard's interest in Near Eastern antiquities had already been fired by the published accounts of Rich and other travellers. He later wrote several popular narratives of his own adventures and excavations, which became best-sellers at the time and still make very good reading on account of their lively style and enthusiasm. In May 1840, after visiting the mounds of Nineveh and Nimrud, he continued south to Baghdad where he stayed with Rawlinson's predecessor at the Residency, Colonel Taylor, learning much from him and from members of his staff about the ancient remains of Mesopotamia. He then travelled east into Iran, where he visited the rock inscription at Bisitun and spent time

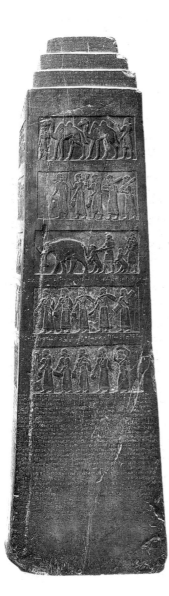

10 The 'Black Obelisk', a tall block of black stone discovered by A. H. Layard at Nimrud in 1846, decorated with twenty small reliefs and with cuneiform inscriptions recording campaigns of the Assyrian king Shalmaneser III (r. 858–824 BC). This side shows tribute from the eastern part of his empire, including Bactrian camels, an Indian elephant and apes; see also Fig. 11. Ht 1.98 cm.

exploring Khuzistan, before abandoning the journey to Ceylon and returning to Baghdad. In 1842 he was sent by Taylor to the British Ambassador in Constantinople, Sir Stratford Canning, who was later to help him diplomatically and financially in his excavations. On his way, he stopped in Mosul and met Paul Emile Botta, the French Consul, who was at that time engaged in somewhat fruitless investigations in the mound of Kuyunjik, the citadel of the ancient Assyrian capital Nineveh. In 1843, Botta moved to Khorsabad, the one-generation Assyrian capital of Dur Sharrukin built by Sargon II (r. 721–705 BC), where his excavations were more fruitful, and many of his finds now grace the Louvre in Paris.

Layard eventually arrived in Constantinople, where he entered Canning's service and carried out various missions for him; however, the British Government failed to make his appointment official. In 1845, therefore, armed with an official *firman*, and with funds provided by Canning, Layard returned to Mosul with the aim of excavating at Nimrud. He enlisted the help of Christian Rassam, the British Vice-Consul in Mosul, and that of his business partner, the Englishman H. J. Ross, and set off on 8 November to sail down the Tigris to Nimrud. Layard spent a troubled night with 'visions of palaces underground, of gigantic monsters, of sculptured figures and endless inscriptions' floating before him. The next day he set his six Arab workmen digging in two areas of the citadel mound, and by evening they had located chambers decorated with inscribed stone slabs in two of the palaces of this Assyrian capital of the ninth century BC. During the next few days more chambers were located and the first of the famous Nimrud ivories were excavated. (These ivories, together with Layard's other finds, will be studied in greater detail in Chapter 4.) Layard increased his force to thirty workmen and discovered his first Assyrian reliefs on 28 November. However, the local Turkish Pasha put an end to his activities by claiming, wrongly, that he was disturbing Muslim graves, and the captain of the Turkish troops stationed nearby was ordered to move headstones from a neighbouring cemetery and re-erect them on the summit of the main mound at Nimrud in order to give substance to the allegations.

While Layard was waiting for a new *firman*, which Canning obtained for him from the Sultan, he visited the caravan city of Hatra and also undertook some soundings on Kuyunjik, the citadel of Nineveh, where he uncovered the human-headed bull colossi which guarded the Nergal Gate. Canning also succeeded in convincing the Trustees of the British Museum that they should fund Layard's further researches. Although they agreed to do so, they were parsimonious in the extreme and put Layard under pressure to 'obtain the largest possible number of well-preserved objects of art at the least possible outlay of time and money'. When he returned to Nimrud, Layard excavated further reliefs which he prepared for shipment to England by sawing off their backs and, where the designs were in two registers,

cutting them in two in order to make them lighter for transport. Layard had hoped that his Assyrian reliefs would be the first to reach Europe, but the race was won by Botta who, thanks to the more effective backing of his government and the greater means at his disposal, was able to ship his Khorsabad reliefs more rapidly to France.

When, after a break during the summer, Layard resumed his excavations at Nimrud in November 1846, the rate of his discoveries increased. Among them was the Black Obelisk which is now one of the glories of the British Museum. Its inscription provided the first independent confirmation of the existence of an Israelite king named in the Old Testament. The Victorians flocked to the British Museum to see the evidence.

Layard also arranged for one each of the human-headed, winged bulls and lions which guarded the doorways of the palaces to be shipped to England – no mean feat, with the limited means at his disposal, since they are 3.5 metres tall and weigh almost 10 tons each. The lion colossus was attacked by a band of robbers on its way to the river and bears a bullet mark as evidence. In 1849 Rawlinson acquired and shipped to the British Museum two of the human-headed, winged bulls and attendant figures which Botta had excavated at Khorsabad in 1843–4; these are 4.40 metres tall and weigh 28 tons.

11 Detail of another side of the 'Black Obelisk' (Fig. 10) showing 'Jehu son of Omri' presenting tribute to Shalmaneser III. This is the same Jehu, a usurper, who appears in the Old Testament as one of Ahab's successors on the throne of Israel. Omri was not, in fact, Jehu's father but Ahab's, and he was the founder of the Israelite capital and dynasty in Samaria (I Kings 16: 15–28; II Kings 9–10).

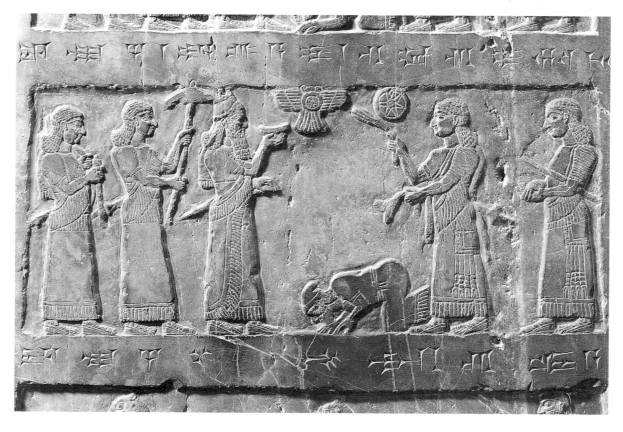

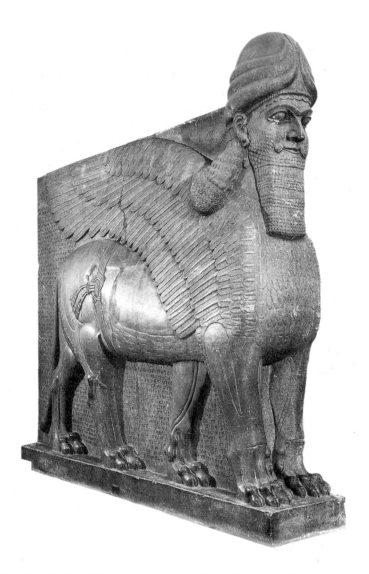

12 Gypsum lion *lamassu*, guardian of one of the doorways in the palace of the Assyrian king Ashurnasirpal II (r. 883–859 BC) at Nimrud in northern Iraq. Ht 3.50 m; wt *c*.13 tons.

In 1847, before his money ran out, Layard also carried out some work at Qalaat Shergat, the site of the earliest Assyrian capital at Ashur. Here he was surprised not to find the stone slabs which lined the walls of the palaces at Nimrud and Nineveh and on which he relied for his location of the walls. Without them as a guide, he was unable to differentiate between the mud-brick walls and the earth fill of the rooms and, indeed, dug through the walls without recognising them. It was only some half a century later, when the Germans had elaborated the technique of wall-tracing, that it became possible to follow the line of mud-brick walls with any accuracy. Layard did send back to the British Museum a large but fragmentary black stone sculpture which, for years, was thought to represent King Shalmaneser III but has now been identified by Julian Reade as a statue of the god Kidudu, guardian of the city wall of Ashur, dedicated by Shalmaneser after his restoration of the wall (WA 118886).

Before he finally left for England, Layard made one other sounding into the south-west corner of the mound of Kuyunjik where, he now realised, the Assyrian levels were buried under a considerable depth of later debris. Here he began to uncover the remains of the monumental façade of the South-West Palace of Sennacherib (r. 704–681 BC). This was a fitting climax to his work in Assyria and brought to seven the number of Assyrian palaces which he had excavated, ranging in date from the ninth to seventh centuries BC.

Official recognition left something to be desired, however, since it consisted solely in his appointment as unpaid attaché to the Embassy in Constantinople. Furthermore, the Treasury refused a grant for the publication of his finds. These, after much delay, finally arrived in October 1848 via Bushire in Iran, Bombay in India, and Trincomalee in Ceylon, having weathered a serious storm and unauthorised unpacking and pilfering which resulted in the loss of much valuable information as to the origin of the pieces. When his finds were eventually put on exhibition, and when his popular account of their discovery was published, Layard found the recognition he received from the public was far more generous than that which he had obtained from official sources.

However, by 1849, Layard was already on his way back to the Near East to serve on the Turco-Persian Boundary Commission. When he reached Constantinople, he found awaiting him a request to continue his Assyrian explorations, for which a sum of £3,000, spread over two years, had been allocated. He was also provided with a succession of assistants who were selected for their skill as draughtsmen. Indeed, it was now recognised that the adequate recording of the relief sculptures which he was uncovering was of paramount importance; only relatively few were sufficiently well preserved to be sent back to the British Museum, and those left uncovered rapidly deteriorated when exposed to the rain and frosts of a winter in northern Iraq. Work continued at Nimrud and at Nineveh, where the South-West Palace of Sennacherib was excavated by means of a series of deep, dark, airless, dusty and dangerous tunnels: one can but marvel at the
7 quality, quantity and accuracy of the drawings executed by Layard and his assistants under these conditions. Seven huge folio albums of drawings survive in the British Museum, some of which were subsequently engraved and published. However, Layard was unlucky in his assistants: Cooper's health broke down, Bell was drowned and Hodder was young and inexperienced, so it is fortunate that Layard was able to rely, for the direction of the excavations, on the services of Hormuzd and Christian Rassam and H. J. Ross. The scale of the undertaking was truly remarkable, for, as Layard wrote:

> In this huge edifice I had opened no less than seventy-one halls, chambers and passages, whose walls, almost without exception, had

14 OPPOSITE Detail of Ashurbanipal's lion hunt relief from the North Palace at Nineveh in northern Iraq, showing the head of the king (see Fig. 121). About 650 BC.

been panelled with slabs of sculptured alabaster recording the wars, the triumphs, and the great deeds of the Assyrian king. By a rough calculation, about 9,880 feet, or nearly two miles of bas-reliefs, with twenty-seven portals, formed by colossal winged bulls and lion-sphinxes, were uncovered in that part alone of the building explored during my researches.

This only takes account of the excavations in the South-West Palace, of which a remarkably accurate plan was produced despite the difficulty of surveying in tunnels. And finally, in addition to other objects found, Layard uncovered two rooms piled with clay tablets inscribed in cuneiform. This was the official library of the Assyrian kings in the seventh century BC and, together with a second library subsequently excavated by Rassam, contained 20,000 tablets and fragments which are still being worked on by scholars of all nationalities in the Students' Room of the Department of Western Asiatic Antiquities in the British Museum.

13

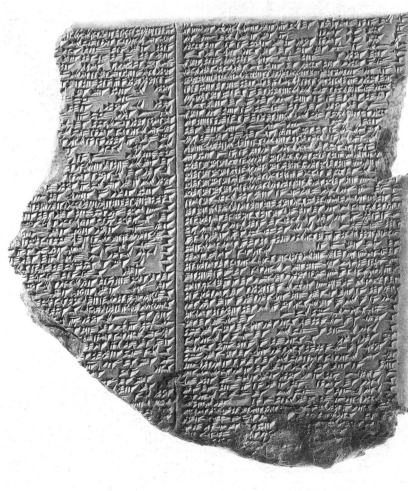

13 The 'Flood Tablet' found in the library of the Assyrian king Ashurbanipal (r. 668–627 BC) and inscribed in cuneiform on clay. When George Smith identified it in 1872 as an Assyrian version of the biblical Flood story, '... he jumped up and rushed about the room in a great state of excitement, and, to the astonishment of those present, began to undress himself.' Ht 13.7 cm.

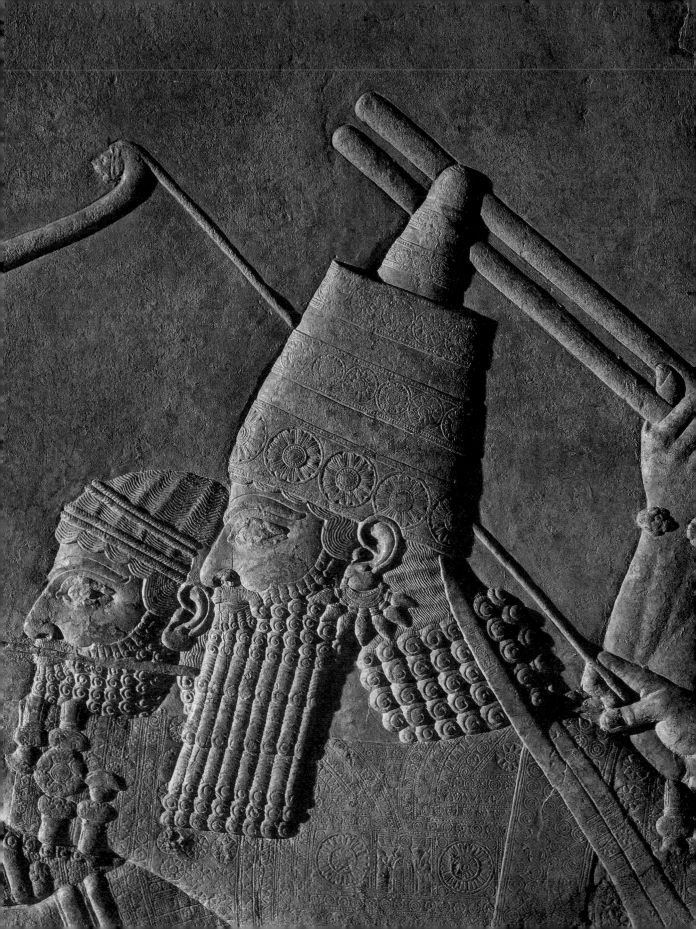

15 One of the three Parthian clay coffins excavated at Uruk in southern Iraq and brought back to the British Museum by W. K. Loftus in 1850. Loftus records that he only succeeded in removing them 'after many fruitless attempts and the demolition of perhaps a hundred specimens'. The body of the coffin and its lid are decorated with mould-impressed figures of soldiers, depicted frontally, and they are covered with green (originally blue) glaze. L. 1.95 cm.

When, after investigating further sites both in Assyria and in Babylonia (many of them subsequently excavated by others with considerable success), Layard finally travelled home in 1851, he had been able to dispatch to London more than 120 cases of antiquities. After the publication in 1853 of his final record of his activities, Layard abandoned archaeology for politics. He became in succession Under Secretary of State for Foreign Affairs, Member of Parliament, Chief Commissioner of Works, and Ambassador in Madrid and finally in Constantinople where he was again able to further the work of the British Museum (see page 34 below). Upon his retirement to a palace on the Grand Canal in Venice he acquired paintings which he subsequently bequeathed to the National Gallery in London. After his death, his widow bequeathed to the British Museum his papers and the jewellery made up of ancient Near Eastern seals which Layard had given her two weeks before their wedding. Several of the Assyrian reliefs which adorned a porch in his father-in-law's house, subsequently used as the tuck-shop in a school, were sold in 1959, and one was acquired by the British Museum. A further relief was later discovered under layers of whitewash and was sold to a Japanese collection in 1994.

Layard's assistant Hormuzd Rassam continued work in northern Iraq, at Nimrud and at Nineveh, where he found the famous lion hunt in the North 14 Palace of the Assyrian king Ashurbanipal (r. 668–627 BC). Technically this 121–3 was in an area allocated to the French archaeologist Victor Place, so Rassam had to excavate at night – not the best conditions for recording and salvaging objects. Place was obliged to accept the *fait accompli* and fortunately the discovery of the second library of cuneiform tablets was carried out under better conditions. Rassam went to London in April 1853 and Rawlinson encouraged William Kennet Loftus and the artist William Boutcher to move to Kuyunjik to continue Rassam's work. In 1855 two events led to a temporary halt in excavations. One was the Crimean War; the other was the loss of a whole shipload of antiquities and reliefs, most of them destined for 16 the Louvre and including some of the Ashurbanipal reliefs, waylaid and capsized by brigands in the lower reaches of the Tigris.

Before working in the north Loftus had, in 1850, explored the mound-strewn plain between the Euphrates and the Tigris south of Baghdad. He had eventually carried out some excavations at Uruk, where the Germans have since found extensive remains dating back to the fourth millennium BC. Loftus had been able to return with some antiquities (now in the British Museum), including wall cones which had decorated columns and pilasters of the late fourth millennium BC, and three Parthian clay coffins dating some 15 three thousand years later. He had also excavated some other sites in the vicinity, among them ancient Larsa and Tell Sifr, where he found a hoard of copper implements and part of an archive of cuneiform tablets. Between 1852 and 1854 Loftus carried out soundings at Susa, in south-western Iran, 101

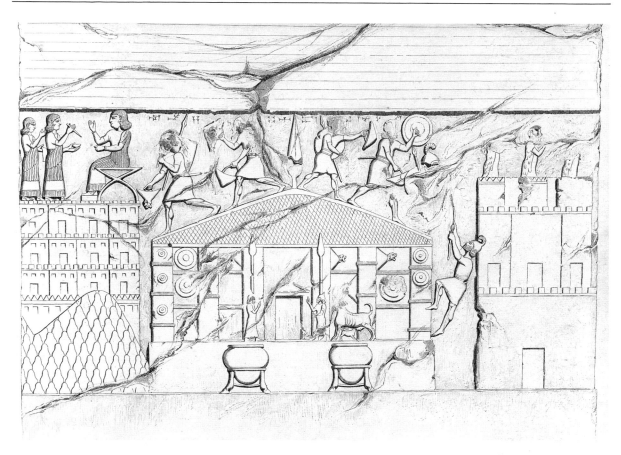

and identified an Achaemenid palace of the fifth to fourth centuries BC. Subsequent excavation in Iran, and especially at Susa, was to be predominantly in the hands of the French.

Further work in the south had taken place, again at Rawlinson's instigation, at the site of Tell Muqqayar, where the British Vice-Consul at Basra, J. G. Taylor, found the inscribed foundation figurines of the huge ziggurat, or temple tower, and Rawlinson was able to identify the site as the city of Ur, mentioned in the Bible as the original home of Abraham. The British were to return to Ur after the First World War (see page 64 below). The sites of Eridu and Borsippa were also identified by foundation inscriptions.

George Smith's discovery of the tablet containing an Assyrian version of the Flood story led to renewed interest in Near Eastern excavation after a break of almost twenty years. Funded by the *Daily Telegraph*, Smith himself went out to Nineveh and succeeded in finding missing fragments of the Flood account. He was sent out twice more by the British Museum but died near Aleppo on his way home in 1876. Hormuzd Rassam, who had in the meantime lived in Aden and elsewhere, was back in London and was asked to resume work on the Museum's behalf. While Rassam was waiting for his

16 Drawing published in 1849 by the French excavators P. E. Botta and E. Flandin of a relief, now lost, from the palace of the Assyrian king Sargon II (r. 721–705 BC) at Khorsabad in northern Iraq. It shows the sack of the temple at Muṣaṣir, on the borders of Urartu, during Sargon's eighth campaign in 714 BC. Note the shields with lion-head bosses, the spears, the sculpture of a cow and calf, and the cauldrons on their stands. See p. 163 for further details of the booty carried off by the Assyrians.

firman in Constantinople, Layard was appointed Ambassador to the Porte and was able to obtain for him a generous concession authorising him to work in eastern Turkey, north Syria and Mesopotamia.

Rassam has been criticised for his methods of excavation but he was, in fact, acting as requested by the Museum, which still wished to obtain as many antiquities as possible for the smallest financial outlay. He has been accused of not keeping records, but photographs and plans have subsequently been found in the Museum's archives. Certainly his brief, and the Museum's inability to find a replacement for him, meant that he had to rely on largely unsupervised teams of workmen. However, during his excavations between 1878 and 1882, Rassam succeeded in finding the bronze strips decorating two sets of Assyrian gates at Balawat, an extensive archive of cuneiform tablets 1 dating to between 1900 and 1600 BC and many other antiquities from Sippar in Babylonia, some Urartian objects from a temple at Toprakkale near Lake 132–5 Van in eastern Turkey, and a large number of tablets and objects from such prestigious sites as Babylon, Borsippa and Nineveh.

Unfortunately, Rassam's method, or lack of it, involved putting trenches into so many sites that the attention of dealers was alerted and this led to illicit digging on a large scale, often by the very men Rassam had left to guard the sites. Wallis Budge, then an assistant and later a Keeper in the British Museum, went out to Mesopotamia in 1888; on his way, in Egypt, he was able to acquire some of the famous Amarna Letters – the diplomatic correspondence, on cuneiform tablets, with the Egyptian pharaohs of the middle of the fourteenth century BC. In Baghdad, Budge purchased objects looted from the sites, many of which he visited. He also returned to Kuyunjik and, in 1889, to Der, near Sippar, only to discover that Der had been looted before he arrived, so that he was obliged to buy back the finds from the dealers. Budge blamed Rassam for the unsatisfactory situation he had found in 1888, and denied the latter's claim that he had excavated the Balawat Gates at the site of that name. The general ill-feeling culminated, in 1893, in an action for slander which was won by Rassam. He was further vindicated when, in 1956, another set of gates (now in Baghdad) was found at Balawat by the British School of Archaeology in Iraq.

Meanwhile, during the eighteenth and nineteenth centuries the growing interest in Classical studies encouraged a number of enterprising travellers and scholars to go to the Middle East. The ruins of Palmyra in the Syrian 164–5 Desert were visited by Robert Wood and James Dawkins, whose abundantly illustrated account, published in 1753, was to have a great influence on the neoclassical revival led by the Adam brothers and their contemporaries. Others visited the Greek and Roman sites on the west and south coasts of Turkey. Some of these travellers continued eastwards into Phrygia and beyond, to the Hittite ruins at Boğazköy and the rock-cut shrine nearby at 17 Yazılıkaya; among them were John Robert Steuart and William Hamilton, 18

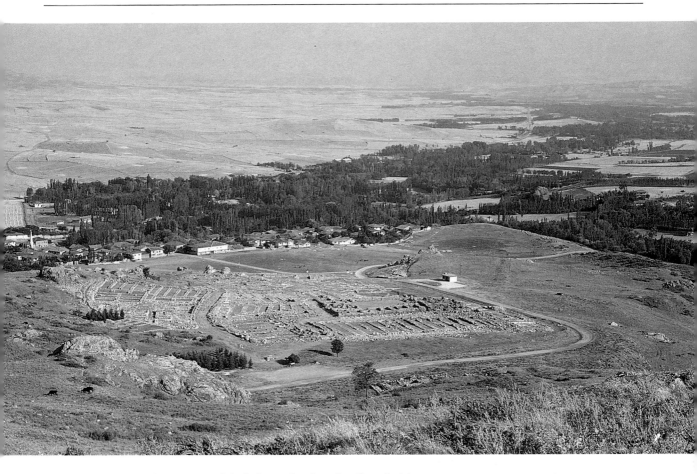

who both published accounts of their investigations in 1842. In his excavations at Hissarlık from 1870 onwards, the eccentric retired German businessman Heinrich Schliemann was also pursuing his search for the Greeks, convinced that he had found the site of the Homeric city of Troy. He discovered several rich hoards of metalwork which he dated to the time of the Trojan wars, around 1200 BC, and it was only later that their true dating in the third millennium BC could be demonstrated. Some of his finds have reached the British Museum. Large amounts of pottery of a similar date were found in 1900–1 by Paul Gaudin at the cemetery site of Yortan, southeast of Troy, of which a substantial proportion was later acquired by the British Museum.

In 1876, A. H. Sayce drew attention to the similarities between some hieroglyphic inscriptions carved on stone, which had been found at Aleppo and Hama in Syria, and the inscriptions cut on the rock-faces at Boğazköy and Yazılıkaya; he suggested that they might have been carved by the Hittites who were known from the Bible. That same year George Smith, the discoverer of the Flood Tablet, copied a similar inscription on the back of a

17 The temple of the storm god (13th century BC) in the Hittite capital, Hattusa (now Boğazköy) in central Turkey, photographed from the citadel where the palaces and administrative buildings once stood. Off the picture to the left the site rises in a huge arc, with walls punctuated by stone gateways along the crests of the surrounding hills.

18 One of the rock-carvings in the open-air shrine known as Yazılıkaya near the Hittite capital (see Fig. 17). It shows King Tudhaliya IV (*c.* 1250–1220 BC) in the embrace of the god Sharruma. The god's name is written above his fist and the hieroglyphs for the king's name and titles are written to the right of the god's horned headdress.

stone sculpture of the goddess Kybele (WA 125007) which he had found at a site on the River Euphrates, on the Syrian-Turkish border. In fact, the statue had first been recorded by Alexander Drummond, British Consul in Aleppo, who had published his findings in 1754 and believed it to be 'the tomb of some dignified Christian clergyman in his sacerdotal vestments'. Smith identified the site as Carchemish, but he died in August that same year and so did not live to see his intuition confirmed by the excavations mounted by the British Museum between 1878 and 1881 under the directorship of P. Henderson. Between 1911 and 1914 the excavations were resumed by D. G. Hogarth and C. L. Woolley, with T. E. Lawrence (of Arabia) as assistant, again for the Museum, and there was a final short season in 1920 before the site became part of a military area. Many of the Carchemish finds, and casts of others, are in the British Museum, together 125 with material purchased by the excavators from various cemetery sites in north Syria, among them Amarna (not to be confused with the site of that name in Egypt) and Deve Hüyük.

Attracted by the presence of further Hittite inscriptions, John Garstang undertook excavations at Sakcegözü in southern Turkey between 1907 and 1911. Later, between 1936 and 1938 he excavated a prehistoric mound just outside Mersin on the south coast of Turkey. At both sites he uncovered a sequence of remains going back to the sixth millennium BC, and he donated collections of sherds to the British Museum.

Further east, the presence of rock-cut cuneiform inscriptions in the neighbourhood of Lake Van had attracted the notice of early travellers and members of the Turco-Persian Boundary Commission. In the 1870s attention was drawn to some bronzes which were said to have come from the site of Toprakkale, just east of Van; some of these were acquired for the British 131–3 Museum by Layard, who also arranged for Rassam to excavate the site, and more bronzes were found in the remains of a temple. The Museum was also able to obtain large numbers of cuneiform tablets and sealed clay envelopes 73b from an unspecified site in central Turkey from which they were being looted by the local farmers during the 1880s; subsequently they were identified as the correspondence of Assyrian merchants of the early second millennium BC and it was established that the site from which they came was Kültepe (see Chapter 3). A large collection of material – mostly bronze 72 weapons and amulets, and some pottery – from graves of the Koban culture of the eleventh to seventh centuries BC in the Caucasus, was presented by Prince Noruz Orousbekov in 1913.

The Russian political ambitions in Central Asia referred to earlier were countered by diplomatic missions to the court of the Shah such as that, in 1810, of Sir Gore Ouseley, who was accompanied by his brother William and by James Morier. They published accounts of their travels, recorded the antiquities, and brought back fragments of reliefs from Persepolis,

which are now in the British Museum. However, it was the Russians who sent Robert Ker Porter to Iran specifically to to record the ancient monuments; this he did in a magnificent series of drawings and watercolours,
19 some of which are preserved in the Department of Manuscripts in the British Library, and eighty-seven of which were published in 1822.

The Punic colonies founded by the Phoenicians in the western Mediterranean were chiefly associated in the public imagination with Carthage, Hannibal, and child sacrifice in the areas known as *tophets*. In the 1850s, the Reverend Nathan Davis, acting on behalf of the British Government, carried out excavations in and around Carthage, near Tunis. In addition to some fine Roman mosaics, he brought back over a hundred Punic stelae of the fourth to second centuries BC which he had found reused in later Roman walls; when, in 1921, the *tophet* of Carthage was discovered (the British Museum has some burial urns from the *tophet* excavations), it became clear that most of these stelae had originally come from there. Davis also purchased a number of neo-Punic stelae of the Roman period from various sites. In 1856 the British Museum bought the 'Great Sardinian Collection' of antiquities excavated on the Tharros promontory on the west coast of Sardinia by Gaetano Cara, Director of the Royal Museum of Cagliari. The
130 objects – including spectacular jewellery and seals – came from tombs of
146d Phoenico-Punic and Roman date.
166–9 The British Museum's collection of antiquities from the Arabian peninsula – mostly from what is now the Yemen – was largely donated by political officers and military personnel, beginning with an important gift in 1862 by Colonel Coghlan of the Royal Artillery of bronze votive plaques inscribed in the bold, well-balanced South Arabian alphabet developed before the middle of the first millennium BC and used well into the Christian era. Earlier material, including ivories, was excavated in 1889 by Mr and Mrs Bent and in 1925 by E. Mackay in grave tumuli on the the island of Bahrain; the dating is problematic but is probably around 2000 BC.

By 1900 a more scientific approach to archaeology was developing in Mesopotamia. German excavators at Ashur and Babylon evolved the methods of tracing mud-brick walls which are now used on all Near Eastern excavations and, because it had begun to be recognised that the context in which objects were found was important, more careful records were kept. The British returned yet again to Nineveh under the directorship of L. W. King (1903–4) and R. Campbell Thompson (1904–5 and 1929–32).

After the First World War, the Ottoman Empire collapsed and its provinces were divided up between France, which took over Syria and the Lebanon as its mandate, and Britain, which assumed control of Jordan and
4r., 46, Iraq. Important excavations were carried out by H. R. Hall at al 'Ubaid,
29 where a temple of around 2500 BC and a cemetery of around 4000 BC were excavated. Hall also initiated work at Ur, which J. G. Taylor had already

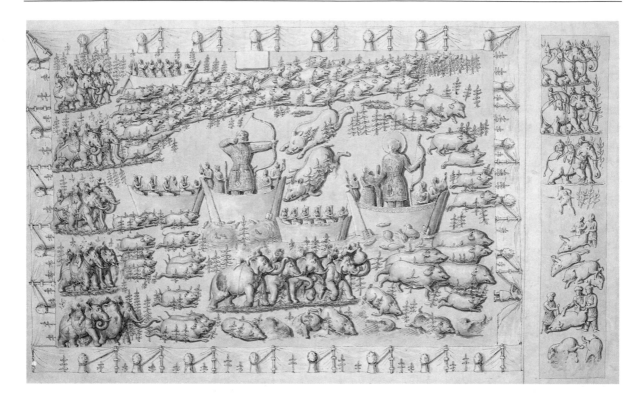

19 Drawing by Robert Ker Porter of a relief (ht 3.85 m) on the left side of a rock-cut arched recess (*iwan*) at Taq-i Bustan in southwestern Iran. It shows a Sasanian king, probably Chosroes II (AD 591–628), hunting boar in marshland. His robe is decorated with mythical creatures called *senmurvs* (see Figs 175–6 and 183–4). On the end wall, in high relief, is the king on horseback, brandishing a spear and wearing robes, again decorated with *senmurvs*, over his armour (ht 4.20 m). Above is his investiture, and on the right wall a royal deer hunt. Qajar inscriptions and a relief were added in 1822 (British Library).

investigated in 1853–4, and was succeeded there by Leonard Woolley. Working for the British Museum and the University Museum in Philadelphia, Woolley excavated and published finds from all periods of the 3,000-year history of the site, including the so-called Royal Cemetery of about 2600 BC which caught the public imagination. According to a new antiquities law, finds were divided between these two institutions and the museum in Baghdad, founded by Gertrude Bell. One of Woolley's team, Max Mallowan, investigated the early levels at Nineveh by means of a deep sounding, as well as the small prehistoric site of Arpachiyah, also near Mosul. 47–50 53–7 23r., 27

In 1931, after the end of the British Mandate in Iraq, a change in the antiquities law meant that for several years there was no division of finds. As a result, the foreign teams working in the country moved elsewhere, mostly to Syria, where Mallowan undertook a survey of sites in the area of the River Khabur, the main tributary of the Euphrates. He carried out several soundings and excavated Tell Chagar Bazar and Tell Brak; excavations at the latter site have since been revived under the directorship of David Oates and, since 1994, of Roger Matthews. From 1949 onwards, Mallowan returned to Nimrud, where he excavated on the citadel; Oates later dug a large Assyrian palace of the ninth century BC at the south-east corner of the site, which is known as Fort Shalmaneser and which had been used by the 24l., 26, 28

Assyrians as an arsenal and store-house. In the 1960s Oates excavated a temple site of the second and first millennium BC at Tell el Rimah west of Mosul, and his wife, Joan Oates, excavated a prehistoric site at Choga Mami in the foothills of the Zagros. Julian Reade dug a third- to second-millennium BC site at Tell Taya, also west of Mosul, and more recently has been excavating in Oman on behalf of the British Museum. Further changes in the Iraq antiquities law meant that the British Museum was able to receive a share of the finds.

Despite yet another change in the law in 1969, which no longer allows the export of antiquities from Iraq, the British Museum was in the field again in 1989, at Nimrud and Balawat, under the directorship of John Curtis. From 1983 onwards, Curtis had also directed rescue excavations north of Eski Mosul, where a dam was being constructed; both series of excavations had the aim of establishing a firmer chronology for many of the objects brought back to the Museum in the nineteenth century.

Apart from the work of W. K. Loftus at Susa in 1852–4, excavations in Iran have been most actively pursued by the French. A collection of magnificent Achaemenid gold and silver artefacts formed part of the 'Oxus Treasure', the chance discovery of which is described in Chapter 4 and which is now mostly in the British Museum. In the 1930s the British Museum also acquired large collections of material from the Iranian surveys and excavations of Sir Aurel Stein (1862–1943). This remarkable man was born in Budapest, partly educated in London and spent most of his life working in India. Between 1900 and 1916 he used India as a base for his three famous Central Asian archaeological expeditions and surveys, including his discovery of the 'Cave of a Thousand Buddhas' at Dunhuang. In order to trace contacts between the Indus Valley cultures and Mesopotamia, Stein undertook a series of expeditions between 1927 and 1936. It is the objects he discovered during his surveys and soundings in Iran which concern us here: they cover all periods from the Neolithic onwards and include material from the important Iron Age site of Hasanlu, since excavated by the Americans. In 1938–9 Stein also carried out aerial and surface surveys from the upper reaches of the Tigris in Iraq to the Gulf of Aqaba at the northern end of the Red Sea, and the results of all this work were published in 1937 and 1940. Further material came to the Museum from the private collection built up in the 1920s and 1930s by Ernst Herzfeld, much of it acquired in Nahavand and alleged to be from the site of Tepe Giyan. The founding of a British Institute of Persian Studies in Tehran in 1961 led to British excavations at a number of sites, including David Stronach's at the Median site of Tepe Nush-i Jan and the early Achaemenid capital of Pasargadae, and Clare Goff's at the site of Baba Jan; the British Museum also supported Charles Burney's excavations at Haftavan and received objects from all these sites.

149, 150

As the aim of this Introduction has been primarily to present the background to the British Museum's Near Eastern collections, this survey has necessarily been biased. Some periods and areas are poorly represented in the Museum's collections. There is, for instance, very little early Neolithic material from sites other than Jericho because this has mostly been 20 excavated in recent decades when more restrictive antiquities laws have been in force. There are also relatively few artefacts from excavations in Syria, the Lebanon and Iran because these areas have been in the predominantly French sphere of operations, and the Turks have not allowed material out of Turkey since their antiquities laws came into force after the First World War.

In this book we shall be concentrating on the Museum's strengths. Indeed, the British Museum houses one of the three great collections of Ancient Near Eastern antiquities (the others are in the Louvre in Paris and the Berlin Museums), and in the following chapters we shall be focusing on a selection of these in order to trace the development of Ancient Near Eastern art.

From Village to Town: before 3000 BC

The Bible tells us that the walls of Jericho came tumbling down as the Israelites entered the Promised Land, but long before this, the site had been used for the flimsy huts of hunters who camped around a natural spring and built a small sanctuary there some 12,000 years ago. Other traces of these hunters and food gatherers have been found round Mount Carmel, and here small items of jewellery and a decorated bone pin are early evidence of the human urge to expend time and effort on decorating a utilitarian object. By about 7000 BC, the descendants of the Jericho hunters had settled in more substantial mud-brick houses and were experimenting with the domestication of plants and animals.

Jericho is a large tell which lies in the fertile Jordan valley, beside a road leading from a crossing of the river up into the Judaean hills and to Jerusalem. The excavation of the earliest levels by John Garstang and later by Kathleen Kenyon (see pages 21–2) revealed that the early inhabitants, who did not yet know pottery (Pre-Pottery Neolithic A), felt the need to protect themselves behind huge walls and ditches dug out of the bed-rock. An impressive tower, perhaps one of several, was excavated; it was round, 10 metres in diameter, stone-built, and still survived to the height of 8.5 metres; it had a stairway inside it. The treatment of skulls found in the slightly later Pre-Pottery Neolithic B level at Jericho, and at other sites in Palestine and Syria, betrayed evidence of the care lavished on the dead in what was evidently a widespread burial custom: Jericho was part of what can be recognised as a culture.

Another manifestation of this culture took the form of lime plaster statues of a type known from fragmentary examples at Jericho. In 1983, however, at least twenty-five were found in a Pre-Pottery Neolithic B

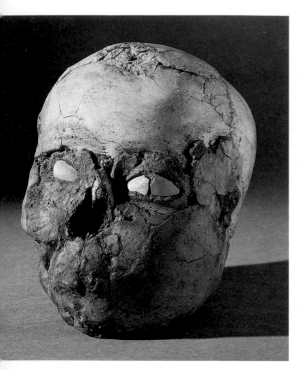

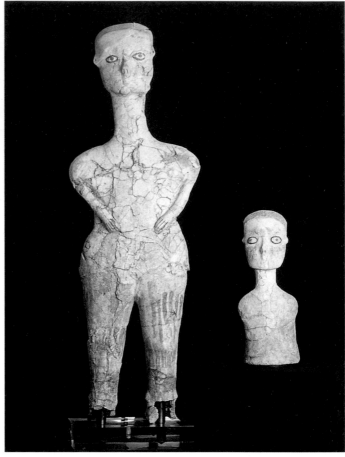

20 ABOVE LEFT Neolithic skull from Jericho. The lower jaw has been removed and the face has been carefully remodelled in plaster, with shells for the eyes and red and black paint to represent hair and moustaches. About 6750–6250 BC.

21 ABOVE RIGHT Examples of the two types of Neolithic plaster figures from Ain Ghazal near Amman in Jordan. The eyes are made of pure white plaster; a black bituminous substance is used to indicate the irises, with the addition of dioptase (an unusual green mineral pigment) to outline the eyes. Orange and black paint indicates the hair and items of clothing, body paint or tattooing. About 6750–6250 BC. Ht of the larger figure 84 cm. Amman, Department of Antiquities.

context at Ain Ghazal just outside Amman, and a further cache was 21 discovered in 1985. They were probably ritually buried after use in some religious cult or ceremony. The figures were built up over an armature of reeds and twine, now perished leaving a hollow. Sexual features were rarely indicated (only three had breasts and only one of these had genitalia). The faces of both types are carefully modelled but, as with the skulls (see Fig. 20), the eyes and the nose are emphasised at the expense of the mouth. Two of these figures will become the property of the British Museum after conservation.

Thus, by 6000 BC there had already been established the pattern of religious and funerary context which accompanies so many of the objects we shall be examining during the course of this survey. What is intentionally buried survives better than what is in daily use and finally discarded after being worn out or broken, and better also than the prestige objects which filled the temples and palaces and which were looted, broken up and melted down, stripped of their gold and precious stones or deliberately smashed.

In the early levels at Jericho obsidian blades were found. Obsidian is a shiny, generally black, volcanic glass which was exported from the area of Hasan Dağ – a volcano in central Turkey (obsidian from deposits in eastern Turkey was exported to other parts of the Near East). One of the sites which prospered from this trade was Çatal Hüyük in the Konya Plain west of the volcano. Here houses were found built up against each other, with communication between them taking place at roof level. Some of the 'houses' seem to have been used as shrines and were decorated with wall-paintings: there were geometric patterns and hand-impressions but some were more elaborate and depicted vultures, hunting scenes and a ceremony involving a huge bull. There were also painted plaster reliefs of goddesses giving birth, and pairs of leopards facing each other which literally changed their spots with each seasonal repainting. The dead were buried beneath the floors – a custom found throughout the Near East at many periods; with them were a variety of objects including jewellery, obsidian mirrors, beautifully worked obsidian knives and belt hooks. Figurines of clay and stone represented naked women, many of them very fat with their hair in top-knots, often paired with young men.

It is no accident that figures such as the Venus of Willendorf (about 30,000 BC) and others like her always appear among the earliest artefacts illustrated in any world history of art. In the types of figurines produced by prehistoric cultures we have a window onto their world. The figurines reflect not only the religious beliefs but also the conventions governing the representations of the human form – what, in a later context, might be termed an artistic convention. Wall-paintings might have provided an equally useful window, had they survived more often, but the figurines, generally made of clay and representing women, are widespread and varied. However, since, within a given area and time-frame, they form groups reflecting ethnic, social or trade contacts, they often provide good evidence for the existence of 'cultures'. A culture is most often referred to by the name of the site where it was first recognised. Some of the figurines in the British Museum can serve as examples.

22 Representative of the Hacılar culture of Turkey is a small figurine which also served as a pot. It dates to around 5000 BC. The pot shape does not explain the omission of sexual features, which is intentional. On this piece the nose and ears are indicated by protuberances but the mouth and eyes are not shown; in other cases, as with the earlier figures from Jericho and Ain Ghazal, the eyes are given prominence by being encrusted with chips of obsidian.

23l. A clay figurine of about the same date may have come from the south coast of Turkey. In outline it is not unlike the pot figurine or the smaller of the Ain Ghazal figures, but the hands and feet are both given prominence. Again no sexual features are depicted, although the navel is indicated by a rosette

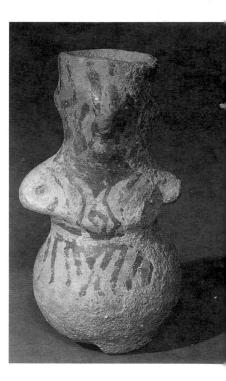

22 Clay figurine which also served as a pot, painted with zigzags, triangles and bands of red paint typical of the pottery of the Hacılar culture. Lugs pierced for suspension form the arms, but because of the pot shape no feet or legs are represented. About 5000 BC. Ht 11.5 cm.

23 *Left* Clay figurine acquired in 1900 and said to have come from the Antalya region on the south coast of Turkey. She wears an elaborate double necklace and bracelets on each wrist; marks on the shoulders and round the navel may indicate tattooing, and a dotted pattern on one hip and ankle may represent an animal skin. About 5000 BC. Ht 4.9 cm. *Right* Stone figurine from Arpachiyah in northern Iraq. Halaf culture, about 5000 BC. Ht 3.9 cm.

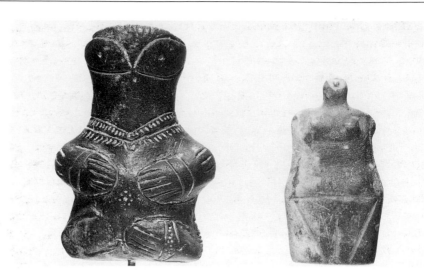

pattern and the hands may be cupped over breasts. The face is dominated by huge eyes; no other facial features, ears or hair are shown.

We are left in no doubt, however, as to the sex of a stone figurine from Arpachiyah in northern Iraq belonging to the Halaf culture (about 5000– *23r.* 4500 BC): she has small breasts but a huge pubic triangle. She has no arms or legs, her face is tilted upwards and the only facial feature is a small nose. Other figures from Arpachiyah are made of clay, painted red, and have breasts but neither head, arms, nor legs. A painted clay figure from Chagar *24l.* Bazar in north-east Syria, which also belongs to the Halaf culture, shows another stylisation with an equally strong – but different – emphasis on the sexual features. She sits with her huge thighs extended and supports her jutting breasts. Her head is missing: in other figures of this type the face is pinched out to form a large nose or chin but is otherwise featureless. Neither hands nor feet are shown.

The Amuq region lies on the borders of Turkey and Syria at the north-east *24r.* corner of the Mediterranean; a small stone figurine from this area, dating to around 4500 BC, shows the influence of the Halaf culture. The pose is naturalistic but there is something hostile about this craggy female. Her small, featureless head pokes forward between hunched shoulders, her back is hollowed and she has large, jutting breasts, but her arms do not extend beyond the elbows. The standing figurines of the same period from southern *25* Iraq are completely different; with their broad shoulders emphasised by paint or clay pellets, narrow waists and hips, and thin, elongated thighs, they are a strange mixture of naturalism and stylisation. Some hold babies on their hips and suckle them from their small pointed breasts; some are male. The genitals are shown naturalistically but without any undue emphasis. The most distinctive feature of these figures is the reptilian stylisation of the heads, which has given them their name of 'lizard'

figurines. The elongated skulls, often decorated with bitumen, may represent the deformation due to binding in infancy. The long, slit eyes are shaped like coffee-beans and they and the mouth are often painted. Several of these figurines have been found in graves.

About a millennium later, thousands of votive stone plaques were
26 deposited at Tell Brak in north Syria, in the foundations of the Eye Temple –
so-called because of the emphasis on the eyes which were cut out and incised on the plaques to the exclusion of almost any other feature. Sometimes two pairs or whole families of eyes are depicted. This stylisation is completely
28 different from that of a small, far more naturalistic, stone head from a composite statue, also found in a deposit below the Eye Temple. This head from Brak is an early, tentative attempt at sculpture in the round, and demonstrates a search for realism that was to become dominant in the art of the Near East; in southern Mesopotamia it was accompanied by dramatic changes. However, before we turn to these, we must examine another vehicle for artistic expression in the Near East, namely pottery.

For some 2,500 years after its invention in about 6000 BC, pottery was hand-made. This does not mean it was crude: some types of pottery were very fine, with a range of complex shapes. In Syria and Palestine pottery was generally undecorated or merely finished with a slip and burnished. In Turkey, the
22 Hacılar culture, which produced the pot figurine discussed above, is characterised by thick-walled jars and bowls covered with bold designs in red paint on a buff ground. It is found predominantly in the lake district of south-west Turkey, but sherds have been excavated as far afield as Mersin on the south coast. The finest pottery, however, came from northern Mesopotamia where whirling designs, sometimes derived from human or animal shapes, adorned the interior of the wide, shallow bowls of the Samarra culture (around 5500 BC). In addition to figurines of the type discussed above, the site of Arpachiyah in northern Iraq produced, during the Halaf period, a range of
27 beautiful but more static designs painted in one or two colours. Some of the designs show increasing stylisation, for instance from naturalistic bulls' heads into figures-of-eight. The Ubaid culture succeeded the Halaf and was first recognised in southern Iraq, whence it seems to have spread; it is
25 characterised not only by 'lizard figurines' but by vessels made on a slow
29 wheel which are often fired a distinctive green and decorated with bold
30–31 designs. Around 4000 BC, potters in Iran were also producing attractive painted pottery. Some five hundred years later, the potter's wheel was invented and wheel-made pottery gradually replaced pottery made by hand; however, these mass-produced wares were generally left undecorated.

Between 3500 and 3100 BC there developed in southern Iraq a distinctive culture centred on the city of Uruk (also called Warka, the Erech of the Bible). As we saw in the Introduction (page 14), a complex administration was needed to regulate the canal and irrigation system which allowed

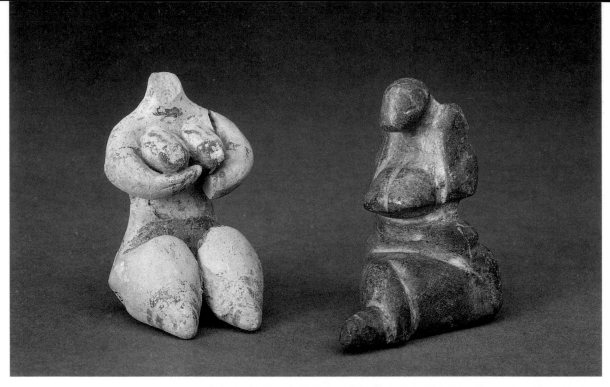

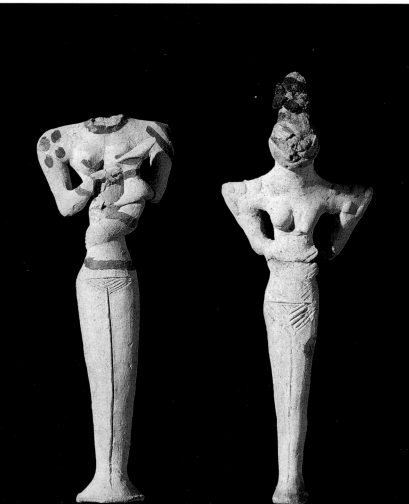

24 ABOVE *Left* Painted clay figure from Chagar Bazar in north-east Syria. Bands of black paint may represent bracelets and anklets as well as armlets, a necklace and a broad loincloth; there are also undulating lines along the breasts, and the nipples are painted. Halaf culture, about 5000 BC. Ht 7.4 cm. *Right* Stone figurine from the Amuq region on the Syrian-Turkish border, about 4500 BC. Ht 7.6 cm.

25 RIGHT Two of the 'lizard' figurines from Ur, typical of the Ubaid culture in southern Iraq. That on the left holds her baby on her hip and suckles it (note the shape of the baby's head). She has brown-painted dots and lines on her shoulders and bands of paint on her neck, wrists, nipples and loins. The other figure stands with her hands (one arm broken) on her hips. She has clay pellets on her shoulders and incised stretch marks on her abdomen. About 4500 BC. Ht of the figure on the left 13.6 cm.

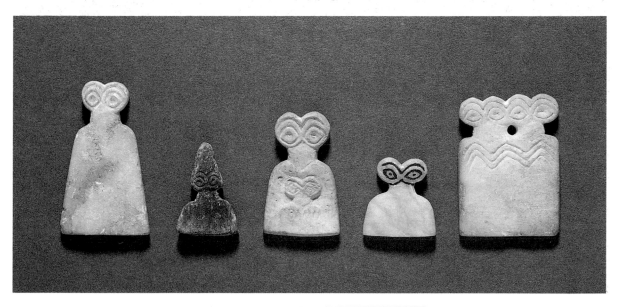

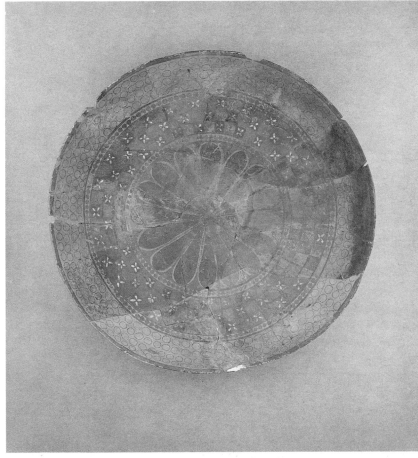

26 ABOVE A group of 'eye idols' from the foundations of the Eye Temple at Tell Brak in north-eastern Syria, about 3500–3300 BC. Ht of the tallest 6.3 cm.

27 LEFT A bowl from Arpachiyah in northern Iraq, painted in red, black and white paint. Halaf culture, about 5000–4500 BC. Diam. 29 cm.

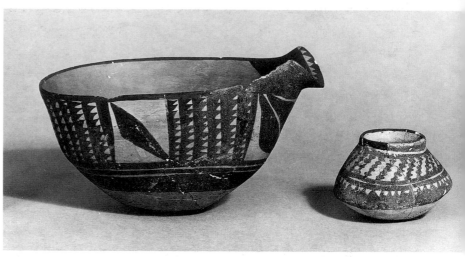

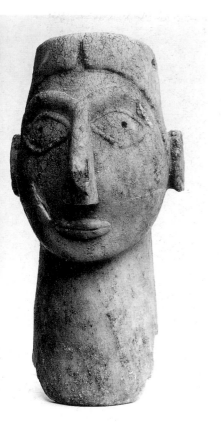

28 ABOVE LEFT Small stone head from a votive deposit below one of the Eye Temples at Tell Brak. The eyes are outlined in relief, the thick eyebrows join over a prominent nose, the small mouth has fleshy lips and the ears are indicated by grooved discs. A headdress was probably attached separately over the hair, which is plain except for a centre parting. It is interesting to compare it with the head shown on Fig. 32 from which it is separated by 3,000 kilometres and about as many years. About 3500–3300 BC. Ht 13 cm.

29 ABOVE RIGHT A spouted bowl and a small jar from the site of Tell al-'Ubaid in southern Iraq, fired to a greenish colour, like much other Ubaid-period pottery, and decorated in blackish-brown paint. Ubaid culture, about 4500–4000 BC. Ht of bowl 8 cm.

agriculture to flourish in southern Iraq. The production of a surplus led to the establishment of a trade network on an unprecedented scale, and the Uruk culture spread eastwards to include Susa in Iran and northwards along the Euphrates valley, where colonies were established in Syria and Turkey. Writing developed to satisfy the bureaucratic needs of the Uruk administration (see page 22). It seems that this administration was centred on the temple, and the importance of this institution is reflected in the remains of monumental architecture which have been excavated at the site: a huge complex of temples included one building which was 80 metres long and elaborately decorated with alternating niches and buttresses. Another building had enormous free-standing and engaged columns whose surfaces were coated with mud-plaster into which were pressed small clay cones, the ends of which had been dipped into red or black paint so as to form a mosaic of geometric patterns. Large-scale sculptures were carved from imported stone. The realism of the 'Warka Head' testifies to a new approach to the representation of the human form of which the Tell Brak head was an earlier and cruder manifestation. The terracotta head of a sheep (WA 132092) and the stone body of a bull (WA 116686) – part of a composite figure – display the same realism.

This realism is also apparent in relief sculpture, for instance on a trough from Uruk and on two enigmatic objects known as the 'Blau Monuments' after an early owner. These show the 'priest-king', so-called because he appears in religious and secular contexts. He has a rounded beard and bunched hair, worn with a distinctive thick hair-band, and he wears a crisscross patterned skirt. The priest-king also appears twice on a basalt relief in Baghdad, where he shoots at one lion and spears another, and on a seal where he shoots at bulls. He uses a composite bow – a short bow made of several different layers of wood and bone to give it the necessary elasticity –

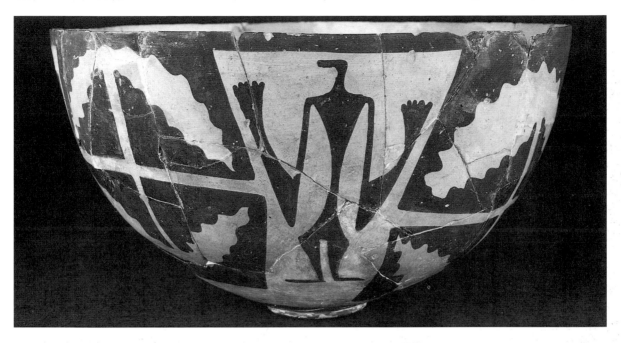

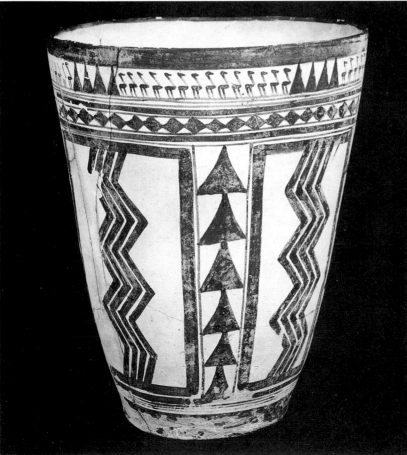

30 ABOVE A bowl with decoration in blackish-brown paint, probably found at Tall-i Bakun near Persepolis in Iran. Its design, repeated three times, can be seen either as Maltese crosses or as linked opposed arcs with deckled outlines, framing a human figure with a small, bird-like head and huge raised hands. About 4000 BC. Ht 15.8 cm.

31 LEFT A tall cup from Susa typical of the beautiful pottery produced between 3300 and 3100 BC in south-western Iran. It bears carefully laid out, largely geometric designs in dark brown paint. Ht 20.5 cm.

32 A cast made from the famous life-size 'Warka Head' found at Uruk in southern Iraq and now in the Iraq Museum in Baghdad. Made of limestone, it has a haunting beauty which it may have lacked when it had a coloured stone wig and inlay for the eyebrows and eyes. It was part of a composite statue which probably stood in a temple. About 3100 BC. Ht 21.2 cm.

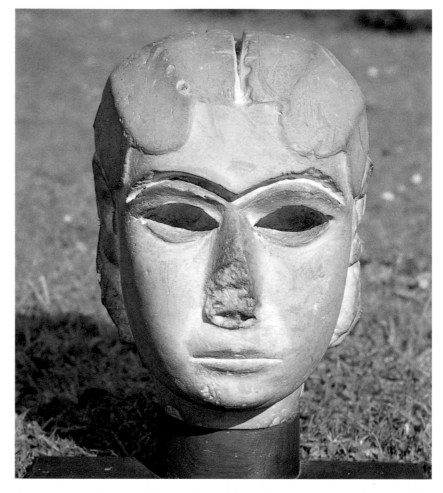

33 BELOW A ceremonial trough from Uruk in southern Iraq, made of gypsum and carved in low relief with processions of ewes and rams approaching a reed building of the type still found in southern Iraq: the *mudhif* (see Fig. 3). From this structure two lambs emerge. Reed bundles with streamers on the *mudhif* and at the ends of the scene are known later as a symbol of the goddess of love and fertility, Inanna; they are repeated on the ends of the trough together with two sheep and rosettes.

for which this is some of the earliest evidence. The stele and seal are detailed enough for the type of arrow to be identifiable: it has a transverse head – a flint set sideways-on into the shaft – and this type of arrow was also used in contemporary Egypt. Ever since the beginnings of agriculture and domestication, one of the most important tasks of the leader of any community was the organisation at regular intervals of hunts to free the countryside of predatory lions and stampeding herds of wild bulls. This task continued to

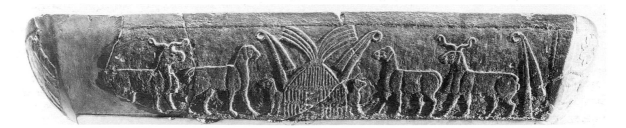

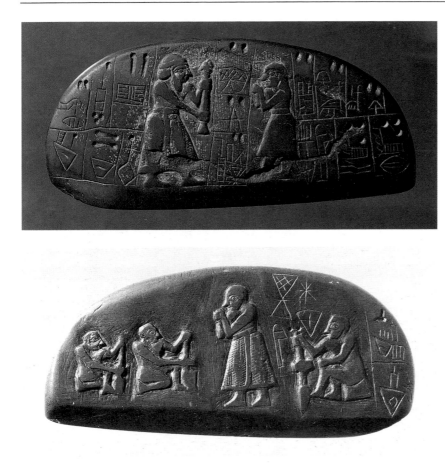

be considered a duty of kings as late as the first millennium BC, when it formed part of a specially organised royal hunt ending in a religious ceremony (see pages 152–3).

The Uruk priest-king also appears in various other roles on seals – feeding flocks, defeating the enemy, or standing before containers of temple provisions. He is depicted at the head of a procession of offering-bearers before the goddess Inanna (or her priestess) on a tall stone vase carved with friezes in relief, known as the 'Warka Vase' (Baghdad). Some sculptures show him naked but with the same distinctive head-band (Louvre and Zurich). As an illustration of trade contacts, however, the most interesting representation of the priest-king is on the ivory handle of a knife found at Jebel el-Araq in Egypt. This is one of many indications of links between Mesopotamia and Egypt just before 3000 BC. The Egyptians adopted the cylinder seal (see page 53 below), and probably learnt the principle of writing from Mesopotamia, but they invented their own hieroglyphic script. Contemporary Egyptian architecture shows a similar use of wall-cones, buttresses and niches, and several of the palettes and knife handles display examples of

34 The 'Blau Monuments'. One side of the chisel is entirely inscribed; on the other are the 'priest-king' holding an animal offering, and a half-kneeling workman (*right*). Three similar workmen and the 'priest-king', with hands raised, appear on one side of the scraper (*bottom left*). The workmen may be making stone vessels similar to the 'Warka Vase' and to that carried by the 'priest-king' on the other side of the scraper, where he stands before a woman with hands raised (*top left*). The authenticity of the Blau Monuments has been questioned but they were known long before the excavations at Uruk revealed the archaic script and objects depicting the 'priest-king'. Dark green slaty schist (phyllite). About 3100 BC. L. of scraper 16 cm.

35 a. Seal of white stone and its modern impression. The 'priest-king' is aiming an arrow at four bulls, of which one at least has been shot. Behind him are a symbol of the goddess Inanna and an attendant carrying his quiver and arrows. The king is using a composite bow and arrows with transverse arrow-heads. Uruk style, about 3100 BC. Ht 2.2 cm.

b. Modern impression from a squat red-brown calcite seal. The design, mostly executed with a drill, shows pigtailed women holding spouted vessels and sitting on mats or platforms; other vessels stand on shelves. Jemdet Nasr style, about 3100 BC. Ht 1.9 cm.

c. A small amulet in the shape of a half-kneeling, pigtailed figure, and the drilled design on the back. Provenanced amulets of this type come from south-west Iran. Jemdet Nasr style, about 3100 BC. Ht 2.8 cm.

d. Modern impression from a gable-shaped black stone seal depicting three gazelles. This type of seal was common from central Turkey to north Syria along what was probably already a main trade-route, but there is little surviving evidence of its having been used for sealing. 4000–3000 BC. L. 6.7 cm.

e. Base of a dome-shaped stone seal depicting a strange ibex-headed creature who grasps the horns of two ibexes. He wears large boots but his legs and arms resemble the tentacles which appear to hang from his body; there seem to be maces rising from his shoulders. Probably from western Iran. Diam. 5.2 cm.

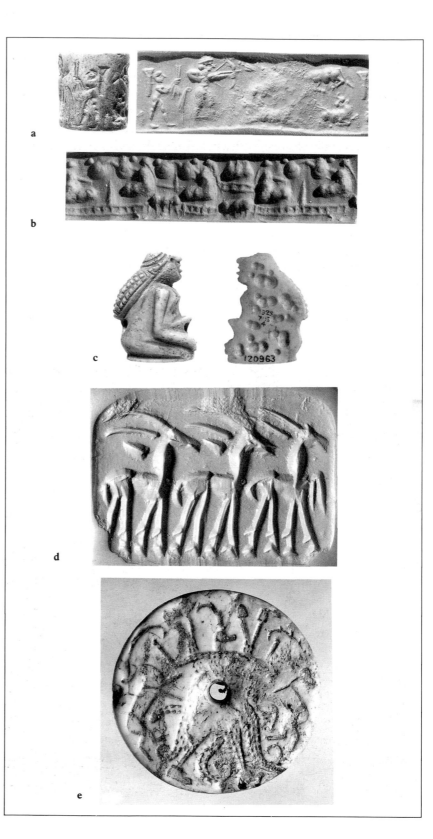

borrowed iconography, some of it clearly based on contacts not only with Mesopotamia but with Elam (south-western Iran) and Syria.

However, it was in the miniature reliefs of a new type of seal, designed to satisfy the requirements of the administration, that the realism of the Uruk period found its fullest expression. The cylinder seal, as its name implies, is a cylinder, generally of stone, with a hole drilled through it from end to end and with a design cut into its surface. When the cylinder is rolled out on a soft material, the design appears in relief. In the Near East the seals were rolled out on clay which, as we saw on page 22, was the main writing material but was also used for securing containers and the locks of store-rooms. Many of the ancient sealings have survived and the designs of the seals can be reconstructed. Thousands of actual cylinder seals have also survived and the illustrations in this book will mostly show modern impressions from them. As the cylinder is rolled out, so the design will repeat itself, and seal cutters made ample use of the design possibilities provided by this frieze-like repetition. During the next 3,000 years they created the most exquisite miniature reliefs which give information about

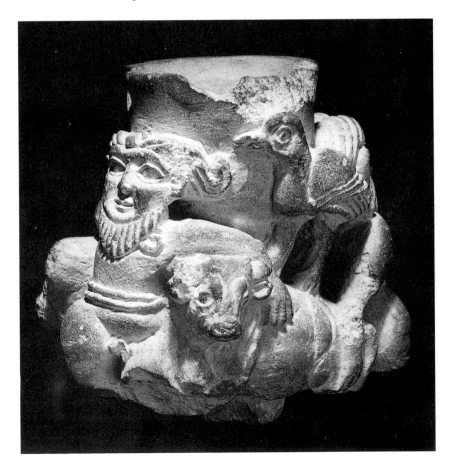

36 A limestone cup from Uruk in southern Iraq, carved on either side with a figure shown frontally, naked except for a belt, with his hair in a centre parting. One of the figures has his hair in curls and holds two bulls protectively around the neck; on the backs of the bulls perch large birds. 3100–3000 BC. Ht 12.7 cm.

53

37 Large magnesite seal, and (*below*) drawing of its impression, carved with a procession of overlapping bulls above a row of *mudhifs* (see Figs 3 and 33) decorated with a symbol of Inanna. They are used as cattle byres from which calves emerge and in which jars of dairy produce are stored. The seal is topped by a figure of a reclining ram cast in copper using the lost-wax process – evidence for the early development of this complex metalworking technique. Uruk style, about 3100 BC. Ht including ram 8.5 cm (Oxford, Ashmolean Museum).

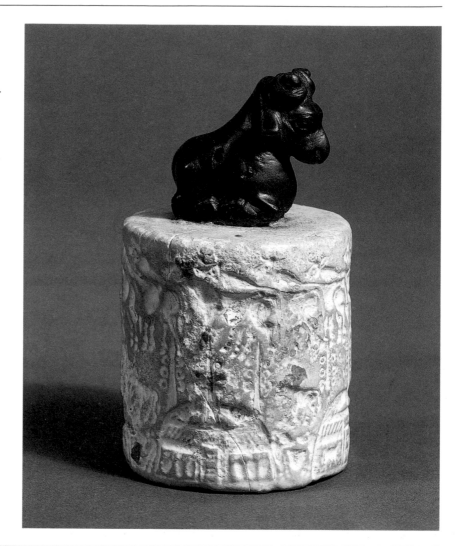

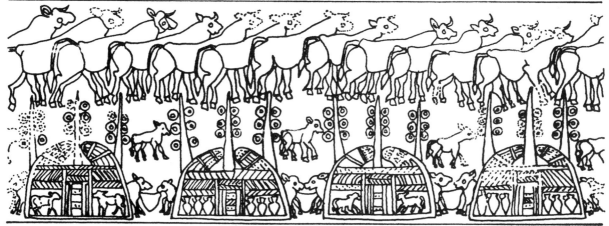

gods, goddesses, kings and queens, what the temples and palaces looked like, how people dressed at different periods and in different areas, day-to-day activities, sport, sex, musical instruments, banquets, warfare and myths.

35a, 37 Two of the seals illustrated here belong to the Uruk style, so-called because seals and impressions found at Uruk are of this type; generally they are large, and they are often unperforated, with carved knobs. It is now
35b known that the Jemdet Nasr style of seal overlaps with the Uruk style chronologically, but the two types are easy to differentiate: the Jemdet Nasr seals are small and squat, with drilled designs often executed on coloured stones. They mostly depict women with pigtails, seated on mats or platforms and engaged in activities associated with textile or pottery production.

 The drilled style on coloured stones is also found on contemporary seal-amulets in the shape of animals, many of which have been excavated at Tell
35c Brak. One type, showing a half-kneeling pigtailed figure, is probably from south-western Iran. These seal-amulets are derived from earlier amulets and stamp seals which have been found all over the Near East. The earliest were decorated with simple intersecting lines forming criss-cross patterns. Later
35d seals show animals and some, in a distinctive gable-shape, come from north Syria and south and central Turkey and date between 4000 and 3000 BC.
35e Some handsome large circular seals of about the same date from western Iran show animal-headed figures grasping snakes, but it is impossible to say whether these are demons, masked hunters or masked priests.

 The art of the Near East was profoundly influenced by the developments of the Uruk period. Not only did the innovations in the fields of pottery-making, architecture, sculpture, seals and writing have a lasting impact, but certain pictorial conventions and iconographical creations originated at this
36 time. For instance, a limestone cup of this period is carved with supporting 'hero' figures in high relief. As we shall see in the next chapter, heroes of this
56a type reappear several centuries later in the art of the late Early Dynastic and
59a–c Akkadian periods.

Temple, Cemetery and Palace: the 3rd millennium BC

38 Modern impressions (**a-c**), and ancient impresssion (**d**) of cylinder seals of about 3000–2800 BC.
a. Cruciform design with crescents and centre-dot circles (the latter indicate the invention of the tubular drill) from a tall, thin seal of baked steatite. Seals with this type of design have been found at Nineveh. Ht 5.0 cm.
b. The way the gazelle is half rising between the ibexes, and the addition of an animal leg and fly are typical of seals found in the Diyala region north-east of Baghdad. The seal is made of rock-crystal, which could only have been carved with the copper tools then available by using a very fine abrasive and considerable time and expertise. Ht 2.65 cm.
c. Antelopes of two types, plants and a cross decorate this seal in the Proto-Elamite style of south-west Iran. It is made of an unusual pale green fine-grained volcanic tuff. Ht 4.9 cm.
d. A lump of clay impressed with a 'city seal' naming a number of Sumerian cities, written in stylised form. The back of the lump bears the marks of the peg and string used to secure a storeroom door at Ur in southern Iraq.

During the earlier part of the third millennium BC the administration in Mesopotamia continued to be controlled by the temple. This period is known as the Early Dynastic period and is conventionally divided into three, although a two-fold division seems more appropriate for certain areas. Writing developed further, so that information other than ration lists and simple trade transactions could be recorded. From the more complex texts we can identify the language in which they were written as Sumerian, after Sumer – at that time the name for southern Iraq. Although it cannot be proved, it is likely that the early inhabitants of Uruk were Sumerian, because there is no indication of a break in continuity between the Uruk and Early Dynastic periods. The country did, however, fragment into a series of city-states which were often fighting among themselves – generally over water rights.

As a result, Sumer appears to have participated less actively in the trade networks of the Near East. These shifted from the main river valleys to an arc running from Susa in the south-east to Syria in the north-west along the foothills marking the boundaries of eastern and northern Mesopotamia. The main evidence for this trade comes in the form of an international cylinder seal style referred to as Piedmont (from the foothills where it occurs) or Ninevite 5 (from the level in the deep sounding at Nineveh where it was first recognised). Tall, thin seals are decorated with ladder patterns, hatched circles, centre-dot circles, rosettes or cruciform patterns. Actual seals in this 38a style and their impressions have been found throughout this area, but only very rarely in Sumer.

However, in addition to the international style, each area had its own regional style. A particularly fine cylinder seal illustrates one of the styles 38b

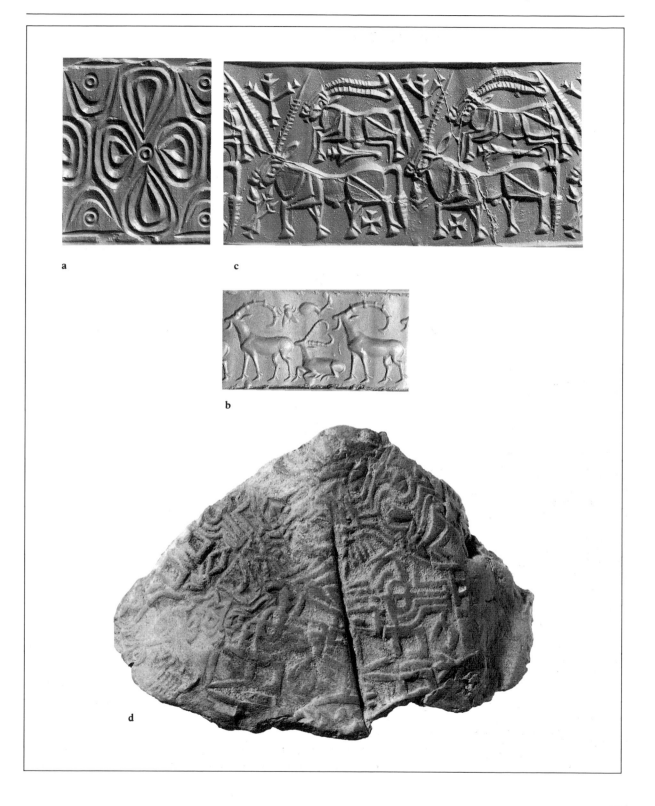

a

c

b

d

39 Scarlet Ware vessel decorated in red and black paint with chariot and banquet scenes and attendant musicians (one plays a bull-headed lyre; see Fig. 53). This is the earliest object so far known to combine these two recurring themes in Sumerian art (see Fig. 50b). From Khafajeh in the Diyala region north-east of Baghdad. About 2800 BC. Ht 34.5 cm. The drawing below is from P. Delougaz, *Pottery from the Diyala Region*, Chicago 1952, pl. 138.

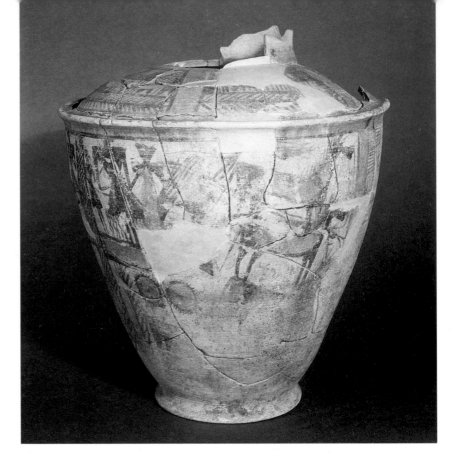

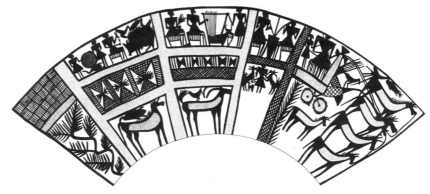

found in the Diyala region north-east of Baghdad. Another regional style, the Proto-Elamite style, developed in south-western Iran in the area known 38c as Elam. Proto-Elamite seals never show humans but often depict animals behaving like human beings. This phenomenon is not restricted to seals: a small statue of a lioness (Brooklyn Museum, New York) stands on its hindlegs in a twisted posture while pressing its forepaws together, and a kneeling silver bull (Metropolitan Museum of Art, New York), clad in a patterned skirt, raises a tall, spouted cup between its front hooves. Some of the postures adopted by the animals, and some of the stylised plants and other motifs which surround them on the seals, are also found on seals and

pottery from sites beyond the eastern borders of Iran, in the Indus Valley. This would indicate early trade contacts which were extended during the next few centuries.

On Sumerian cylinder seals, humans are often depicted taking part in banquets and sometimes engaged in ritual sex. A particularly interesting group of seal impressions bears what look like random patterns; however, 38d upon closer inspection they turn out to be the stylised writing of the names of certain Sumerian cities. Not only do these city-seals indicate that the Susa–Syria trade network had its counterpart in a federation of Sumerian cities, but they are perhaps the earliest evidence for the transformation of the cuneiform script into art.

The tradition of decorated pottery had not entirely died out. In the Diyala region around 2800 BC, 'Scarlet Ware' developed from an earlier and 39 simpler type of painted pottery. Handsome jars are decorated with scarlet and black paint, and although some of the designs are geometric patterns, others are more elaborate. At Nineveh, and at a number of other sites in 40 northern Mesopotamia, the so-called Ninevite 5 pottery appears in painted and in incised and impressed wares in a variety of attractive shapes. In comparison the pottery from Sumer is plain and utilitarian; some ornament is applied to upright handles and footed stands, although this is generally crude. In a cemetery at Yortan in western Turkey, dating from about 2700 to 2500 BC and excavated in 1900–1, Paul Gaudin found burials of between one and six adults in huge jars. With the bodies were hand-made, black-burnished vessels, some already with the distinctive cut-away spouts so 41 popular in the next millennium, and some imitating birds; one, from a neighbouring cemetery, is shaped like an owl – a bird frequently connected with funerary rites.

40 Examples of bowls in the earlier painted (*left*) and later incised (*right*) Ninevite 5 styles (between 3000 and 2500 BC). From Nineveh. Ht of vessel on right 11.5 cm.

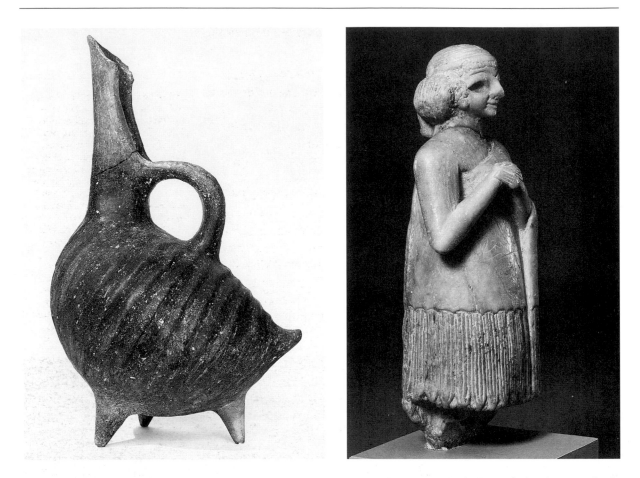

41 ABOVE LEFT Bird-shaped tripod jug with a cut-away spout, hand-made in a black burnished ribbed ware, from the cemetery at Yortan in western Turkey. About 2600 BC. Ht 29.6 cm.

42 ABOVE RIGHT Small votive statue of a woman standing with her hands clasped; her huge eyes would have been inlaid – perhaps with shell and lapis lazuli – to attract the deity's attention. Her garment was probably a sheepskin worn with the fleece inside, wrapped around her and over one shoulder, with long strands of wool hanging below. Her hair is elaborately dressed. About 2500 BC. Ht 22.1 cm.

In the last chapter we saw how the depiction of the human body developed from the stylisation of prehistoric times to the realism of the Uruk period. This realism continued into the third millennium, but the emphasis changed. Whereas the prehistoric figurines were probably connected with fertility and were thought to be endowed with magical properties, the statues of the Early Dynastic period in Mesopotamia seem to have depicted the worshippers – both men and women – who set them up in temples so that they would be permanently represented before the deity. They stand with 42 hands clasped and huge eyes focused sightlessly on the object of worship; sometimes an inscription on the shoulder provides information as to the name of the worshipper and his or her deity. These statues have been found in temple ruins and in caches where consecrated furnishings and votive objects were discarded and buried when a temple was redecorated or rebuilt. The few metal figures which have survived testify to the skill of the copper-, silver- and goldsmiths, but generally old metal furnishings would be melted down and used for making new ones.

One hoard of statues from Tell Asmar in the Diyala region, dating around 43

2700 BC, has become famous. Mary Chubb, who was present when the hoard was discovered, describes the scene as follows:

> Seton [Lloyd] and Hans [Frankfort] were alone in the Abu Temple when I reached it. They were crouching in front of the niche beside the altar, and a fresh pile of rubble lay round them on the clean floor. . . . Down in the floor of the niche was a long, oblong cavity – and in it I could see a gleaming, tightly packed mass of white and cream and grey and yellow stone statues; here a strange eye stared up, there a hand, long fingers curled round a cup, seemed to tremble with life. Most were over a foot in length. Many of them were broken, though all the pieces were in place; . . . it looked as though they had been complete when buried, but that the weight of the numerous rebuildings of the Temple above must have cracked and crushed them. More statues came up, men and women, the men in fringed and tasselled kilts, the women with long cloaks thrown over one shoulder, leaving the other bare. All had their hands clasped before them, some holding cups. 'They are worshippers, of course,' Hans said. (M. Chubb, *City in the Sand*, London 1957, p. 139 f.)

43 Votive statues from Tell Asmar, all but one with huge inlaid eyes and eyebrows, and small mouths. The eight standing men are broad-shouldered, with narrow waists; they wear belts and fringed skirts and have pointed elbows and small hands; one is clean-shaven but the others have shoulder-length hair and beards indicated by ridges or zigzags. One bearded man is kneeling, naked except for a belt and hat. The two women wear edged robes: the smaller has plaited hair; the larger, who has one small breast uncovered, originally had a child beside her, inserted separately into the base. About 2700 BC. Ht of tallest figure 72 cm (Iraq Museum, Baghdad, and Oriental Institute, Chicago).

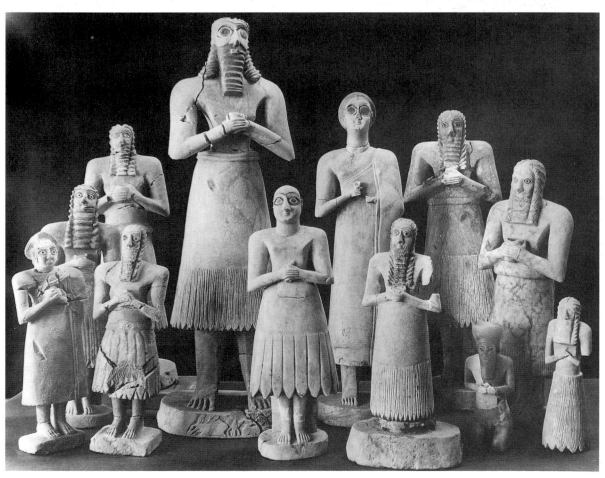

Later, Frankfort revised his opinion and thought that the two tallest figures were deities, but they too are probably worshippers. They have huge eyes inlaid with lapis lazuli or shell set in bitumen. The eyebrows, also originally inlaid, meet over the nose as in the Brak and Warka heads (Figs 28 and 32). The underlying geometry is clearly apparent, with wedge-shaped torsos, cone-shaped skirts and cylindrical legs. The figures vary not only in size but in quality of carving, presumably reflecting the taste and fortune of those who commissioned the sculptures. (A parallel case can be seen among the votive plaques in the Oxus Treasure, where taste and money certainly did 147 not go hand in hand.) The figure of a kneeling, naked man shows real originality, but most are stereotyped. Nevertheless, they have a monumental quality, so that it always comes as a shock to see how relatively small they actually are. Similar or related figures have been found as far afield as Tell Chuera in northern Syria and Shahdad in south-eastern Iran.

The Sumerians were unaccustomed to working in stone, which was not available locally and had to be imported. The Egyptians had discovered the difficulty of depicting three-dimensional standing figures without the benefit of a dorsal pillar, but only one figure in the Tell Asmar hoard has such a pillar, and almost all the other figures, despite their thick legs, are broken at

44 Two examples of the greater realism and more compact forms of the votive figures of about 2500 BC. These are less stereotyped and give the impression of being portraits. *Left* A female worshipper, whose eyes were originally inlaid and whose hair hangs in a long plait at the back. Note that unlike the earlier statues in Fig. 43, the legs have not been carved in the round. *Right* Kurlil, an official, seated with hands clasped. Respectively from Tello (ancient Girsu) and Tell al-'Ubaid in southern Iraq. Ht 30 cm, 37.5 cm.

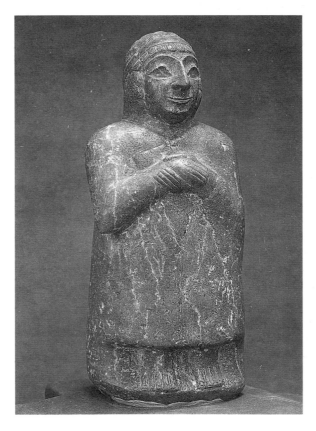
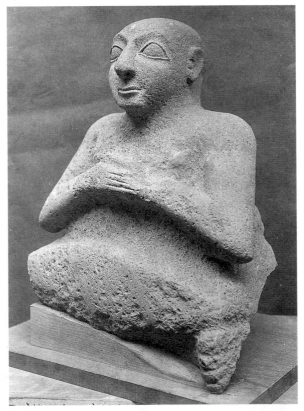

the ankles. The Sumerians were subject to the restrictions imposed by the sizes and shapes of stone which were easiest to transport from the mountains by donkey caravan. It has been suggested that this was the reason for the fairly small, slab-like shape of Sumerian sculpture as opposed to the cube shapes of Egyptian sculptures, for which the stone was transported by ship. A fragmentary figure of this period in the British Museum has not been improved by the loss of its nose, which was attached separately, presumably because the block of stone from which the figure was cut was not thick enough to accommodate it (WA 91667). The shape of the blocks of stone which reached Mesopotamia continued to dictate the shape of the sculptures

44*l.* throughout their history. The serene female worshipper from Lagash, who stands smiling, with hands clasped before the deity, barely emerges from the block of stone from which she was cut; the same is true of the statue of

44*r.* Kurlil which was found at the site of al-'Ubaid. They resemble in shape the later Babylonian *kudurrus*. Free-standing figures generally remained strictly

112 frontal and the statue of the ninth-century Assyrian king Ashurnasirpal II still reflects these constraints.

The representation of worshippers undergoes some development during the Early Dynastic period. By about 2500 BC they are generally shaven-

45 headed and beardless, and their garments are tufted all over, probably to represent the fleece of the sheep- or goat-skins from which they were made. By then the trade route along the Euphrates was functioning again and many votive statues of this type have been found at the site of Mari, on the Euphrates in Syria, which has been excavated by the French. Similar figures were also depicted in relief.

An inscription tells us that Kurlil was responsible for building work on a temple dedicated to the Sumerian fertility goddess Ninhursag. His statue was excavated beside the ruins of the temple, built on a platform within an oval enclosure around 2500 BC at al-'Ubaid in southern Iraq (the same site gave its name to the prehistoric painted pottery described in Chapter 1). Many of the temple furnishings were recovered where they had fallen or been stacked in the angle between the stairway to the shrine and the platform. The temple entrance was guarded by bitumen lions covered with copper, with inlaid eyes and tongues. It was flanked by columns, inlaid with triangles of mother-of-pearl and red limestone set in black bitumen, imitating palm trunks and recalling the clay-cone mosaic columns from Uruk over half a millennium earlier. There were also copper and limestone friezes of birds and a milking scene, reclining copper calves and standing copper bulls in fields of enormous stylised flowers made of coloured stones. But the most

46 striking element of the façade decoration was the huge copper frieze which probably originally stood above the door. The survival of such large-scale copper artefacts is most unusual and presents a tantalising glimpse of what once existed.

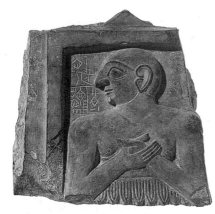

45 ABOVE Fragmentary inscribed stone plaque depicting Enannatum, ruler of the Sumerian city of Lagash around 2450 BC. The torso is shown frontally, the head is in profile and, despite a certain degree of realism, the eye is still huge (cf. Fig. 43) and is balanced by a large nose on one side and a highly stylised ear on the other. Note the sheepskin skirt. From Tello (ancient Girsu) in southern Iraq. Ht 19 cm.

However, the greatest revelation was provided by the so-called Royal Cemetery of Ur, excavated by Leonard Woolley from 1926 onwards. The cemetery was dug outside the walls of the city but about 2,000 years later the walls of Nebuchadnezzar's larger city were built over it. Here some 1,840 burials were found, dating to between 2600 and 2000 BC, with the earliest burials by far the most numerous. The types of interment varied from simple inhumations, with the body merely rolled in a mat, to elaborate burials in domed tombs reached by descending ramps. Seventeen of these early burials Woolley called 'Royal Graves' because there was evidence that there had been a built tomb and that the dead were accompanied by extraordinarily rich grave-goods and by the bodies of sacrificed retainers. Various theories have been advanced as to the identity of the main occupant of each tomb. Some were men and some women; some of them we know by name because of the inscriptions on seals buried with them, but it is not known whether they were kings and queens or priests and priestesses. The buried retainers included soldiers, male and female attendants and musicians, and one burial, in what is called the Great Death Pit, was accompanied by seventy-four bodies – six men and sixty-eight women – who had, it seems, been given a drug and had then lain down in orderly rows. So far, the only written evidence for the practice of human sacrifice in Mesopotamia is a Sumerian text recounting the 'Death of Gilgamesh' which refers to the hero-king of Uruk being accompanied to the Nether World by 'his wives, children, musicians, chief valet, and attendants'. Two of the richest burials were built one behind the other, with the access ramp of the later tomb, that of the 'Queen' Pu-abi, passing over the earlier one from which the body of

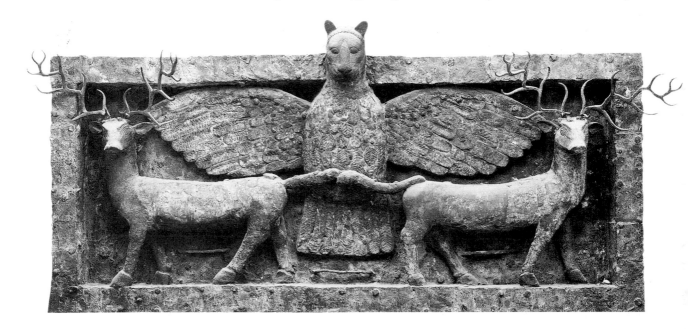

the main occupant – referred to as the 'King' but not known by name – was missing, although the reasons for this were not clear. It has been suggested that the body may have been removed to symbolise the king's return from the Nether World – a re-enactment of the Sumerian myth of Tammuz – but this is not generally accepted.

The tombs contained such rich grave-goods that it is impossible to do them justice here, even if we confine ourselves to those which were part of the British Museum's share. Weapons and vessels of gold, silver and electrum (an alloy of gold and silver) were in abundance. These materials were combined with shell, coloured limestone and lapis lazuli, set in bitumen on a wooden frame, to make a series of remarkable mosaic panels and three-dimensional objects. Woolley's workmen had been told to alert him whenever they came upon an area which sounded hollow. These hollows were then filled with wax or plaster which was allowed to set and Woolley was able to recover a cast of the wooden objects which had perished over the millennia. In this way the 'Royal Standard of Ur' itself was excavated.

This intriguing object, of uncertain purpose, is a fine example of narrative art. The action develops from bottom to top, and from left to right on the two lower registers and from right to left in the uppermost, towards the main figure, probably the ruler, who is taller than the rest (a convention known as social perspective) and whose head overlaps the frame (cf. Fig. 46). On the War side, four large chariots are advancing, three of them driving over fallen enemies. They have four intricately constructed solid wheels (spoked wheels did not appear till about 1800 BC). There are two men in each chariot – a driver and a spearman who stands on a running-board at the back; spare spears are shown at an angle at the front. This cumbersome vehicle is drawn by two onagers (wild asses); reins run through nose-rings (the bit is first attested a millennium later) and through rein-rings on the yoke-pole. A similar rein-ring of silver, ornamented with an electrum onager (WA 121348), was found in Pu-abi's tomb. The chariots cannot have been very effective in warfare because they were heavy and the harness went round the necks of the onagers (instead of across the shoulders) so that the animals would have been throttled had they drawn the chariots at any speed or for any distance. In the middle register the infantry are wearing leather cloaks, and helmets (actual copper examples were found, worn by soldiers buried in the 'King's' tomb). They are preceded by other soldiers guarding prisoners. The procession continues onto the top register where the prisoners are escorted towards a robed figure – the focus of the scene – and his entourage; behind him is the chariot from which he has just alighted.

On the Peace side, at the bottom, there are figures heavily laden with booty, and onagers. In the middle register, figures escort the animals required for the feast, most of them probably also booty: goats, cattle, fish,

47 The motif of pairs of goats browsing in a tree, often on a hill, was common in Near Eastern art at most periods. Examples in the round have rarely survived (though see Fig. 49), but there are many carved on seals. On this small shell plaque the background has been cut away and filled with bitumen so that the design stands out. From Pu-abi's grave in the Royal Cemetery at Ur (*c.* 2600 BC). Ht 4.4 cm.

46 OPPOSITE Copper frieze (considerably restored) from the temple at Tell al-'Ubaid. It shows a lion-headed eagle (a symbol of the the storm god which had originated in the Uruk period) grasping two stags in its talons. The scene is executed in high relief within a heavy copper frame. By allowing the eagle's leonine head and the antlers to break out of the confines of the frame, the unknown artist has devised a way of showing that the eagle's power is not restricted by the framework in which it has been 'captured'; this artistic device has been reinvented by generations of artists since. About 2500 BC. Ht 1.07 m.

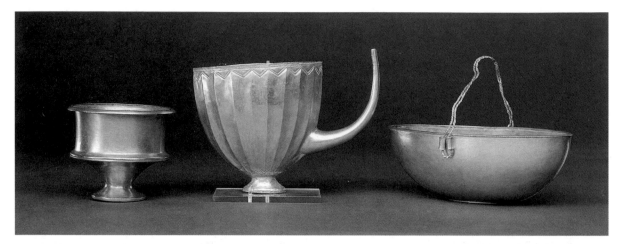

48 ABOVE Some of the gold vessels from Pu-abi's grave in the Royal Cemetery at Ur (*c.* 2600 BC). *Left* Electrum (gold with 25% silver) goblet containing green eye-paint. It has a double-walled upper part brazed onto the lower. *Centre* Fluted gold feeding cup, bi-convex when viewed from above, decorated with zigzags and chevrons. *Right* Plain boat-shaped vessel with a reinforced rim and double tubular lugs brazed onto both sides, through which passes loosely twisted gold wire. These are early examples of brazing, whereby a gold and copper alloy with a lower melting point than electrum was used as a solder. Ht 8.8, 12.4, 7.0 cm respectively.

49 RIGHT The 'Ram in a Thicket', one of a pair from the Great Death Pit in the Royal Cemetery of Ur (*c.* 2600 BC). The ram's head and legs are covered in gold leaf, its ears are copper (now green), its twisted horns and the fleece on its shoulders are of lapis lazuli and its body fleece is made of shell. Its genitals are gold. A gold-covered cylinder rising from its shoulders provided support for some object, now missing. The tree is covered in gold leaf, with golden flowers, the whole supported on a small, rectangular base decorated with a mosaic of shell, red limestone and lapis lazuli. Ht 45.7 cm.

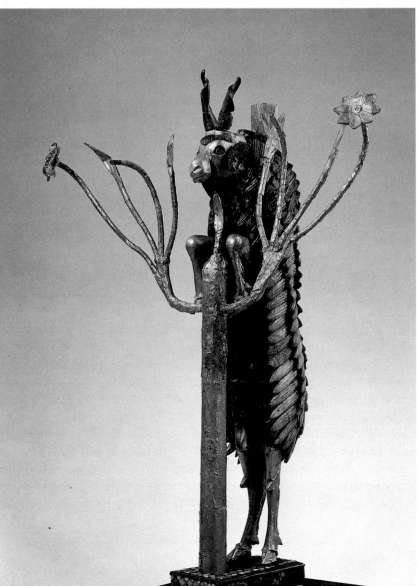

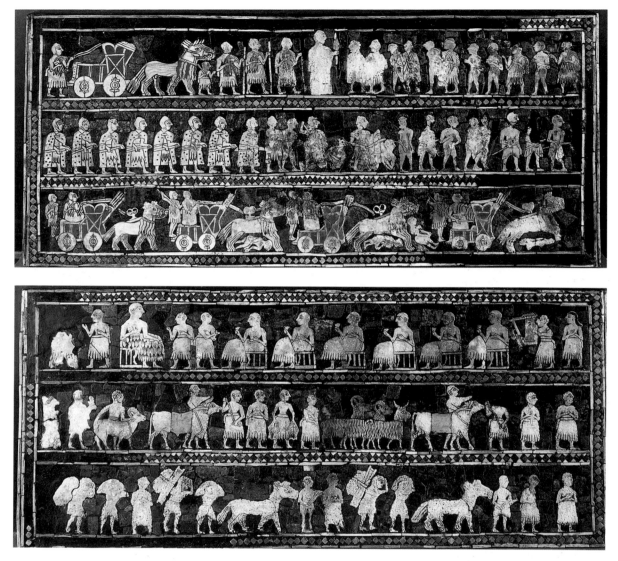

and sheep of different types whose long fleece indicates that selective breeding for wool was already well developed. On the upper register, seated officials hold cups and face the main protagonist while attendants wait on them and musicians play and sing. The different status of the figures is emphasised by variations in dress but all sit on similar seats which have bulls' legs at the front.

Registers had already been used to tell a story on the Warka Vase, referred to in Chapter 1, and on the Scarlet Ware vessel from Khafajeh which is related by subject matter to the Royal Standard. This way of recounting a narrative in registers reached a high degree of sophistication in the reliefs of the Assyrian kings of the ninth to seventh centuries BC (see Chapter 4) and is

39

50 a–b The 'Royal Standard of Ur' was found in grave 779 in the Royal Cemetery (*c.* 2600 BC). It consists of four mosaic panels of shell and red limestone against a background of lapis lazuli chips set in bitumen, originally on a wooden framework. The trapezoidal panels at each end showed animal scenes, but are damaged. The main panels are known as 'War' and 'Peace' because they illustrate a military victory and celebration banquet. Ht 20.3 cm.

still the basis of the strip cartoons of the present day. The static framework serves as a counterpoint to the movement of the scenes within; sometimes, in the case of the representation of dynamic activities, it helps to emphasise them.

One of the musicians on the Royal Standard carries a lyre, the sound-box of which is decorated with a bull's head. Thanks to Woolley's careful excavation, actual musical instruments of this type were recovered. Two of 53 these instruments had been found in the tomb of Pu-abi but they lay so close to each other that it was thought that they formed a single instrument, and this is how they were restored. Now the two have been separated and shown to be a boat-shaped harp and a portable or table lyre with a bull's head above a panel decorated with inlay (see Fig. 192 for the panel from a similar lyre). The bull may have been used to indicate the pitch of the lyre and was still being carved on the yoke of Egyptian lyres more than 2,000 years later.

The skill of the craftsmen entrusted with the inlay of objects in the Royal Cemetery was not restricted to prestige 'standards' and musical instruments. Several gaming-boards were found with designs of rosettes, paired eyes and patterns of five dots on the twenty squares making up the game (e.g. WA 120834). This 'Game of Twenty Squares' was played all over the Near East for millennia; after the fall of Babylon in 539 BC Jewish refugees may have carried it to India, where it was still being played by members of a Jewish community in Cochin a few years ago. A gaming-board of about the same date as the Ur board has been found at Shahr-i Sokhta in eastern Iran. Another link between the Ur game and the east is provided by an enigmatic object resembling a stone handbag, also found at Ur; it may be a weight from 54 eastern Iran or Afghanistan, and it is decorated with similar rosettes and eyes.

Not all inlaid objects from Ur were successful, however, and a series of ostrich eggs decorated with inlaid rims and feet are particularly unpleasant 54 examples of kitsch. However, they demonstrate the search for the exotic which is better illustrated by vessels made from imported stones and found in a variety of attractive shapes. Whereas some of these vessels were made at Ur, others were imported ready-made. Small straight-sided vessels with relief design must have originated in south-central Iran, where a source of chlorite was exploited by the inhabitants of the site of Tepe Yahya. Another vessel from Iran, or perhaps from further east, was found at Khafajeh and 51 was for a number of years thought to be a Sumerian product. It is the same shape as most of the other chlorite vessels but bears a figurative design which is presumably linked to a local mythology. The composition is well balanced: the kneeling figure holds the 'tails' of the streams of water and controls the fertility of the land, while his more dynamic counterpart grasps the necks of the snakes and controls the destructive forces of nature. However, the balance emphasises the deliberate contrasts: for instance, the

lack of concern of the feeding zebu on the one hand and the way the snakes and felines look at the standing man on the other. The final scene may show the chaos which ensues when men or gods are not in control. Fragments of a similar vessel (WA 116455) found at Ur probably depicted another version of this scene, and the horn on the head of the only surviving figure may, as we shall see, identify him as a deity. However, the figures on the Khafajeh vessel may be royal heroes, for a similar hairstyle is worn by the man on a lapis lazuli seal from eastern Iran where he is clearly taking part in a banquet. Zebus are not native to Mesopotamia and their presence on the Khafajeh vessel and on the seal, and the way their horns are depicted as if seen from above (rather than in profile, as is the convention in Mesopotamia: see, for example, Fig. 35a), indicates a connection with the civilisation which was developing along the Indus Valley in Pakistan and north-west India. There was to be increasing evidence for such contacts during the next few centuries.

The jewellery from Ur provides other evidence for contacts with the east. The lapis lazuli was, as we have seen, imported from Afghanistan. Some of

51 Image produced by rotating a vertical-sided chlorite vessel similar to that in Fig. 54 in front of a camera. Though made in Iran or further east, the vessel was found at Khafajeh, north-east of Baghdad. A man in a net skirt (cf. Fig. 35a) kneels on two zebus standing back to back, and grasps streams watering vegetation and a palm-tree; above are two undulating lines (rain clouds?), a crescent moon and a rosette sun. A similar figure, with a rosette but without the side plaits, grasps two snakes and stands between two felines lying back to back, with heads turned towards him. A lion and eagle attack a bull with a small animal below. About 2600 BC. Ht 11.5 cm.

52 Fragmentary stamp seal made of brilliant blue lapis lazuli. It has a handle on the back and was once square. Originally two figures faced each other. That on the left in the impression is largely missing but held a cup, above which is a globe. The man on the right has his hair hanging in sidelocks and down the back; he sits with his legs folded beneath him and his hands with their palms almost together. To the right are a long-horned, bearded goat facing left above a zebu facing right (damaged). At the top may be rain clouds and rain, an arbour or a fenced enclosure. About 2400–2000 BC. Ht 3.2 cm.

53 Lyre from the grave of Pu-abi as restored in 1971–2. Ht 1.125 m.

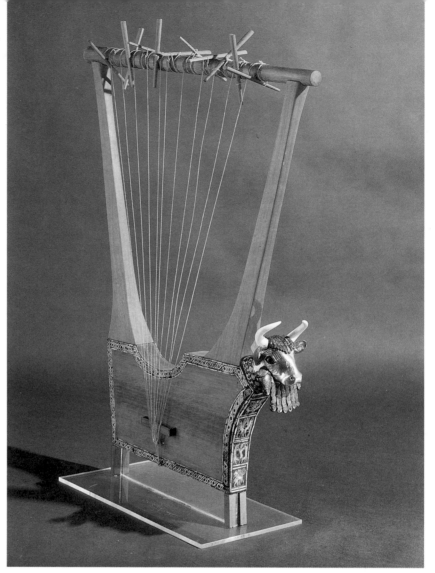

54 BELOW A handbag-shaped weight (?) found in the 19th century at Ur, and a selection of vessels from the Royal Cemetery (*c.* 2600 BC). The body of the footed cup third from the left is an ostrich egg. All the other vessels are of stone and the small chlorite one second from the right was an import from Iran. Ht of black and white pot in centre 15 cm.

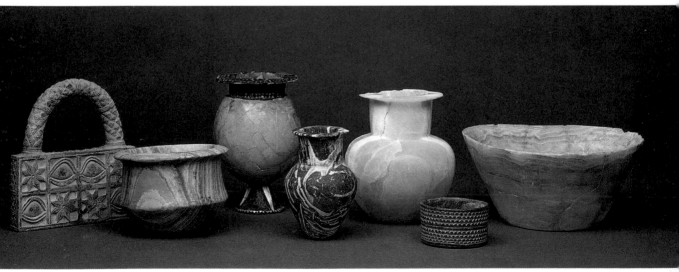

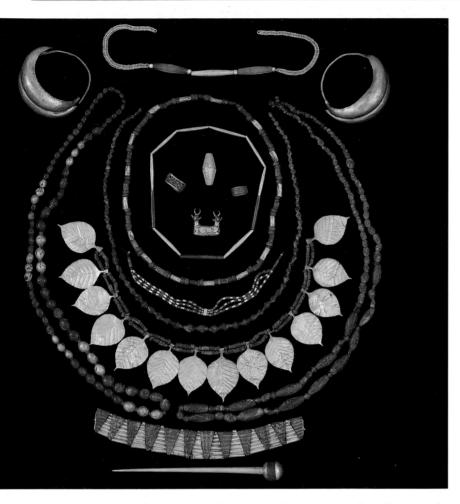

the beads may have been imported ready-made, some may have been made at sites such as Shahr-i Sokhta in eastern Iran, and some were probably fashioned at Ur. There are discoid, annular, double conoid, leaf-shaped, melon-shaped, segmented, round, barrel-shaped, faceted, cylindrical, trapezoidal and many other types of beads in a variety of sizes, and most also occur in gold versions. Chokers were built up of alternating lapis lazuli and gold trapezoidal multiple beads. The carnelian beads are mostly round or double conoids, but some are flat. Sometimes the carnelian has been etched with an alkali to leave a white pattern – a technique which probably originated on the west coast of India; this area is also a plausible source for the carnelian and the few agate beads.

Many techniques were employed in the making of the jewellery. Cloisonné is illustrated by the central disc of a necklace where spaces between gold circles are filled with lapis lazuli and carnelian chips. A gold ring with lapis lazuli lozenges filling the spaces in a lattice of gold is another

71

example of the technique. Filigree was used on a little holder for gold tweezers, scoop and applicator (Iraq Museum, Baghdad). Although it has been claimed that granulation was used at Ur, it does not seem that true granulation occurs, although small gold balls were fused together to form beads. True granulation, whereby minute balls of gold were attached to a backing of gold, probably first appeared around 1800 BC. Gold rosettes are made of narrow strips of gold looped backwards and forwards between gold rings. A gold stud has its head incised to form linked spirals, and the chain on a head ornament is executed with the double loop-in-loop links still found in much Victorian jewellery. Small animals and fish were made of gold leaf over a bitumen core, and of different stones. All this jewellery was combined in headdresses which are works of art in themselves and which were topped by huge pins cut from sheets of silver to form stems ending in rosettes of inlaid stones which quivered as the wearer moved. They were worn with strings of beads and chokers, and huge, boat-shaped earrings made of sheet gold. It has been possible to reconstruct these headdresses and necklaces because they were excavated where they lay on the skeletons of those who had worn them. The garments were secured with toggle pins, and from these hung strings of beads and often a cylinder seal.

Cylinder seals were found in many of the Ur graves. A large number were made of lapis lazuli – among them Pu-abi's own depicting a banquet, which 56c was a popular motif. A further seal from the Royal Cemetery shows the 56b other main theme for cylinder seals at this time, the contest scene. The crossed bodies of animals on this seal create an intricate pattern of relationships within the composition; they are characteristic of this period and survive into the succeeding Akkadian period, as do the lions' heads seen from above; the long manes are also distinctive and are lacking on earlier versions of the contest scene. One of these earlier scenes depicts a figure 56a traditionally known as the nude hero together with a bull-man. The upper part of a bull-man's body is human, but with the horns and ears of a bull; from the waist down his body is that of a bull. These two, both generally shown frontally, form a popular motif on later seals. Lions also appear on this seal, but whereas the head of one of the lions is shown in profile, those of the other two are seen from above; they are smaller and more pinched and their manes, with patterns of arcs confined within narrow outlines, lack the exuberance of those on the later seal. The composition is clearer, with none of the crossing over found later; it is also more static. Perhaps a century separates these seals; both are masterpieces of composition and execution, but the aims of the seal-cutters were different.

During the Early Dynastic period there was a growing emphasis on the individual. Seals began to be cut with inscriptions identifying the owner and giving his titles and profession. Rulers achieved greater status in the secular realm and gradually the palace and temple became separate institutions,

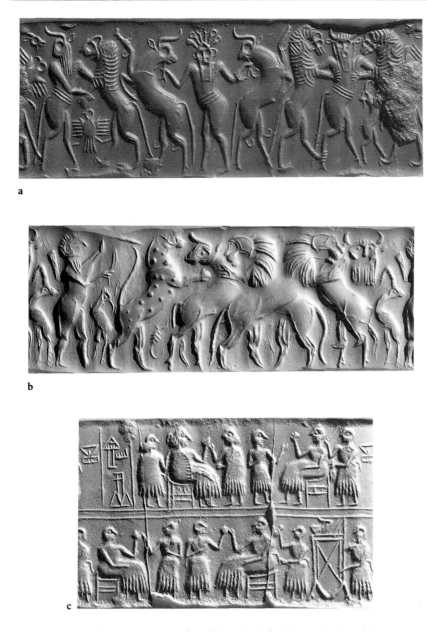

a

b

c

56 a. Modern impression of an Early Dynastic II seal made from the core of a very large marine shell. The provenance of this seal is not known but it closely resembles seals found at the site of Tell Fara in southern Iraq dating to about 2700 BC. A hero, naked except for a belt and an elaborate headdress, grasps the halters of two bulls in a gesture of protection which recalls that on the Late Uruk period vessel (see Fig. 36). On either side of this group are two early versions of the bull-man – one in profile and one full-face – fighting with lions. Ht 5.3 cm.

b. Modern impression of an Early Dynastic III seal made from a cream-coloured stone, found in a grave in the Royal Cemetery at Ur (*c.* 2600 BC). It shows a contest scene with, in the centre, crossed lions attacking a bull and the so-called 'human-headed bull' – probably a bison. The bull is also being attacked by a leopard, but a bearded hero, brandishing weapons, is coming to its assistance. Among the figures are small gazelles and a scorpion. Ht 4.3 cm.

c. Modern impression of the Early Dynastic III lapis lazuli seal of Pu-abi found in her grave in the Royal Cemetery at Ur (*c.* 2600 BC). It depicts a banquet scene in two registers reminiscent of the banquet on the Royal Standard (see Fig. 50b) except that one of the principal banqueters is a lady, perhaps Pu-abi herself as her name and title appear in the cuneiform inscription behind her. She is attended by two women whereas the man facing her and the two men on the lower register have male attendants. There is a leg of meat on a stand beside the lower banqueters. Ht 4.9 cm.

each with its own hierarchy and administration. Sumer and probably most of Mesopotamia, Syria and perhaps Iran, were divided into a series of city-states which were often at odds with each other. The fortunes of a city were those of its patron deity and it became necessary to identify these various deities. For this purpose the horned headdress was developed some time around 2500 BC or shortly after.

An early depiction of a god appears on a limestone plaque from Ur which, judging by its shape and the hole in the centre, was originally set up in a

57

57 Limestone plaque from Ur
(*c.* 2500–2400 BC). The design is
divided into two registers. Above,
three women follow a naked,
beardless priest with abundant hair
who pours a libation on an altar
before a bearded and robed god in
a horned headdress. Below, a man
and a woman carrying animal
offerings (perhaps the donors of
the plaque) and a woman shown
frontally stand behind a shaven-
headed beardless naked priest who
pours a libation before a building
which has the niches and
buttresses typical of Mesopotamian
temple architecture, with gateposts
on either side. Ht 22 cm.

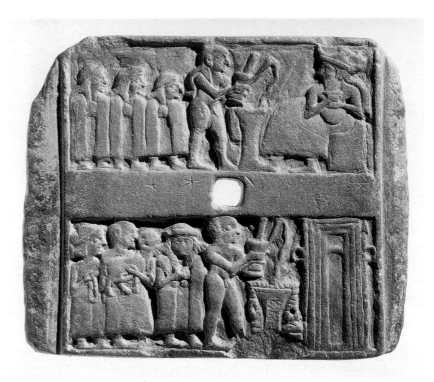

temple; it was found in a religious institution, the Gipar-ku. The identity of
the god is not clear: he holds a pot of a type which was often an attribute of
the water-god Ea in later iconography (a similar vessel was found in the
tomb of Pu-abi), but the gate-posts on either side of the temple façade are
sometimes thought to be symbols of the goddess Inanna. However, the
women on the plaque may provide a further clue as to the god's identity. All
but one are probably priestesses and they wear their hair in a distinctive style
which is later that of the En-priestess of the moon god at Ur, an important
post usually filled by the ruler's daughter. If the En-priestess is to be
identified on the Ur relief, then she is probably the figure shown frontally on
the lower register, whose hair is indicated in greater detail. Libation vessels
of the type the priests hold have been found in the Royal Cemetery (e.g.
WA 121450); the vessel could be grasped by the foot or the neck and did not
have a handle, indicating that the contents were not hot. Handles are
relatively rare on Mesopotamian vessels and are much more common on
those of Iran (at certain periods), Turkey, Syria and Palestine, presumably
because hot liquids were more often being poured in these areas.

In connection with this plaque, the convention used for depicting figures
in relief should perhaps be discussed. The head is generally shown in
profile, the torso is frontal and the legs are in profile. This twisted posture
avoids the problems presented by a frontal depiction of the face or feet: the

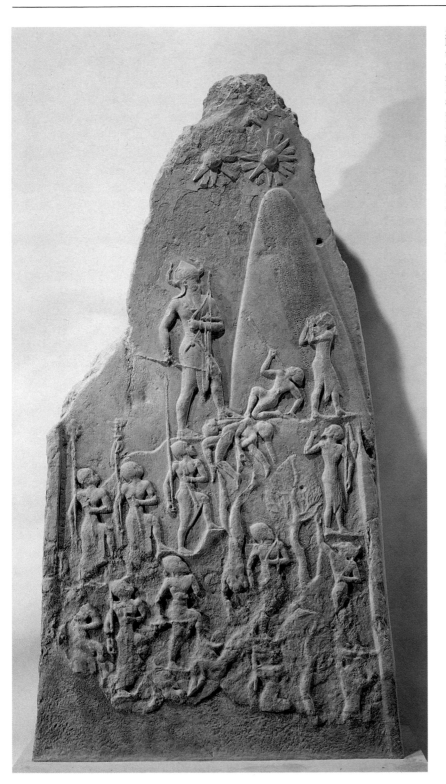

58 Stele set up by the Akkadian king Naram-Sin (r. 2254–2218 BC) to commemorate his conquest of the Lullubi in the Zagros mountains on the borders between Iraq and Iran. The king stands on a mountain pass between astral symbols, wearing the divine horned helmet; his fringed garment, knotted over one hip, became for centuries that of the warrior king (see Fig. 82b). He holds a bow and arrow and towers over dead and wounded Lullubians, some with broken weapons in a row along the right edge of the stele. Akkadian soldiers with spears and standards climb the wooded slopes. Ht 2 m (Paris, Louvre).

nose, for instance, would either have to jut out beyond the rest of the relief, thus necessitating the removal of large quantities of stone and leaving it vulnerable to breakage, or it would appear foreshortened and squashed. The figure of the principal priestess on the Ur plaque demonstrates this.

However, although this twisted profile was the normal way of representing two-dimensional figures and figures in low relief throughout the Near East and also in Egypt until the final years of the Assyrian empire, there were certain exceptions. Some of these we have already seen. The nude hero, the bull-man and the human-headed bull are almost always shown full-face at all periods, and for at least a thousand years this was also the case for the goddess Inanna/Ishtar (see Figs 59e and 82a). In Babylonian iconography between about 1850 and 1750 BC, a nude female figure and a goddess whose iconography may have derived from the representation of the priestess on the Ur plaque were also shown frontally (Fig. 82a and compare Figs 57 and 82c). It is not clear why an exception to the rule should have been made in these cases, and why this convention should have survived the millennia. Perhaps there was some particular significance in the depiction of both eyes in these specific cases.

From about 2334 BC the separate city-states were united under a king called Sargon, who established his capital at Akkad. The site of this city has not been located but may lie buried beneath one of the mounds which were later to become part of Babylon. There may have been economic reasons for the shift of power northwards. Intensive irrigation results in considerable evaporation and increased salination; records show that during the latter part of the third millennium the wheat yield decreased and salt-resistant crops had to be planted instead. Some sites were abandoned, and without regular maintenance some canals silted up, leading to the enforced abandonment of further sites. There may also have been a political reason for the shift northwards: Sargon was not a Sumerian but a Semite. The language he spoke, Akkadian, belonged to the Semitic language-group of which Arabic and Hebrew are modern descendants. Doubtless Sargon did not wish to associate himself too closely with one of the old Sumerian city-states. Akkad was also more centrally located and Sargon had imperial ambitions for his dynasty which reached their apogee under his grandson Naram-Sin (r. 2254–2218 BC), who set up stelae recording his conquests. Akkadian power extended up the Tigris into Assyria and up the Euphrates into Syria, and perhaps even into Turkey where, according to tradition, there were Akkadian trading colonies. One of the most enduring icons for victory ever devised commemorated Naram-Sin's victory against the Lullubi in the 58 Zagros mountains of eastern Mesopotamia. It is also the earliest datable Mesopotamian landscape.

That stele had a tremendous impact on the tribal rulers of the Zagros who, during the next few centuries, cut rock reliefs on the cliffs along the main

route between Mesopotamia and Iran. Here they still stand triumphant over their enemies. Much later still, Darius the Great (r. 521–486 BC) chose the site of Bisitun, further along the same road, for his huge victory relief and its trilingual inscription which led to the decipherment of cuneiform (see page 24).

The Naram-Sin stele had an interesting subsequent history. It was still standing in Sippar when, around 1157 BC, the Elamites brought about the fall of the Kassite dynasty and carried it off, together with other works of art which they set up in Susa as booty (an inscription on the mountain cone beside Naram-Sin informs us of this event). There, in 1898, it was excavated by the French; it is now in the Louvre in Paris (see page 120).

Sargon must have been an extraordinary person: certainly his achievements were remembered for millennia and legends grew up around the circumstances of his birth (he was said to have been found as a baby, floating on the Euphrates in a basket – a much earlier version of the events accompanying the birth of Moses in the Bible). His name means 'true king' and was borne by other great kings whose origins were equally doubtful, the greatest being Sargon II of Assyria (r. 721–705 BC). In the context of this study Sargon of Akkad is chiefly remarkable for having established an imperial style in art.

The Akkadian empire lasted less than a century and a half, and as the capital city has not been located, and Akkadian cities in the vicinity are probably buried under alluvium and a high water-table, its innovative art and architecture are mostly known from outlying cities and colonies, notably Tell Brak in north Syria. In their homeland, therefore, the art of the
59 Akkadians is best documented by their seals, which have survived in great numbers. The reason for their survival lies in their large size, the beautiful stones from which they were often made and the exceptional quality of the carving, which meant that they were frequently kept in circulation and reused by later owners (see page 19). The size of the seals meant that they were less easy to use and were probably carried as status symbols; indeed, very few impressions of Akkadian seals have survived. There may have been an official policy of making seals a vehicle for the new imperial style, and certainly Akkadian seals are easily distinguishable from those of the preceding Early Dynastic period.
59a Contest scenes continued to be popular, but the Akkadian craftsmen returned to the clearer forms of the earlier Early Dynastic II style and generally avoided the crossed animals of the later Early Dynastic III style. The participants are the same: the predator is a lion with its head generally seen from above (the leopard disappears from the repertory); bulls, sheep, goats and human-headed bulls are in need of the protection provided by bearded heroes, naked but for a triple belt, depicted full-face, generally with triple curls on either side, or by bearded, kilted 'royal heroes' shown in

profile wearing decorated hats, and by bull-men, who are generally, and increasingly, shown full-face. The power of the design no longer resides in its dynamic composition but in its static, balanced monumentality.

By the middle of the next century, these Akkadian characteristics had 59b evolved into a classic style with two pairs of contestants and an inscription panel. The continuous and repeating frieze was replaced by a design which can be viewed either with the pairs framing the inscription or with the

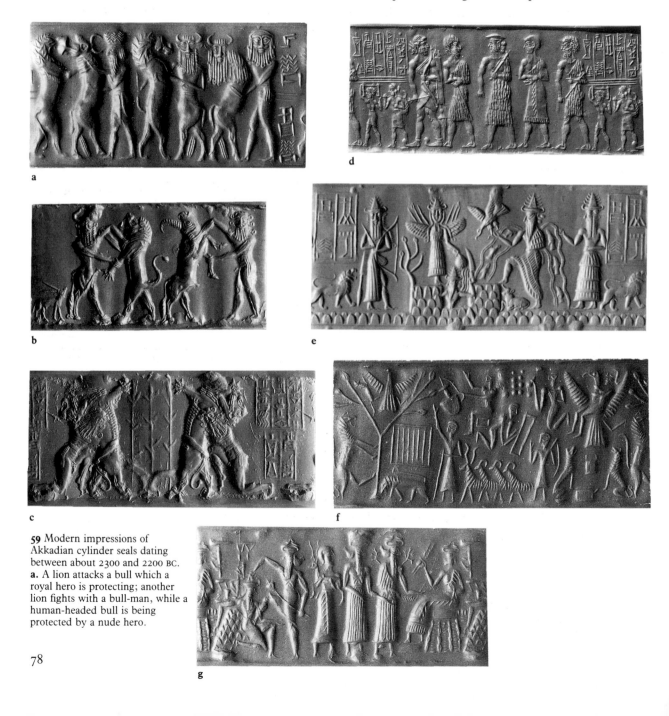

59 Modern impressions of Akkadian cylinder seals dating between about 2300 and 2200 BC. **a.** A lion attacks a bull which a royal hero is protecting; another lion fights with a bull-man, while a human-headed bull is being protected by a nude hero.

inscription panel framing the contestants, thus creating a heraldic balance. Many of these later Akkadian seals are concave-sided and made of greenstone, a very popular material used almost exclusively at this period. Another characteristic feature of Akkadian seals is the way in which the elbows of the contestants point upwards. Sometimes the heraldic balance is carried still further and one workshop, probably a royal one, specialised in identical pairs of contestants whose contorted postures are executed in mirror-image. On the example illustrated here, the patterning of the stone makes it difficult to see the design unless the seal is rolled out. Nevertheless, despite the hard stone and the small scale of the carving, the unknown artist has even managed to differentiate between the front and back of the lions' paws.

A fine seal in the Louvre, probably a product of the same workshop, shows, also in mirror-image, two nude heroes kneeling to offer vases of water to two water-buffaloes; the inscription names the owner, a scribe of King Shar-kali-sharri (r. 2217–2193 BC). It is probable that water-buffaloes were imported from the Indus Valley at this period and kept in a royal zoo; they generally appear on high-quality seals which often belong to royal officials. Full advantage was taken of the decorative possibilities provided by the curve of the huge horns of these animals, but the way these horns are depicted as seen from above is but a bolder version of the way they were depicted in their homeland. Seals provide the best evidence for links with the east: there is even an Akkadian seal (Louvre) belonging to a Meluhhan interpreter, and it is probable that, at this time, Meluhha was the name for the Indus Valley area. A cylinder seal carved with Indian animals (elephant, rhinoceros and crocodile), depicted in Indus style, was excavated at Tell Asmar in the Diyala region (Iraq Museum, Baghdad). There is evidence that Sargon of Akkad either instigated these links, or at least actively encouraged them, for the seal impression of his daughter's scribe, found at Ur, already depicts a water-buffalo. This daughter, En-hedu-anna, was installed as En-priestess of the moon god at Ur.

Sargon also seems to have been responsible for a reorganisation of the pantheon. The Sumerian deities were mostly associated with fertility and animal husbandry but the Akkadian deities were predominantly astral, representing sun, moon and stars. In order to unite the country, and in an attempt at breaking the close connection between gods and goddesses and their cities (which does not seem to have been altogether successful), Sumerian and Akkadian deities were combined and a standard iconography devised so that they could easily be identified visually. The fine seal of Adda illustrates the process. The deities all wear the horned headdress which indicates their status, and here the iconographic principles which were to govern the representation of the main deities are clearly formulated for the first time. Below the inscription panel is a lion, the attribute of a hunting god

Inscribed in cuneiform with the name of the owner, who was a scribe. Serpentinite, ht 3.5 cm.
b. A bull-man fights with a lion, and a water-buffalo with a nude hero; there is a small African oryx below the space left for an inscription. Concave-sided greenstone seal brought back by A. H. Layard. Ht 3.3 cm.
c. Two nude heroes kneel on one knee and bend a lion back over their shoulders; one arm is wrapped around the lion's neck and the other encircles the lion's body and grasps its tail. An earlier inscription was erased and replaced by less skilfully cut reeds where the frame used to be; the new owner was the scribe of Puzur-Shullat, a priest. Slightly concave with bevelled edges, this banded red and white jasper seal is from the collection of C. J. Rich. Ht 3.6 cm.
d. Seal of the scribe Kalki, servant of Ubil-Ishtar, brother of a king who is not otherwise identified but who may have been Sargon. Black and white speckled diorite, ht 3.3 cm.
e. Akkadian deities on the concave-sided greenstone seal of the scribe Adda. Ht 3.9 cm.
f. A serpentinite seal depicting the legend of Etana. Etana is being carried off by the eagle; as they fly up they are watched by shepherds, sheep dogs, a man working a churn (the large vessel with a stopper which is being rocked backwards and forwards to produce butter), and others perhaps engaged in cheese-making. Ht 3.8 cm.
g. A worshipper carrying an animal offering is introduced by his personal god and a vegetation god to a goddess, who also holds ears of wheat and who is seated on a wicker throne. Beneath the inscription giving the owner's name are two fighting gods and a hill or mountain. Greenstone, ht 3.5 cm.

whose precise identity is not known and who is shown full-face, holding his composite bow and an arrow, with his quiver on his back, below which hangs a tassel for cleaning his arrows; he is ready for action with the front of his skirt tucked into his belt. The Sumerian goddess of fertility, Inanna, was combined with Ishtar, the Semitic warrior-goddess associated with the planet Venus, and the attributes connected with these three aspects are represented by a bunch of dates held by the small goddess, the weapons rising from her shoulders, and her wings. The sun god Utu/Shamash, god of justice and omens, with rays rising from his shoulder, cuts his way through the mountains of the east (represented by a scale pattern) with his saw-toothed knife. The water god Ea or Enki has no clear Semitic equivalent and lost popularity after the Akkadian period, but here he is given prominence as the god of the subterranean waters, the god of wisdom and craftsmen (including scribes); he is identified by a bull, by the streams of water flowing from his shoulders with fish swimming up them, by his two-faced attendant Usimu, who stands behind him, and by the presence of the Zu-bird who stole the Tablet of Destinies (see also Fig. 194a).

Another scribe, Kalki, chose a purely secular theme for his seal's design. 59d He is shown shaven-headed, holding a tablet and standing behind his master, the prince Ubil-Ishtar. The latter is probably the figure in a hat, with his hair in a double bun, wearing a fleecy robe and carrying an axe, who stands at the centre of the composition with everyone else looking towards him. On either side are two officials in fleecy robes carrying weapons. The party advances towards the left, preceded by a figure – perhaps a mountain guide – who wears a distinctive hairstyle, a kilt and the boots with upturned toes normally worn by foreigners from mountainous areas of Turkey and Iran; he carries a composite bow, an arrow and a quiver with a tassel hanging below it. Behind come two servants carrying the furniture and belongings of the party. It is tempting to see in the scene the highlight of Kalki's career, when he accompanied a royal diplomatic or trading mission and brought back, possibly from south-western Iran, the rare stone from which his seal was carved.

Many seals show mythological themes. One particularly popular subject 59f was the legend of Etana, who was a shepherd and appears on king-lists as king of Kish. According to the legend, the eagle had betrayed the serpent's trust and stolen its young (in the version depicted on the seal it seems that a lion replaced the serpent). As a result its wings were broken and it was imprisoned. Etana rescued the eagle, which agreed to carry him up to heaven so that he could ask the gods for a son. Etana fell once but the eagle swooped down and caught him, and the text breaks off as he falls again; presumably, however, he achieved his goal, for according to the king-list he was succeeded by his son. Other seals show the 'Battle of the Gods'; this 59g popular scene may well have been connected with the agricultural cycle.

The banquet scene which had been so popular in the Early Dynastic period was replaced in Akkadian times by presentation scenes before seated deities. Some Akkadian presentation scenes show a worshipper and groups of standing deities; this grouping of standing figures was revived in the next millennium, but the seated presentation scene became almost the only subject for seals during the last century of the third millennium.

The Akkadian empire probably collapsed under pressure of Gutian invaders from the east, although a change in climate and resulting economic instability have also been suggested as a cause for the wane of Akkadian power. After a period of chaos there was a Sumerian revival in the south, with dynasties at Lagash and Ur. Finally the Third Dynasty of Ur gained the upper hand under its founder, Ur-Nammu (r. 2112–2095 BC), although it was the reorganisation of the administration under Shulgi (r. 2094–2047 BC) which heralded a brief period of expansion before the collapse of the dynasty in about 2004 BC.

A spectacular seal is dated by its inscription to the reign of Ur-Nammu. It shows two goddesses, one of whom is leading the owner of the seal by the hand in a way that is distinctive of this period, while the other stands with both hands raised in the posture which was to become almost universal for interceding goddesses in the second millennium. On later official seals the king holds a cup which symbolises the office he is conferring on his servant; he is seated on a distinctive fleece-covered stool, and the crescent moon is generally replaced by a combined symbol with the sun-disc, inscribed with a star, within the arc of the crescent. A long inscription, divided into two panels one above the other, is also typical of the period. Sometimes a deity

60 Modern impressions of seals of the Third Dynasty of Ur.
a. A greenstone seal which belonged to Hashhamer, governor of the city of Ishkun-Sin, servant of Ur-Nammu, 'strong man, King of Ur' (r. 2112–2095 BC); this was the first Sumerian text to be published (1820). The king is seated on an elaborate throne and raises a hand to greet Hashhamer, who is being introduced by two goddesses. Ht 5.28 cm.
b. The owner of this limestone seal, Aham-arshi the scribe (son of a well-known scribe and administrator named Babati), is being led by a goddess before King Ibbi-Sin (r. 2038–2004 BC), who holds a cup and is seated on a padded stool. Ht 3.2 cm.
c. The owner of this chlorite seal is led by a goddess before a bearded god whose seat resembles a temple. Ht 1.8 cm.

b

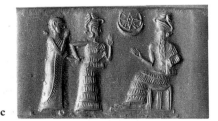

c

a

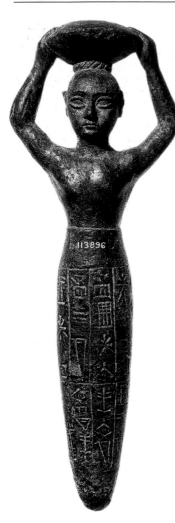

113896

61 Copper foundation peg from a temple at Uruk, bearing an inscription of Ur-Nammu (r. 2112–2095 BC). The upper part of the peg is shaped like a shaven-headed man – probably the king himself in his role as priest – carrying a basket of building materials on his head. Ht 27.3 cm.

replaces the king, but deities do not hold cups and they sit on thrones resembling niched temple façades. These seals are repetitive but their iconography corresponds to extremely precise rules regarding the dress of the figures in different combinations, their types of headdress and their seats; the rules apply as much to these court seals as to the smaller, cruder seals of private individuals, with brief, two-line inscriptions, where the worshipper is generally led by a goddess in a vertically striped robe before another goddess, who is seated. The direction of the scenes also becomes established, with the deity or king who is the focus of the scene sitting or standing on the right, facing left, when viewed on the impression. This was to be the normal direction for all types of scene, regardless of medium, in Mesopotamia and beyond, throughout the remainder of the period covered by this book. 60c

The strict adherence to conventions apparent in the art of the Third Dynasty of Ur is evidence of the establishment of an official canon. This contrasts with the imperial style of the Akkadian period, which is no less distinctive but which allowed the artist the freedom to express himself and to be innovative. Whereas the art of the Akkadian period had been new and exciting, and had mirrored the vigorous and expansionist vision of its leaders, the Ur III canon was a reflection of the restrictions of a bureaucratic administration. The one was looked upon as a golden, heroic age and influenced the art of later periods; the other was the swan-song of the Sumerians.

Ur-Nammu was responsible for considerable building activity at Ur, including the first ziggurat, or stepped temple-tower, which still dominates the landscape. He also undertook building activity elsewhere, as is testified by a foundation figure from a temple at Uruk. Here the king shows himself, not as a ruler freeing his land from predators, but as a priest carrying the building materials for his god's temple. This continued to be an aspect of the role of kings, and similar figures were buried in the foundations of buildings for over three centuries: the British Museum has examples, e.g. WA 102462, inscribed with the name of Rim-Sin, the last king of the Larsa dynasty (r. 1822–1763 BC). The seventh-century BC Assyrian king Ashurbanipal not only had himself depicted in lion hunts but also in the role of royal builder (e.g. WA 90864) – a reflection of his interest in continuing (or reviving) ancient traditions. 61

Probably in part contemporary with Ur-Nammu was Gudea, ruler of Lagash. A foundation figurine from one of his cities, Girsu, shows a kneeling god holding a peg (WA 102613), while another peg is topped by the figure of a bull browsing in a reed marsh. However, Gudea is chiefly famous for a remarkable series of statues of himself (most of them in the Louvre) which he set up in the temples of his city and its vicinity. The finish of these statues, most of which are carved in hard diorite, testifies to the increased 63 62

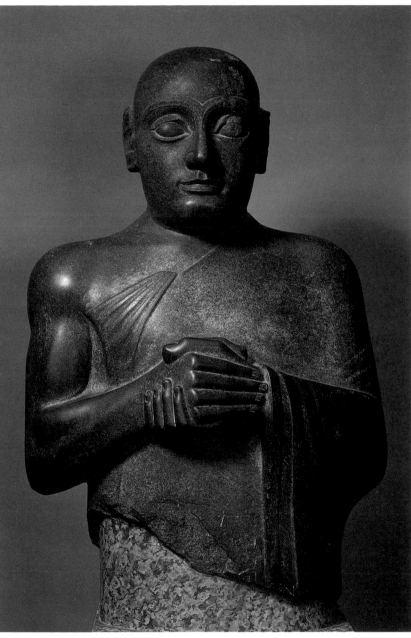

63 ABOVE Copper foundation peg topped by a bull browsing in a reed marsh, recording the rebuilding by Gudea of the temple of the goddess Nanshe in her city of Sirara (now Zerghul in southern Iraq). Ht 19.4 cm.

62 Diorite statue, probably of Gudea of Lagash (*c.* 2100 BC), showing him shaven-headed, with hands clasped. His robe, its border marked by fine diagonal incisions, is draped over one shoulder but the other arm is left bare. The inscription panel on his skirt is broken and the lower part of the body is missing. Ht 73.6 cm.

technical skill of the craftsmen. As in the Early Dynastic period, the sculptor was very much aware of the underlying geometry, but the result is completely different: he lovingly depicts the powerful round shoulders, the curves of the arm muscles, the wedge shape of the hands. The head is smooth and round, the eyes are no longer inlaid but are set between prominent lids above which arch eyebrows which meet above the nose and

64 Black stone (diorite?) statue of a woman (head and lower part of the body missing) standing with hands clasped. Her long shawl is decorated with an ornate border and fringes; it passes across the front under both armpits, crosses over at the back, and the ends hang down on either side in front. Ht 18 cm.

are marked with herring-bone incisions. A huge, fragmentary statue of Gudea, or one of his near contemporaries (WA 98069), must have been at least twice life-size; it shows that, at this period, the size of the imported blocks of stone no longer restricted Sumerian sculptors.

Smaller statues of the last century of the second millennium also show worshippers. Women had elaborate hairstyles, as demonstrated by the head 64 of a female worshipper from Ur (WA 118564) and by a stone hair-piece – part 65 of a composite statue – which is dated by its inscription to the reign of King Shulgi. The statues of worshippers were set up in the sanctuaries of temples, but there is little evidence of what the statues of gods and goddesses were like. They were probably made of metal or wood, covered and inlaid with precious materials, and have not survived. One exception, from Ashur in northern Mesopotamia, is a plaster plaque, now broken, depicting a naked goddess who was originally about 20 centimetres tall, standing frontally in a decorated niche (WA 118996). Her features were dominated by her huge eyes, but they have been considerably abraded; she is square-shouldered and stands with her thin arms stiffly alongside her body; her round breasts are close together and the beginning of her pubic triangle can be seen above the break. Black and red painted decoration adorns her body: round her

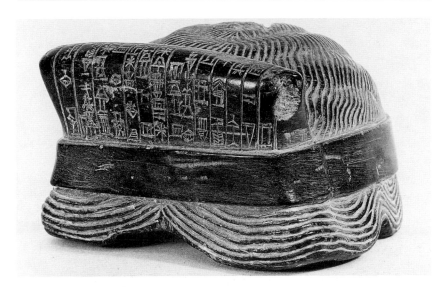

65 Black stone (diorite?) hair-piece from a composite statue. The cuneiform inscription on the hair looped up at the back is a dedication to the goddess Lama for the life of King Shulgi (r. 2094–2047 BC). Ht 5.65 cm.

neck she has a choker made of triangular multiple-beads (see Fig. 55), and she has feather-like patterns over her shoulders. There is something very primitive about this cult figure when it is seen alongside the sophistication of the contemporary Akkadian seals discussed above, or the slightly later statues of Gudea.

So far this chapter has dealt mainly with the art of Mesopotamia. This is because, during the third millennium BC, the culture of Mesopotamia was predominantly an urban one; its large town sites are easy to identify and have been extensively excavated. Elsewhere in the Near East the cultures were more rural. The few exceptions mostly lacked the richness of their Mesopotamian counterparts, being local market-towns where products from surrounding villages were bought and sold, many of these products – with the notable exception of pottery – being made of perishable or recycled materials. The artistic creations that have lasted have come from international emporia. Furthermore, town sites of this period in Iran, Turkey, Syria and Palestine have either been excavated by non-British archaeologists or have been dug since the introduction of laws restricting the export of antiquities, and so are poorly represented in the British Museum's collections.

The fact that metal objects are so often melted down and reused has already been mentioned; most of those that have survived have been found in graves. Among these are animal-shaped standards such as those from Kirkuk, which may have decorated a canopy above a burial. Similar standards and others with geometric patterns, a considerable amount of jewellery, gold vessels and a distinctive type of dagger with a crescentic hilt were found in graves of about 2300 BC at Alaca Hüyük in central Turkey (now mostly in the Museum of Anatolian Civilisations in Ankara); much of

66 ABOVE A bull and a goat of copper from a grave near Kirkuk in northern Iraq. The dates proposed range from 2700 to 2250 BC and a date around 2500 BC would be supported by the objects found with them (see Fig. 70 left). The way the hooves are depicted also has parallels in earlier times. Ht of goat 24.3 cm.

67 RIGHT A silver bull inlaid with gold and set on a copper stand, which probably decorated the canopy over a princely burial at or near Alaca Hüyük in central Turkey (*c.* 2300 BC). The lean shape of the animal and its thin muzzle offset the huge spreading 24 cm.

this material has parallels at Ur in the Royal Cemetery, showing that traditions of fine craftsmanship in gold take little account of geographical and chronological boundaries (see also the 'Median' jewellery hoard from Tepe Nush-i Jan, page 177). A silver two-handled cup (WA 132150) of similar date, from near Troy in western Turkey, displays the same clean lines as the bull standard. Ceremonial axes have also frequently been found in burials of the late third millennium BC and demonstrate the excellence of metalworking techniques at this time. They appear as a status symbol on the contemporary Akkadian seal discussed above.

68 Ceremonial or votive axes of the late 3rd millennium BC. *Top left* Copper or bronze crested axe-head which has parallels from graves at Mahmatlar in central Turkey. Its short thick blade indicates a ceremonial rather than a practical function. Ht 9.5 cm. *Top right* Copper or bronze fenestrated axe. From the French excavations at Byblos in the Lebanon. Ht 9 cm. *Centre* One of two axes of arsenical copper obtained by Sir Percy Sykes in about 1900 from a cemetery at Khinaman near Kerman in Iran. Both have a curved back, which resembles that of the Turkish example to the extent that the 'crest' is indicated by grooves and incisions, and both have a thick blade which droops at such an angle that it could not have been functional. Two animals decorate the blade and shaft-hole of the illustrated example. L. 12.4 cm. *Bottom* The whole of this bronze axe has been transformed into a series of animals which, though realistically rendered, form an interlocking pattern. A boar's back forms the (blunt) blade (the same feature appears on an axe in the Metropolitan Museum of Art in New York), with the thin, stripy (silver-inlaid) line of a tiger's tail running above its muzzle; the elongated bodies of the tiger and of its prey, a goat, run along the axe and both animals look back towards the blade. This axe may be from Bactria (now Afghanistan), but it was found further south in what is now Pakistan. L. 17.8 cm.

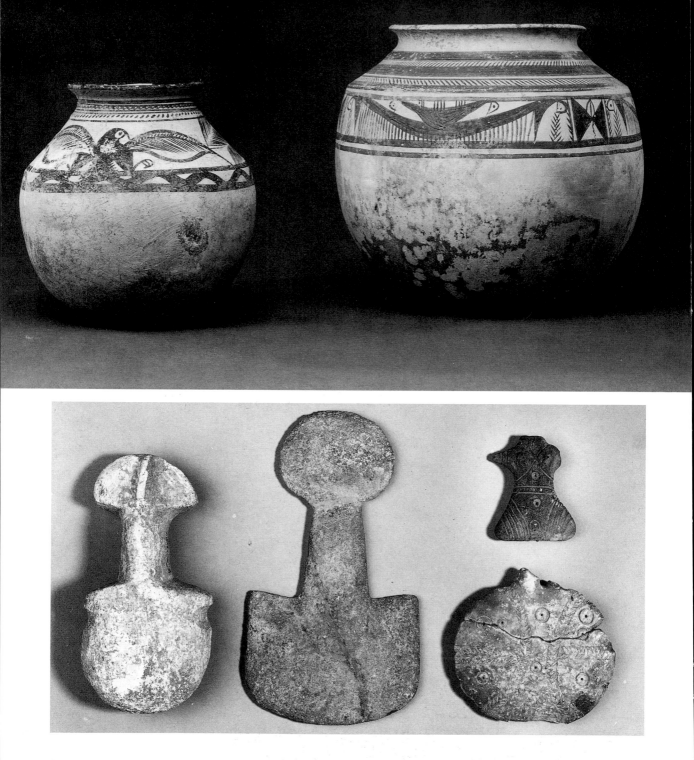

The two principal vehicles for artistic expression in prehistoric times – namely painted pottery and figurines – are still to be found at this period in less urbanised areas. A stylised rendering of animals is painted in dark brown on globular jars of buff clay from Tepe Giyan in western Iran around 2000 BC, and in Turkey, Syria and northern Iraq a number of figurines carry on the traditions of earlier times and illustrate several regional variations.

A less stylised version of the female body appears on stone moulds used for casting lead figurines which can be dated around 2000 BC. Most come from central Anatolia but one was found at Sippar near Baghdad, where it would have arrived as an item of trade (WA 91902). The figure stands with one hand near her navel and the other cupping one breast; she has long hair, multiple chokers and a prominent pubic triangle. Around her are the moulds for a series of amulets, pins and ornaments, including a circular one with a cruciform design also found on the metal stamp seals used at that time in Turkey. Similar moulds continued to be made into the next millennium, at a period when close contact between Mesopotamia and Turkey stimulated the spread of literacy through large areas of the Near East.

69 OPPOSITE, TOP Bowls from western Iran, from Tepe Giyan or its neighbourhood, decorated with stylised birds, bird-headed monsters and vegetation. Ht of larger vessel 28 cm.

70 OPPOSITE, BOTTOM *Left* A stylised stone figurine found in the same grave as Fig. 66 near Kirkuk, northern Iraq. This type of stylisation is more commonly found in Turkey at this period. Ht 15.8 cm. *Centre* A stylised stone figurine for which there are close parallels from south-west Turkey dating from the middle of the 3rd millennium onwards. Ht 19.8 cm. *Right, upper* A stylised clay figurine. Similar figures have been found in eastern Turkey and eastern Iran. About 2000 BC, acquired in 1913 in Istanbul. Ht 6.5 cm. *Right, lower* Parallels of around 2000 BC from Kültepe in central Turkey make it probable that the two necks of this fragmentary stone figurine were topped by triangular heads with centre-dot circles for eyes. The bands of herringbone pattern and centre-dot circles could represent a garment, and the hatched square at the bottom may indicate pubic hair. Ht 10.2 cm.

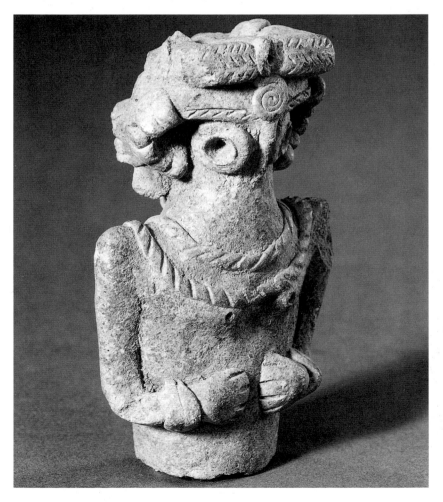

71 LEFT Upper part of a female clay figurine of central Syrian type. She has an elaborate hairstyle, huge eyes, necklaces, small breasts and her hands at her waist. About 2400–2000 BC. Ht 9.8 cm.

Trade and Diplomacy: the 2nd millennium BC

According to a later tradition, Sargon of Akkad had, in about 2300 BC, mounted an expedition to rescue some merchants who had run into trouble in Turkey; slightly later, merchants from Ur are also supposed to have set up trading outposts there. So far these claims cannot be substantiated, but it is certain that around 1920 BC merchants from the Assyrian city of Ashur established a trading colony or *karum* built over the remains of two previous settlements around the foot of the huge city mound of Kültepe, just north of Kayseri in central Turkey. The merchants' colony (Level 2) was destroyed by fire around 1840 BC and then rebuilt (Level 1b), before being finally destroyed in about 1740 BC. The remains of the *karum* now lie buried beneath the fields surrounding the mound and the first evidence for its existence came in the form of clay tablets and sealed envelopes inscribed in a dialect of Akkadian in the cuneiform script, which farmers began finding towards the end of the nineteenth century AD when they were digging in their fields. The British Museum bought many of these, but it was several decades before the precise source of the tablets was finally discovered, since the farmers did not wish to divulge the location of such a rich form of revenue. Levels 1b and 2 have since been extensively excavated, and so have the remains of the huge square palace on the mound; the two earlier levels (3 and 4) of the *karum* have barely been touched.

The tablets have come to be known as the 'Cappadocian Texts' because Kültepe lies in what was later the Roman province of Cappadocia. It has been possible to establish from them the mechanics of a trade which brought tin and textiles from Ashur to Kanesh (the ancient name of the *karum*). These items were carried by donkey caravan and went through customs at the palace of Nesa on the main city mound. The Assyrians then traded their

72 The site of Kültepe in central Turkey. In the foreground, a street and the mud-brick walls of part of the Assyrian trading colony (*karum*) have been excavated. Beyond are the slopes of the huge mound on which the city of Nesa once stood.

72

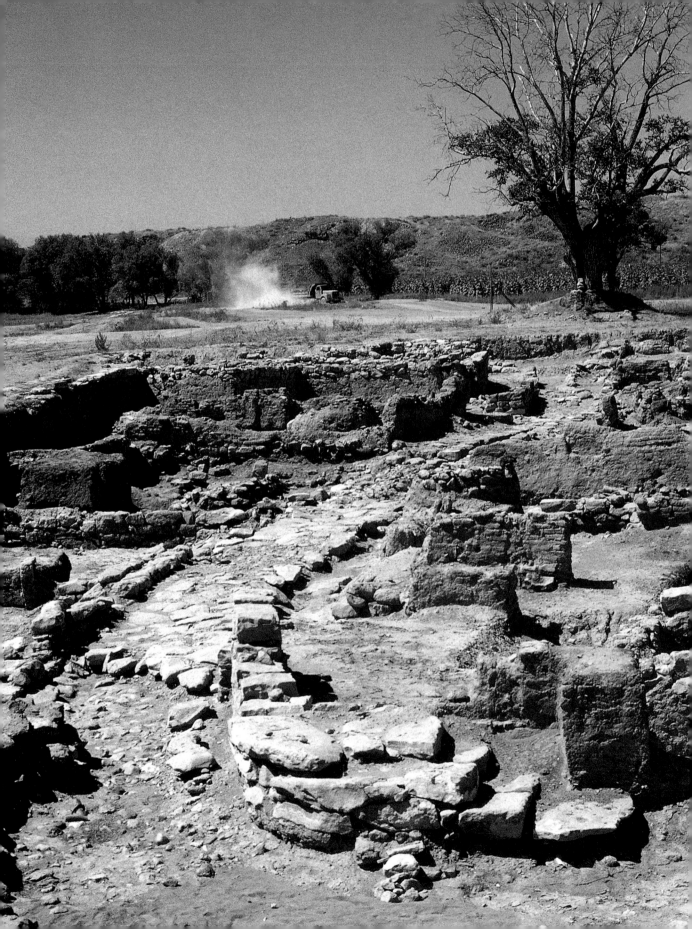

merchandise for silver and gold; they were also involved in the lucrative local copper and wool trade. All this, and much more, can be learnt from the tablets, which record the business transactions and contracts of the merchants and their Anatolian counterparts, together with family and business correspondence exchanged between Kanesh and Ashur. Evidence from a number of sites shows that other cities had their own colonies of merchants and were closely involved in the trade.

The tablets were encased in clay envelopes which were then inscribed with a summary of the contents of the tablet and sealed with the seals of the participants in the transaction or witnesses to it. From their impressions it is evident that the seals were tiny – even allowing for shrinkage of the clay on which they were rolled. Some of the seals must have been brought from Ashur, while others must have been cut locally, copying Assyrian designs. Local Anatolians continued to use stamp seals but they also adopted the cylinder seal shape, carving their cylinders in their own distinctive styles with motifs adapted from Mesopotamian iconography. Some of the envelopes bear the impressions of seals of Syrian and Babylonian merchants.

The Assyrian seals of this period often depict the type of presentation scene which was developed in the Ur III period, but the tufted garments, stools and headgear are represented in a distinctive toothed way and the hand holding the cup is shaped like a two-pronged fork. Some scenes are more lively, for instance that depicted on a seal made of haematite (a 73a
metallic-looking dark-grey iron oxide used for the majority of seals during the first four centuries of the second millennium BC).

The main characteristic of the local Anatolian style is the filling of any and 73b–c
every space so that animals, birds and detached heads are dovetailed to fit into an intricate and finely cut design. The bodies of these creatures and the garments of the figures are covered with hatching in different directions. Often Mesopotamian motifs are misunderstood: for instance, on the seal impression illustrated here, the main figure faces right, not left as in 73b
Mesopotamia, and although he sits on a god's throne, he does not have the horned headdress of a deity. Before him is a huge jar with drinking straws: often here, and in Syria, figures are shown drinking wine or beer through tubes because of the surface scum produced by the fermentation process. Although many impressions of cylinder seals of Anatolian type are known, few actual seals have survived. Stamp seals were the type of seal most used 73d–e
by the local population; these were often hammer-handled.

The worshipper and the griffin-headed figure on two of the seals illus- 73b, e
trated here hold vessels which have huge spouts in relation to their size. Many examples of such jugs, generally made of fine red burnished ware, have been found in excavations at Kültepe. Sometimes the vessels are so elaborate that they were clearly for ceremonial rather than practical everyday use, but the inhabitants of the area had a predilection for complicated or

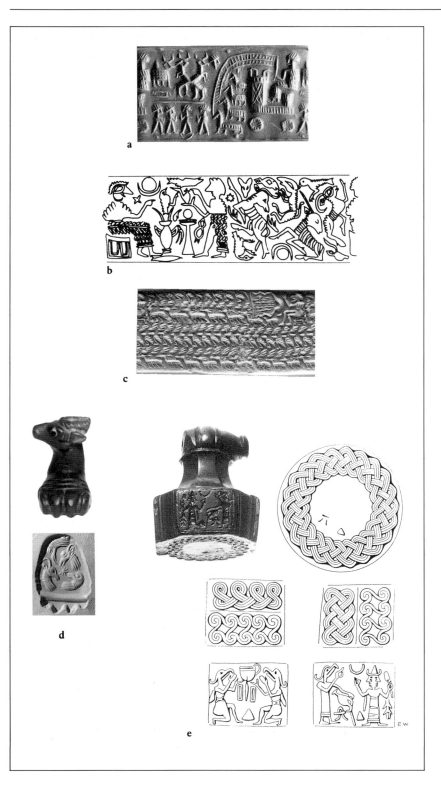

73 a. Modern impression of an Assyrian-style haematite seal. A figure (the ruler?) is seated in a chariot drawn by four equids, probably asses, whose hatched reins form an arc. To the left the scene is divided into two registers: above, a bull with a cone-shaped altar on its back, crossed bulls and a human head; below, two men approach two others. About 1920–1840 BC. Ht 2.5 cm.

b. Drawing (enlarged) of the design on an Anatolian Group seal rolled out on the clay envelope of a tablet from the Kültepe *karum*. A figure sits facing right; before him are a huge jar with drinking straws, an altar or table with bread(?) on it, and an attendant bringing a long-spouted jug. The remainder of the design is filled with astral symbols (some upside down), animals, birds, fish, detached heads etc. About 1920–1840 BC. Ht of impression 1.1 cm.

c. Modern impression of an Anatolian Group bone or ivory seal said to have been found near Mardin in south-eastern Turkey. A lyre-player is surrounded by rows of animals and birds. About 1920–1750 BC. Ht 2.2 cm.

d. Anatolian brown stone stamp seal. The base is shaped like a lion's paw, while the handle is like a small horned animal with eyes inlaid with lapis lazuli. The design on the base is a pattern of animal and birds' heads. About 1920–1840 BC. Ht 2.2 cm.

e. Hammer-handled haematite seal (damaged). On the octagonal base are patterns surrounding a hieroglyphic inscription (largely erased). Four of the sides are blank and the other four are engraved with elaborate patterns typical of the period (and also popular in Syria) alternating with cult scenes depicting griffin-headed demons (perhaps priests wearing masks) kneeling and facing each other, or pouring a libation before a two-faced god similar to the water god's attendant on Fig. 59e. About 1700 BC. Ht 3.5 cm.

amusing shapes. Some of these vessels are in white burnished wares with red and black painted decoration; shapes include boots, shells, men paddling boats, animal and bird heads and whole animals.

Less sophisticated, but with an appeal of its own, is the stone mould apparently found at Nineveh and so perhaps brought home from Anatolia by an Assyrian merchant (WA 92666). It is the descendant of the stone moulds discussed in Chapter 2 and was also used for casting lead figurines. It depicts a pair of figures, both shown frontally with hands clasped and identified as deities by their horned headdresses and flounced robes; the goddess wears a choker of a type which would have had an elaborate necklace counterweight hanging down the back, and the god is bearded. The other side of the mould could also be used for casting small amulets shaped like a decorated sun-disc, a crescent moon and a small nude female figure with hands clasped.

Excavations at Ashur, at the other end of the trade route from central Turkey, have revealed little information concerning this period but we know that Ashur became the seat of a dynasty under an Amorite king, Shamshi-Adad I (reigned *c.* 1809–1776 BC), who established one of his sons, Iasmah-Addu, as ruler of the city of Mari on the Euphrates. The archives of Mari have been excavated by the French and have provided fascinating information on international politics, intrigues, transactions and the daily life of the inhabitants of this and other cities in northern Mesopotamia and beyond from about 1800 to 1760 BC. Iasmah-Addu was lazy and immature, and in one of the letters his father wrote to him, 'How much longer must we keep you on a leading rein? You are like a child, you are not a grown man, you have no hair on your cheek. How much longer will you fail to direct your own household properly?' Epistolary activity was intense and archives have been found at other sites in Syria and northern Mesopotamia, and in Babylonia, particularly at Sippar; they combine to provide a better picture of life in the Ancient Near East between 1900 and 1600 BC than can be reconstructed for any other period.

Some of the Mari letters refer to dealings with Elam in south-western Iran where there was a lively local dynasty centred on Susa, but the British Museum has scant remains of this period. Other Mari letters tell of contacts with kingdoms in Syria and northern Palestine. Excavations by Woolley in Level VII at Tell Atchana have thrown light on this period of Syrian history when the site, known as Alalakh, seems to have been a vassal city of the kings of Iamhad, now Aleppo. During Shamshi-Adad's reign, Zimri-Lim, the son of the previous king of Mari, had sought refuge at the court of Iarimlim of Iamhad and married his daughter, Shiptu, who returned with him to Mari when he ousted Iasmah-Addu and recovered his father's throne. Alalakh seems to have been the summer residence of the kings of Iamhad and they built a palace there. A fine male head, now in Antakya

74 The head of a lion-shaped vessel of red burnished ware. The vessel would have been filled through a hole in its back and emptied through its nostrils. The pointed muzzle is not particularly leonine but it prolongs the curve of the neck and head, on the one hand, and of the ferocious, gaping jaws on the other – a sophisticated subordination of realism and function to shape. About 1920–1840 BC. Ht 11 cm.

Museum in Turkey, was thought by Woolley to be the head of Iarimlim, to whom he ascribed the palace also, but in fact several kings of Iamhad, and a cousin of theirs who was governor of Alalakh, all bore the same name. This we know from the royal archives which Woolley discovered in the palace. The main archive probably dates from around 1720 to 1650 BC. In the archive rooms, Woolley found large tusks of elephant ivory, imported from Egypt or perhaps even India, and objects carved from ivory and bone. Contact with Egypt was further demonstrated by the impressions of the seals of the kings, their ministers and the merchants and inhabitants of Alalakh on the clay envelopes of the documents stored in the archive room. The kings, wearing distinctive tall, oval headdresses and robes with thick, possibly fur-trimmed borders, are shown standing before goddesses from whom they receive the Egyptian *ankh* (symbol of life). Figures wear Egyptian dress and the Egyptian *atef* crown and hold the *was* sceptre or the

75a

95

75 a. Reconstructed drawing, from fragmentary impressions on clay envelopes in the British Museum and Antakya Museum (Turkey) of the seal of King Niqmepuh of Iamhad (Aleppo), identified in the cuneiform inscription. The king, wearing the royal headdress, faces two goddesses, one in Syrian dress who presents him with the Egyptian *ankh* and the other in Babylonian dress. Excavated in Level VII at Tell Atchana (ancient Alalakh). About 1700 BC. Ht 2.5 cm.
b. A haematite cylinder seal which is unprovenanced but which probably came from a workshop which made seals for the kings of Iamhad. The Syrian storm god Adad faces the Syrian goddess. At right angles to the main scene are two bull-men holding the tendrils of a stylised tree beneath a winged sun-disc. The whole scene is framed by elaborate borders. Ht 2.8 cm.
c. Drawing of one of the scarab-shaped seals from Tomb P19 at Jericho. About 1700 BC. Glazed steatite, L. 1.5 cm.

ankh. Hathor and Isis figures appear. Most popular was the Egyptian winged sun-disc which entered Near Eastern iconography at this time and was later transmitted to Hittite, Assyrian, Urartian and Achaemenid art (see Chapter 4). 75b

Other, more local influences are also apparent on the seals. One of the goddesses on Fig. 75a wears a square-topped, horned headdress (as it is shown frontally, and not in profile, it resembles a top-hat); her robe is decorated with thick borders which may represent fur trimming. Because we do not know her name she is generally called the 'Syrian goddess'. The storm god Adad was particularly popular. He wears a distinctive pointed, 75b horned headdress, has his hair in a long curl down his back, wears a kilt, holds an axe and a flail, and brandishes a mace. Bull-men seem to have faded from the Near Eastern repertory after the Akkadian period, but they had made a reappearance on Babylonian seals of the nineteenth century BC and 82a also appeared on the contemporary seal impressions of the Assyrian merchants in Turkey. In Syria, however, they are far closer to their Akkadian 59b prototypes. Other subjects were also taken over from the Akkadian range of motifs, particularly contest scenes where a nude, bearded hero with curls

wrestles with an inverted bull, grasps its tail and places his foot on its neck. Because of their association with a well-dated archive, the Alalakh seal impressions have made it possible to redate a whole group of haematite seals which had previously been thought much later.

The finds made during the excavations of Level VII at Alalakh showed evidence of other contacts. Woolley uncovered fragmentary wall-paintings in the palace which suggested to him some similarity with those which had been excavated on Crete, and on one fragment there was even the horn of a bull recalling the famous 'Toreador fresco' from Knossos. One of the seal impressions (in Antakya, Turkey), probably dating to around 1700 BC, had a scene of bull-leaping on it but, although this was relatively close to the later Cretan bull-leaping scenes of around 1550 BC, it was of local manufacture and other Syrian seals of this period show similar scenes. However, the gap between the Alalakh and Cretan material has now to some extent been filled by the finds made by the Austrian archaeologist Manfred Bietak at Tell el-Daba in the Egyptian Delta, which include fragments of wall-paintings showing unmistakable bull-leaping scenes dating to around 1650 BC. It was around that date, or perhaps slightly later, that the Hittite king Hattusili I marched into Syria, captured Aleppo and destroyed the Level VII palace at Alalakh. A century and a half later, however, the site was to have another brilliant chapter in its existence.

Southern Palestine seems to have been under more direct Egyptian control or influence. The Middle Bronze Age tombs dug into the rock at Jericho between 1900 and 1600 BC contain evidence of Egyptian contacts in 75c the form of large numbers of scarab-shaped seals of burnt steatite, which were carved with Egyptian motifs. At this period scarabs seem to have been even more popular in Palestine than in Egypt and were probably made locally. Wooden furniture and containers were surprisingly well preserved in some of the tombs, one of which, P19, has been reconstructed in the British Museum.

Tomb P19 was a low, oval chamber reached through a vertical shaft. It had originally been excavated around 2200 BC but there were few remains of the first occupant of the tomb and of his grave-goods because, some 500 years later, the tomb had been reopened, the original burial pushed to one side, and a woman of about 28 had been buried with storage jars, baskets, wooden platters and dishes containing meat and other types of food and drink; there were also three tables and a stool. Slightly later the tomb had once again been opened and six further bodies were laid out in a row on one side of it. Analysis of the skeletal remains established that these were the bodies of girls aged 11, 15 and 17, a boy of 11 and two young men of 24 and 28. All six had been killed by blows to the head and the three males had had their right hand cut off. Two other Jericho tombs of about the same date contained similarly executed and mutilated bodies. All three tombs were

also unusual in that they contained scarabs of amethyst, a stone imported from Egypt at this time. There have been several suggestions as to the reasons for these executions. It is most unlikely that this was the type of mass burial which took place at Ur (see Chapter 2) with retainers accompanying the owner of the tomb into the next world: there is no evidence of such a custom in any of the other 504 tombs investigated at Jericho, and the bodies of those executed were buried some time later than the main burial. It has been suggested that the victims were tomb robbers caught in the act and buried in the tomb they were robbing, but the bodies were carefully laid out, with their seals and personal possessions, so this also seems unlikely. The 75c most convincing explanation is that these were members of one important

76 *Left* Copper male figure made by the lost-wax process and said to have been found near Jezzine in the Lebanon. The man has a disproportionately large head, braided hair hangs down his back, and he has a jutting beard. He wears a broad-belted kilt with fringes down the front and side, and he held something, probably weapons, in his extended fists which are both pierced; there are tenons below his feet for fixing to a base. Ht without tenons 24.4 cm. *Right* Flat cast male figure of copper or bronze, naked except for a belt, holding a curved sword and spear. Probably from Syria. About 2000–1750 BC. Ht 23.7 cm.

family who were executed by Egyptian overlords, possibly after some uprising: Egyptians frequently cut off the right hand of prisoners of war.

76 A different type of discussion has centred on a copper figure said to have been found near Jezzine in the Lebanon, where other figures of the same type supposedly originated. Their authenticity was questioned until a group of closely similar figures was excavated at Tell Judeideh on the Syrian-Turkish border. The excavators dated their find to the early third millennium BC, but it seems likely that the figures came from a pit dug down from a higher level, probably a thousand years later. Metal figurines of other types were popular throughout southern Anatolia, Syria and Palestine at this time.

After the death of Shamshi-Adad his kingdom collapsed and, as we have seen, his son was replaced by a descendant of the previous Mari royal family, named Zimri-Lim. He, in turn, was overthrown by Hammurabi of Babylon (r. 1792–1750 BC). Hammurabi was the greatest ruler of an Amorite dynasty which had been founded at Babylon a century earlier. For a time it had been subject to one or other of the two dominant dynasties in southern Mesopotamia, those of Isin and Larsa. Hammurabi succeeded in overthrowing Rim-Sin of Larsa and gaining control of much of Mesopotamia. The early centuries of the second millennium BC are therefore known as the Old Babylonian Period (the Middle and Late or Neo-Babylonian periods will be examined later in this chapter and in Chapter 4

78 respectively). Hammurabi is best known for his law-code, inscribed on a stele on which he is depicted facing the sun god. The god's horned headdress is depicted with the horns in profile; this is the first well-dated example of the divine headdress shown in profile, instead of frontally, on a profile head (compare, for example, Fig. 82b), and marks a break with a long-established convention; it demonstrates the sculptor's new way of looking at the world around him. Conversely, the depiction of the sun god with rays rising from his shoulders is a return to the convention of the Akkadian period some five hundred years earlier, which had long been abandoned. The text of the stele had a profound impact on the Mesopotamian world although it was by no means the first law-code of that type; it was repeatedly copied for well over a thousand years, long after the stele had been taken as booty to Susa in 1157 BC. The relief on the stele also had a profound impact on Mesopotamian art; similar reliefs are found on other

79 stelae, and the British Museum has a fragmentary example.

77 A copper figure provides a three-dimensional version of the king on the Hammurabi stelae. As on the stelae, the king wears the round cap with a broad border which had been the headdress of royalty since at least the reign of Gudea of Lagash some time before 2100 BC. Three-dimensional figures of

80 the goddess Lama also appear at this period. From Ur III times she is
60a depicted on seals with both hands raised, interceding for the owner before a

77 A copper statue of a beardless male worshipper with his right hand raised in a gesture of respect for the deity. He is probably a king, judging by his turban and dress – a large shawl with a fringed and decorated border which was wrapped around the body and over one shoulder. He wears a crescent round his neck. The faint inscription names Etel-pi-Shamash, an official at Isin in southern Iraq, perhaps the son of Idin-Dayan, King of Isin (r. 1974–1954 BC). Ht 35 cm.

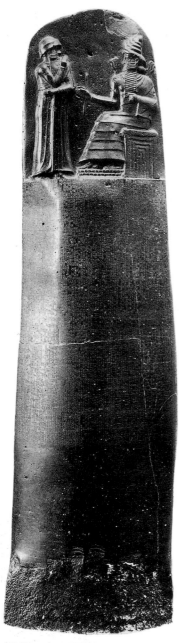

78 Hammurabi's law-code in 3,500 lines is inscribed on both sides of a huge diorite stele 2.25 m high and weighing 4 tons. At the top, Hammurabi stands with one hand raised; he faces the seated sun god, who holds divine emblems and has rays rising from his shoulders (Paris, Louvre).

deified king or a deity. Since such scenes, carved in haematite, were the most popular subject on Old Babylonian seals, the suppliant goddess became the most representative icon of the times and was adopted into the 82b–c iconography of the surrounding lands, where she survived for centuries. Old Babylonian seals, though not as stereotyped or restricted in terms of subject matter as those of the Third Dynasty of Ur, nevertheless conform to a strict iconographical canon. On classic Old Babylonian seals from about 1850 BC onwards, figures are generally shown standing, instead of sitting as had previously been the case.

A stone statue from Ur shows the upper part of a woman who wears the flounced robe and choker of a deity but who clasps her hands in worship (WA 132101). Her headdress is missing, so we cannot tell whether she was a priestess or perhaps the consort of a god. Her eyes are inlaid (but the pupils are missing) and traces of red and black paint survive. Fine stone carvings of 81 rams' heads were also found at Ur.

Figures of deities and worshippers were also made of terracotta, and the skill expended on the modelling, firing and painting of these large-scale pieces shows that although they may have been a cheaper substitute for bronze and stone they were still highly prized. The torso of a woman with hands clasped (WA 135680) is almost life-size. She wears her hair in an

79 OPPOSITE Stone stele fragment dedicated by Itûr-Ashdum, most likely a city governor under King Zimri-Lim of Mari, who had switched allegiance after Hammurabi's conquest in 1760 BC. According to the text Hammurabi would have been facing the goddess Ashratum. Probably found at Sippar, south of Baghdad. Ht 45 cm.

80 LEFT Three examples of the goddess Lama, who stands with arms raised (in the case of the figure on the right, the arms were made separately and are missing). She wears a multiple-horned headdress and a tiered garment generally referred to as flounced, but it is not clear if it consisted of a fine, pleated material or was a fringed wool imitation of earlier sheepskin garments. Her necklace counterweight hangs all the way down her back. *Left* Gold, ht 3.55 cm. *Centre and right* Copper or bronze, excavated at Ur; ht 7.1 and 9.3 cm.

81 The head of a ram, probably from a standard of the water god Ea, carved in a hard black stone (diorite?), with the texture of the horns and fleece highly stylised, and recesses for inlay. Similar examples came from Ur. About 1900–1700 BC; from the collection of C. J. Rich. Ht 8 cm.

elaborate style and has a necklace and bangles, but there are no details of dress and the strong features are simply rendered. The head of a god is
83 smaller but equally competent and the paint is better preserved.

Smaller-scale terracottas were mass-produced in moulds and widely distributed; they illustrate popular, rather than official cults and are probably responsible for the wide dissemination of iconographical themes. Most numerous are naked or bikini-clad female figures with hands clasped or playing musical instruments, but naked male lute-players, embracing couples (clothed and unclothed), beds and a few erotic scenes indicate that fertility was a major consideration of those who acquired them. Several show deities and may have been set up in private chapels. In the Bible there is a lively account (Genesis 31:22–35) of how Rachel stole her father's household gods and hid them in a camel saddle on which she sat. When her father, Laban, came to her tent to search for them she said 'Don't be angry, my lord, that I cannot stand up in your presence; I am having my period.' And Laban fell for the oldest trick in the world. The story demonstrates the importance attached to these sometimes crude figurines. Several from Ur
84a show a goddess wearing a headdress like a Christmas tree. Another type, represented at Ur, Kish and elsewhere, shows what has been interpreted as a
84b temple façade with the cult statue in the centre, framed by frontal lions

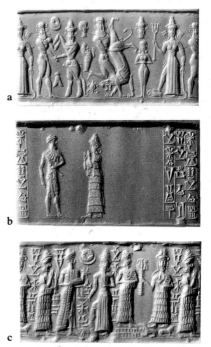

a

b

c

82 ABOVE Modern impressions of Old Babylonian cylinder seals made of haematite between about 1850 and 1750 BC, possibly at Sippar, south of Baghdad.
a. A revival of Akkadian contest scenes (see Fig. 59b) with heroes, bull-man and lion, a small nude figure and the goddess Ishtar with her foot on a lion and weapons rising from her shoulders (see Fig. 136d); the use of small 'filling motifs' is typical of the period. The seal groups almost all the figures, usually depicted frontally (see p. 76). Ht 2.45 cm.
b. The 'king with a mace', probably a concept of warrior kingship based on an Akkadian prototype (Fig. 58), and the interceding goddess Lama. The inscription names the owner as 'Sin-lidish, son of Shamash-nishu, servant of the god Nergal'. Ht 2.65 cm.
c. The goddess Lama and the king in ceremonial robes with an animal offering face the sun god Shamash, who places one foot on a mountain and holds his saw-toothed knife (see Fig. 59e); a deity on a podium faces a goddess depicted frontally on lions. The owner of the seal was 'Ini-Ea, son of Warad-Amurru, servant of the gods Amurru and Shamash'. Ht 2.65 cm.

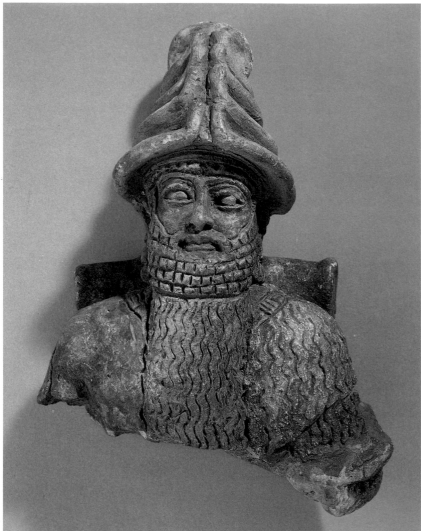

similar to those found at numerous sites from the mid-third millennium onwards, and door-jambs decorated with demon heads and statues of female deities holding vessels from which flow streams of water. The temple built around 1800 BC at Tell el Rimah in northern Iraq had stone door-jambs bearing similar decoration. Demon heads, sometimes shaped like coiled intestines, were supposed to resemble the giant Humbaba who protected the cedar forests of Lebanon and who had been killed by the epic heroes Gilgamesh and Enkidu. Some terracottas, however, have genre scenes, 84c–d possibly illustrating myths or legends. Finally, some terracottas show cult scenes with harp and lyre players, drummers and boxers (e.g. WA 91906).

After Hammurabi, the economic basis of the Babylonian kingdom seems to have collapsed. Several theories have been put forward to explain this, including increased salination leading to a severe restriction in the type, quality and quantity of crops which could be grown, and a diversion of the

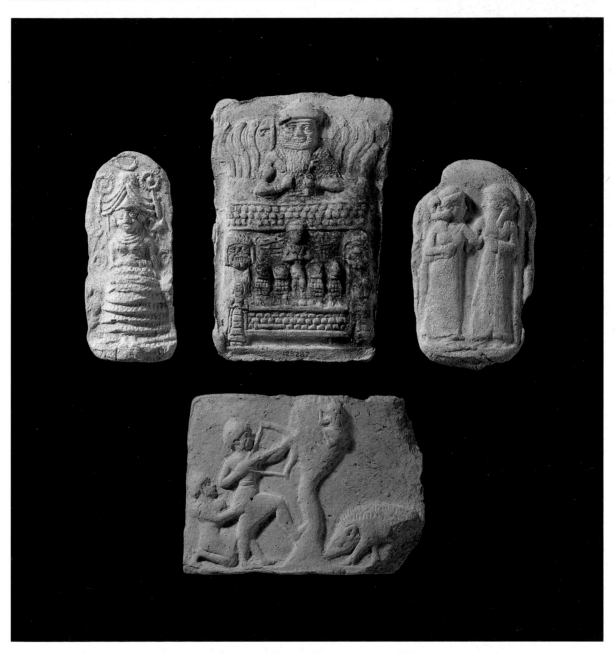

83 ABOVE LEFT Upper part of a clay figure of a god wearing a multiple-horned headdress, a necklace and a flounced robe draped over one shoulder. Hair, beard and chairback are painted black and the skin is red. Excavated at Ur in southern Iraq. About 1800–1750 BC. Ht 18 cm.

84 Old Babylonian terracotta plaques of about 1850–1650 BC.
a. A goddess with an elaborate horned headdress. Found at Diqdiqqeh near Ur. Ht 10.6 cm.
b. The deified king or warrior god with weapons above a temple façade. Ht 13.6 cm.
c. A loving couple. Found at Diqdiqqeh. Ht 10.5 cm.
d. A kneeling helmeted archer seems to be trying to restrain another who is aiming an arrow at a monkey in a tree, beyond which is a wild boar. Ht 9.0 cm.

Euphrates for political ends which backfired when it was found it could not be reversed. Whatever the reasons for the decline in the fortunes of Babylonia, its final collapse in 1595 BC was the result of a totally unexpected raid by the Hittites from central Turkey. They swept down the Euphrates, overthrew Babylon and disappeared as suddenly as they had arrived, carrying off with them the city-god of Babylon, Marduk.

Who were these Hittites who so abruptly burst onto the international stage and brought about the end of a dynasty which had been established for centuries? We know something of their history because they adopted the cuneiform script of their neighbours and predecessors and their archives have been excavated at their capital Hattusa (now Boğazköy). They also used a hieroglyphic script which has been found on some inscribed seals and rock reliefs, but it was mostly written on perishable materials which have not survived. Their language, which they called Nesite, was Indo-European and, like other Indo-Europeans including the Luwians, they probably entered Turkey, perhaps from south Russia, in the last part of the third millennium BC. The country they invaded seems to have been called Hatti and to have been inhabited by Hattians so the newcomers, confusingly, came to be known as 'inhabitants of the land of Hatti' and therefore Hittites. The Hattians and Hittites probably lived peaceably until, in about 1740 BC, a large number of sites (including the city of Hattusa) and their *karums* were destroyed, perhaps, but not certainly, by the Hittites. Some time later, Hattusa was rebuilt and the Hittite ruler Hattusili established his capital there. The Hittite raid on Babylon was preceded by raids into Syria (one of which destroyed Aleppo and Level VII at Tell Atchana) but a period of dynastic instability meant that these initial successes were not followed up.

There is evidence for a period of disruption between 1600 and about 1500 BC all over the Near East and in Egypt. Then, gradually, come signs of recovery and growing stability. Palaces were rebuilt, cities were re-inhabited, trade resumed and works of art were once again commissioned. The campaigns of the Egyptian pharaoh Tuthmosis III in Syria during the early fifteenth century led to a revival of political and territorial ambitions.

In Turkey the Hittites began to look southwards again. Most of the information and artefacts which have survived relate to the period between about 1400 and 1200 BC, which is known as the Hittite Empire. Suppiluliuma I restored Hittite fortunes, wrested control of Syria from the Egyptians and made his son king of Carchemish, on the Euphrates where it crosses from Turkey into Syria, thereby inaugurating a long period of Hittite rule in that city which probably continued uninterrupted into the first millennium BC. Opinions are divided as to whether he came to the throne around 1380 and reigned for about sixty years, or around 1340 and reigned for only twenty years. The dates are important since they affect Egyptian chronology.

A queen of Egypt wrote to Suppiluliuma while he was encamped before Carchemish: 'My husband has died and I have no son, but of you it is said that you have many sons. If you would send me one of your sons, he could become my husband. I will on no account take one of my subjects and make him my husband. I am very much afraid.' Suppiluliuma sent an envoy to check on the authenticity of this bizarre request and received a second desperate plea from the queen. Convinced, he duly sent one of his sons but the latter was murdered on his arrival in Egypt. The queen is generally thought to have been Ankhesenamun, a daughter of the Egyptian pharaoh Akhenaten and widow of Tutankhamun. The poor little queen was probably forced to marry Ai, a priest who became the next pharaoh and who had no doubt engineered the murder of the Hittite prince.

During the fourteenth century BC the Hittites and their neighbours to the west, the Arzawans, took part in the international correspondence with the Egyptian pharaohs known as the Amarna Letters. These letters were written on clay tablets in the cuneiform script in Akkadian, the language of Mesopotamia which was used for diplomatic correspondence throughout the Near East. One of them is from Suppiluliuma. He complains that since the accession of the new pharaoh, perhaps Tutankhamun, the gold and silver statues the previous pharaoh had promised have not been sent. Nevertheless, he, Suppiluliuma, is sending silver drinking vessels – one shaped like a stag and the other like a ram – and two huge silver discs, a total 86 weight of 18 minas of silver (about 9 kg). There is a silver stag-shaped Hittite drinking vessel in the Metropolitan Museum of Art in New York. Trade in precious metals and objects was obviously carried out at the highest level.

87 Of local manufacture and smaller proportions, however, is a little gold figure of a Hittite god. Hittite deities wore the horned headdress of Mesopotamian deities but in a taller, more pointed version. This little kilted figure has the stocky proportions of Hittite gods on rock-cut reliefs decorating a gate at Boğazköy and the open-air sanctuary at nearby Yazılıkaya. His round, clean-shaven head with carefully modelled features and large eyes is set on a thick neck which juts forwards. This same characteristic jutting 85 neck is found on a small ivory figurine of a young girl. The identity and function of this charming figure are uncertain.

When he was digging at Carchemish before the First World War, Leonard Woolley made a particularly interesting discovery. He was excavating levels containing evidence of the sack of Carchemish by Nebuchadnezzar of Babylon in 605 BC, and within the walls of the city he found a cremation burial. This was unusual because at that time cremation cemeteries were generally outside the city. Although the bones were in a coarse domestic pot instead of the normal urn, the burial was a rich one and this led Woolley to suggest that it was that of an important person who had died or been killed during the siege. The grave-goods included a large cylinder of

85 Ivory figurine of a young Hittite girl with her hair drawn back from her low forehead into a long plait which reaches almost to her waist. Her breasts are small and her body lacks the curves of an adult. The stance is artificial but the execution is naturalistic, with the exception of the ear volutes and the small double triangles at the knees echoing the shape of her pubic triangle (originally inlaid). There is a dowel-hole in the base. 1400–1200 BC. Ht 12 cm.

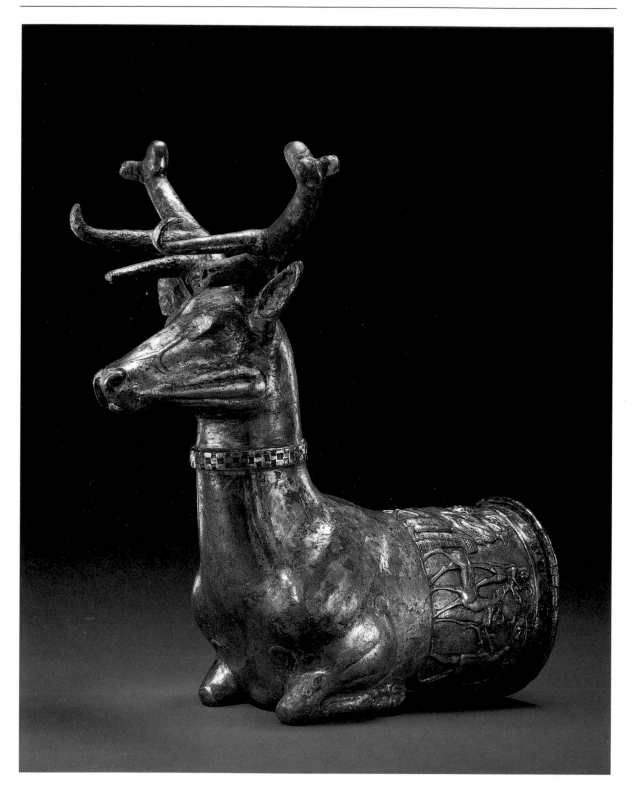

86 OPPOSITE A stag-shaped Hittite silver drinking cup with a handle, decorated with two gods facing right, each holding a bird of prey; one is seated with a cup and the other holds a crook and stands on a stag; they are identified by Hittite hieroglyphic inscriptions on gold insets in front of them, and between them is an altar. Three men in short robes approach: one pours a libation, one holds a tambourine or loaf of bread and one kneels holding a vessel. Beyond are a tree, a stag's head and legs, a quiver, a hunting bag and two spears. Ht 18 cm (Metropolitan Museum of Art, New York, Norbert Schimmel Collection).

87 LEFT Small gold figure of a god wearing the distinctive Hittite version of the horned headdress of deities, a kilt and the boots with upturned toes of a highlander (see Fig. 59e). The curved weapon he carries could be a sword or his attribute as a hunting god. 1400–1200 BC. Ht 3.94 cm.

88 ABOVE Some of the small figures of gold and lapis lazuli from a cremation burial at Carchemish on the Euphrates, at the frontier between Turkey and Syria. Buried in about 605 BC but probably an heirloom of the late Hittite Empire, about 1300–1200 BC. Ht of the largest figure 1.75 cm.

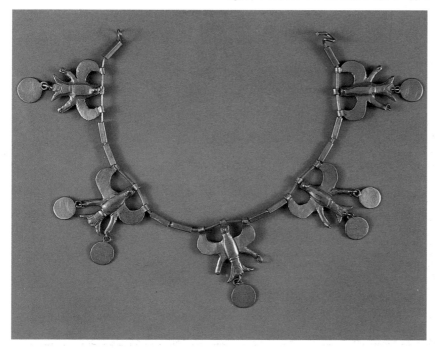

89 Necklace of golden beads and spread eagles grasping discs, perhaps from western Turkey. Ht of eagle 2 cm.

lapis lazuli and gold tassels from the end of a belt. Minute gold beads, which had fused together because of the heat of the cremation, had probably been stitched to a garment. A gold disc and strip with openwork decoration and small gold figures inlaid with lapis lazuli or steatite represent Hittite gods as they were depicted in the Yazılıkaya shrine; they may have been attached to heirlooms which were placed beside the burial while the ashes were still hot. Two of these, one inlaid and one with incised decoration, show the Hittite 88 sun god wearing royal robes, carrying the carved rod which was an emblem of kingship, and identified by the winged sun-disc on his head – the latter, as we have seen, a symbol of kingship imported from Egypt, probably via Syria. The iconography of these minute jewels is so close to that of gods and goddesses at Yazılıkaya that it is likely that they were heirlooms from the thirteenth century BC, when the rock-cut sanctuary was carved with the deities worshipped by the Hittite king Tudhaliya IV and his Hurrian 18 mother, a princess from Cilicia on the Turkish coast, or from Syria.

Although the best-known, thanks to references to them in the Bible and to their fortunate habit of using the cuneiform script, the Hittites were not the only people in Turkey at this time. To the west lay the kingdom of Arzawa, and many other lands are mentioned in Hittite texts: however, the problems of reconstructing the political map of Turkey are numerous. A gold necklace 89 with eagles holding discs in their talons may have come from the west of Turkey. An origin closer to Syria may be postulated for the bronze figure of a robed god, with ears pierced for earrings, who wears a dagger in his belt (WA 134926). His headdress has been reduced to a series of horizontal ridges rather than horns, and is tall and pointed, resembling a dunce's cap.

The Hittites continued to use stamp seals, except in their territories in north Syria where they used cylinder seals. Often the seals are similar to the earlier hammer-handled haematite seals and one example in the British Museum (WA 115655) is interesting because it bears the same sequence of designs as on some other seals and on the silver stag-shaped drinking cup in 86 New York referred to above. It was acquired near Boğazköy in 1886 and the design on its circular base surrounds a hieroglyphic inscription giving the name and title of the owner. It shows a seated god holding a bird; behind him are a stag's head and two legs, a hunting bag, a quiver (?), two spears and a tree; before the god are an altar, a bird-headed figure pouring a libation and a figure playing a drum; at the end of the scene two bull-men kneel on either side of a sun-disc on a stand.

In their expansion into Syria, the Hittites came into conflict with the Mitannians, who had established a kingdom stretching right across north Syria and northern Mesopotamia. One of the Mitannian vassal kings around 1500 BC was named Idrimi and ruled at Alalakh, a city whose earlier fortunes have already been traced (page 94) and where he built a palace (Level IV). His life can be reconstructed from the long inscription which

90 covered his statue. Idrimi claimed descent from the kings of Iamhad
(Aleppo) of the eighteenth century BC and he may be wearing a version of
the dress worn by the kings of Iamhad on the seal impressions found in the
75a Level VII archive discussed above. Idrimi is not beautiful (he was described
by C. J. Gadd as 'the ugliest man I never met'). He gazes balefully from huge
eyes, and the corners of his mouth turn down. His lack of chin is evident
despite his plain beard. He lays his right hand on his breast and his left lies
clenched on his lap.

The inscription runs from the side of his face to the bottom of his skirt; the
back is uninscribed. It tells how, due to a hostile incident, Idrimi and his
family had had to flee from Aleppo to his mother's family at Emar (now
Meskene), on the Euphrates. Determined to restore the family fortunes,
Idrimi left Emar and went to Canaan, where he found other refugees from
his father's kingdom; he mounted a sea-borne expedition to recover his
patrimony and eventually became a vassal of the Mitannian king Barattarna,
who installed him as king in Alalakh. Later, he raided into Hittite territory
and used the booty to build his palace. He restored the towns in his kingdom
and had been reigning thirty years when he had his statue inscribed by the
scribe Sharruwa.

But did Idrimi in fact commission the inscription? Jack Sasson has
suggested that, in fact, Sharruwa lived much later than Idrimi and carved
the inscription in order to bolster national pride by providing evidence of
the city's glorious past, at a time when the foreign domination of the Hittites
was on the wane. He bases his arguments on the unusual autobiographical
style of the inscription, and on the fact that it is quite unparalleled for a
scribe to claim authorship. Furthermore, Idrimi's statue was not found in
Level IV – the level of his palace – but in the Level IB temple (about 1250–
1200 BC). It seems that the statue was, at that time, socketed onto a specially
made grey basalt base carved as a throne, with lions – or more probably
sphinxes – on either side, whose raised wings would have hidden the
uncarved sides of the statue, but of which there remain only the legs (visible
from the sides but not from the front). At the time of the final destruction of
Alalakh (see below), the statue was toppled from its base and its head and
feet were broken off. Later the fragments were carefully collected and
buried in a pit dug for the purpose. Sasson has argued that the statue was
contemporary with Level I and was not the antiquity it purported to be.

Whatever the truth of the matter, there is no doubt that a king named
Idrimi was associated with Level IV because documents of his reign, sealed
with his seal, have been found in the archives Woolley discovered here also.
Idrimi's seal was later used by his grandson, Niqmepa, as a dynastic seal.
Niqmepa used another royal seal, which is in the style of the Level VII seals
but does not seem to have belonged to a ruler of Iamhad. He was not alone
among his contemporaries in using the seals of his forebears, and other

kings, as well as private individuals, used earlier seals as status symbols or to authenticate their dynastic or hereditary claims, after the unsettled period separating Levels VII and IV.

One of the reasons for this emphasis on stone seals lay in the widespread use of an alternative and less prestigious material known as faience (a confusing name since it has nothing to do with the much later products of the city of Faenza in Italy). The technology of faience is closely related to that of glass, and the main component of both is silica. Faience contains less alkali than glass and is fired at a lower temperature so that only the surface is vitrified or 'glazed'. Although faience occurs from the fourth millennium BC onwards, its use was not widespread until the second half of the second millennium BC when glass technology was developed. Faience cylinders were cheap to produce and easy to carve. The same designs were repeated over and over again, with local variations. Although their brightly coloured vitrified surface has now generally worn away, they must have been attractive and were widely traded as beads and seals. These simple objects, which rarely have artistic merit, are nevertheless a good indication of the trade patterns of the period. Similar designs, possibly from the same workshops, have been found from the Caucasus to the Gulf and from Greece to Iran; some were found in the wreck of a ship which sank around 1300 BC off the south coast of Turkey, near Kaş. The popularity of these faience seals is illustrated by the large number used to seal documents in the archives found at Nuzi, near Kirkuk in northern Iraq. Brightly coloured necklaces from the Fosse Temple at Lachish in southern Palestine give some idea of the attractive appearance of faience beads; they were made around 1300 BC, either in Egypt or under strong Egyptian influence (WA 132125–6).

The workshops producing seals, and the archives where their use is best attested, are spread throughout northern Syria and northern Iraq in the area which came under the domination of the kingdom of Mitanni. The Mitannian capital was at Washshukani, somewhere near the head-waters of the River Khabur in Syria, and the kingdom seems to have been ruled by an Indo-European aristocracy who worshipped Indo-European gods and for whom the chariot was a prestige vehicle. The population of the Mitannian kingdom was ethnically different, however; it was Hurrian. Hurrians, speaking a non-Semitic, non-Indo-European language, probably first entered Syria and Mesopotamia from eastern Turkey during the second half of the third millennium, and by 1700 BC they formed about a third of the population at Alalakh. Two hundred and fifty years later they were the dominant element in the population. Idrimi of Alalakh was, as we have seen, a vassal of the Mitannians and so, until they broke free in the fourteenth century BC, were the Assyrian kings.

There has been much discussion as to whether there is such a thing as Mitannian or Hurrian art. It seems more likely that the predominantly east–

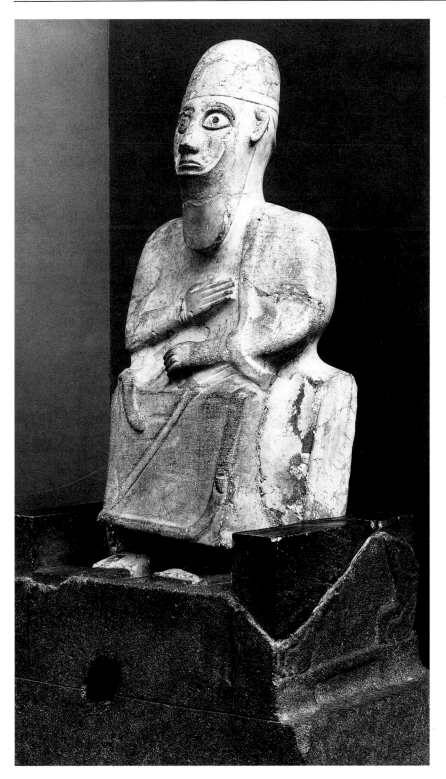

90 Statue of King Idrimi excavated at Tell Atchana on the Syrian-Turkish border. It is inscribed in cuneiform and set on a grey basalt throne flanked by sphinxes (damaged) and carved from hard white dolomitic magnesite, with glass-inlaid pupils. Idrimi's body merges with the block on which he sits. He is bearded, wears a round-topped headdress with band and neck-guard, and a garment with narrow borders, perhaps fur-trimmed (see Fig. 75a). Marks of the tubular drill used for cutting away the stone are visible around the feet. Ht of statue 1.035 m.

west trade routes which traversed the kingdom carried ideas, iconography and techniques which were adopted and adapted to form something more specifically Syrian in the west and Assyrian in the east. A distinctive type of painted pottery is found throughout the area occupied by the Mitannians, although it too has variations, being known as Nuzi Ware in the east and Atchana Ware in the west. Tall, thin-walled beakers, precariously balancing on a small foot, are painted in a dark brown or black paint upon which the predominantly floral decoration is applied in white paint in horizontal bands alternating with triangles, zigzags or running spirals. At Tell Atchana the local variation, probably the work of a single workshop, shows exuberant vegetation loosely based on Egyptian designs and linked by dotted, undulating bands. The same basic design was not restricted to cups but was skilfully adapted to vessels of very different shapes, sometimes combined with rosettes or mountain-scale patterns. 91

Glass, which has already been mentioned in connection with faience, is also thought to be an invention of the period. There are a few small glass beads (but no vessels) of the third millennium BC but these were probably produced accidentally by over-firing faience; however, the discovery of two lumps of true glass in late third-millennium contexts at Eridu and at Tell Asmar in Iraq is less easy to explain. It was the invention of the technique of core-forming, whereby a thick coating of molten glass was applied over a removable earthenware core, that enabled vessels to be produced. The earliest datable example of the technique was found at Tell Atchana (Alalakh) in Level VI (i.e. before 1500 BC), but it has been suggested that it was imported from northern Mesopotamia, where the technique suddenly appears, associated with the same type of thread decoration, at a number of sites including Tell Brak, Nineveh, Ashur and Nuzi. The transfer of the technique via the Levant ports to Egypt took place soon afterwards. Another, contemporary, technique for making mosaic glass beakers consisted in laying small cylindrical rods of coloured glass side by side to form chevron patterns; the result was fired in a mould, ground and polished. Examples have been found in northern Iraq and at Marlik, south of the Caspian Sea in Iran. 92

The term 'Mitannian' is applied to a seal style but that style, as we have seen, is linked to a material (faience) and a technique of manufacture rather than to a political entity. However, the same is not true of the seal style developed during the fourteenth century BC by the Assyrians. At the beginning of this chapter we saw how, in the early centuries of the second millennium, the Assyrian capital at Ashur had grown rich on the proceeds of trade with central Turkey, and Shamshi-Adad I made it the capital of his north Mesopotamian kingdom. Under Hammurabi, Babylon eclipsed Ashur, but when, in the fourteenth century, Assyria emerged from the dark age which followed the fall of Babylon in 1595 BC, it was as a vassal of

91 ABOVE 'Atchana Ware' with decoration in white paint applied to a background of dark brownish-black paint. Ht of beaker 21.5 cm.

92 Fragments of a mosaic glass beaker (originally similar in shape to that on Fig. 91) in alternating red (now green) chevrons. Excavated at Tell el Rimah in northern Iraq. Around 1500 BC. Ht of largest fragment 7.7 cm.

Mitanni. However, during the course of the century the increasing political awareness in the Near East affected Assyria, and Ashur-uballit I (r. 1363–1328 BC) succeeded in throwing off the Mitannian yoke. He even dared to initiate correspondence with the Amarna pharaohs, sending a chariot, two horses and a 'date' of lapis lazuli. However, the pharaoh's gift in return was not as generous as Ashur-uballit had hoped, and he had no scruples in writing to complain that it had not even covered his messengers' travelling expenses; he asked for a lot more gold because he was building a new palace. From his reign onwards, Assyria grew ever more powerful, and although there was a period of eclipse during the dark age at the turn of the millennium, the political basis for the Neo-Assyrian empire of the ninth to seventh centuries BC was first established in what has come to be known as the Middle Assyrian period, when the foundations of the Assyrian style were also laid.

Contemporary seal designs reflect these political developments and even anticipate them. The cylinder seals rolled out on the tablets in the archives found at various sites within the Assyrian kingdom, but especially at Ashur, show a predominance of 'Mitannian' seals replaced, as early as the reign of Eriba-Adad I (1390–1364 BC), by a Middle Assyrian style with an emphasis on balanced compositions featuring a revival of earlier composite creatures 93 and the creation of new ones, for instance griffins, winged horses and centaurs. The Middle Assyrian style can be documented as it evolves from reign to reign. The stones used in Assyria and in Babylonia are also often new types, such as variants of chalcedony in attractive colours including carnelian, which had been used only rarely for seals up till then. New techniques now enabled these hard stones to be cut with beautiful designs.

Another distinctive artefact of the period is made of faience. It consists of a small human mask, originally with inlaid eyes, eyebrows and necklace, with holes pierced in the ears for earrings (WA 120430). The inlays have generally vanished, but an example from Tell el Rimah was inlaid with coloured glass. The earrings have also vanished but were probably made of gold. The purpose of these small masks is uncertain. Some were, presumably – like the Warka Head, their predecessor by about 2,000 years – part of a composite figure of which other parts were made of perishable materials such as wood and textiles, and they may have been set up in temples, like the Rimah head; this latter was found with a faience pubic triangle, suggesting that both pieces belonged to a naked figure. One example was found at Mari lying on the chest of a body in a grave; since no earrings were found in the holes in its ears, it was suggested that these were for the thongs attaching it round the neck of the deceased. These objects are concentrated within the Middle Assyrian area but are also found further east, west and south; they are generally dated around 1300 BC.

Excavations at Ashur and at a short-lived Middle Assyrian capital, Kar-

Tukulti-Ninurta, have produced beautifully worked ivories and objects of faience and lead. Some have found their way into the collections of the British Museum. Another interesting artefact is a green serpentinite whetstone with a bronze ram's head as its handle, excavated by Rassam at Sippar in 1881 or 1882 (WA 93077). It is inscribed with a dedication to the sun god Shamash by Tukulti-Mer, a king of Hana on the Euphrates in the eleventh century BC. Since the emblem of Shamash was the saw-toothed knife with which he cut his way through the mountains of the east at dawn, a whetstone was a particularly appropriate votive object. Its discovery at Sippar demonstrates the continued importance of that city as a centre for the worship of the sun god.

94 An approximately life-size statue of a lusciously plump naked woman was excavated at Nineveh. The seven-line inscription above the waist on the back informs us that she, and others like her, were set up by Ashur-bel-kala 'in the provinces, cities and garrisons for enjoyment'. This has been taken as an expression of the purely secular role of the sculpture but need not

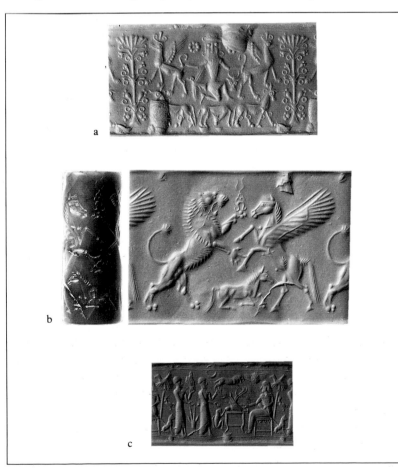

a

b

c

93 Modern impressions of Middle Assyrian seals.
a. A nude hero grasping two griffins, with bulls and a cow (?) below, a stylised tree and other symbols. Pale pink chalcedony, about 1400–1300 BC. Ht 2.9 cm.
b. A lion and a winged horse fight over a wingless foal. The triangular composition is typical of the reign of Tukulti-Ninurta I (r. 1243–1207 BC). Pink chalcedony, ht 4.1 cm.
c. Perhaps the ratification of a treaty. A man, who wears his hair in Assyrian style and holds a mace, touches a stag's head on a table. Facing him are two men, each holding a tablet (treaty tablets?); one touches the stag's antler and the other holds an animal-headed drinking vessel (see Fig. 86). Above are the crescent and winged sun-disc; the animals probably symbolise the cities of those participating in the ceremony. The seal, which is carnelian, was bought at Nineveh between 1846 and 1848. Ht 2.1 cm.

115

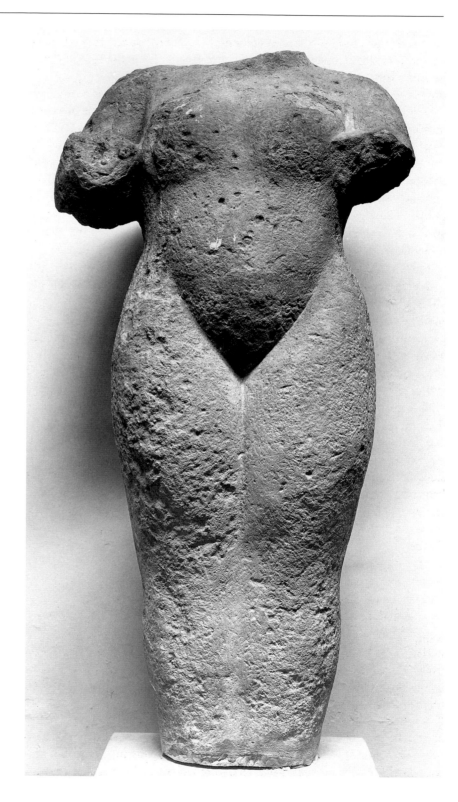

94 Fragmentary stone statue of a
naked woman, excavated by
Rassam in 1853 in a ditch near the
Ishtar Temple at Nineveh. Her
forearms were separately attached
with dowels and must have been
raised. She has relatively flat
breasts and buttocks; her pubic
triangle was originally decorated
with flat curls, but these have been
almost entirely worn away. There
is an inscription on the back.
About 1060 BC. Ht 94 cm.

necessarily preclude the representation of a goddess; some, indeed, have argued that this is precisely what this statue is and that the lack of detail indicates that she was originally dressed in rich garments. Since no head is preserved, the presence or absence of a horned headdress cannot be invoked in favour of an identification. What is certain, however, is that the piece is a most unusual work of art and is unique on such a scale. The only surviving parallels are two small half-clad figures showing the same rounded bellies and pubic triangles: one is winged (and probably therefore a goddess) and decorates an alabaster vessel found at Ashur; the other is a bone or ivory figurine from Nuzi wearing the horned headdress of a goddess. Both are probably a couple of centuries earlier. A suggestion that the sculpture was an earlier Babylonian piece carried off as booty by the Assyrians is also hypothetical, since no comparable sculpture has been found in Babylonia.

The attribution of a second piece of sculpture is less certain, although most scholars now agree that it should also belong to the reign of Ashur-bel-kala rather than to that of his father, who is named in the inscription. It is the so-called 'Broken Obelisk', found in the same ditch as the nude figure just discussed. This is, in fact, the stepped top of a rectangular stele (WA 118898) and is the first of a series of Assyrian monuments of this type. It bears a relief showing the king standing before the symbols of the gods; from the winged sun-disc two hands emerge, one of which extends a bow and arrows to the king, who holds on a leash round their necks two pairs of prisoners who raise their hands in supplication.

Once even more hotly debated was the attribution of yet another Assyrian stele known as the 'White Obelisk' (WA 118807). It is decorated on all four sides with scenes of military campaigns, the bringing of tribute, victory banquets, religious and hunting scenes. The accompanying inscription names an Ashurnasirpal and should be dated to around 1050 BC, although some scholars have opted for a later date. Holly Pittman has suggested that the seemingly disordered sequence of scenes actually makes sense if it is seen as the record of the decoration of the walls of a throne-room. Such decoration would have been painted or executed in glazed bricks, but very little survives. In any case, grouped together here we have the earliest representations of what were to be the main themes of Assyrian narrative art from the ninth century onwards.

Babylonia had a separate development since it was too far south to have been part of the Mitannian kingdom. After the fall of Babylon in 1595 BC the records cease; later king-lists give the names of rulers and their length of reign but little else is known of them. These names are predominantly Kassite and it seems that the Kassites stepped into the power vacuum created by the fall of the dynasty of Hammurabi. Not much is known of their origin. Their distinctive names and those of their gods indicate that they were possibly of Caucasian stock and were led by an Indo-Aryan aristoc-

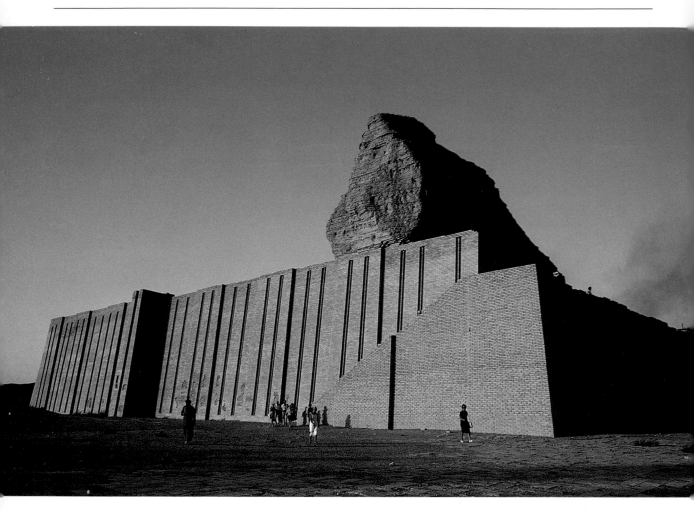

95 The ziggurat rising above the ruins of the Kassite capital of Dur Kurigalzu (now Aqar Quf) just north of Baghdad. The lower part is restored; the brickwork of the upper part was reinforced, every few courses, by layers of reed matting which still survive. 14th century BC.

racy. They were thought to have entered Mesopotamia from the east, but there is growing evidence for a north-western origin and Kassite names are attested at Hana on the Middle Euphrates from the eighteenth century BC onwards. However, it is only from the late fifteenth century that we can link historical events and rulers.

One of the reasons for this dearth of information relates to the dark age already referred to. With the collapse of the urban-based economy, the major source of texts disappeared. As we have seen, a rural economy based on villages and country estates provides less scope for the archaeologist: there is also less need for complicated record-keeping and accounts, so there are fewer or no texts. A further difficulty in identifying Kassite remains lies in the fact that the Kassites were not innovators: they adopted the language and way of life they found in southern Mesopotamia and became completely integrated. They restored existing temples, and it is only under Karaindash (about 1420 BC) that there is evidence at Uruk of a new form of temple.

95 During the next century there was extensive building activity at their new capital at Dur Kurigalzu (now Aqar Quf, just north of Baghdad). The site is still dominated by the ziggurat they built, which is exceptionally well preserved. Excavations of the palaces there have produced very fine gold-work, elaborately decorated glass and lively terracottas. The goldwork shows that very fine granulation, generally in chevrons or triangles, was 96 used. This technique is also to be found on gold from other sites, probably of slightly earlier date.

Between 1375 and 1333 the Kassite kings Kadashman-Enlil I and Bur-naburiash II exchanged several letters with the Amarna pharaohs from which it is clear that Egyptian and Babylonian princesses were traded for gold and lapis lazuli, chariots and beds inlaid with precious materials. Dowry lists include textiles, vessels of metal and stone, carved ivory objects and furniture. There are constant complaints on both sides about the way messengers and princesses are being treated, with the Kassite kings pointing out on more than one occasion that the gold they had been sent, when melted down, had proved of poor quality. Lapis lazuli is almost always qualified as 'genuine', probably because there were excellent glass imitations of the rare blue stone. In sending lapis lazuli to Egypt the Kassite kings were continuing a well-established tradition. A temple hoard of about 1800 BC found at Tod in Egypt contained scrap lapis lazuli including broken and worn seals from much earlier periods. Another hoard was found at Thebes in Greece and contained a large number of Kassite seals of lapis lazuli, including a seal naming a high official of Burnaburiash, possibly part of the booty seized by the Assyrian king Tukulti-Ninurta I (r. 1243–1207 BC) when he captured Babylon and raided its temple and palace treasuries.

97a In the British Museum there is a seal belonging to the father of that same high official. It is typical of seals of the 'First Kassite Group'. The long inscription left only a relatively tall, narrow space, which was filled with the figure of a seated god accompanied by symbols. Whereas the inscription is beautifully engraved, the scene is stereotyped and uninspired, executed

96 Examples of gold jewellery with granulation from Tell Atchana on the Syrian-Turkish border and from Tell el-Ajjul in southern Palestine (the eagle-shaped ear- or nose-ring). 1600–1400 BC. W. of eagle 3.25 cm.

97 Modern impressions of cylinder seals.

a. Kassite, with a god seated before symbols and a long prayer to the sun god Shamash by Sha-ilimma-damqa, son of Lugal-mansi. Neutral chalcedony, about 1360 BC. Ht 4.0 cm.

b. Kassite, with animals fighting and a prayer to the Babylonian god Sugamuna, written horizontally (an innovation of the period). Dark green chalcedony, about 1250 BC. Ht 3.9 cm.

c. Despite affinities with contemporary Kassite seals, the worshipper's bouffant hair-style, the curious way he extends his arms in a double L-shape, and the outward curve on the god's headdress are all typical of seals from Iran from 2000 BC. Similar seals from Haft-Tepe in south-western Iran can be dated to between 1500 and 1300 BC. The cuneiform inscription is problematic. Variegated red, brown and white jasper, ht 3.65 cm.

with cutting-wheels of different sizes and with small drills. The use of these tools made it possible for the Kassites, their contemporaries and their successors to use harder stones such as chalcedony and other quartzes, and other brightly coloured and unusual stones. Seals of the 'Second Kassite 97b Group', like the lapis lazuli one from Thebes which has already been mentioned, are far more imaginative in their designs and are better cut.

Possibly the best-known Kassite artefacts are the so-called 'boundary 98–100 stones' or *kudurru* which were set up in temples as records of land grants. They are irregularly shaped stone boulders, often of black limestone or diorite, carved with a text and with the symbols of gods and goddesses, or with the figures of kings. They are most plentiful from the twelfth century BC onwards and continue into the next millennium (see Chapter 4). This means that they were mostly carved after the fall of the Kassites and the capture of the major Babylonian cities by the Elamites from south-western Iran, under their king Shutruk-Nahhunte I, in about 1157 BC. Among the booty carted off at this time, and excavated by the French at Susa over thirty centuries later, were several *kudurrus*, and the famous stelae of the Vultures, of Naram-Sin and of Hammurabi which had been set up in the major cities 58, 78 of Babylonia in the third and early second millennia BC. These are now preserved in the Louvre in Paris, together with many other objects

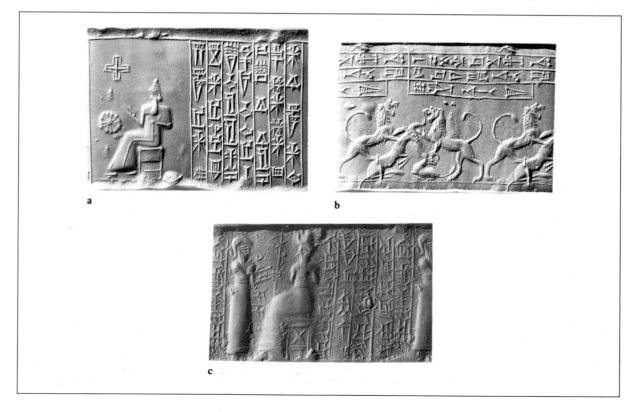

a

b

c

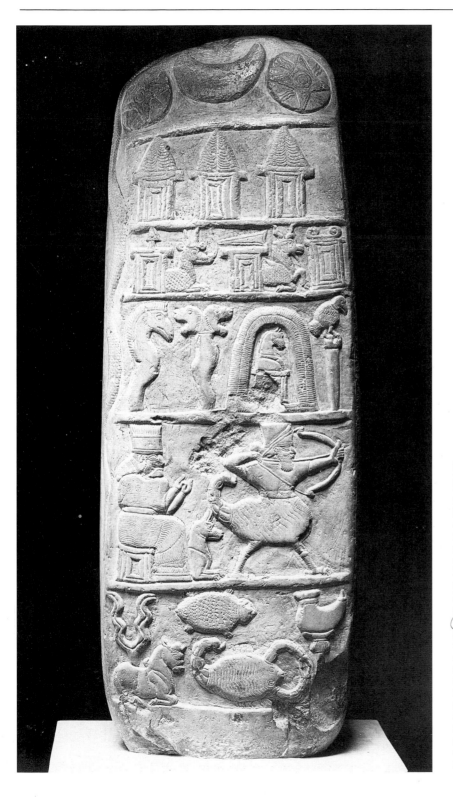

98 Limestone *kudurru* found in 1882 at or near Sippar, south of Baghdad, with an inscription (on the back) of Nebuchadnezzar I (r. 1125–1104 BC) and six registers of divine symbols: (1) star (Ishtar); crescent moon (Sin); sun-disc (Shamash); (2) divine headdresses on altars (Ea?/water, Anu/sky, Enlil/kingship); (3) altars with: spade and dragon (Marduk/Babylon); wedge or stylus and goat-fish (Nabu/writing); scroll (?); (4) ritual weapons (two warrior gods); altar with horse's head under rainbow (part of the constellation Andromeda?); bird on a perch (Sugamuna and Shumalia); (5) Gula and her dog (the city of Isin and healing); the constellation Sagittarius or Scorpio; (6) lightning fork and bull (Adad/storm); turtle (Ea/water); scorpion (Ishara/oaths); lamp on stand (Nusku/fire and light). Ht 65 cm.

99 OPPOSITE Detail of the top of a diorite *kudurru* of the reign of Marduk-nadin-ahhe (r. 1099–1082 BC), showing many of the same symbols as Fig. 98, framed by an undulating snake which also occurs frequently on boundary stones. Ht of detail *c.* 24 cm.

100 Black limestone *kudurru*, also of King Marduk-nadin-ahhe (see Fig. 99), captioned 'the avenger of his people', holding a bow and two arrows. He wears quilted slippers and a feather-topped Babylonian crown (later the headdress of deities, see Fig. 136b), decorated with rosettes, winged bulls and a tree. His garment, with pleats at the back and straps across the chest, remained the Babylonian royal dress for centuries and was also adopted at Carchemish (see Fig. 125). Its elaborate design includes the first dated examples of hexagons (see Fig. 136c-d). Above him are divine symbols and part of a snake dividing the scene from the text on the back and sides. Ht 61 cm.

101 OPPOSITE Some of the mould-made clay figurines excavated by Loftus at Susa. Their elaborate hair-style bulges out above a jewelled diadem, and they wear earrings, chokers and a pendant, crossed chains passing through a cylinder between their breasts, bracelets, anklets and possibly jewelled briefs, although this feature is more likely to depict particularly abundant pubic hair with stretch marks above (see Fig. 25). For a similar stylisation of the knees, see Fig. 85. About 1300 BC. Average ht 17 cm.

excavated at Susa which have thrown light on developments in Iran during the second half of the second millennium. The alternation between sedentary and nomadic cultures, which has been a permanent characteristic of Iranian history, results in periods when very little is known of the art and cultural developments of the population. 97c

In the second half of the fourteenth century BC, Untash-Napirisha sponsored a Middle Elamite royal style which is best exemplified in the religious city he built at Choga Zanbil near Susa. A glazed wall-plaque from the site, bearing his name, was presented to the Museum by the excavator, Roman Ghirshman (WA 132225). It has relief floral decoration in the corners reminiscent of that later painted onto similar wall-plaques from Assyria in the ninth century BC. Some 200 clay figurines of fat women holding their breasts were excavated by W. K. Loftus at Susa, of which forty are in the British Museum. A bronze attachment, possibly forming the arm-rest of a chair, is shaped like a charming little Ondine. It is said to have been found in an area of western Iran between Susa and Shiraz where later rock reliefs are located. 107 101 102

Also to be dated to around 1300 BC are bitumen discs in copper frames, with a decorated surface originally covered with gold leaf attached to a silver base by heating and burnishing – a technique known as diffusion bonding; in one case this gold leaf survives (WA 134907). Horned animals recline around a central rosette between bands of rope patterns. The purpose of these roundels is not clear, but they may have been harness decoration.

It is to one of the sons and successors of Shutruk-Nahhunte, the conqueror of the Kassites, that we owe a particularly touching chalcedony jewel which can be dated between about 1150 and 1120 BC. It is inscribed in Elamite in the cuneiform script: 'I, Shilhak-Inshushinak, enlarger of the kingdom, this *ia-ásh-pu* from [the land of] Puralish I took. What I painstakingly made I placed here, and to Bar-Uli, my beloved daughter, I gave [it].' The word used to describe the stone is the same as our word jasper. Chalcedony and jasper are both quartzes but over the millennia the term jasper has slightly changed its meaning and is now applied to a quartz made opaque by a higher proportion of impurities. 103

The Elamite defeat of the Kassites was but one of the shattering events which took place during the twelfth century BC. All over the Near East populations were on the move, and this caused major repercussions. Indo-European Medes and Persians were entering Iran at this time and settling in the west of the country. As a result, Shutruk-Nahhunte's raid had no sequel, and a new dynasty, known as the Second Dynasty of Isin, was able to seize power in Babylonia; it was responsible for the boundary stones which we examined above. The Assyrians hung on to their independence, but the days of territorial expansion were gone and new peoples, the Aramaeans, were settling on their borders.

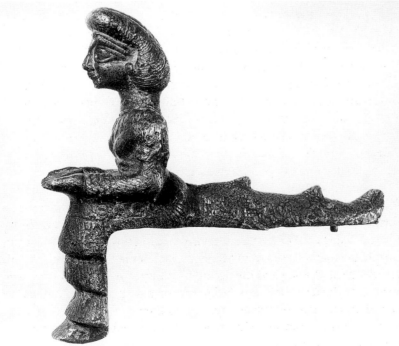

102 LEFT Bronze attachment with three rivet-holes, shaped like a seated female figure with a long fish-tail extending behind her. A broad belt secures a long-sleeved patterned and flounced dress. She has a narrow diadem beneath jutting hair (see Fig. 101), which is pulled back behind the ears to reveal large stud earrings. She wears a necklace with a counterweight ending in a tassel at waist level, double armlets and four bracelets on each arm. Her hands are extended, palm uppermost, as if holding or expecting an offering, and her small bare feet are set close together. Ht 11.7 cm.

103 A large lump of blue chalcedony pierced for suspension and carved with a scene which is described in a caption alongside it. The king sits on a chair with bull's feet and a back-rest ending in a duck's head; beneath the chair is a trumpet-shaped object of uncertain meaning. He is bearded and his jutting Elamite hair-style is already attested around 2000 BC. He holds the stone in his left hand. His daughter, perhaps still a child, wears the stone round her neck and is drawn much smaller; she touches the king's right hand, which rests on his knee, and raises her other hand. 13th century BC. L. 4.0 cm.

In the west the Israelites had moved into the land of Canaan during the latter part of the thirteenth century. The country at that time was under strong Egyptian influence. A burial of this date found at Tell es-Sa'idiyeh, on the east bank of the River Jordan, contained a skeleton lying face-down. There were two fish skeletons on the back of the skull, and over the genitals was a bronze bowl containing an ivory cosmetic box shaped like an Egyptian 104 *bulti*-fish. This is the Nile *tilapia* which lays its eggs and then hatches them in its mouth; this peculiar habit led to the *bulti*-fish becoming an Egyptian symbol of resurrection and thus particularly appropriate in a funerary context.

Further west a major economic catastrophe caused a chain reaction with large numbers of people forced to become refugees. It is not known whether this was the result of natural disaster or due to one of the periodic outbreaks of piracy which have plagued the Mediterranean at various periods in its history. The Trojan wars recounted by Homer are probably to be seen in the context of these events. The ever-increasing army of refugees, referred to as the 'Sea Peoples' in the texts, moved through the Aegean and Turkey, south into Syria and Palestine and were finally defeated in major land and sea battles by the Egyptians under Ramesses III in about 1195 BC. The

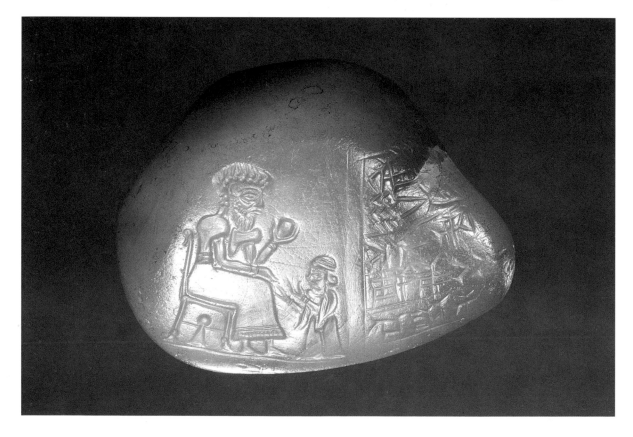

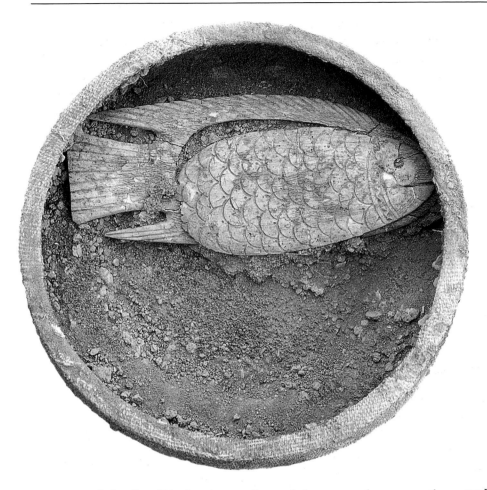

remnants of the Sea Peoples eventually settled; among them were the Peleset, later known as the Philistines, who gave their name to the area called Palestine. But in their wake the Sea Peoples had left a trail of destruction. Many major cities disappeared for ever, including Alalakh and Ugarit. The Hittites were so weakened by the invasion that they fell prey to their traditional enemies the Kaska, who swept down from the Black Sea. These political upheavals heralded a new dark age.

104 Bronze bowl, to which fragments of textile are adhering, containing an ivory cosmetic box shaped like an Egyptian *bulti*-fish, excavated at Tell es-Sa'idiyeh in Jordan. Diam. of bowl 13.8 cm.

Great Empires: the 1st millennium BC

The dark age brought about by the political upheavals and mass migrations of the late second millennium BC continued for several centuries and encompassed almost the whole of the Ancient Near East. Egypt was also affected and its chronological framework is as a result so unreliable that it has even been suggested that the Third Intermediate Period which succeeded the New Kingdom is, in fact, the result of a series of errors and that some 350 years should be deducted from the generally accepted chronological scheme. Although it is certain that there are some inconsistencies and errors, it is impossible to remove even a few years in the chronology of one area without seriously affecting that of another. Throughout the dark age, the Assyrians continued to keep a detailed record of their kings and the lengths of their reigns. Frequently we have annals recording the events of these reigns, and we have contemporary monuments inscribed for the kings themselves. Although the king-lists for southern Mesopotamia are less complete, the number of correlations with events in Assyria make it quite impossible to remove 350 years from the history of Mesopotamia. Although few inscriptions survive in Anatolia and Syria, there is growing evidence of continuity in the branches of the Hittite royal family ruling in Carchemish and Malatya, and the names of dynasts succeeding each other in neighbouring city states are also recorded. As the Assyrians became more powerful, so their contacts – peaceful and otherwise – with their neighbours became more numerous, and from the ninth century BC onwards events can be dated either precisely or to within a very few years.

Because of its firm chronology, Assyria is normally used as the starting-point for any discussion of Near Eastern art during the first four centuries of the first millennium BC. Paradoxically, however, the artefacts of the early

centuries of the first millennium are probably less well dated than those of any other period in Mesopotamian history. There are several reasons for this. Assyrian art is marked by strong continuity, and monuments of the Middle Assyrian period (see Chapter 3) served as models for the later kings of Assyria, who often consciously revived earlier styles. As Assyrian power grew, so its influence on the artistic production of its neighbours increased. Craftsmen beyond the borders of the Assyrian empire attempted to imitate the Assyrian court style, while others from subject nations were brought to Assyria and produced objects for their Assyrian patrons in a mixture of local and Assyrian styles and iconographies. As a result, there is an internationalism in all types of artefact. For instance, Assyrian reliefs show similar items of furniture being carried off as booty from a variety of locations, and the surviving decorated metal fittings of such furniture are almost identical throughout the Near East. The problem is further compounded by the fact that the richest source of information is provided by finds made in the storerooms of the Assyrian palaces: these were used for storage for several centuries, with material from different campaigns – geographically and chronologically – often being stored together. It is also difficult to make comparisons between one class of object and another since the iconographical repertoire and the decorative motifs used by the different groups of craftsmen rarely overlap. The Assyrian reliefs can be relatively closely dated

105 Reliefs decorating Room G in the North-West Palace of King Ashurnasirpal II at Nimrud in northern Iraq. The seated king is waited on by attendants with fly-whisks who are beardless and may be young or eunuchs. One holds a cup and has a long towel over his shoulder; the others carry a bow, quiver and sword (the hilt and scabbard are decorated with the foreparts of lions). The king has a tightly curled, stylised beard and wears a turban wrapped round a cone, with a fringed end hanging behind, armlets ending in rams' heads and bracelets decorated with rosettes (a protective symbol). A winged genie on the left holds a sprinkler and bucket. About 865 BC. Ht 2.36 m.

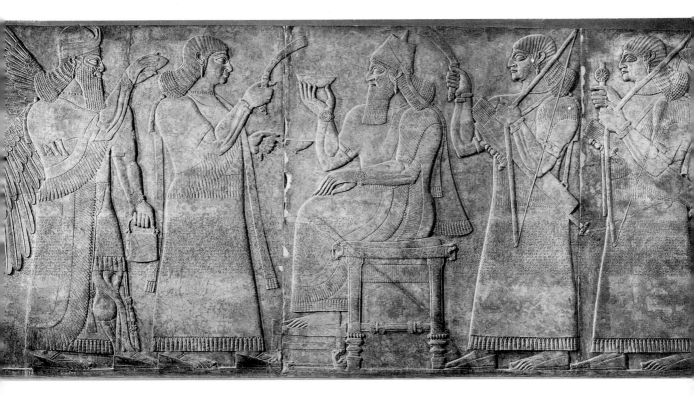

because they were set up in their palaces by known kings; however, the scenes depicted on ivories and cylinder seals are either completely different or are treated in quite another way. The following examples, drawn from comparisons between reliefs and seals, serve to illustrate the problems.

When Ashurnasirpal II (r. 883–859 BC) built his new palace on an earlier mound at Nimrud, he decorated the main rooms with gypsum slabs over two metres high which were carved in low relief, and with huge gateway figures of winged human-headed bulls and lions. It is thought that the palaces of the Neo-Hittite and Aramaean cities of northern Syria and south-eastern Anatolia served as an inspiration, although the execution was in a different style and on quite another scale. Some of the scenes depicted military campaigns, generally divided into two registers by a band of 11 cuneiform inscription (this latter was largely cut away in order to facilitate transport to London, but can be reconstructed as it is a standard inscription repeated throughout the palace). Some of the reliefs showed the king and his 105

106 Detail of the decoration on one of the garments on the relief immediately to the right of those illustrated on Fig. 105. Ht of band 8.5 cm.

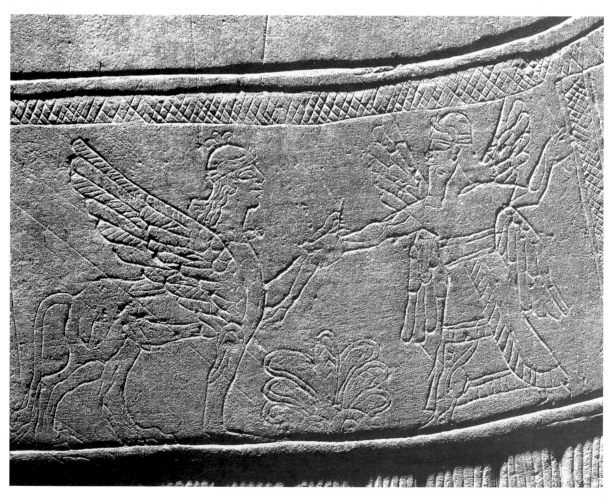

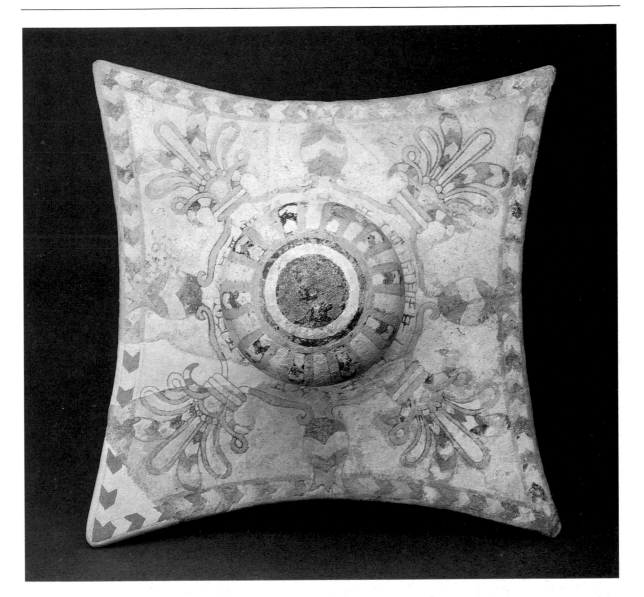

court: these covered the whole height of the slabs, although the inscription ran across these slabs too. The king sits on a padded stool but the hexagonal design of the material covering the seat already appears on the dress of 100 Marduk-nadin-ahhe in the early eleventh century BC and reappears on a 136c–d group of spectacular royal seals which were probably made in a royal workshop around 720 BC.

The robes of the king and his courtiers are edged with bands bearing incised decoration representing elaborate embroidery or weaving. Some of the motifs on these bands show winged divine heroes or goats on either side of typically Assyrian stylised trees similar to those depicted on a larger scale

107 Glazed wall plaque set up by King Ashurnasirpal in the Kidmuri Temple at Nimrud (restored from fragments). The design is painted in black and pale yellow on a white ground. Plaques with knobs of this type were fixed to the walls of palaces and temples and may have been used for attaching wall-hangings in winter. About 865 BC. W. 28 cm.

131

on the reliefs and also found on Assyrian seals. Another motif shows a [108] striding, four-winged minor god who brandishes a dagger and grasps a [106] sphinx by the paw; the asymmetrical composition and the palmette beneath are typical of Babylonian seals, although the palmette also appears on [136a–b] decorative Assyrian glazed plaques, and the fact that the upper wings of the [107] god are shorter than the lower is also typical of Assyria (in Babylonia the wings are the same length). On cylinder seals, the presence of such a Babylonian scene would only be expected after the capture of Babylon by Tiglath-pileser III in 729 BC, and the palmette on the sphinx's headdress was once thought to be a criterion of the reign of Sargon (721–705 BC). Finally, the motif of the divine hero between two bulls, also found on these decorative bands, is a composition which, on seals, also only appears under [136c] Sargon. So these tiny, barely visible details on Assyrian reliefs of the ninth century serve to place a question-mark beside attempts to define the chronology and geographical distribution of the seals. Nor do the reliefs help in the dating of the furniture fittings which have been found in the storerooms of Assyria. The same bronze sheaths with volutes appear on the stool of Ashurnasirpal in the first half of the ninth century, on the throne of [105] Sennacherib at Lachish just after 701 and on the chair of Ashurbanipal's [117] queen in the mid-seventh century BC. [120]

The surviving reliefs from the throne-room of Ashurnasirpal II at Nimrud were organised according to a carefully planned scheme. Large figures of winged minor gods stood on either side of the doorways and of a recessed panel at the east end of the room, behind the throne dais. This [108] panel shows the king twice, wearing ceremonial robes and standing on either side of a stylised tree, sometimes referred to as the 'Tree of Life' or the 'Sacred Tree'. It is also possible to view the tree as the map of a well-irrigated garden with a main canal (the trunk) and side-channels (the branches) watering individual plants. It was certainly a symbol of the well-being of the country and its fertility, and it was repeated in all four corners of the room. Syrian examples of stylised trees placed under winged sun-discs had first appeared almost a millennium earlier, but this elaboration was new, as was [75b] the addition of a tail to the winged sun-disc and the depiction of the god rising from it. Behind the figures of the king are two minor deities who hold a bucket and cone and are carrying out a protective or purification ceremony for which there are Babylonian antecedents also going back a thousand years. On certain occasions the king's throne seems to have been moved so as to be opposite one of the entrances into the throne-room, and a second recessed panel, with a similar scene, stood against the south wall opposite the central doorway.

On his left, when seated on the dais, the king would have seen reliefs depicting two of his principal activities and their outcome: the hunting of lions and bulls and the capture of foreign cities on the upper parts of the

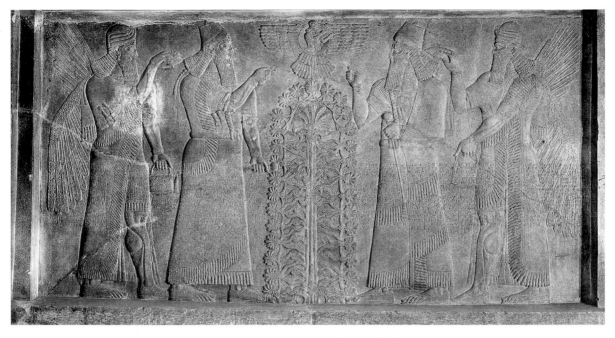

reliefs, with, below, the pouring of libations over the dead lion and bull and the receiving of booty and prisoners. Few of the reliefs on the northern wall have survived, but the western half of the southern wall depicted more of Ashurnasirpal's campaigns. The central slab in this sequence shows the Assyrian camp above, seen in bird's eye view as a perfect circle. To the right the royal horses are being groomed and soldiers are relaxing after a successful campaign, dancing and playing ball with the heads of decapitated enemies to the accompaniment of lute and harp! Below, rather more sedately, the king receives the population of a defeated city. The action on the four slabs on either side leads towards this central slab: on the left, above, a successful chariot and cavalry charge, and below, the well-ordered crossing of a river by the Assyrian army; to the right, above, the return of victorious chariotry after the siege of a city on a hill at the extreme right, and below, an elaborate siege scene culminating in the procession of prisoners – men, women and children – leading towards the central slab. In each episode, the king is shown playing an active part and is accompanied by the sun god in his winged disc.

There is nothing tentative about the arrangement of the throne-room of Ashurnasirpal II. Holly Pittman has recently argued that it was not the execution of a new concept, rather the revival of a decorative scheme used in Middle Assyrian times but probably executed in glazed bricks, fragments of which survive (see page 117). Glazed brick decoration was certainly used in Babylonia and huge panels have been restored in Berlin. Glazed bricks were also used by Ashurnasirpal and it is instructive to compare the scene on Fig.

108 Recessed relief panel from the throne-room of King Ashurnasirpal's North-West Palace at Nimrud. About 865 BC. Ht 1.93 cm.

133

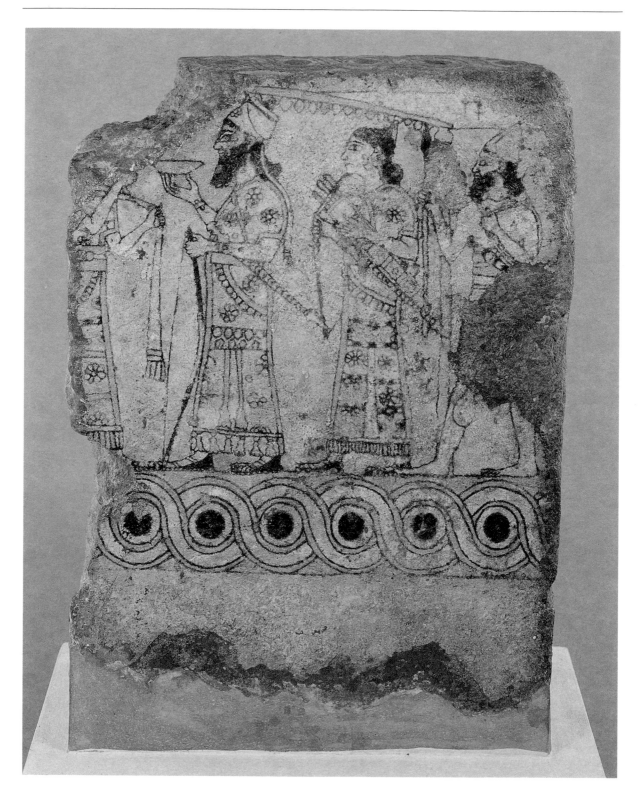

105 with that on a glazed brick (Fig. 109) and on an ivory panel (Fig. 110) which, judging by details of the dress and border, is probably a century or more later and well illustrates the difficulties in attempting to cross-date Assyrian material from one medium to another. The stone reliefs were painted, but little trace remains on the slabs in the British Museum. The sandals of some of the larger figures and the end of the standing king's bow still retain traces of red – perhaps because the lower parts of the reliefs had to be repainted more frequently due to wear and the cleaning of the adjacent

109 OPPOSITE Glazed brick showing the king holding a bow and a cup between two attendants, one with a towel and the other with sword, bow and quiver. They are wearing rosette-patterned robes and stand under an awning; behind them is a helmeted soldier. Beneath and on the upper edge of the brick are guilloche borders. The decoration was executed in yellow, black and green (perhaps originally red) paint. Excavated at Nimrud. About 865 BC. Ht 30 cm.

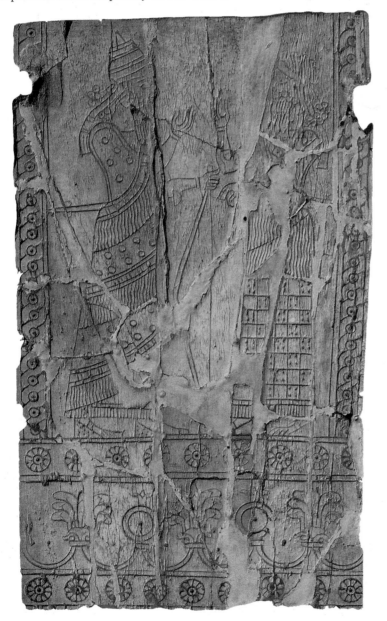

110 Incised Assyrian-style ivory panel depicting a king (with a bow) and a courtier, both with one hand raised, within borders of guilloches, rosettes and palmettes. The grid decoration of the courtier's robe became fashionable in the reign of Tiglath-pileser III (745–727 BC). Excavated at Nimrud. Ht 15 cm.

floor. Reliefs excavated at Nimrud in the 1950s show that the beards and hair were painted black, as were the rims and pupils of the eyes; the whites of the eyes were painted white, and gold jewellery was picked out in yellow. Some of the demons on seventh-century sculpture have red ruffs. As his reconstructions indicate, Layard evidently thought that the reliefs were entirely covered with paint, but it seems more likely that certain features were given prominence in this way.

The slabs are carved in low relief with the background cut away around 105 the figures so as to define them sharply. The effect of volume is produced by 108 rounding certain forms, for instance the eyes, noses and chins of the figures, the eyes of the horses and the calf muscles of soldiers and minor gods which are stylised into perfect tear-drop shapes. The foreleg muscles of animals are marked by an inverted U. Certain pictorial conventions of the Assyrians have somewhat odd results: for instance, an archer will not be shown with the arrow at eye level because it would cut across his eye, thus diminishing his effectiveness, and so it is shown at shoulder level. For the same reason the bow and bow-string are not allowed to cut across the archer's face. Two solutions to the problem were therefore adopted, and both are already found under Ashurnasirpal II: either one bow-string was omitted so that it appears 111 to pass behind the archer's head and, when released, would have decapitated him, or the archer is shown according to a double perspective so that it seems as though he is being viewed from the front, except that the position of the bow and his hands can only make sense if he is seen from the back. The two solutions may even be combined. 115

The impression of movement is conveyed by depicting consecutive actions as taking place simultaneously: for instance on Fig. 111 a chariot is shown riding down a wounded enemy archer who has two arrows in his back, and probably the same figure is shown under the horse's hooves with his bow and quiver lying beside him (see also Figs 35a, 119, 146a and 174, where two chronologically separate moments are combined in one scene). A vulture flying above the chariot points one wing forward towards the field of battle, where there will be rich pickings. In all the scenes of battle depicted for over three centuries on Assyrian reliefs, no Assyrian is ever shown wounded or at a disadvantage.

In their reliefs, the Assyrians produced some of the finest artistic creations of all time. They were not, however, as successful with sculpture in the round and, after several attempts in the ninth century BC, seem largely to have abandoned it; at any rate, little survives. One of the most famous examples shows Ashurnasirpal II, presented strictly frontally. He seems 112 barely to emerge from the block of stone from which he was carved, and when he is viewed from the side it is clear that the sculptor conceived the statue as two reliefs back to back. The king nevertheless has a grim monumentality despite his small size.

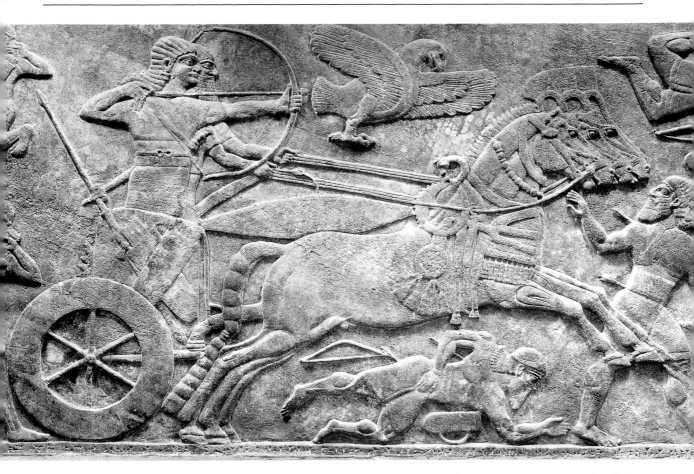

More successful were the huge human-headed, eagle-winged lion and bull figures which guarded the doorways into the main rooms of Assyrian palaces (exceptionally, lions guarded the entrance of the Ishtar Temple at Nimrud). Some were cast in bronze, but those that survive were carved from slabs deep enough to accommodate the width of the animal; one side remained uncarved as it was let into the wall. The head, worked almost entirely in the round, emerged from the end of the slab, and the body was carved in high relief. Under Ashurnasirpal the guardian figures were monoliths about 3.3 metres high, but those of Sargon's reign were over 4.4 metres, and under Esarhaddon (680–669 BC) they became so large (about 5.7 m high) that they had to be made of several blocks of stone fitted together. Moving such figures was a major feat of engineering. Their monumentality contrasts with the detailed carving: beards, moustaches and hair are elaborately curled, feathers delicately incised, and the winged, human-headed lions have intricately knotted bands around their bodies. During the ninth and eighth centuries BC, the figures had five legs so that they would have the full complement whether they were viewed from the

III The upper register of a relief decorating the throne-room in Ashurnasirpal's North-West Palace at Nimrud. Two Assyrians in a chariot pursue fleeing enemies while a bird of prey hovers expectantly overhead. Compare this 9th-century chariot with that on Fig. 121, some two centuries later. The chariot was drawn by two horses with the third as an outrigger or reserve horse. The remains of the band of cuneiform which divided the two registers can be seen at the bottom. About 865 BC. Ht 90 cm.

137

112 Statue in the round of King Ashurnasirpal II, identified by an inscription below his beard. He wears ceremonial robes as on Fig. 108, but without the headdress, and holds a mace and a small sickle-sword. Layard found the statue in 1850 in the Ishtar Temple at Nimrud. It had been toppled from a block of red limestone in which it had originally been set, and both were broken. The block itself must have had a special significance: it is crudely shaped, although the Assyrian stonemasons were certainly capable of producing right angles, and may have been inherited from an earlier period. About 865 BC. Extremely hard magnesite. Ht of statue 1.06 m.

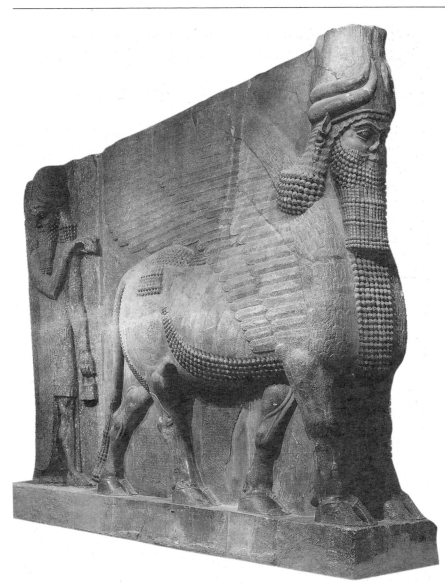

113 One of a pair of winged bull-colossi which guarded an entrance to Sargon's palace at Khorsabad. It was sawn up for removal by Layard's mason Behnam. Between the legs there is a long cuneiform inscription, and roughly scratched on the plinth is a grid for the Game of Twenty Squares (a descendant of the game played at Ur, see p. 68), probably incised by guards or those waiting to gain admittance. On a separate block behind the bull is a winged protective deity with bucket and cone, similar to those on Fig. 108 but with his head turned outwards. About 710 BC. Mosul marble (gypsum). Ht 4.42 m.

side or from the front, but from the reign of Sennacherib onwards the extra front leg, when viewed from the side, was dispensed with, and this was also the version adopted by the Achaemenid Persians at Persepolis. In many cases the stone thresholds between these gigantic figures were carved with intricate patterns which probably imitated carpets. In Sennacherib's palace at Nineveh, a sequence of doorways was described by Layard (*Nineveh and Babylon*, London 1853, p. 445) as follows:

There were thus three magnificent portals, one behind the other, each formed by winged bulls facing the same way. . . ; the largest colossi, those in front, being 18 feet high [5.4 m], and the smallest, those

114 Part of a decorated stone threshold from a doorway in Sennacherib's South-West Palace at Nineveh. Very similar slabs were carved in the North Palace at Nineveh of Sennacherib's grandson Ashurbanipal. The design probably imitates actual floor-coverings. About 700 BC. 50.8 × 96.5 cm.

leading into the inner chamber, about 12 [3.6 m]. It would be difficult to conceive any interior architectural arrangement more imposing than this triple group of gigantic forms as seen in perspective. . . .

The Black Obelisk and the Balawat Gates are the main surviving monu- 10–11 ments of Ashurnasirpal's successor, Shalmaneser III (858–824 BC). The gates (together with two smaller sets of gates from the reign of Ashurnasir- 1 pal) were found at a small site near Nimrud, where there was a palace and a temple to Mamu, god of dreams. Tablets inform us that the gates were made of fragrant cedar wood; they were hung on huge cedar-wood trunks capped with bronze and turning in stone sockets. Each gate was decorated with eight bronze bands approximately 27 centimetres high, and each bronze band was embossed and chased with two friezes representing, in fascinating detail, Shalmaneser's campaigns during the first ten years of his reign, identified by cuneiform inscriptions. The friezes were edged with rows of rosettes which held the nails fastening the bands to the gates. The sequence of the bands can to some extent be deduced from the diameter of the ends which were wrapped around the trunk; the trunk tapered towards the top and these upper bands were also the least well preserved because they were nearest the surface of the mound. The height of the gates can be estimated at

6.8 metres thanks to the discoloration, at regular intervals, of the inscribed vertical bands which edged the gates.

1 One of the scenes on the Balawat Gates shows a sculptor executing a relief at the source of the Tigris which can still faintly be seen *in situ*. It is of a type well known from actual examples, both free-standing (e.g. WA 118805) and carved on strategic rock faces during Assyrian campaigns, generally within a round-topped frame. The king is shown pointing with one finger towards the symbols of the gods, in the same way as on the niched reliefs in the

108 throne-room of Ashurnasirpal II, and he wears the same ceremonial robes. This scene was accompanied by a long inscription. Similar sculptures were executed under successive kings and would have been the type of monument most frequently seen by the peoples of the Assyrian empire (one is depicted in the royal gardens on Fig. 8). They encapsulated the ideal of the power vested in the monarch by the gods and were a permanent record of his achievements on their behalf.

115 The next king to leave a pictorial record of his campaigns in the form of relief sculpture was Tiglath-pileser III (r. 744–727 BC). The sculptures and their division into registers by bands of inscriptions were much as they had been under Ashurnasirpal II, but the grid-like decoration of textiles seems to have been an innovation of the period. Whether the textiles were woven or embroidered or whether metal plaques were stitched to the cloth is uncertain, but it has been suggested that the Phrygians of western and central Turkey may have been responsible for instigating this fashion; certainly in

115 Relief from the palace of Tiglath-pileser III at Nimrud. Assyrian archers behind body-shields are shown besieging a city on a hill with a scaling-ladder and a battering-ram aimed at a corner tower. The capture is also depicted (another instance of sequential actions being shown as simultaneous), and inhabitants are being butchered and impaled. Below are the remains of the cuneiform inscription which divided the registers. Note the partial omission of the bow-string, arrow and body-shield and the archer's twisted posture. About 730 BC. Ht 91 cm.

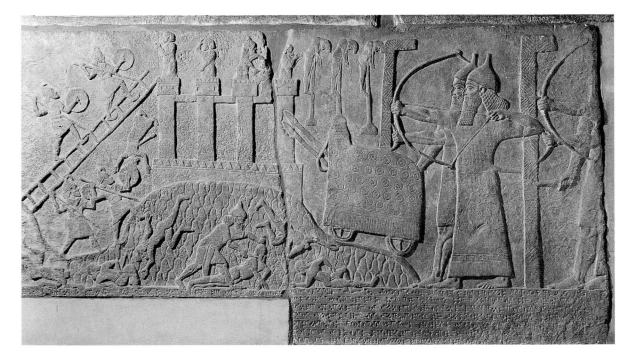

Phrygia decoration in grids of squares was also applied to painted pottery and to architecture.

Like his famous predecessor Sargon of Akkad in the third millennium BC (see Chapter 2), Sargon II (r. 721–705 BC) was probably a usurper and adopted the name Sharru-kînu ('True King') on his accession. He founded a new capital, Dur Sharrukin (now Khorsabad), some distance north-east of Nineveh, and built a great palace there which he decorated with reliefs and gateway figures on a huge scale. His slabs are characterised by a higher, more rounded relief and a greater interest in landscape. Most of the slabs excavated are in the Louvre, but the British Museum has a pair of colossal winged bulls, a slab showing Sargon and a high official, probably the crown-prince, and a fine hunting scene which decorated the king's private apart- 116 ments.

The division of slabs into registers was abandoned for some of the scenes in Sargon's palace and this innovation was developed under his successor, Sennacherib (r. 704–681 BC), who moved the capital to Nineveh. Here he built a palace on the south-western part of the mound of Kuyunjik which came to be known as the 'Palace without a rival'. Vast courtyards were surrounded by suites of rooms, most of them lined with reliefs depicting Sennacherib's campaigns. The most important of these were entered through doorways lined with colossal human-headed lions or bulls, and the sequence of doorways described above led to the famous Lachish Room (Room XXXVI) where the reliefs depicted a single episode from Sennacherib's third campaign.

Lachish was a town in southern Judah, on the borders with Egypt. Sennacherib hoped to conquer Egypt, and his campaign against Hezekiah's kingdom of Judah in 701 BC was a preliminary to that conquest. The Egyptians, at that time ruled by a Nubian dynasty, dispatched an army to the aid of the Judaeans. The campaign is described by Sennacherib in his annals and, from the Judaean point of view, in the Bible (II Kings 18–19 and Isaiah 36–7). The reliefs of Sennacherib's time are distinctive in that the geographical background is generally indicated, for instance date-palms for Babylonia and, in the case of Lachish, a scale pattern overall to show hilly country, planted with vines and fig-trees. In order to give the impression of the implacable advance of rank upon rank of Assyrian troops, on some of the slabs these are arranged in horizontal rows reminiscent of registers: slingers, archers from different parts of the empire, identified by differences in dress, and then, as they near the tell on which towers the city of Lachish, archers behind huge body-shields and spearmen in more active postures, holding round wickerwork shields.

The siege itself must have been visible through the doorway. Before the 7 city the Assyrians have raised a huge siege mound upon which they have laid ten ramps of dovetailed boards. Siege engines are inching their way up these

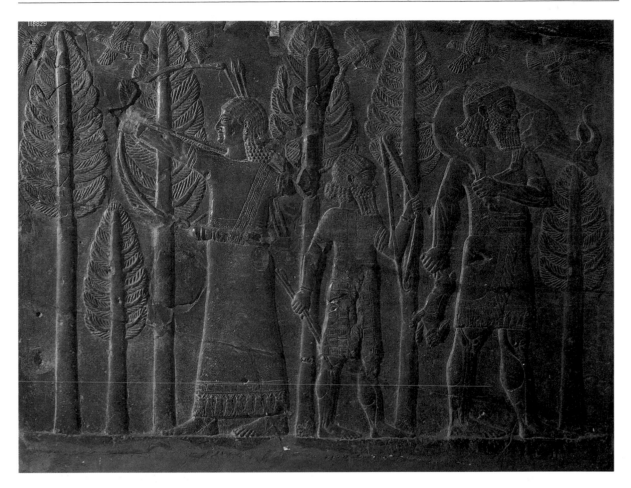

but the Lachishites are hurling stones and burning torches onto them; in order to prevent their catching fire, one of the men in each engine ladles water onto its battering ram and leather exterior. The siege mound can still be seen at the site of Lachish itself: it is aimed at a point in the defences where it would have been difficult for the besieged to concentrate large numbers of defenders. On the relief the siege ramps are shown fanning out, but in reality the siege engines would have advanced side by side, forming a protective wall behind which Assyrian troops could move forward. From a postern gate, already surrounded by Assyrians, the elderly, women and children are being evacuated past the bodies of impaled spies.

To the right of the city the aftermath of its capture is depicted: processions of Assyrians with booty and Lachishites going into exile with their possessions loaded onto camels and into carts, the children witnessing, as they pass, two men spread-eagled on the ground who are being flayed alive. These processions are divided, as were the attacking Assyrians on the left of the city, into horizontal rows, and are moving in the same direction.

116 Relief from the palace of Sargon II at Khorsabad, possibly from the king's private apartments. In a wooded landscape, Assyrians are engaged in hunting. An archer is shooting; another carries an antelope and a hare he has shot, while a bearded servant (drawn much smaller to indicate his lack of importance) holds his bow and arrows for him. Birds fly among the trees. Note the grid-patterned tunic of the servant; only the figure on the left wears sandals. About 710 BC.

143

117 OPPOSITE Detail of a relief from Room XXXVI of the South-West Palace of Sennacherib at Nineveh. Sennacherib sits on his throne, the arm-rest and seat of which are supported by figures of minor deities, made of gilded bronze or ivory (see Fig. 132); his feet rest on a footstool. He holds two arrows (probably a symbol of victory, see Figs 100 and 136d) and a bow; army officers, led by the crown-prince, approach. The scale-patterned background indicates the hilly Judaean countryside. Sennacherib's face was smashed at the time of the sack of Nineveh in 612 BC when the palace was looted and burnt. About 700 BC. Ht of whole relief 2.65 cm.

The culmination of all this movement towards the right is Sennacherib 117 himself, seated on his throne at the centre of the end wall of the room; an accompanying inscription identifies him and provides the name of the city. Kneeling prisoners plead for mercy, while others move forward and some are executed. These curly-haired prisoners are dressed differently from the Judaeans with their fringed kilts and turbans and it is possible that they are Nubian members of the garrison; furthermore, the captured chariot with its elaborate yoke which is being brought out of Lachish may well be Nubian, since Nubian horses and chariotry were renowned.

The king sits at the top of one of the hills near Lachish and immediately behind him (and identified by a caption) lies his tent, built to an interesting design which would have caught the prevailing breeze and channelled it through the tent; the same principle was later adopted for the *iwan* type of architecture made famous by the Sasanians for their palaces and adapted under Islam for mosques, palaces and schools. Other tents of this type, together with more traditional ones, are shown in the fortified Assyrian camp, seen from above on the side wall to the right. From the camp the movement is towards the king on his throne. His chariot awaits him at the bottom of the hill and soldiers with horses stand in attendance behind. Nearer the camp is another chariot of different type: the closest parallels for it are chariots on the reliefs of Ashurnasirpal II's reign and it was perhaps a vehicle for state occasions in the same way as carriages from the last century are used on state occasions by present-day royal families. Inside the camp, priests perform a ritual over a war-chariot in which stand divine symbols.

This sequence of reliefs has been described in detail because it serves to show the information which a careful study of Assyrian reliefs can provide. The dress of the Judaean Lachishites and Nubians, of the various regiments of the Assyrian army, of the crown-prince and king, is carefully rendered and although the figures may be stereotyped, they can, for that reason, be easily recognised when they reappear. For instance, after they went into exile, the Judaeans seem to have been employed in construction work related to the building of Sennacherib's palace: another sequence of reliefs 180 in Court VI of the same palace depicts the moving of the huge bull-colossi from the quarry, and men wearing the same distinctive fringed turbans as the Judaeans are shown working there and hauling on the ropes. A famous slab (WA 124947) shows curly-haired, long-robed men, similar to the Nubians on the Lachish reliefs; they play lyres decorated with the heads of ducks or geese, and actual lyres of this type have been found in Egypt. Because these figures have often, and wrongly, been identified as Judaeans, the relief has been used to illustrate Psalm 137 which was written by later exiles from Judah and begins: 'By the rivers of Babylon we sat and wept when we remembered Zion. There on the poplars we hung our harps, for there our captors asked us for songs.'

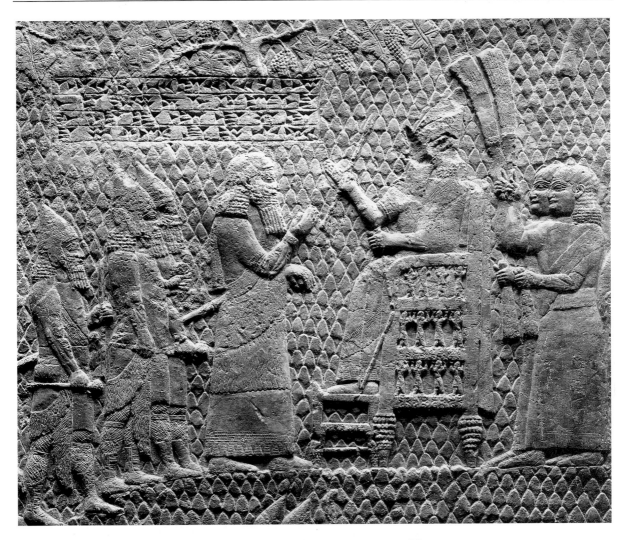

The reliefs in Sennacherib's palace are remarkable on many counts. The scale is huge (the reliefs in Room XXXVI were 2.65 metres high) but the scenes, filled with small figures and rarely divided into registers, are carefully composed and were conceived specifically for the room or court-yard where they were found, sometimes – as in Court VI – as part of an enormous composition 40 metres long. The high quality of the carving is remarkably consistent. There are idiosyncrasies, such as in Room XXXVIII where a river runs through the scene and the trees below it are shown upside down. That different craftsmen were used, even on one and the same slab, becomes apparent upon close examination: for instance the slab forming the corner to the left of the enthroned Sennacherib in Room XXXVI depicts Nubians in procession with, on one side of the corner, their curly hair shown as little circles and on the other, by a grid of lines.

Many of the reliefs were badly damaged when the palace was sacked and burnt in 612 BC and the Assyrian empire collapsed before the combined onslaught of Chaldaeans from Babylonia and Medes from Iran. The gypsum from which most of the reliefs were carved turned to plaster of Paris when burnt; other slabs are fire-blackened where burning rafters collapsed against them. The upper parts of the reliefs suffered particularly badly, since they were either shattered when the burning roofs collapsed or were left exposed and were badly damaged by the rain and frost of northern Iraqi winters. Unfortunately, it was generally on the upper parts of the reliefs that the captions were placed and these have often disappeared. As a result, although – thanks to the identifying background – the general area of a campaign is usually clear, the specific cities depicted are seldom known. However, whereas the upper parts of the side walls of the Lachish Room had crumbled away, the relatively narrow end wall is better preserved and one of the corners survives to its full height. Those who looted and burnt down the palace could not resist disfiguring the face of Sennacherib whenever they came across his likeness – either on his throne, as in the Lachish Room, or, more often, supervising activities from his parasol-shaded chariot. Larger inscriptions on the backs of the slabs are as follows:

> Palace of Sennacherib,
> great King, King of the world,
> King of Assyria, the almighty one,
> the Lord of all kings.

Not all the rooms in Sennacherib's palace had been carved with reliefs at the time of his death. In some cases the blank slabs were decorated with scenes illustrating the campaigns of later kings, notably those of Sennacherib's grandson, Ashurbanipal (r. 668–627 BC). Sometimes, Sennacherib's reliefs were usurped, the surface was cut back and another relief was carved instead. This process is well illustrated by a relief which had been part of a cycle showing a campaign in marshy territory, perhaps in southern Babylonia; the reed beds still survive on the left but they have been cut away on the right of the slab, which has been recut with a scene showing a fleeing horseman and advancing Assyrian infantry against a background of palm-trees by a river (WA 124773). Other rooms had been left undecorated on purpose because they had been lined with a special type of fossiliferous limestone covered with distinctive elongated white flecks; the Assyrians called it *pindu* stone and it came from Mount Nipur (Cudi Dağ in south-eastern Turkey).

One of these rooms, Room XXXIII, was taken over by Ashurbanipal, who had a sequence of slabs – six of which survive – decorated with episodes of a campaign against the Elamites and Chaldaeans, probably around 650 BC. The harder stone enabled these reliefs to survive better than most. The

118–19

118 Detail of Fig. 119, the Battle of Til Tuba.

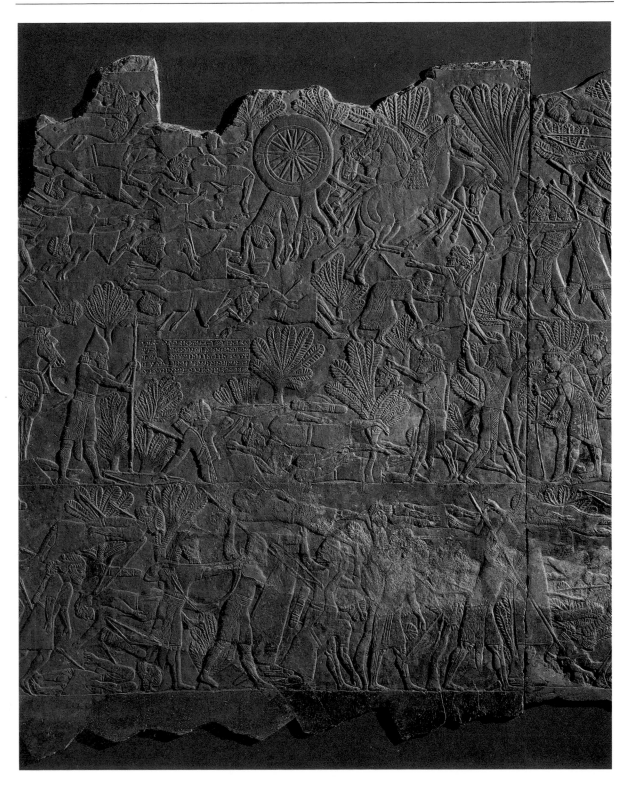

119 Two of the six slabs
illustrating the Battle of Til Tuba –
the defeat of the Elamite king
Teumman by the forces of
Ashurbanipal, King of Assyria (the
upper registers show events in
Babylonia). The wheel of the
overturned chariot can be seen at
the top of the left-hand slab (see
Fig. 118), the subsequent flight on
foot and execution of the king and
his son are slightly lower, at the
juncture of the two slabs. Ht
2.02 m.

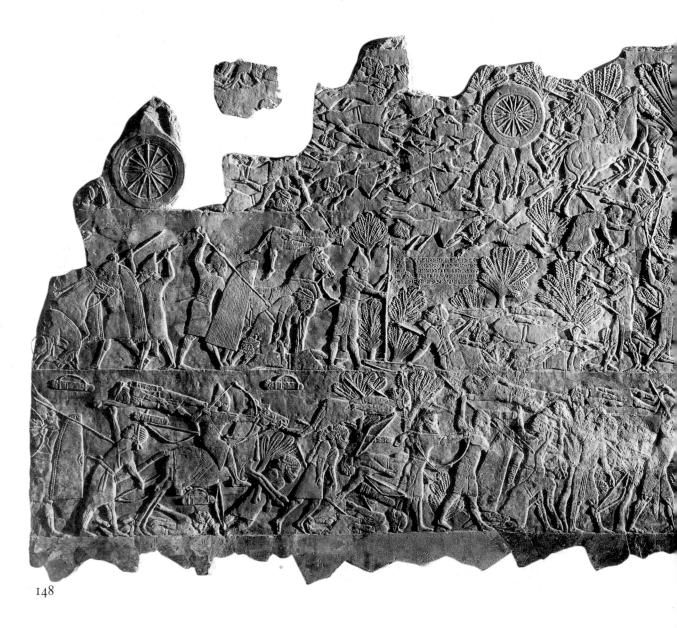

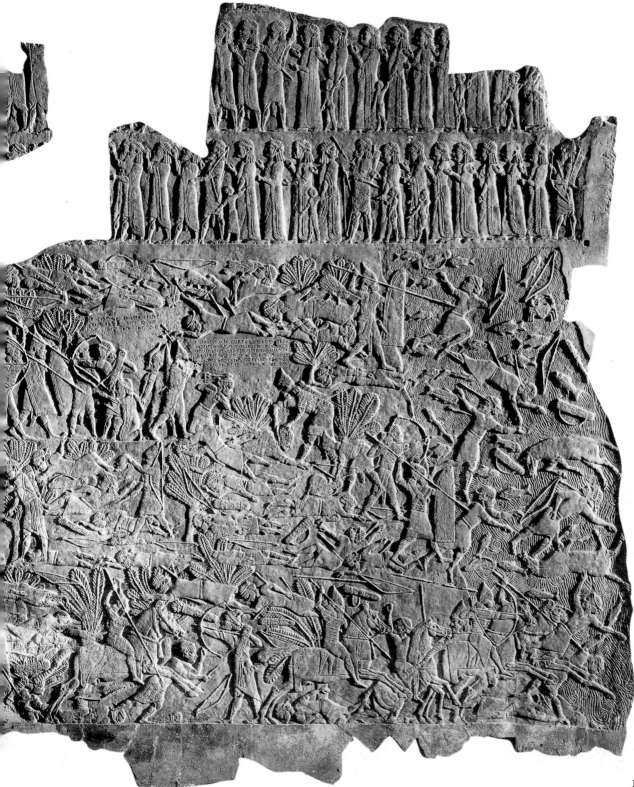

Battle of Til Tuba, or of the River Ulai, is well known from texts, from another sequence in Ashurbanipal's North Palace (carved on a different stone), from the captions on the reliefs themselves, and from tablets recording the captions which enable uncaptioned scenes to be identified. Numerous episodes are illustrated among the apparent confusion of the Elamite defeat. The Elamites are characterised by their shorter hair and beards, by head-bands worn knotted at the back, and by the fact that they are the recipients of everything unpleasant. On the left (not shown), the Elamites are driven from Til Tuba, a strategic elevation which they had held. The Elamite king, Teumman, is identified by his crown with a long feather hanging down the back, by his fringed and ornamented robe and his laced boots. He has been wounded in the back by an arrow and, together with his son, Tammaritu, he flees from the battlefield in a chariot. As they drive through a wood, the chariot overturns and they are thrown from it; Teumman's crown falls off and reveals his equally distinctive receding hairline. Tammaritu rescues the crown and urges his father to flee on foot, saying 'Come on, don't delay'. However, 'with the help of the deities Ashur and Ishtar', they are surrounded; Tammaritu attempts to make a stand but is hit on the head with a mace and they are beheaded 'one in front of the other'. Soldiers retrieve Teumman's head and crown, and a scene shows Elamite dignitaries identifying the head as that of their king. Then, as the battle continues and the Elamites are driven into the River Ulai, which is choked with their bodies 'for three days', the head of Teumman is rushed by chariot to Ashurbanipal, who was in the northern Assyrian city of Erbil.

On the next sequence of slabs (WA 124802) the head reappears hanging round the neck of Dunanu, a Chaldaean captive, in a scene where Teumman's Chaldaean allies are being tortured. This is witnessed by the ambassadors Teumman had sent to Ashurbanipal, bearing tablets inscribed with an insulting message which had led to the fateful campaign, and by ambassadors from Urartu, to the north of Assyria; the Elamites are being made to show them the tablets in an attempt to dissuade Urartu from following the example of Elam. Ashurbanipal (face damaged as usual) stands in his chariot to the right. Below, Teumman's royal city, Madaktu, is shown, encircled by a river and canal; it consists of a citadel and a walled city surrounded by palm-groves and country houses. The people of Madaktu emerge from the city, singing, clapping, ululating and playing different types of harps. They have come to greet their new king, an Elamite refugee at the Assyrian court named Ummanigash, who is led firmly by the wrist by an Assyrian official. In another scene, Chaldaeans are being forced to grind up the exhumed bones of their father.

The head of Teumman makes a final appearance on the 'Garden Party' 120 relief from Ashurbanipal's North Palace, which includes one of the very rare examples of the representation of an Assyrian queen. The king and his

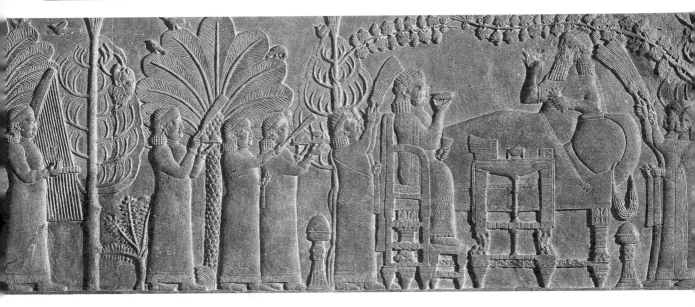

queen are relaxing in a screened-off garden near Nineveh, fanned by eunuchs and court ladies who, on other slabs in the sequence known from drawings and fragments, are shown bringing food and accompanying the banquet with harps, a lyre, drums, pipes and a lute; high-ranking Elamites are also forced by highly amused young Assyrians to wait on the king. The queen sits on a throne which is a simplified version of Sennacherib's in the Lachish Room. She wears a crown like a castle decorated with towers and crenellations, and a richly ornamented, fringed dress; her elegantly slippered feet rest on a footstool. In her left hand she holds a bunch of flowers similar to the tight little bunches of jasmine still made today, and in her right hand she raises a metal cup decorated with gadroons, of a type well known from actual examples. The king, also richly dressed, reclines on a couch, one elbow rests on a bolster and a rug covers him. This is the earliest securely dated example of the reclining banquet, which the Greeks and Romans adopted from the east and which was to become a symbol of oriental decadence. The couch is ornamented with leaping and reclining lions and with panels resembling the 'woman at the window' ivories (see page 160). The king, too, holds a bunch of flowers and raises a cup (damaged, as are both royal faces – see also Fig. 117). His bow, quiver and sword rest on a table nearby and a thick necklace of Egyptian type – perhaps symbolising his conquest of Egypt – is suspended from the bed-head. Onions(?), a small tripod vessel (probably of stone) and a box (probably of ivory) stand on a cloth-covered table beside the couch. At either end of the couch stand incense burners which, like the flowers, were probably a necessary precaution because, among the birds and cicadas that fill the trees, there hangs the head of Teumman.

120 The so-called Garden Party relief from Ashurbanipal's North Palace at Nineveh, depicting the king and queen relaxing in a garden. About 650 BC. Ht 56 cm.

151

Although Ashurbanipal seems to have entrusted the conduct of his campaigns to his generals, he was by no means content to relax in the company of his queen. Another sequence of reliefs shows the king taking part in the royal hunt. In Chapter 1 we saw how hunting lions became the royal prerogative and a symbol of the king's care for his country. The king depicted on the White Obelisk (see page 117) and Ashurnasirpal II seem to have revived the practice. Ashurbanipal sent his huntsmen out to trap lions and bring them back to the Nineveh zoo where, presumably drugged and docile, they are depicted wandering around among cypresses overgrown with vines, and date-palms at the foot of which grow daisies, lilies and other plants, while priests play lyres and harps (WA 118914–6). When the time comes for the royal hunt, however, all this changes. The king's equipment is carefully checked to see that the arrows are straight and the bows properly strung. Spare bow-strings and finger- and wrist-guards are provided. The bow is handed to the king as he stands in his chariot in a royal enclosure, while an attendant restrains one horse and two other attendants back the second horse into the traces, one of them grasping it by the ear. With the king in the cab are the driver, holding the reins, and two attendants, one of whom steadies one of the huge metal-studded, eight-spoked wheels, while the other takes charge of two spears. Spare horses are brought into the royal enclosure by young men. The rich ornamentation of the king's dress, his jewellery and the details of the horses' harness are beautifully rendered, but more impressive still is the portrayal of the high-spirited horses with rolling eyes and flaring nostrils, the bells on their harnesses surely ringing as they toss their heads.

Screened off from the royal enclosure and protected from any danger by rows of spearmen with shields and hunting-dogs with their armed handlers, the people of Nineveh are climbing to the top of a mound (on which stands a royal kiosk decorated with a relief showing a lion hunt), in order to find a good vantage point from which to watch the proceedings; some carry their picnics with them. Then the hunt starts.

The lions have been caged and attendants retreat into small protective cages above as they release them. Mounted beaters drive the lions towards the king, whose initial sweep across the hunting ground is not depicted. But his return is shown as, with his bow and arrows, he finishes off wounded lions and lionesses. Arrows fly. One lion leaps towards the chariot but the two attendants hold it at bay with their spears: it is clear that they are not allowed to kill the lion, for this is the king's prerogative. In the next scene the lion has leapt onto the axle and is almost in the cab but the king turns and dispatches it with his dagger. Another wounded lion grasps a wheel of the chariot in its paws and sinks its teeth into it; as the wheel turns the lion is lifted off the ground and the king hands his bow to his attendant, seizes his spear and kills it.

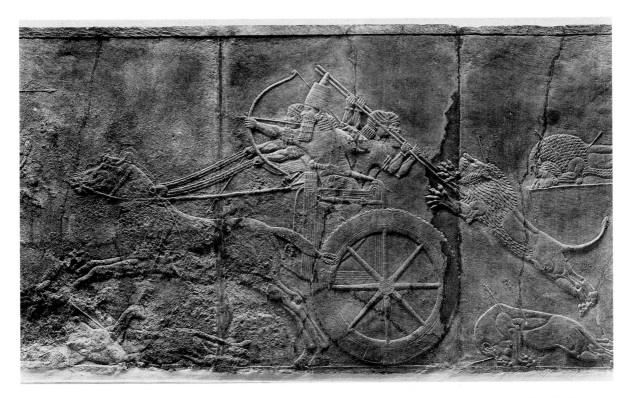

Dead and dying animals strew the hunting ground; they drag their paralysed hindquarters, vomit blood, seek to push aside arrows with their paws and writhe in their death-throes. The sculptor shows far more sympathy for these royal beasts than for defeated and tortured human enemies. Paradoxically, the impossibly contorted postures of the lions and the stylised rendering of their muscles and fur seem to emphasise the realism of the scene. Yet the purpose of all this carnage is not only to show the king's prowess with various weapons, but to make an offering to the gods: the dead lions are laid out side by side before an offering table and the king pours a libation over the bodies as musicians play and other attendants stagger in with more lions.

The great lion hunt which has just been described is but one of many hunting scenes. The king is shown on smaller, equally finely cut reliefs divided into registers and, in one case, modelled in higher relief in clay (WA 93011). Dressed in special richly decorated royal robes, which are
122–3 sometimes hitched up in front, he hunts on horseback and on foot; he grasps a lion by the tail and twists it round; fallow deer are trapped in a netted enclosure and shot; the king lies in wait in a hide and shoots at a herd of gazelle; onagers are chased by hunting dogs and shot; and on one occasion the king saves some Elamite vassals from an attacking lion. In many cases the king's face has been purposely damaged, but sometimes his features

121 Part of one of the lion-hunt sequences from the North Palace of King Ashurbanipal at Nineveh. About 645 BC. Ht 1.60 m.

153

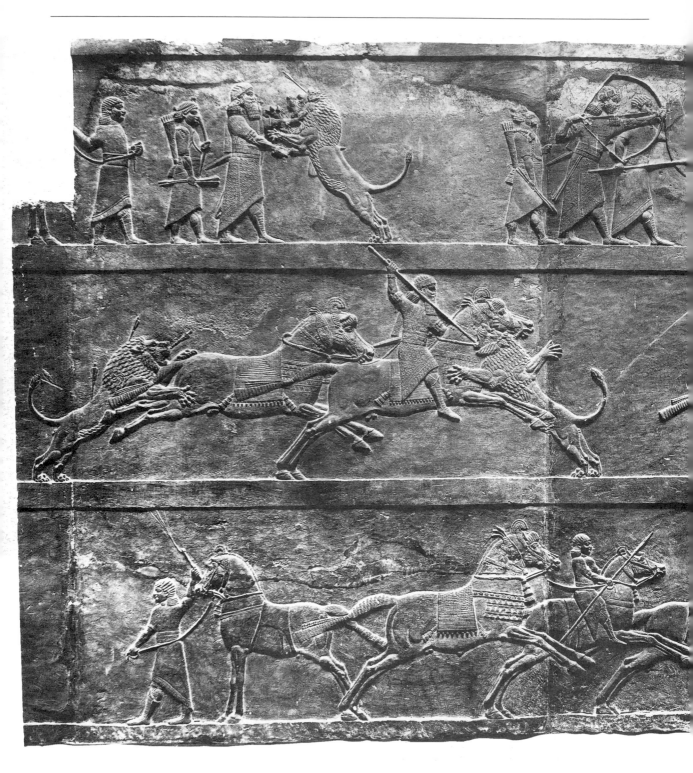

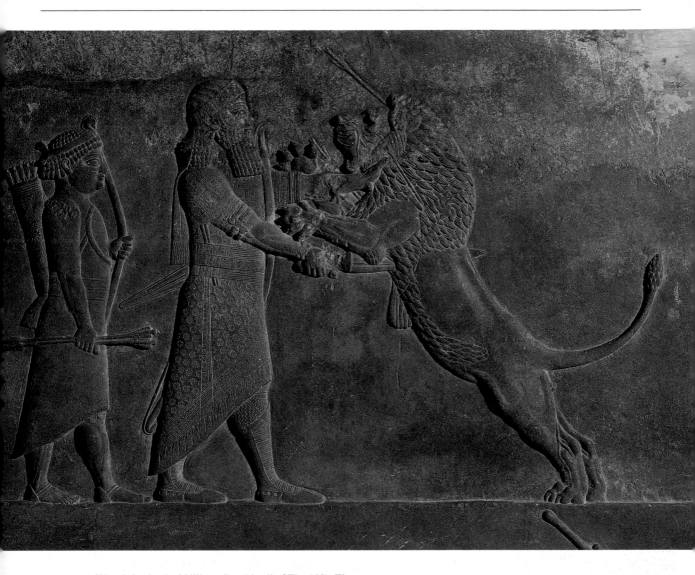

123 ABOVE King Ashurbanipal killing a lion (detail of Fig. 122). The king wears a richly decorated garment which is hitched up in front to allow freedom of movement. He wears armlets, a bracelet, and an arm-guard on his left arm, and high laced boots, probably of soft leather, over stockings. His bow is slung over his left shoulder and he wears a scabbard at his waist. Behind him is an Elamite attendant carrying the king's quiver, a spare bow and two arrows ready for use (cf. Figs 100 and 136d).

122 OPPOSITE Carved stone slabs from the North Palace of King Ashurbanipal of Assyria (r. 668–627 BC). In the top register, on the right, the king shoots a lion (not shown) which has been released from a cage; on the left he is stabbing the wounded lion with his sword (see Fig. 123). In the middle register a wounded lion attacks the king's spare horse, while the king spears another lion. In the bottom register, on the left, is a beater in a fallow-deer hunt, while on the right the king's spare horse is led by an attendant taking part in an onager (wild ass) hunt. Ht 1.66 m.

124 OPPOSITE Black basalt relief slab from Tell Halaf showing the local – and less sophisticated – version of a lion hunt. Note the 'flame' pattern on the lion's haunch, the 'stitching' along its back and the criss-cross representation of the fur of its mane and belly, and compare Fig. 126. Early 9th century BC. Ht 61 cm.

survive, his eye fixed steadily on his prey, impassive but for a slightly 14 curling lip. This impassivity contrasts with the hectic action which the artist has succeeded in conveying.

Some of the Assyrian reliefs just described rank, without doubt, among the outstanding works of art of all time. The stone from which they were carved came for the most part from local outcrops of gypsum known as Mosul marble, which is dazzling white when first cut. The reliefs are therefore restricted to the Assyrian cities round Mosul: Nimrud, Khorsabad and Nineveh. Ashur, to the south, had no reliefs, it seems, while in Babylonia repetitive designs were produced on mould-made glazed bricks: rows of lions, bulls, *mushhushshu* dragons, rosettes, decorative borders with palmettes and, behind the king's throne, a huge composition with a row of columns topped by triple proto-Ionic capitals, executed in white, yellow and pale blue on a rich, deep blue background. The contrast with the scenes depicted around the Assyrian throne is striking. The accidents of discovery discussed in Chapter 1 have resulted in much of the material from Babylon now being in Berlin.

North-west of the Assyrian heartland, the Aramaean inhabitants of the town of Guzana (now Tell Halaf) in the early ninth century BC adorned the palace of their king, Kapara, with small, crude but lively reliefs carved from 124 rough-textured limestone painted red, alternating with black basalt. Unlike the Assyrian reliefs, where the design runs on from slab to slab, the Tell Halaf reliefs each show a complete scene. The same interest in colour contrast is found further west at Carchemish, at the crossing of the Euphrates on the Syrian-Turkish border, where slabs were carved in alternating black basalt and ochre (probably originally white) limestone. This predilection for colour contrasts in building materials continued to be a feature of Syrian mosque and palace architecture in Islamic times and was exported by Syrian architects working, for instance, in Konya and Cairo. Other Syrian sites produced sculptured slabs in local Neo-Hittite or Aramaean styles, or in Assyrian styles. At the Assyrian provincial palace at Til Barsip, on the Euphrates south of Carchemish, the French excavators discovered remarkable wall-paintings with scenes comparable with those on the Assyrian reliefs. The predominant colours were white, black, red and blue, with outlines and detailing in black. Experts are still divided as to which paintings belong to the reign of Tiglath-pileser III and which to those of later kings.

125 OPPOSITE The series of reliefs from the 'Royal Buttress' at Carchemish, photographed at the time of excavation. Yariri, the regent, is shown holding the young king, Kamani, by the arm. Young princes play with knuckle-bones and tops, and one is learning to walk. The queen or a nurse-maid carries a baby. The inscription in Hittite hieroglyphs describes Yariri's promotion of Kamani and his building activities. Unfortunately the reliefs were later badly damaged; they are now in the Museum of Anatolian Civilisations in Ankara (a cast is in the British Museum). About 800 BC. Ht 1.10 m.

The reliefs from Carchemish are more sophisticated that those from Tell Halaf but they, too, generally show one subject per slab. They indicate continuity with the traditions of the Hittite empire, which collapsed around 1200 BC, but also build on the art of Syria. Several rulers were responsible for decorating the public buildings and processional ways of their city with sculptures. Limestone and basalt slabs with mythical scenes, forming the

so-called 'Herald's Wall', date to around 900 BC. Each displays a three-figure composition, generally with two deities or mythical creatures attacking a victim between them; such compositions had appeared on Middle Assyrian seals of the thirteenth to twelfth centuries BC but here they are successfully transposed to a monumental scale. Each composition is complete in itself; there is not the directional dynamism of later Assyrian reliefs. The 'Long Wall of Sculpture' was decorated around the same time with processions of gods, chariots driven over the bodies of enemies and rows of foot-soldiers on slabs of alternating colours. Ashurnasirpal II would have seen these reliefs when he visited the city in 870 BC, and they seem to have been the direct inspiration for the decoration of his own palace at Nimrud. A

125 remarkable series of basalt reliefs on the 'Royal Buttress' depicts the Hittite royal family around 800 BC, identified by inscriptions in the decorative hieroglyphic Hittite script; in marked contrast to the practice in Assyria, the queen and all the young princes are depicted, including a baby and a toddler. Later reliefs show Assyrian influence, and Carchemish finally came under direct Assyrian domination in 717 BC.

Some of the slabs from Tell Halaf show animals and monsters with distinctive markings; similar markings also appear on ivories and metalwork: a flame pattern on the haunch, a notched line along the back with

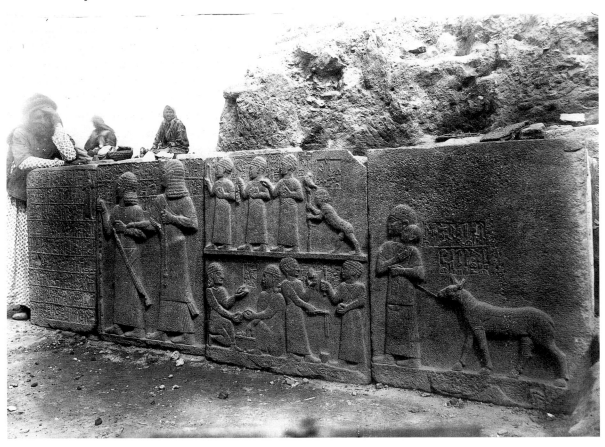

126 Decoration on a cylindrical ivory box made from the end of a tusk and carved in Syrian style. A lion seizes a young hunter by the back of the neck, while an archer (not shown) approaches from the left and a chariot and dog hasten from the right. Beyond is the fragmentary figure of a nude goddess holding flowers (not shown). Note the patterning on the lion's body (cf. Fig. 124) and the plants which have given this group of ivories its name of 'flame and frond'. Excavated in the South-East (Burnt) Palace at Nimrud by W. K. Loftus in 1855. Probably early 9th century BC. Ht 8.5 cm.

groups of short lines at right angles at the ends, a line of adjacent hatched 126
triangles indicating the fur under the belly, a group of lines – sometimes in a box – for the ribs, and a feature described as 'resembling an open peapod near the hock'. The ivories have recently been studied, simultaneously and completely independently, by Georgina Herrmann and Irene Winter, the two foremost scholars in the field of ivory studies. Both agree that the ivories probably date to the early ninth century BC, but whereas Herrmann maintains that her 'Flame and Frond' group first appeared in Tell Halaf, Winter argues for a Carchemish origin.

This highlights the difficulties of attributing groups of stylistically related ivories to geographical areas except in the broadest sense. The closest in style and subject matter to the Assyrian reliefs are flat ivory panels with 110 decoration incised or, occasionally, in low relief. They were presumably made in Assyrian workshops, although not necessarily by Assyrians, and the presence of bronze nails and nail-holes indicates that the ivories were fixed to pieces of furniture or to square or rectangular boxes. In Syria there seems to have been a greater use of the hollow sections of the tusks, which were made into small round boxes with their sides carved in high relief with little figures hunting, feasting and playing musical instruments; the proportions are squat, with elaborate and stylised patterning of the surfaces. The solid tips of the tusks were often shaped into nude female figures, either singly or in groups of up to four, back to back, forming the handles for mirrors, fans or fly-whisks. Flat panels were also carved in Syrian style for bed-heads or throne-backs, and continue a tradition dating back to the second millennium BC when similar panels were, it seems, made in Ugarit on the north Syrian coast; they combine local and Egyptian motifs, includ-

127 An ivory panel shaped like a stylised tree of Phoenician type, once gilded and inlaid with lapis lazuli, curving up and round in a double volute resembling an architectural motif. Addorsed griffins, originally with brightly inlaid wings, feed from jewelled fruit which hang from the branches. Excavated in Room X in the North-West Palace at Nimrud. 8th century BC. Ht 14.3 cm.

128 One of a pair of Phoenician-style ivories (the other is in Baghdad) excavated from a well at Nimrud. Under a dense network of lilies and papyrus, originally with lapis lazuli and carnelian inlays (some survive), a Nubian boy with jewelled armlets and bracelets, his tight curls and kilt covered with gold leaf, is being attacked by a lioness like a large cat, with a lapis lazuli disc on her forehead. There is something strangely disquieting, almost erotic, in the way the Nubian boy abandons himself to the lioness, who cradles him as she tears at his throat. Ht 10.2 cm.

ing a Neo-Hittite form – with volutes – of the Egyptian winged disc (e.g. WA 132692).

Other ivories have cut-out shapes which were originally filled with coloured glass inlays, indicating that in this case ivory and glass workshops must have co-operated. The presence of predominantly Egyptian motifs in ivories of this group indicates a western origin, with Samaria (the capital of the kingdom of Israel) and Arslan Tash (south of Carchemish) both being plausibly suggested as centres of manufacture. This latter site was probably the place of origin of a group of ivories known as the 'woman at the window' (WA 118155–9) showing the face of a woman, wearing an Egyptian wig, looking over a balcony supported by a balustrade of little columns with palmette and volute capitals; the whole is set within a triple frame with tenons for fitting the plaque into a piece of furniture (as shown on Ashurbanipal's couch). In some cases, a strip of light greenish glass inlaid over gold foil at the bottom provides the earliest evidence for the gold-glass technique.

The most sophisticated ivories, however, are those in Phoenician style, either made by Phoenician craftsmen working in Assyria, or plundered from Phoenician centres along the Levantine coast. They incorporate Egyptian motifs, which are sometimes treated in a somewhat cavalier fashion; for instance, in an openwork ivory plaque depicting a striding sphinx among stylised flowers the double Egyptian crown on the sphinx's head has been so abbreviated in order to fit it into the space available that it is scarcely recognisable.

In addition to the types of ivories just described, there are many decorated ivory wands, knobs, combs, gaming pieces and strips. Little reclining calves, of which several are products of the 'Flame and Frond' workshop discussed above, decorated the edges of trays and the lids of boxes. Elements of furniture include lions in the round, lions' feet and bulls' feet, elegantly curved legs or arm-rests, palmettes and volutes. Many items of the harness and trappings of horses were made of ivory, while others were made of metal; they were often given as royal gifts together with horses and chariots, but they were also items of trade and booty and their places of manufacture are difficult to identify. Although several of the ivories are inscribed on the back, the inscriptions consist either of fitters' marks or the name of the place from which they were looted (which does not necessarily mean they were made there). Although the vast majority of ivories were found in the storerooms of the Assyrian palaces, especially at Nimrud, significant numbers were also found, as already mentioned, at Samaria and Arslan Tash, at Salamis in Cyprus, in Urartu to the north of Assyria and – in a distinctive local style – at Hasanlu in north-western Iran.

The surviving ivories were found in palaces, temples and rich burials, thus indicating the value placed on these luxury objects; many of the finest

were found in wells at Nimrud into which they had probably been thrown, for later retrieval, at the time of the fall of Assyria in 612 BC. The material used in the first millennium BC was elephant ivory, rather than the hippopotamus ivory which was favoured in the second millennium. There has been much debate as to where the ivory came from. There were elephants in the marshes of the Orontes valley and the Lake Jabul area south of Aleppo, but only for limited periods and probably, therefore, imported; the suggestion that there was a native pygmy Syrian elephant can be discounted. Whether the imported elephants came from Africa or India cannot be ascertained, as both types of ivory age in the same way. In the reign of Seleucus I (305–281 BC), war elephants were imported from India and stabled at Apamea on the Orontes, and it is tempting to suggest that this was the revival of an earlier trade; certainly it is an Indian elephant which is depicted on the Black Obelisk. The rarity of the material made ivories a highly prized commodity although, paradoxically, it seems that they were often gilded so that the ivory would not have been visible; they were also coloured and some were fire-blackened, probably intentionally. They became a symbol of ungodly luxury and decadence and were condemned in the Bible (e.g. Amos 3:15 and 6:4).

Forming another related category of luxury object were the large tri-dachna shells incised with a variety of designs adapted to their shape (e.g. WA 117999). These were often Egyptianising and sometimes the hinge of the shell was shaped like a siren head reminiscent of the handle attachments of large cauldrons, the fashion for which spread throughout the Mediterranean at this time (e.g. WA 22494).

Metal bowls were another type of artefact manufactured primarily in the west. Many bronze bowls, some of them inlaid with silver studs, were found in the Assyrian palace storerooms. The designs incised on them came from a variety of sources; some are Syrian with rows of animals surrounding a central geometric motif (e.g. WA N.1), and some are again based on Egyptian motifs, or combine both types. A particularly fine example of the latter, made of gold, has been found in one of the unlooted tombs of Assyrian queens discovered by Iraqi archaeologists at Nimrud from 1988 onwards. The jewellery these burials contained has been a revelation because very little has survived the pillaging of the Assyrian palaces at the time of the fall of the Assyrian empire and knowledge of jewellery was therefore hitherto based on depictions on the reliefs. An openwork crown decorated with rosettes and winged figures in a trellis of gold vines with lapis lazuli grapes is particularly startling. Previously, one of the most spectacular items of jewellery known from the period had been a Phoenician gold bracelet or diadem found at Tharros in Sardinia. Many fragments of gold votive jewellery of the eighth to seventh centuries BC were found in the excavations of the Temple of Artemis at Ephesus, together with fibulae

(ornamented safety-pins) of Phrygian type. The Phrygians, Lydians and Lycians in central and western Turkey had a thriving culture influenced by their Greek neighbours, but the British Museum has few objects from these areas which date to the first half of the first millennium BC. Such is not the case, however, with regard to eastern Turkey.

Metal furniture fittings have already been mentioned, together with the difficulty of assigning them to specific workshops. One group, however, was certainly made to the north of Assyria, in the kingdom of Urartu. This

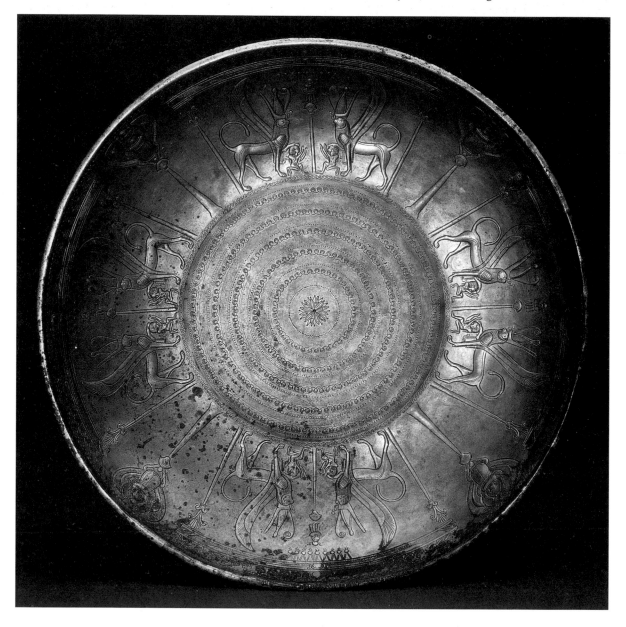

highland area does not seem to have had a well-defined political identity until the Assyrian threat caused the clans to unite and establish a dynasty 131 ruling from Tushba (now Van) on Lake Van. The kingdom – known in the Bible as Ararat – extended across the borders of modern Turkey, eastwards into Iran and northwards into the Republic of Armenia. The Urartians built impressive fortresses, with beautiful ashlar masonry, to guard the mountain passes into their kingdom and the strategic sites within it; the model of one survives (WA 91177). Although they sought inspiration from the long-established cultures of their neighbours, the Urartians combined these influences into a distinctive art of their own. The presence of rich mineral deposits in eastern Turkey provided impetus for a lively metalworking industry; Urartian products are of a particularly good quality and were highly prized by the Assyrians, who carried off huge quantities of booty from Urartian sites, notably from Muṣaṣir, in a mountainous frontier region now in north-eastern Iraq. This city was sacked by Sargon II of Assyria 16 during his eighth campaign in 714 BC; drawings of reliefs showing the destruction of the city survive, as does the king's own detailed account:

> [The palace] rooms full to the brim with accumulated treasures, I broke the seals of its storerooms: 34 gold talents and 18 minas [c. 1,160 kg], 167 silver talents and 2.5 minas [c. 5,700 kg], pure bronze, lead, carnelian, lapis lazuli . . . 11 cups of Ursa [King Rusa] with their lids, cups from the Land of Tabal, with golden handles, silver quivers, silver arrows set with gold, 34 silver cups, . . . incense-burners from the Land of Tabal, . . . 13 bronze basins, . . . 120 bronze objects, craftwork of their country, whose names are difficult to write, . . . iron objects. . . .

In the temple, Sargon's officers found similar quantities of metal ingots and objects, including '393 silver cups – heavy and light – produced in the lands

130 Phoenician gold bracelet or diadem, made up of separate hinged segments joined by silver pins, from a tomb at Tharros on the island of Sardinia. The voluted palmettes are outlined in granulation and are similar to those on Figs 127 and 146d. 7th–6th century BC. L. 13.2 cm.

129 OPPOSITE The interior of a Phoenician bronze bowl excavated by Layard in the North-West Palace at Nimrud. A central rosette is surrounded by five concentric bands of a vegetal pattern typical of Levantine metalwork, and by a broad band decorated with an Egyptian motif repeated four times: two winged, falcon-headed sphinxes, wearing the Egyptian red and white crowns, face each other and rest a paw on the head of a kneeling kilted man; a winged sun-disc and standards – one topped by a winged scarab-beetle – frame the scenes. Around the rim are small birds flanking discs with uraei. 8th century BC. Diam. c. 21 cm.

of Assyria, Urartu and Habhu' – an indication of the problems facing us when we attempt geographical attributions of objects – and large quantities of arms. Descriptions of statues cast in bronze provide some indication of the treasures which have been melted down over the millennia and are now lost. They include 'a statue of Rusa with his two horses and charioteer, and its pedestal, all cast in bronze'.

The citadel at Van dominates a fertile plain beside the lake; nearby, on another rock outcrop known as Toprakkale, stand the remains of the citadel of Rusahinili, reached by a rock-cut stairway and artificial tunnel. Within the citadel was a temple to the god Haldi. Attention was first drawn to the site when bronzes appeared on the market in the 1870s and Layard obtained some of them for the British Museum; others are in museums in St Petersburg, Paris, Berlin and New York, and in private collections. In 1880, with Layard's encouragement, summary excavations were carried out on behalf of the British Museum by two foreign residents in Van, Dr Raynolds and Captain Clayton, briefly supervised by Rassam. As a result the British Museum has a rich collection of objects from the temple, including the customary lions' feet, palmettes and volutes from several pieces of bronze furniture dating to around 700 BC, one of which was a throne. As in the case of the throne of Sennacherib, the seat and arm-rests would have been

131

131 The medieval citadel, built on Urartian foundations, dominates the modern city of Van in eastern Turkey; beyond, on the nearest rock outcrop on the left, stood the Urartian citadel of Rusahinili (now Toprakkale).

supported by figures of deities standing on reclining bulls (which may have had human heads: WA 91243) and of human-headed, winged bulls with human hands clasped; they were cast in bronze, originally gilded, the faces – now missing – would have been made of ivory, and there would have been inlays of glass and semi-precious stones. A small reclining bull (WA 91248) was probably part of a matching footstool. An inlaid bronze upright, now twisted out of shape, was topped by a reclining lion with open jaws and bulls' hooves; it may have been an arm-rest.

132l.

133

132 Urartian figures of about 700 BC from Toprakkale, which probably supported thrones (cf. Fig. 117). *Left* A bronze figure of a winged bull with human torso. The head and horns were probably made of ivory, sockets in the wings contained inlay, and the bronze was covered with gold leaf. Ht 22.3 cm. *Right* Ivory griffin-headed demon. Ht 17.2 cm.

Several shields were found at Toprakkale and, as we know from the drawing of the temple at Muṣaṣir and from Sargon's description, they were hung on the temple walls. They are decorated with concentric circles of embossed and chased lions and bulls arranged in such a way that they change base-line in each quadrant so that none is ever upside-down (WA 22481); this is a distinctively Urartian arrangement. Large cauldrons on tripods would have stood outside the temple (according to the same drawing) and the handle of one of these, in the shape of a winged bull's head, shows a distinctive fringe of curled hair hanging down between the bull's eyes (WA 91242). Similar attachments were exported and copied all over the Mediterranean world.

Broad metal belts were also popular throughout the Near East and beyond during the first millennium BC, and a large number have been found in Urartu. One type has an elaborate pattern of monsters of a sort not

133 Figure of a lion with bull's hooves and a groove in its back, from an Urartian bronze upright, probably from a piece of furniture but now twisted out of shape. The bronze was originally inlaid and covered with gold leaf. Note the stylisation of the animal. Excavated at Toprakkale in 1880. About 700 BC. Ht of lion 10 cm.

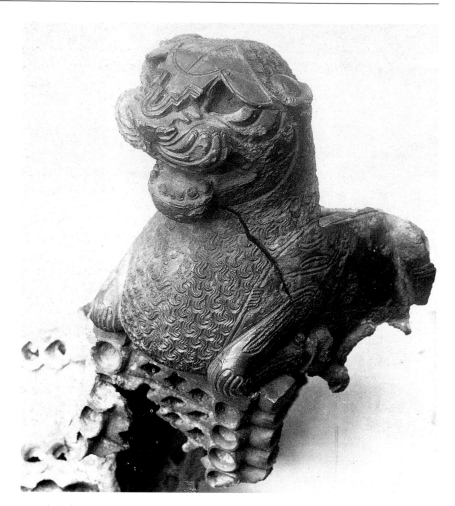

previously attested in Near Eastern iconography, despite millennia of fruitful imagination (WA 135998). Similar monsters appear on a typically Urartian seal. 136f

Less distinctive, however, are the ivories found at Toprakkale. Whether they were Urartian copies of Syrian and Assyrian ivories, or imports, is not clear. Particularly fine examples are in the shape of griffin-headed demons 132r. similar to those on Assyrian reliefs but best paralleled by ivories excavated at Altıntepe, also in Urartu; one is fire-blackened, probably intentionally, and both raise their arms – perhaps to support another piece of furniture.

One last type of Urartian artefact deserves some comment. With their country under snow for half the year, the Urartians had to be able to store large quantities of oil, cereals and wine. Their storerooms contained huge jars capable of holding up to 1,200 litres each. The manufacture and firing of these jars was a considerable feat which the the makers of the burial jars at Yortan (see Chapter 2) and the Hittites had already mastered centuries

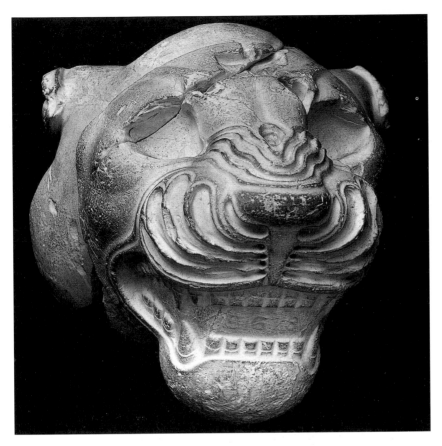

134 Lion's head of white limestone, originally inlaid, from the temple of the sun god Shamash at Sippar, just south of Baghdad. Although it was found in Babylonia, this head bears an inscription naming the Assyrian king Esarhaddon (r. 680–669 BC) and his father Sennacherib. It is not clear, therefore, whether this is a Babylonian or an Assyrian piece. Ht 10.2 cm.

before. The contents of the wine jars were removed by means of round, red-burnished jugs: a small room next to the wine cellars at Karmir Blur contained 1,036 of these (WA 132902) and some were brought back from Toprakkale (WA 135748–9).

Although many of the features of these bronzes, for instance the inverted U-shaped muscles or the stepped decoration on the lion's nose, are found in the art of Urartu's neighbours, they are combined in a way which makes them unmistakably Urartian. If the Urartian lion's head is compared with that from Sippar in Babylonia or with some of the lions from Ashurbanipal's lion hunt, or with Assyrian bronze lion-shaped weights (e.g. WA 91220), it becomes clear that although the conventional patterning is much the same on all four examples, in Babylonia and Assyria it is applied over the underlying rippling muscles, to emphasise them, whereas in the case of the lion from Urartu the patterning replaces muscles. This is true of all the Urartian bronzes: the basic shape of the figure is overlaid with patterned dress or curly mane and stylised lines indicating the muscles, but there are no inner dynamics. The Urartian bronzes are static, the lion is frozen in a permanent roar. It was perhaps this Urartian disregard for the underlying

anatomy of their figures that enabled them to create such fanciful and anatomically impossible creatures. Even the Babylonian *mushhushshu* seems plausible compared with the monsters on the belts and on the cylinder seals, 136f which look as though they would overbalance very easily.

The stone-carving tradition of the second-millennium *kudurru* continued into the first, but generally in the form of small tablets. One particularly fine 135 example, together with its impressions in clay, was buried in a clay box in the foundations of the temple of Shamash at Sippar. Another, dating from the same reign, records the gift of an estate by Nabu-apla-iddina to an official who is his namesake (WA 90922). The king is shown on the right, wearing the Babylonian style of dress already worn in the eleventh century by Marduk-nadin-ahhe, with a fringe round the hem, pleats at the back, and 100 a belt around the waist and diagonally across the torso. (This type of dress seems to have been adopted at Carchemish by the adult members of the 125 royal family.) Above, as on a *kudurru*, are the symbols of various deities. Round-topped stelae (WA 90864–6) record the building works by King Ashurbanipal and his brother Shamash-shum-ukin, king of Babylon; they were deliberately archaising and recall the reliefs and foundation figurines of the third millennium BC showing the king as a builder. Another round- 61 topped stele (WA 90837), which probably dates to the reign of Nabonidus (555–539 BC) shows a god facing right, which is unusual, with his hand raised in blessing. His robe is fringed and patterned in the style normally adopted by Babylonian deities, and he holds a staff. Before him are the moon, sun and star symbols. The inscription on the back records the return of plenty after a drought.

These reliefs give a meagre impression of Babylonian art, but the seals 136a– produced by the Babylonians show that they had a remarkable mastery of the techniques of cutting semi-precious stones. Cutting-wheels were used to carve friezes of animals in pursuit of each other which are far more lively than the equivalent scenes from Assyria, which were executed in a softer stone (serpentinite) in a linear technique. Another favourite subject shows a hero holding a sickle-sword behind him in his lowered right hand while he grapples with a lion, griffin or some other monster; sometimes he rests his foot on an animal which he is protecting, thus forming a triangular scene reminiscent of those on Middle Assyrian seals. Typically Babylonian, at least on seals, are the little plants at the end of a scene. During the second half of the eighth century BC, this asymmetrical composition became a more symmetrical one by the addition of a figure.

It is probable that the revolution in Assyrian seal-cutting during the 136c–d second half of the eighth century BC was due to the importing of Babylonian craftsmen and techniques after the capture of Babylon in 729. Thereafter it is difficult to differentiate the seals of the two regions, but in Babylonia minor gods have four wings of equal length whereas in Assyria the lower

135 A limestone tablet with unusual deckled edges excavated at Sippar south of Baghdad in 1881, below the temple of the sun god Shamash. It records the restoration of the temple by Nabu-apla-iddina, king of Babylon (*c.* 870 BC). The god, holding the divine rod and ring beneath astral symbols, sits on a throne supported by bull-men. From a canopy with columns decorated to imitate palm-trunks, with volutes at top and bottom foreshadowing the Ionic capital, two minor gods lower a huge sun-symbol on a stool, to which a priest and interceding goddess conduct the king. Beneath are water and sun symbols. Ht 29.5 cm.

136 a–d Modern impressions of cylinder seals.
a. Neo-Babylonian, with a kilted hero fighting a lion, flanked by a crescent, star and plant. Grey-brown chalcedony, probably 8th century BC. Ht 3.6 cm.
b. Neo-Babylonian, with two winged deities or genies wielding sickle-swords, grasping the legs of a bird and placing one foot on a sphinx between them; at the end is a palmette plant. Grey chalcedony, about 750–700 BC. Ht 3.6 cm.
c. Neo-Assyrian, with a winged hero or genie between two bulls. The cuneiform inscription – written to be read on the stone and not (as previously) on the impression – is a prayer to the god Nabu. Carnelian, about 720–700 BC. Ht 3.65 cm.
d. OPPOSITE (*enlarged*) Neo-Assyrian, depicting a high official, perhaps a eunuch (the earring above him may be a royal gift or sign of approval), before the goddess Ishtar who stands on her lion, is heavily armed, and holds a bow and two arrows (cf. Fig. 100); also two goats and a palm-tree. The seal is made of an unusual green stone, grossular garnet, which must have been imported from Pakistan, Kashmir or the Urals. About 720–700 BC. Ht 4.3 cm.
136e The sealing surface of a scarab-shaped haematite stamp seal which may have originated in the Carchemish area. Below a Hittite version of the winged sun-disc are two vultures, a lion and a bull. About 700 BC. Ht 2.5 cm.
136f Urartian serpentinite stamp cylinder and its modern impressions. It is carved with a vertical fish and typically Urartian winged, scorpion-tailed, two-legged monsters, with the heads of a lion, a bird and horned animals. 8th–7th century BC. Ht with loop 2.95 cm.

a

b

c (enlarged)

e

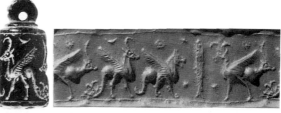

f

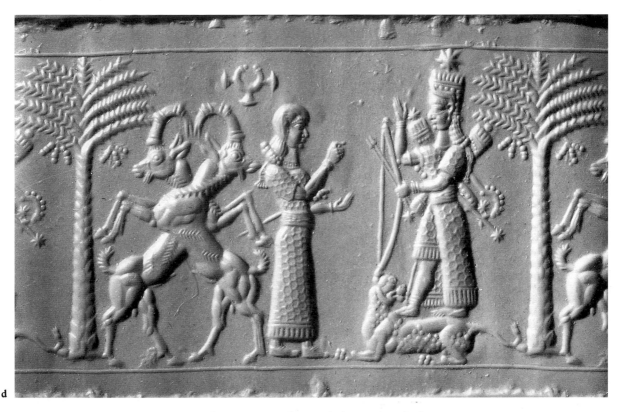

d

wings are longer and the composition is more often strictly symmetrical. There are some spectacular seals from this period, some perhaps the product of a single Assyrian workshop active during the reign of Sargon, from about 720 BC. However, as an indication of the difficulty of dating artefacts at this period, it should be pointed out that the seal in Fig. 136d has recently been dated a whole century earlier by one authority.

Although formal inscriptions were still written in cuneiform, Aramaic – written in an alphabetic script on a perishable material – was increasingly being used, particularly in the west. The parchment and papyrus rolls were sealed with small lumps of clay for which a stamp seal was more suitable. In Syria, as in Urartu, the stamp-cylinder was often used when a dual administration was in force, and the Assyrian royal administration used stamp seals from the second half of the ninth century BC onwards (e.g. WA 84672). The design on these royal seals was always the same, although size, borders and details might vary: the king is shown grasping the mane of a rearing lion and stabbing it; similar scenes appear on Ashurbanipal's reliefs and, later, on those of the Achaemenid Persians at Persepolis.

Much of Assyrian and Babylonian religion consisted of magical spells and rituals invoking the aid of protective demons. Amulets and fibulae bear the likeness of a particularly unprepossessing demon, Pazuzu, who protected

136e
136f

123

women in childbirth from the attacks of a female demon, Lamashtu; the latter is lion-headed, with a female torso and the legs of a vulture, and she stands on a mule, suckling a boar and a dog at her empty breasts (e.g. WA 117759). In contrast, there is a charming Syrian figurine from Carchemish: a woman wearing an elaborate hat holds a baby (WA 108757). Clay protective figures of minor deities and guardian dogs were buried under the floors of Assyrian palaces, especially near doorways. Many Babylonian objects would also have been modelled in terracotta, but few have survived. One such object is the head and forepaws of a somewhat crude but lively – even bouncy – lion (or dog?) with rather different markings from those discussed above, and with huge staring eyes (WA 22458).

More sophisticated are the figures made of Egyptian Blue, a sintered mixture of quartz and a silicate of copper and calcium. A fragmentary figure, found by Layard in the temple of Ninurta at Nimrud, depicts a frontal, four-winged minor goddess with arms extended (WA N.475). The same material was used for small bottles, but more common were the glazed faience bottles, patterned with yellow and green leaves, made by a related technique (e.g. WA 135188). The thriving glass industry of the second millennium BC seems virtually to have disappeared during the dark age and only reappeared in the eighth century BC. Vessels were often cast (blown 139 glass was not invented until the first century BC).

Meanwhile, north-east and east of Assyria there had been, and continued to be, large-scale population movements. Weapons and a variety of other grave-goods, including numerous amulets, have been found in tombs on both sides of the Caucasus mountains. Bronze belts and axes were also found 137,140 as grave-goods in tombs in north-western Iran and in Luristan in western Iran; as these were generally looted, the dating is equally uncertain but is generally taken to range from the eleventh to the eighth centuries BC.

The Luristan graves supplied the antiquities market with a large number of bronzes from the 1920s onwards. Because an object from Luristan was likely to fetch a high price, artefacts were said to have come from there when they had actually originated elsewhere in Iran or even further afield, and many forgeries were made in the 'Luristan' style. At its best, Luristan metalwork is of excellent quality; age-old subjects such as the 'Master of Animals' and lions attacking horned animals are combined in a lively, 138 abbreviated manner. Many of the bronzes were whetstone handles or horse-trappings, including horse-bits with ornamented cheekpieces; one gives yet another variation on the theme of the human-headed, winged bull (WA 130677). Pins with decorated heads may have been dedicated in shrines. From Baba Jan, one of the few excavated sites in Luristan, came 176 tiles which decorated the ceiling of a large columned room of the eighth century BC (e.g. WA 135755). The designs are all variations on the square and cross, and a similar motif appears on pottery. A group of metal drinking 141

137 ABOVE The design on a bronze belt said to have come from Ardebil in north-western Iran. Metal belts in different styles have been found throughout the Near East and into Europe but the designs on them and the way they were fastened vary greatly. Here the belt tapers and forms a loop at one end and the animals incised on it are recognisable despite being decorated with patterns of dots, triangles and 'stitched' edges. 11th–7th century BC. L. 82 cm.

138 Bronze finial for a standard, from Luristan in western Iran. Two elongated upright ibexes hold the rings for the pole in their hooves; the long necks of two lions curve up on either side but their bodies merge with those of the ibexes. 10th–9th century BC. Ht 18.1 cm.

140 Three bronze shaft-hole axes of very different types from the Caucasus (top) and from Luristan in western Iran, dating from the 11th–8th century BC. *Top* Two dogs and two long-necked birds are incised around the upper part of the shaft-hole, and a wave-like pattern made up of dogs' heads around the lower. Two rows of cross-hatched circles between feather-patterned bands, and different dogs adorn each side of the blade. Koban Culture. L. 16.4 cm. *Middle* Clean lines based on geometric shapes. L. 23.4 cm. *Bottom* Crescentic 'halberd' axe with a spotted, reclining animal decorating the shaft-hole, and the blade issuing from the jaws of a stylised lion's head. L. 23 cm.

139 OPPOSITE *From left to right and top to bottom:*
a. Squat *alabastron* of pale green cast and cut glass. Inscribed 'Palace of Sargon, King of Assyria' (r. 721–705 BC), prefixed by the royal lion, this is one of the rare closely datable objects of this period. Excavated by A. H. Layard in the North-West Palace at Nimrud between 1845 and 1847. Ht 8 cm.
b. *Alabastron*, core-formed from black glass with a thread of white glass wound round it and combed into a feather pattern. Excavated at Cameiros, Rhodes, but paralleled at the Assyrian capital Ashur. 7th century BC. Ht 16 cm.
c. Green glass *alabastron*, probably cast using the lost-wax process. From Puzzuoli (Puteoli) in Italy but probably imported from the Near East. 7th–6th century BC. Ht 21.1 cm.
d. Colourless glass jar probably cast using the lost-wax process. Possibly from Rassam's excavations at Babylon. 8th–6th century BC. Ht 7.4 cm.
e. Macehead of opaque blue glass imitating lapis lazuli; cast in a two-piece mould or by the lost-wax process. 8th–7th century BC. Ht 6.6 cm.

cups with representations of animals or feasting dignitaries and musicians presents yet another dating problem (WA 134734). Details of the dress and decoration would indicate an eighth-century date, but some of these vessels were inscribed in antiquity with the names of Babylonian kings of the tenth century (and one perhaps belonging to the eleventh). Either these inscriptions were copied onto the vessels to give them added prestige, or the iconographic details they display have been dated too late.

'Amlash', south-west of the Caspian Sea, is another dealer's provenance. Here again rich tombs were looted but fortunately some, at Marlik, were excavated and have provided a guide as to the type of object which genuinely comes from the area, as well as a chronological framework. Some attractive

141 A bridge-spouted jug, probably from a cemetery of the 10th–9th century BC at Tepe Sialk, south of Tehran. It is decorated in red paint on a cream background with the figure of a bull and geometric motifs. Ht 19.4 cm.

vessels shaped like bulls, stags or zebus (WA 132974), with the head forming the spout, appeal – by their simplicity and satisfying volumes – to present-day taste and there are consequently many forgeries. A bronze cup shaped like an hour-glass, with an incised kneeling man, a lion, a hare, a bird and numerous gazelles in two registers, could be as early as the fourteenth century BC or as late as the eighth (WA 134685).

A third major dealer's provenance is 'Ziwiye', where a rich burial was discovered in about 1946; the body and grave-goods were in a bronze coffin of Assyrian type which can be dated to around 700 BC. So many objects have been attributed to this burial that they would have filled several coffins and it is now impossible to isolate those which were genuinely associated with it. Some are decorated with animals resembling those of the so-called Animal 142 Style of Central Asia, more particularly of the Scythians who made their appearance in the history of the Near East at this time and were to play an increasingly important part in political events during the first millennium BC: for instance, a gold strip is edged with birds' heads, and hollows for inlay alternate with strange, embryonic lions with distinctive heart-shaped ears (WA 134383–4).

Little is known about the identity of the various groups whose artefacts we have just examined. It is certain, however, that even before the dark age Indo-Aryan tribes had been entering Iran (the word Iran means 'Land of the

Aryans'). Among these tribes were the Medes and the Persians, and eventually the two rival dynasties became united through marriage. It was the Medes, allied with the Babylonians, who, in 614 and then again in 612 BC, swept through Assyria, destroying its cities and bringing that great empire to its knees. And it was the Persian king Cyrus the Great who captured Babylon in 539 BC, thus bringing to an end the Neo-Babylonian empire, whose greatest king had been Nebuchadnezzar II (604–562 BC).

The Medes are first mentioned in Assyrian records of the ninth century BC, and in the seventh century BC they made Ecbatana (modern Hamadan) their capital. The material culture of the Medes remains elusive: a Median site excavated at Tepe Nush-i Jan, just south of Hamadan, produced impressive architecture but very few artefacts. The most important find was a bronze bowl containing 231 silver objects, some of which are now in the British Museum (WA 135072–85). They were probably buried between 650 and 575 BC but, unfortunately for the history of Median art, the bowl was plain and the objects consisted of double spiral pendants and quadruple beads which could have been made as much as 1,500 years earlier, a plain bracelet, plain spiral rings of a type known from the third millennium onwards, bar ingots, and scrap silver in various forms. A single earring made of hollow balls soldered together, with granulation filling the interstices, was the only distinctive object dating approximately to the time of burial.

However, when the Persians under Cyrus the Great (r. 550–530 BC) gained ascendancy over the Medes, they inherited the territories already under Median rule and set out on a series of conquests which eventually gave them control of an empire stretching from the Indus to the Nile and brought them into conflict with the Greeks, first in western Turkey and then in Greece itself. The Achaemenid Persians – as they are known, after a legendary ancestor, Achaemenes – used materials and employed workmen from all over their empire to create a distinctive imperial style and build their great cities – first at Pasargadae in the province of Fars, then at Susa 143 and Hamadan and at that most Persian of sites, Persepolis. Bricks were made by Babylonians, cedar wood came from the Lebanon, and *yaka* timber was brought from Gandhara and Carmania; gold from Sardis in the west and Bactria in the east was worked by Medes and Egyptians (who also 'adorned' the walls); lapis lazuli and carnelian came from Sogdiana, turquoise and other stones from Chorasmia, silver and ebony from Egypt, and ivory from Ethiopia, Sind and Arachosia. The stone was quarried near Persepolis but was worked by Ionians and Lydians from western Turkey. When they returned to their homes, these craftsmen carried the new style with them and it was adopted, with local variations, throughout the Near East.

Persepolis was one of the first sites to attract the attention of western travellers. On a huge terrace cut into the natural rock, Darius the Great

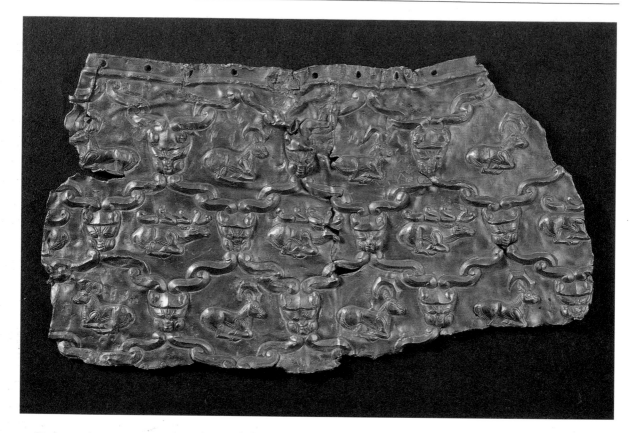

142 Fragment of gold sheet, probably from a belt, embossed and chased with alternating rows of reclining ibexes and stags enclosed in a network which incorporates the heads of lions. Similar compositions occur on contemporary Urartian belts, seals and seal impressions. The stags resemble those of the so-called Animal Style of Central Asia. Perhaps from Ziwiye in north-western Iran, 800–700 BC. L. 16.5 cm.

(r. 521–486 BC) and his successors built a whole series of palaces, columned halls and storerooms, reached by monumental stairways. The mud-brick superstructures have vanished, but the soaring columns on massive bases, with huge double bull- or griffin-capitals, the carved doorways, window-frames and façades of fine-grained, grey limestone still make a tremendous impact on the viewer. The stairways to various buildings – and in particular those to the Apadana, a typically Persian type of building – were carved with reliefs showing the peoples of the empire bringing their tribute and gifts to the king's treasury; several fragments of these were brought to England at the beginning of the nineteenth century. Figures are shown in true profile and not the twisted profile that has appeared so far in this book. It is probable that this innovation was introduced from Ionia by the stonemasons and sculptors employed at Persepolis. The scenes are carved in low relief, but the relief appears higher than in Assyria because the edges are more 144 rounded and the background was cut back evenly and not predominantly round the figures.

There is no doubt that the Achaemenid kings had aimed to outdo the Assyrians: there are human-headed winged bulls 6 metres high, built – as 143 were the largest Assyrian bulls – of separate blocks. The king fighting a lion

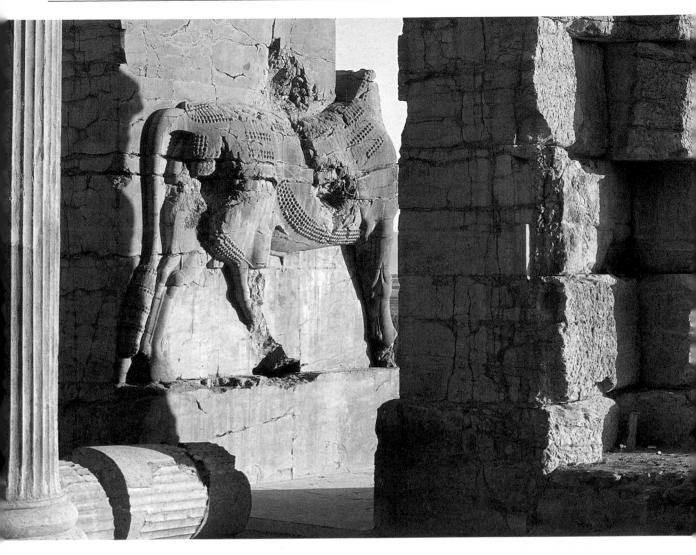

the subject of Assyrian royal seals – is enlarged to giant proportions and decorates one of the doorways into the Hall of One Hundred Columns. Subject peoples support items of furniture – as they did in Assyria – but these are now huge stools and beds on which the king sits under a canopy or stands before an altar. The whole produces an impression of immutable power – a reflection in stone of the phrase 'the law of the Medes and Persians which cannot be broken' (Daniel 6:8). The long processions of figures derive their sense of direction from repetition, not from the representation of movement. Even the scenes of combat – the king fighting lions or monsters, or lions attacking bulls – are static royal icons, frozen in time.

Some of the Persepolis reliefs depicted the royal guard, but the most 145 spectacular representations of this élite corps were executed in glazed brick

143 One of the huge Achaemenid Persian winged human-headed bulls from the Gate-House of Xerxes (r. 486–465 BC) at Persepolis, near Shiraz in Iran. It differs from all but the latest Assyrian winged bulls in being built of separate blocks and having only four legs (cf. Figs 113 and 180). Ht about 6 m.

(in imitation of Babylonian practice and probably executed by Babylonians) in the Palace of Darius at Susa. It has been demonstrated that these figures were designed according to a strict canon of proportions based on a unit corresponding to the height of a brick, namely 8.5 centimetres. The technique employed to make these huge panels was extremely complex and required three firings: the first, of the undecorated moulded bricks, the second to fix the threads of thick glaze to form separate compartments for the colours, and the third to fix the colours themselves. The glaze was a siliceous vitreous fluid coloured by lead antimony, copper, ferrous manganese and tin to produce various shades of yellow, blue, green, black, brown and white. The figures wear robes decorated with a variety of motifs: four-petalled rosettes in squares, stars in circles, or crenellated castles in squares.

The Persians did not only excel in monumental sculpture. Although the stamp seal was widely used, the royal administration reverted to the use of cylinder seals. The seals are beautifully cut with very fine tools and they show the same eclectic choice of motifs transformed into something distinctively Achaemenid. The coffin in a looted tomb at Ur was found to contain some 200 little pieces of clay of no interest to the thieves, bearing the impressions of cylinder seals, stamp seals, seal-rings, metalwork and coins. The deceased may have been a collector or jeweller. The coin impressions have enabled the group to be fairly closely dated and most of the seals must belong to the latter part of the fifth century BC. Some of the impressions are of early Greek seals, some are Egyptianising, some are Achaemenid and some are Graeco-Persian. However, the greenstone scarab seals from a variety of Phoenician sites, including Tharros on Sardinia, make greater use of Egyptian and Levantine motifs.

When they moved west in search of new markets for their goods, the Phoenicians not only carried with them the techniques and iconography which had been developed in the Levant over the centuries; they also took the knowledge of the alphabet which was adopted by the Greeks (see Chapter 1) and by the inhabitants of the colonies they founded in the west. These Punic colonists (as they are known) gradually developed a distinct culture but did not forget their Levantine origins. Some of the customs they brought with them were not as laudable as the alphabet: the practice of child sacrifice was roundly condemned in the Bible but it seems to have survived far longer in the west. In the *tophet* or burial place at Carthage, just outside present-day Tunis, many child and animal cremations have been excavated. The position of the urns was indicated by decorated and inscribed votive stelae, many of which are in the British Museum (see page 37).

Coloured glass was popular in Phoenicia, and the Achaemenid Persians probably learnt the art of making glass from the Phoenicians. A fine colourless Achaemenid glass bowl of the late fifth or early fourth century BC

144 A fragment of sculpture from Persepolis depicting a small, human-headed, winged lion (cf. Fig. 12), seated with one paw raised between stylised plants and bands of rosettes. He wears the horned and feathered crown of Babylonian and Assyrian deities and has ears derived from an amalgamation of the ears of Assyrian winged bulls (Fig. 113) and the elongated ears of demons and griffins. The curved wing-tip is ultimately of Phoenician derivation. The execution, however, was probably the work of Ionian sculptors. Early 5th century BC. Ht 75 cm.

145 A glazed-brick panel from a frieze decorating the palace of Darius I (r. 521–486 BC) at Susa in south-western Iran. It depicts a royal guard, perhaps one of the king's own bodyguard known as Immortals. The complex manufacturing process is described in the text. Ht 1.99 m.

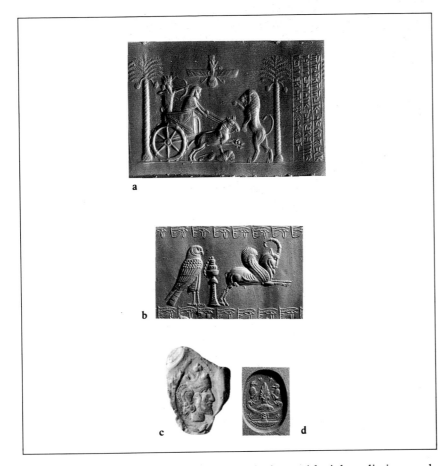

a

b

c d

146 a. Modern impression of a chalcedony cylinder seal found at Thebes in Egypt before 1835. An Achaemenid Persian king in his chariot drives over the body of one lion and shoots another (see p. 136), beneath the winged disc of the Zoroastrian god Ahura-Mazda and between two palm-trees. The king is named in Old Persian, Elamite and Babylonian as 'Darius, the great king', probably Darius I (r. 521–486 BC). Ht 3.7 cm.
b. Modern impression of a chalcedony cylinder seal acquired in Kermanshah in western Iran. It depicts a falcon, an incense-burner and a rather wooden but extremely finely cut prancing, winged ibex between borders of Egyptian *udjat* eyes. 5th century BC. Ht 2.7 cm.
c. Ancient impression on clay of a metal or stone seal-ring found in a tomb at Ur. It shows a composite male head with a bird forming the ear and beard, an ibex head, to which a ram's horn has been added, replacing the hair, topped by a snarling lion's head as a helmet; below are two leaves or ears of wheat. Late 5th century BC. Ht of impression 2.1 cm.
d. Base of a greenstone Phoenician seal shaped like a scarab beetle, found in a tomb at Tharros in Sardinia. Below astral symbols, two monkeys perch on the volutes of a Phoenician stylised tree (cf. Figs 130 and 127) topped by a palmette of Greek type. 5th century BC. Ht 1.7 cm.

(GR 70.6–6.7) was cast and decorated on the base with eight radiating petals in high relief alternating with engraved arrow shapes; it is said to have been found at Cumae in southern Italy.

148 The Achaemenids also built on the metalworking traditions of their predecessors and produced beautiful metal drinking horns and bowls. One silver bowl is decorated with gadroons alternating with applied gold Bes-headed winged lions; a similar bowl, made of gold, was part of the famous Oxus Treasure (WA 123919) which was found by chance in 1877, probably at Takht-i Kubad on the banks of the Oxus. It was then taken to India for sale, but on the way the merchants were robbed. Most of the treasure was recovered by a British political officer, Captain F. C. Burton, as the bandits were dividing it up. The grateful merchants allowed Burton to purchase one of a spectacular pair of armlets which is now on loan to the British Museum from the Victoria and Albert Museum. The remainder of the treasure was sold in Rawalpindi where it was acquired by Major-General Sir Alexander Cunningham; he sold it to Sir Augustus Wollaston Franks who bequeathed it to the British Museum in 1897.

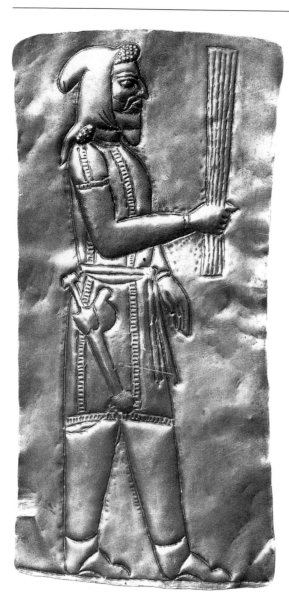

147 The two largest of the votive gold plaques from the Oxus Treasure. Both show a male figure facing right and holding a bundle of rods or *barsom* used in Zoroastrian ritual. *Left* Competently embossed and incised figure in Median dress, wearing a short sword. Ht 15 cm. *Right* This naïve drawing, within its frame of dots, could have been the work of a child. Note the stubble on the chin, and the dots indicating the earring and hair. Ht 22.7 cm.

The objects that make up the Oxus Treasure are of various origins and dates, but it is not clear whether a hoard of coins (which might date the deposit) was originally part of it or not. The treasure seems to have been a votive deposit in a temple, which was subsequently moved and buried at some time of political upheaval. Some of the objects are Achaemenid. Among these are the gold bowl and armlets already mentioned, a silver handle shaped like a leaping ibex, a gold jug, a silver dish and two gold model chariots (one fragmentary). There was a fine gold scabbard (unfortunately cut up by the bandits), the shape of which is identical to that of short swords depicted on the Persepolis reliefs. It is decorated with scenes from a lion hunt which owed much to Assyrian inspiration; the border, however, consists of Animal Style birds' heads not unlike those on the gold strip from Ziwiye (see page 176), and there are other examples of this Central Asian style. Some of the objects show Greek influence, notably a solid silver statuette of a naked man wearing a gilded helmet. There were human and animal heads, and figures in the round, embossed discs, rings, seals, bracelets and amulets – all of which could have been dedicated in a temple. The most convincing argument in favour of a votive destination for

149

150

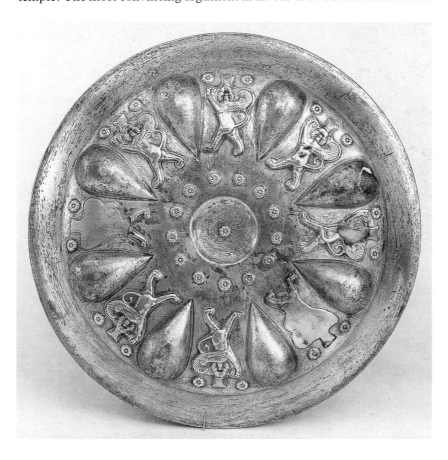

148 Achaemenid silver bowl decorated with gadroons which alternate on the underside with applied winged lions, their heads resembling that of the Egyptian god Bes (two are missing), and rosettes. About 500–400 BC. Diam. 17.5 cm.

185

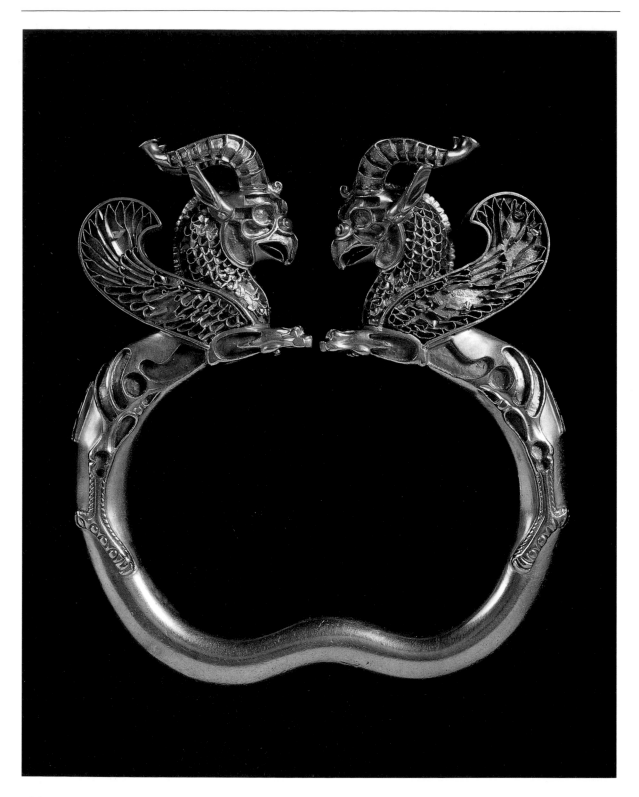

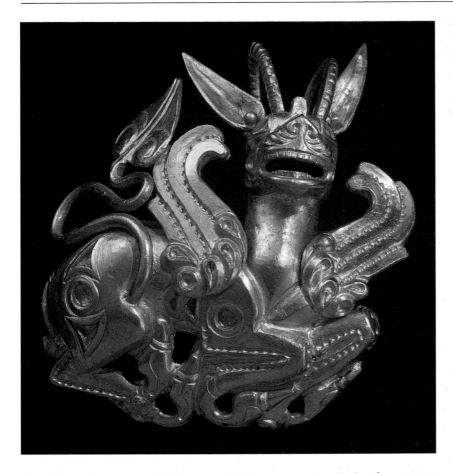

150 A gold embossed ornament from the Oxus Treasure mounted on two pins. Its head is that of a horned lion with long ears, and its body that of a reclining, winged stag; its tail ends in a heart shape and it is decorated with hollows for inlay. 5th–3rd century BC. W. 6.15 cm.

the objects is a group of fifty-two gold plaques ranging in size from 2.3 to 22.7 centimetres; most of these were incised with figures of men wearing a hood, tunic and trousers, two (perhaps three) depict women, two show horses and one a camel. The quality of the execution bears no relationship to the size – and presumably cost – of the plaque: one of the largest has a naïve drawing which could have been made by a child. It should be noted that these figures are also depicted in true profile.

Among the diversity of objects in the Oxus Treasure, those in Achaemenid style are unmistakable. It was the Persians' great achievement to have taken elements from the disparate cultures of their huge empire and to have forged them, within a single generation, into a distinctive imperial style. In this they were repeating the feat of the Akkadians almost two millennia earlier, and using art as an instrument of royal propaganda with the message 'this is Akkadian' or 'this is Achaemenid', still recognisable today.

149 OPPOSITE One of a pair of omega-shaped gold armlets from the Oxus Treasure, with ibex-horned griffin terminals. The piece was originally inlaid with precious stones (one remains) – the head and body by the champlevé inlay technique, and the neck and wings in cloisonné. 5th–4th century BC. Ht 12.3 cm.

CHAPTER 5

Parthians and Sasanians beyond the Euphrates: *c.* 238 BC-AD 651

In 334 BC Alexander the Great crossed the Hellespont and the Achaemenid empire collapsed. Alexander died in 323 BC but the impact he had on the world he had conquered, extending from Greece to the borders of India, was out of all proportion to the brevity of his life. He had encouraged his soldiers to marry foreign wives and settle in the east, and although they absorbed eastern ways they brought with them new ideas, new methods and techniques, and where they went, their craftsmen followed. The interchange of ideas, which had begun in Achaemenid times but had then been restricted to an élite, suddenly exploded into the new and vigorous culture which we call Hellenism, and influenced all aspects of life.

One of Alexander's generals, Seleucus (r. 312–281 BC), gained control of most of the Near East although he and his descendants had to fight for the western provinces which were claimed by the descendants of another general, Ptolemy, who controlled Egypt. These western provinces became part of the Greek and Roman world: their local religions and traditions were absorbed and converted, and the art produced in those regions belongs in 151–2 another book.

The kings of the Seleucid dynasty were called Seleucus or Antiochus, and they gave their names to various cities called Seleucia and Antioch or, after two of their wives, Laodicea and Apamea. Their capital was established at Seleucia-on-the-Tigris, south-east of modern Baghdad, and Susa was refounded as Seleucia-on-the-Eulaios. At this latter site W. K. Loftus found an alabaster statuette of a woman wearing Greek dress. Another was excavated by Hormuzd Rassam at Borsippa, near Babylon. Although in 153

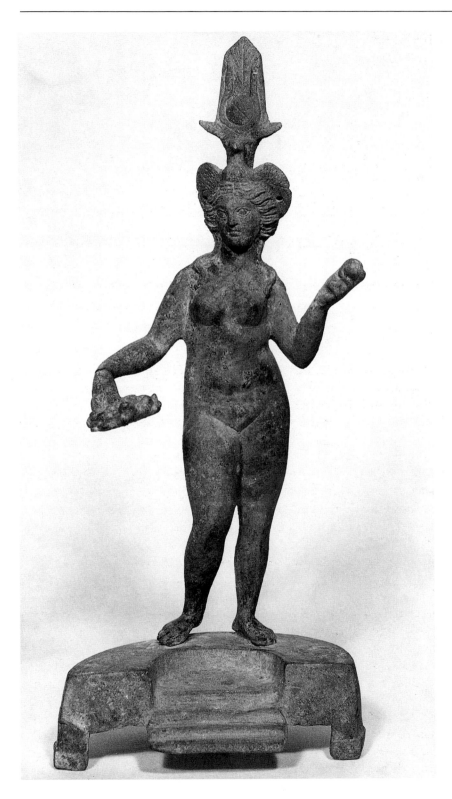

151 Bronze figure of the Goddess of Byblos in the Lebanon, standing on a small stepped altar and holding a wreath and a fruit. The stance, with the weight on one leg, is Greek, but the proportions are Near Eastern; the headdress, which serves to identify the goddess, combines the Egyptian horned sun-disc of Isis and double plumes with a bird. 1st century AD. Ht 22 cm.

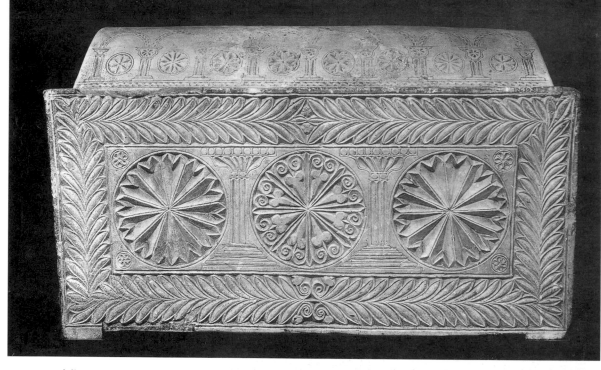

152 ABOVE A limestone ossuary from a chamber-tomb in Jerusalem. It is decorated with Roman architectural motifs including, on the lid, one of the earliest representations of an arcade, perhaps the colonnade built by Herod the Great (73–4 BC) in the temple at Jerusalem. Found in 1870. Ht 43 cm.

153 RIGHT Alabaster female figure excavated by Rassam at Borsippa near Babylon. Details such as the border of her cloak and the ornament she wears round her neck have been added in plaster, and traces of paint survive. The use of pigment to give prominence to the eyes is particularly Near Eastern (cf. Fig. 43). By analogy with terracottas from Seleucia-on-the-Tigris, it seems that the object below her right hand is a crescent attached to her cloak: she may have been a priestess of the moon goddess Artemis – a transposition of the age-old tradition of royal priestesses of the moon god at Ur (see p. 74). 3rd century BC–2nd century AD. Ht 46 cm.

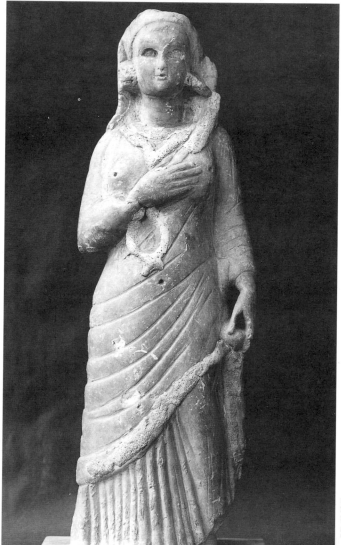

154 The brick arch of the great *iwan* of the 3rd century AD Sasanian palace at Ctesiphon, near Baghdad. It is some 30 m high and 43 m long and was flanked on both sides by a façade decorated with blank arcading and pilasters (that on the right collapsed at the beginning of this century).

concept such figures are Greek, in execution they are very much in the local idiom and illustrate the marriage of east and west which took place at this time.

Hellenism, and the changes it brought about, were resisted by the traditionalists, particularly when religious practices were affected by the new ideas or syncretisms. The traditional cultures of the east reasserted themselves under the Parthian (or Arsacid) dynasty. The Parthians were Iranian nomads from Central Asia who, under Arsaces, had by 238 BC seized control of the old Achaemenid satrapy of Parthia, east of the Caspian Sea, and set up their capital at Nysa as a royal city. Within a century they had gained control of Seleucia-on-the-Tigris and founded Ctesiphon on the opposite bank of the river. The Euphrates became their frontier with Rome, but the Parthians' control of the Silk Route brought them into contact with

154

the Han dynasty in China. Caravan cities such as Hatra just west of the Tigris near Ashur, Dura Europos on the Euphrates and Palmyra in the Syrian Desert passed the trade westwards towards Rome, and grew rich from the proceeds. The art of these cities is heavily influenced by both eastern and western traditions. In 53 and 36 BC respectively, the Roman armies under Crassus and Mark Antony were no match for the Parthians and their mounted archers, who could turn in the saddle and shoot their small bows – the famous 'Parthian shot'. In AD 116, however, Trajan was briefly able to capture Ctesiphon, and from then on Parthian power declined.

During the first two centuries of their dominance the originally nomadic Parthians had continued to be strongly influenced by Hellenism, but 156 thereafter a new spirit of independence appears in such works as the large bronze statue from Shami in western Iran (now in the Iran Bastam Museum in Tehran). This reaction against Hellenism is reflected in Parthian coinage: the coins of earlier kings have affinities with the products of Hellenistic mints, but later dynasts are shown wearing Parthian tiaras and their coins are executed in a flatter, less modelled and more linear style, although for the most part the inscriptions continue to be in Greek.

The Parthians revived the tradition of carving rock reliefs at the same sites used by the Achaemenid Persians and, before them, the inhabitants of western Iran and the Zagros in the late third and early second millennia BC. The figures on Parthian reliefs often wear their hair in a distinctive fashion, in huge bunches on either side of their faces, and they are strictly frontal. Because of this frontality, although the viewer is made to participate in the scene, there is no communication between the figures within the composition and the result is remarkably static. The introduction of frontality, which marked a break with previous Near Eastern tradition (see page 76), had important repercussions: it continued into Sasanian times and was adopted into Byzantine art.

At Hatra stone statues and reliefs of the gods dating mostly to the second 158 century AD have been found in the temples, and local adaptations of Greek gods were popular. The merchants and priests of Hatra, and occasionally the women, had statues of themselves set up in their temples. The posture is still strictly frontal and the figures raise one hand stiffly, but they are richly attired.

155 A lintel of grey limestone brought back from the Parthian settlement at Nineveh by George Smith in 1874. It depicts strangely elongated, rather dog-like winged dragons on either side of a vase or altar, against a frieze of stylised plants. Early 3rd century AD. L. 1.84 m.

156 A grey limestone stele from the religious terrace-site of Masjid-i Soleiman in the kingdom of Elymais in western Iran. Although the figure has been identified as Athar, god of fire, or as Herakles, it probably depicts Hermes, the Greek messenger of the gods, or his local counterpart. He is nude apart from a diadem with ribbons and a cloak; he seems to have wings on his head and ankles and he holds a bag in one hand and a staff (?) over his shoulder. Although frontality had often been used for the heads of male nude figures, the lower part of the body had always been shown in profile (e.g. Fig. 59a–c). Late 2nd–early 3rd century AD. Ht 30.4 cm.

157 BELOW Bronze griffin, perhaps a handle; its elongated form indicates a late Parthian date in the 3rd century AD. L. 18 cm.

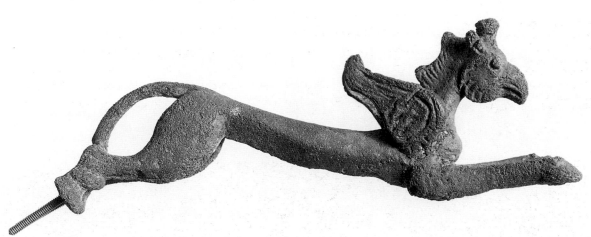

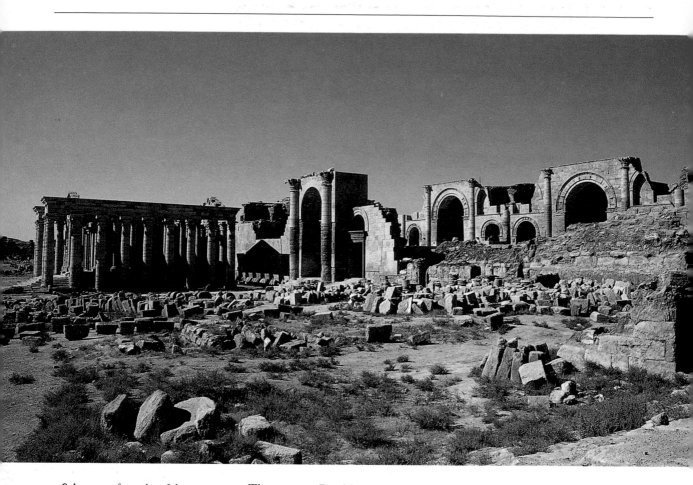

158 A group of temples of the 1st to 2nd centuries AD at Hatra in northern Iraq is a vivid illustration of the meeting of two cultures: on the left is a temple in the Roman architectural tradition with triangular pediments and columns, while the other temples belong to the oriental tradition and are based on an open, arched hall – the *iwan* – often flanked by smaller *iwans*. Later, the *iwan* became a basic element in Islamic architecture.

There was a Parthian settlement on the site of the old Assyrian capital of Nineveh, and a lintel from there was brought back by George Smith in 1874. 155 The elongation of the monsters on it is also found on bronze artefacts, and 157 similar animals are depicted on the belt carved on a statue from Hatra, towards the end of the period of Parthian domination. The Hatra statues display a wide range of ornamental belt buckles and pins, and actual examples have survived. The survival of such artefacts reflects the Par- 159 thians' nomadic origins, where such portable items emphasised the status of the wearer. Belt-clasps of the first to second century AD from Georgia are 162 another manifestation of this same fashion.

Jewellery, such as that found in Parthian tombs at Nineveh, although also 160–1 much worn by nomads, is a status symbol of universal impact. Turquoise and garnet inlay was popular in the east, as demonstrated by the spectacular burials of this period excavated by the Russians at Tillya Tepe in Afghanistan, and the fashion seems to have spread.

Terracottas can sometimes be identified as Parthian because of the dress worn by the figures depicted. Some of these, from Uruk, show a man

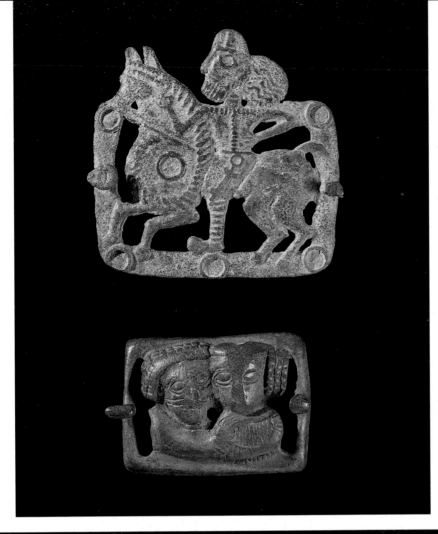

159 Two Parthian bronze belt-buckles of the 2nd–3rd century AD. *Above* A rider with abundant hair; the circular depressions were for inlay (now missing). Ht 8.1 cm. *Below* An embracing couple. Ht 4.8 cm.

160 BELOW Parthian gold jewellery of the 1st century AD, originally inlaid with garnets and turquoises, some of which survive. *Above* Gold openwork brooch embossed with an eagle and goat, from the treasure of the Karen Pahlavs found in a chamber-tomb near Nahavand in Iran. W. 9.34 cm. *Below* A necklace or diadem, perhaps from Dailaman near the Caspian in northern Iran, with loop-in-loop chain (see Fig. 55) and fine granulation in triangles round a central black stone; the eagles and rings were a symbol of Parthian kingship (but see also Fig. 89). W. of central medallion 4.6 cm.

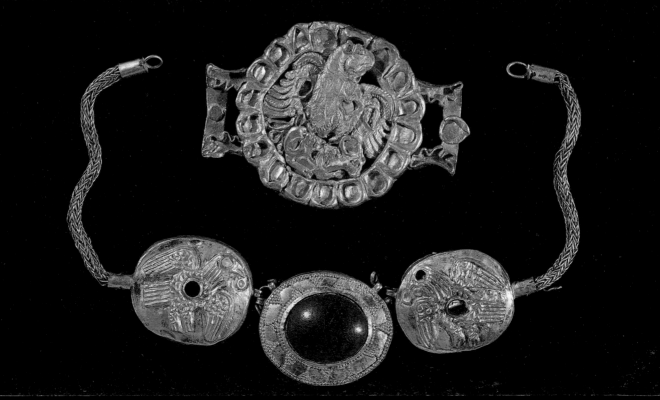

161 The head of a silver pin in the shape of a voluted capital and with an extremely detailed representation of a Parthian couple at a banquet. The bearded and moustachioed man wears a belted tunic and trousers and reclines, holding a cup in his left hand while resting his elbow on a cushion. His right arm is round his wife, who sits beside him. She wears a long dress with flounced hem, cups her breast in one hand and rests the other on her knee. Vesta Curtis has dated the pin to *c.* 190 AD on the basis of the woman's hairstyle. W. of pin-head 3 cm.

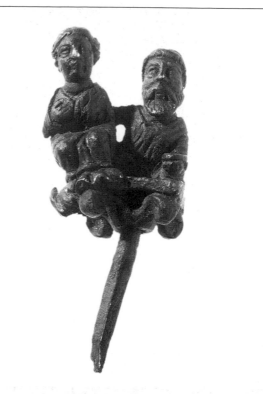

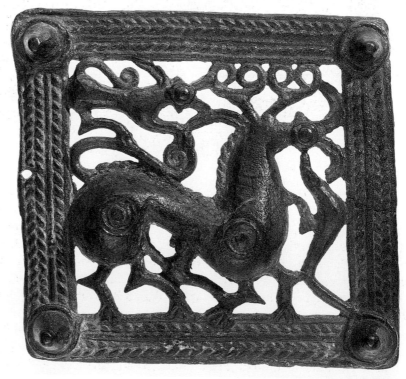

162 Stag, dog, bird and fish on a Georgian belt-clasp of the 1st–2nd century AD, made of leaded tin bronze. Ht 9.7 cm.

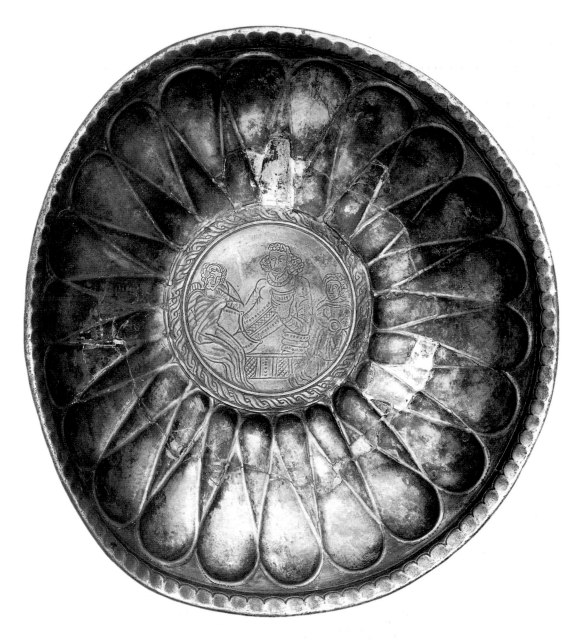

reclining at a banquet and raising a cup, but the execution is crude (e.g. WA 51–1–1, 98 or 91786). The motif is also found on metalwork. A different type of terracotta object from Parthian Uruk is a huge sarcophagus shaped like a slipper and partly covered with green glaze; Loftus brought back three examples. He also brought back glass vessels and terracottas – including one showing two musicians (WA 91917) – found in the burial vaults, as well as architectural fragments and figured capitals from a Parthian building (e.g. WA 92219, 92231).

Palmyra, a city in an oasis in the Syrian Desert, also grew rich from the caravan trade. As it lay west of the Euphrates it was heavily influenced by Greece and Rome, but from the first century AD Parthian dress and the rule

163 Parthian gadrooned silver bowl on a low foot. It is decorated with a banqueting scene depicting a reclining man, bearded and wearing his hair in the Parthian style, who holds a cup; beside him sits his wife and behind him is his son or an attendant. 2nd–3rd century AD. Diam. *c.* 21 cm.

164 The ruins of Palmyra, a caravan city of the 1st–3rd centuries AD in the Syrian Desert, with Diocletian's camp in the foreground, the main colonnaded streets intersecting at the Tetrapylon, the Temple of Bel in the distance on the right, and the oasis beyond.

of strict frontality were adopted. The monuments set up by the rich Palmyrenes reflect a growing awareness of their Near Eastern roots. In the third century AD a local dynasty gained a considerable degree of autonomy. Finally, under their famous queen Zenobia, Palmyrene troops wrested control of Syria from the Romans, conquered Egypt and embarked on the conquest of Asia Minor (now Turkey). The Romans eventually reacted, defeated the Palmyrenes, captured Zenobia and took her to Rome, where she appeared in their Triumph wearing golden chains.

This dominance of women in Palmyra, though contrary to the general

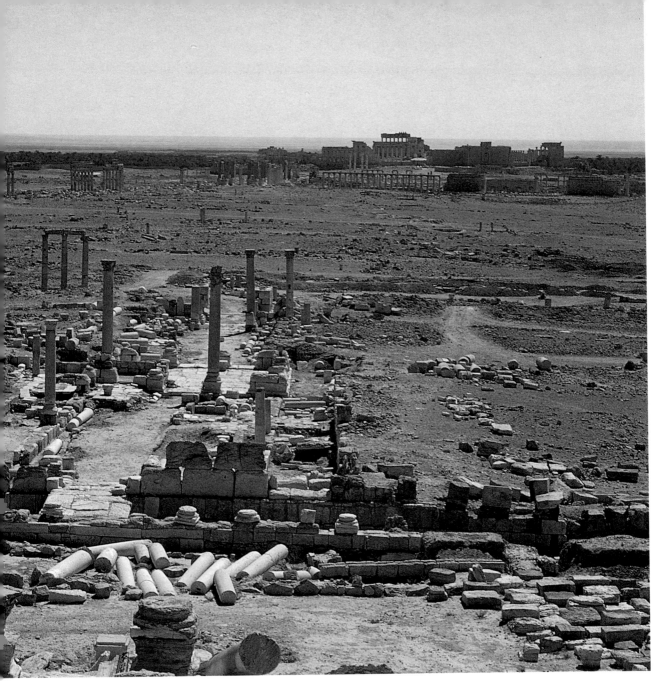

trend in the Near East, is reflected in their tomb monuments. The dead were buried in elaborate tomb-towers in a valley nearby. The main tomb was hollowed out of the rock and the head of the family was shown in high relief, reclining at a banquet, holding a cup. The other occupants were buried in long stone slots and identified by portrait busts at one end. These show 165 proud and domineering women dressed in their finest jewels, which still bear traces of the paint which once highlighted them. By contrast, however, most of the men look timid and brow-beaten. The emphasis on portraiture and the use of the bust are both heavily influenced by Rome.

165 Two of the limestone busts, originally picked out in colour, which decorated and identified the ends of the burials in tomb-chambers at Palmyra. They are inscribed in Palmyrene script and date between 150 and 200 AD. *Left* Aqmat, daughter of Hagago, holds her veil in a distinctive manner. Ht 51 cm. *Right* Moqimo, son of Moqimo, is depicted against a 'curtain of death'. His eyes are painted grey and he holds a scroll. Ht 63 cm.

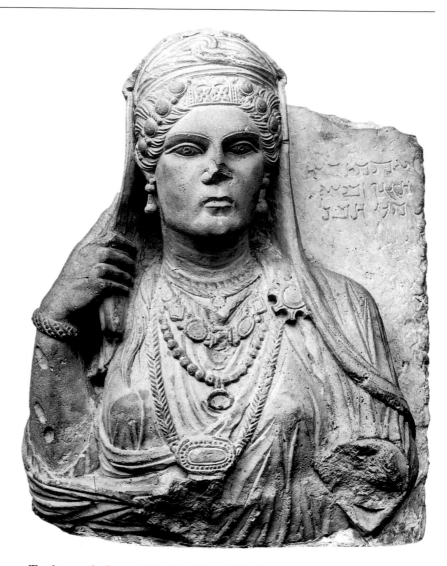

To the south, beyond the frontiers of the Parthian empire, the kingdoms of Arabia, particularly in what is now Yemen, grew rich through trade in spices with the Roman empire. The art they developed owes something to Rome but is extremely distinctive. A local alabaster was used for sculptures of both men and women set up in temples, and for votive and funeral 166 plaques. Part of a bronze altar decorated with projecting bulls' heads on the 169 side, three rows of sphinxes shown frontally, and a long dedicatory inscription in the South Arabian script naming the god Rhmw (WA 135323–4) is remarkable more as a technical *tour de force* than as an artistic *chef d'oeuvre*. Where smaller bronzes are concerned, however, we are left in no doubt as to 167–8 the bronzesmiths' versatility and skill.

The Parthian dynasty was weakened by pressure from the Romans in the

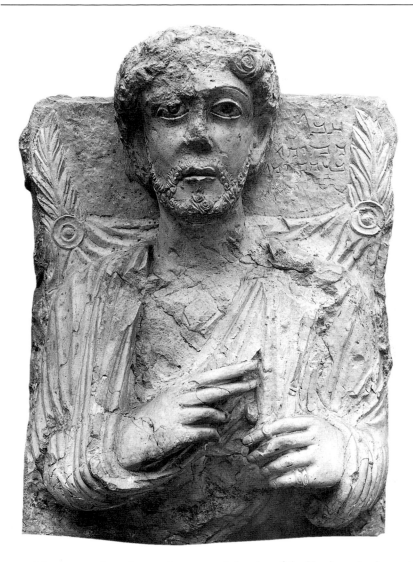

west, Alani nomads to the north-west and the rise of the Kushans in the east. However, it was one of their own governors, Ardashir, who ruled Fars from Istakhr just north of Persepolis, who finally overthrew the last Parthian king, Artabanus V. Ardashir (r. AD 224–40) set up the Sasanian dynasty (AD 224–651), called after one of his ancestors who claimed descent from the last Achaemenid king. The Sasanians, therefore, aimed to revive the glories of the Achaemenid empire; Zoroastrianism, which had been widespread in Achaemenid times, was made the state religion. Sasanian territorial ambitions brought them into conflict with Rome, and Shapur I (r. AD 240–72)
170 defeated no less than three Roman emperors: Gordian III, Philip the Arab and Valerian. Shapur depicted these defeats in numerous reliefs, in a conscious echo of that of the Achaemenid king Darius I at Bisitun.

201

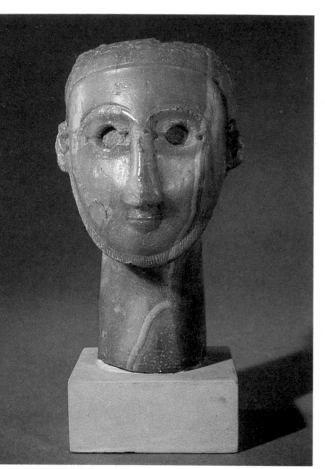

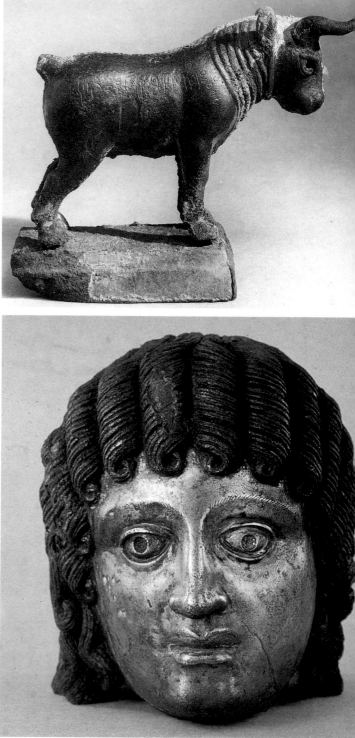

166 ABOVE Votive alabaster head of a bearded man, probably from Haid bin Aqil, the cemetery for Timna in South Arabia (cf. Fig. 28). 2nd–1st century BC. Ht 21.5 cm.

167 ABOVE RIGHT A bull on a base, cast in bronze over a central core. It was one of a pair, according to the South Arabian Himyaritic inscription: 'To Dhat-Himyam, two bulls.' The eyes were originally inlaid. The bull's solid stance is found on other bronzes and is distinctive of the local style. 1st–2nd century AD. Ht 21 cm.

168 RIGHT Bronze head of a youth, made from different alloys and owing much to Greek and Roman influence. From Ghaiman in western Saba' in the Yemen. 1st–2nd century AD. Ht 20.8 cm.

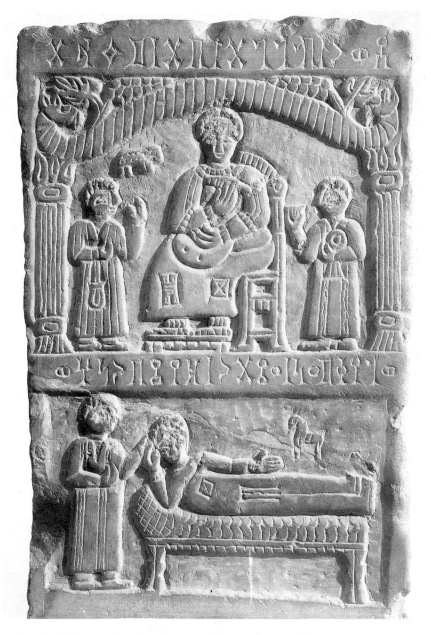

169 A votive stele of the 1st century BC or AD inscribed in the South Arabian script and Sabaean dialect: 'Ghalilat, daughter of Mafaddat. May Athar destroy whoever breaks it.' The scene above shows Ghalilat with her children beneath an ornamental canopy; she holds a lyre, and the size of her chair and her footstool show her to have been an important person. Below, Ghalilat attends to her husband. Note the robes decorated with woven bands, and H-shaped and square panels which are typical of textiles of this period. Ht 46 cm.

Rock reliefs continued to be carved by successive Sasanian rulers and in their variety and detail they are an important source of information. The kings can be identified thanks to their royal headdresses, which change from reign to reign and which are also shown on their coins. Often they are depicted frontally; frequently they are on horseback, surrounded by their courtiers, who are identified by their crests and are all mounted on richly caparisoned horses. Some of the earliest drawings of these reliefs, and

170

19 certainly the first accurate ones, were made by Sir Robert Ker Porter.
Among the latest reliefs are lively hunting scenes which take place in royal
parks known as *paridaiza* (the origin of our word 'paradise'): one of them is a
boar hunt in marshland to the accompaniment of music; it is in marked
contrast to the Assyrian reliefs showing Babylonian enemies being hunted
down and killed in the marshes of southern Iraq.

Sculpture in the round has rarely survived. However, there is a huge
statue, almost 10 metres high, of King Shapur I, carved from a stalagmite in
a funerary cave near Bishapur in Iran. On a smaller scale is a bronze figure in
171 the British Museum.

Gold and silver vessels were made in large quantities, and for decades
193 they have been a popular item for forgers to copy. Many techniques were
172 used: some were incised, some embossed and chased, often with hunting
174 scenes. One of the latter depicts a stag hunt with the curve of the stag's body
following that of the bowl and its eyes mournfully raised skywards in
counterpoint to the king's stern but impassive expression. The movement
implied by the stag's leaping into the picture and the king having presum-
ably jumped onto its back, is also indicated by the fluttering of the light
material of the king's pleated tunic and trousers, and by the wind-blown

170 OPPOSITE A Sasanian relief
above a pool near Darabgird, east
of Shiraz. It depicts the victory of
the Sasanian king Shapur I
(r. AD 240–72) over three Roman
emperors. The king, on horseback,
lays a hand on the head of Philip
the Arab; Valerian hastens towards
him, and Gordian III lies behind
the horse. Ht of relief 5.4 m.

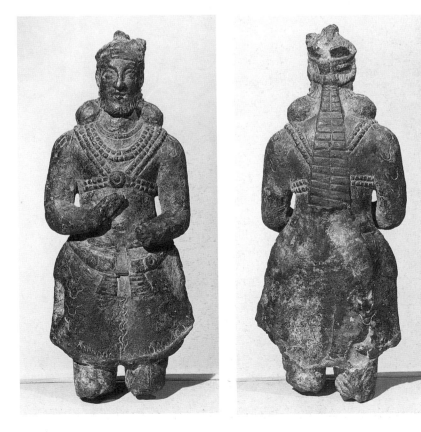

171 Two views of a fragmentary
Sasanian bronze figure of the 4th
or 5th century AD: a king wearing a
distinctive jewelled harness or
breast chain as an emblem of
royalty. The identifying
beribboned headdress, rising from
a crenellated crown, is broken.
The king would have held a sword
(cast separately) and rested his
hand on its hilt. There are several
Sasanian swords in the Museum's
collections: they are long and have
silver or gold scabbards decorated
with a scale pattern. Ht 18.7 cm.

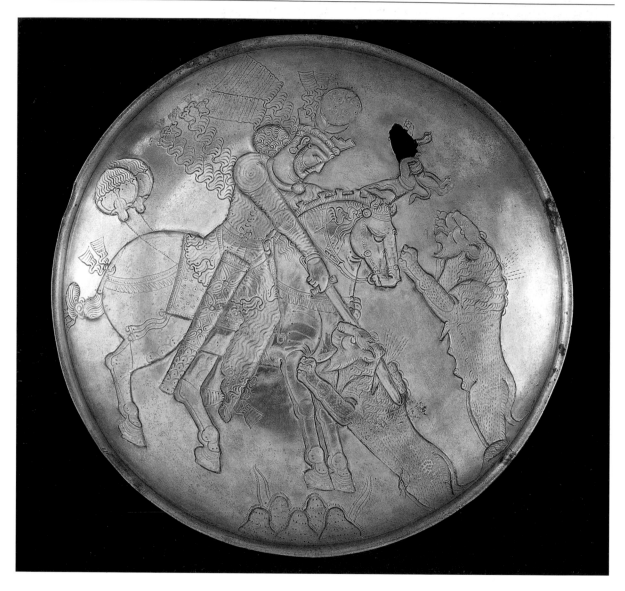

172 A Sasanian silver bowl depicting a king on horseback, wearing a crown close to that of King Bahram V (AD 421–39); he brandishes a lion-cub as a decoy and slashes at a leaping lion which bites into his horse's chest. Below is a pattern of mountains. The light, feminine textiles, fluttering bows and enormous pompoms contrast with the grim determination on the king's face and the savagery of his onslaught. Diam. 27.4 cm.

bows on his headdress, around his beard, streaming out behind him, and even on his shoes; but it is belied by the king's static posture, vertical at the centre of the design.

In other cases some areas of the design were executed in repoussé on separate sheets of metal and applied to the vessel; these raised areas have often become damaged or have broken away. Such is the case with a bowl which was acquired in Rawalpindi and probably made in the eastern part of the Sasanian empire in the late fourth century AD (WA 124093). It depicts an official being invested with the ring of office by a king; the latter is shown frontally, seated on a throne supported by griffins. Round the edges, the

206

173 A silver and gilded bottle with a perforated base, embossed with vine scrolls inhabited by birds and foxes; the grapes are being harvested by two naked youths. A brief *pointillé* inscription in Pahlavi has been pricked into the rim. Said to be from Mazandaran in Iran, 6th–7th century AD. Ht 18.5 cm.

king is shown again, semi-reclining on a couch, surrounded by his courtiers and musicians. A similar technique was used in the execution of silver and

173 gilded bottles, although an example in the British Museum is embossed, or perhaps even cast.

175 Finally, another very fine silver bowl, with the design inscribed in a patterned circle and picked out in gold, shows a mythical creature, generally identified as the *senmurv* mentioned in the texts, with the foreparts of a dog

19 or lion, wings, and a peacock's tail. This creature, again inscribed in a circle,

176 appears on Sasanian textiles and on representations of them, on a stucco plaque, on wall-paintings, on glass vessels and on a Sasanian seal

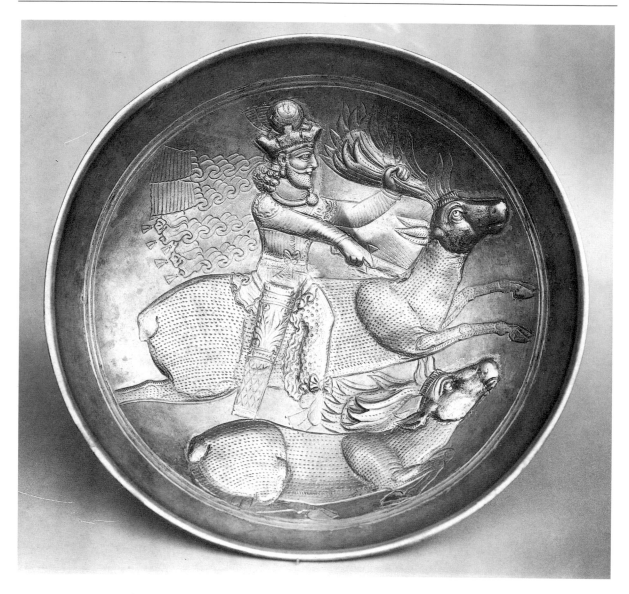

174 A Sasanian silver bowl with a design, picked out in gold, showing a king engaged in a hunt. A stag has leapt into the field from the left and its hind-legs are still partly out of the picture; the king straddles it, grasps its antlers and stabs it between the shoulders while, below, the same or another stag lies dying. The crown is that of Shapur I (AD 240–72) but the style would indicate a date perhaps as late as the reign of Shapur II (AD 309–79). Diam. 17.9 cm.

(WA 120341). It was also adopted into Islamic and Byzantine iconography. The adaptation of a motif to various materials and uses, regardless of scale, is a feature of Sasanian art. A bronze in the British Museum (which may be post-Sasanian) shows a composite creature related to the *senmurv* with the fur or feathers under its neck forming a leaf pattern (WA 123267).

Sasanian seals are distinctive and represent a last flowering of the art of seal cutting which was such an important vehicle for the transmission of Near Eastern motifs in time and space. Many are cut on flat stones such as almandine garnet and carnelian, which were set in rings or as pendants. However, the typical Sasanian seal shape is like a finger-ring carved out of

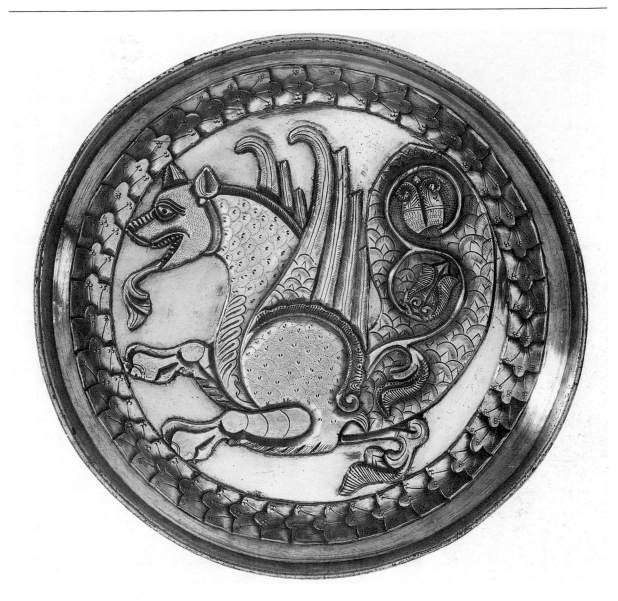

175 Silver Sasanian bowl with a design, picked out in gold, depicting the mythical *senmurv* (see also Figs 176 and 183–4). 7th century BC. Diam. 19.3 cm.

stone, but with a hole generally much too small to have fitted on a finger and which would therefore probably have been worn as a pendant. The sides are sometimes decorated with raised circular facets or scroll patterns, and the seals were carved from attractive, colourful stones such as quartzes (chalcedony, carnelian, agate, onyx and jasper) and lapis lazuli, although haematite, which had been so popular for cylinder seals in the first part of the second millennium BC, also made a comeback. The bases bore portraits, animals, flowers, allegorical and magical subjects, and devices (perhaps of tribal origin), carved with varying degrees of competence and sometimes surrounded by an inscription in the Pahlavi script. At their most rudimen-

176 A stucco plaque depicting the mythical *senmurv*. Part of the architectural decoration of a late Sasanian or early Islamic building at Chal Tarkhan in Iran, 7th–8th century BC. Ht 16.9 cm.

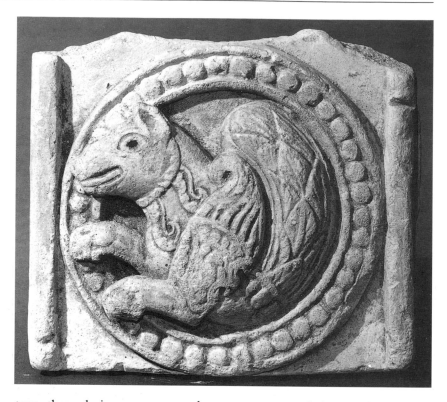

177 BELOW An exceptionally large carnelian Sasanian seal carved with the head of a bearded man who wears an elaborate headdress. The inscription, in Pahlavi characters, names him as 'Vehdin-Shapur, chief store-keeper of Iran'. He was probably an official under Yazdagird II (r. AD 439–57). Ht 4.6 cm.

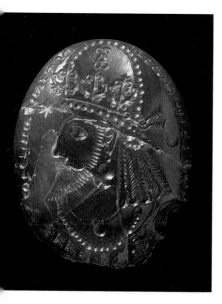

tary, these designs are extremely easy to copy and there are numerous forgeries on the market. A large number of seals could be impressed together on circular or domed cakes of clay which were shaped round the string or strips of leather attached to goods or documents.

Sasanian pottery was often decorated with stamped designs – frequently animals – related to some of those on the seals. A small, circular terracotta plaque shows a lively representation of tumblers and, perhaps, weight-lifters, one of whom wears a patterned coat (WA 93028). Glass technology had advanced and it was now possible to produce blown transparent vessels. Cutting-wheels were sometimes used to execute simple linear designs but more often to decorate the surface of vessels with facets. 178

Although under the Sasanians Zoroastrianism had become the state religion, the incantation bowls found predominantly in southern Meso-potamia demonstrate the presence of several other religious groups and the survival of many of the ancient gods and demons. These shallow bowls are inscribed on the interior, mainly in Aramaic but also in Syriac, Mandaic and Pahlavi, with spells to protect the owner from evil, and some are decorated with spirited but crude representations (e.g. WA 91728).

All this changed with the introduction of a new religion: the Islamic conquest brought about the collapse of the Sasanian empire in AD 651. Although Islamic art inherited many of the concepts of Sasanian art, the

178 A pottery jug stamped repeatedly with the framed motif of a browsing deer. 6th century AD; excavated at Borsippa in southern Iraq. Ht 33.5 cm.

religious taboo on the representation of the human form – which was at times extended to all representational art – led to a complete change in direction. Yet many of the iconographical motifs of the previous millennia were so deeply ingrained in the traditions of the countries of the Near East that they survived in one form or another. Many had already been passed eastwards and westwards and had become part of the artistic vocabulary of other cultures. These survivals and revivals will be the subject of the next, and last, chapter of this book.

CHAPTER 6

Survival and Revival

With the advent of Islam in the seventh century AD, the Near East enters a new religious and political era which is reflected in a new art and architecture; the story of Ancient Near Eastern art ends and the narrative is taken up by the Islamicists. Or does it end? A culture may change beyond recognition but it does not die. In this chapter we shall examine a few of the ways in which echoes still reach us of the art of the Sumerians, Akkadians, Babylonians and Assyrians, Medes and Persians, Hittites and Urartians, Canaanites, Israelites, Judaeans, Phoenicians, Parthians and Sasanians, and many others – including a vast number of peoples who have remained nameless.

To put the matter of survival into context, however, survivals in fields other than art should perhaps briefly be examined. It is well known that the alphabet was transmitted to the west by the Phoenicians; its very name derives from its first two letters: *aleph* (bull; originally shaped like a frontal bull's head, then turned sideways in Phoenician, and finally turned once more through ninety degrees to form our A) and *beth* (house; a house-plan with entrance, again turned sideways to form our B). Several common words have been transmitted through Greek or Arabic from Akkadian or Sumerian, for instance cherry, alcohol, saffron, jasper, myrrh, horn, cane and canon, lute, alkali. The Sumerians devised a sexagesimal system of numbering whereby the basic unit was 6 and its multiples; indeed, 6 is the lowest number which can be divided by 1, 2 and 3. We have inherited from this system our division of the day into 24 hours each of 60 minutes made up of 60 seconds, and our division of a circle into 360 degrees. Tablets from Tell Harmal and Tell ed-Dhibai near Baghdad record the existence, around 1800 BC, of what we call 'Pythagoras' theorem', and methods of calculating the areas and dimensions of squares, triangles and circles; their approximation of the square root of 2 was still being used by Ptolemy some 2,000 years

later. The division of the year into months and weeks also comes from the Near East. Astronomy and astrology were developed by the Babylonians and transmitted to the west through the Greeks and Arabs. Many of the constellations were given their names by the Babylonians and – in translation – we still use them today. The signs of the zodiac are all present, fully developed, on seal-ring impressions on texts dating to between 304 and 132 BC from Hellenistic Uruk. These motifs go back far further, of course, and some are present on *kudurrus* and seals of the second millennium BC and earlier, although not as part of an integrated system. Capricorn, for instance, with its strange combination of goat and fish, is first attested on a cylinder seal of the Ur III period just before 2000 BC.

First and foremost, the Bible kept alive the knowledge of the peoples named above and of the art they created. (The word 'Bible' itself derives from the city of Byblos on the Lebanese coast where books first replaced scrolls.) The biblical story of the Flood, for instance, is now known to have its Mesopotamian counterpart. Feminists may be interested to know that the strange story of Adam's 'spare rib' from which Eve was created (Genesis 2:20–3) makes perfect sense once it is realised that in Sumerian the feminine particle and the words for rib and life are all *ti*, so that the tale in its original form must have been based on Sumerian puns. The geographical location of the Garden of Eden was Sumer (see page 10). All these stories, and many more, have provided a rich harvest of pictorial representation throughout the millennia, for which the original inspiration was the Ancient Near East.

The imagery of the Bible has also inspired us through the millennia. For instance, in the Book of Revelation 4:6–8 we read of four living creatures who surrounded the throne in heaven. 'The first . . . was like a lion, the second was like an ox, the third had a face like a man, and the fourth was like a flying eagle.' In the early Christian Church these four winged creatures
179 became the symbols of the Four Evangelists, respectively Mark, Luke, Matthew and John. The best-known is probably the lion of St Mark, which no visitor to Venice can miss. (In fact, it has even been suggested that the great winged lion on a column in the Piazzetta was an antique bronze brought back by the Venetians from the south coast of Turkey. However, it is far more likely to be Romanesque in date and European in origin.)

The writer of Revelation based his description of the four living creatures on the cherubim in the vision of Ezekiel (Ezekiel 1, especially 1:10, and 10:14). This vision is dated to 593 or 592 BC, when Ezekiel was in exile in Babylonia. Ezekiel would have been familiar with the imagery used in his country of exile: if he travelled in the north he would have seen the ruins of the great gateways of the Assyrian palaces, destroyed only twenty years before, guarded by the colossal figures whose symbolism impressed and inspired him); he would certainly have heard them described, possibly by
180 descendants of the Judaean prisoners captured at Lachish in 701 BC and

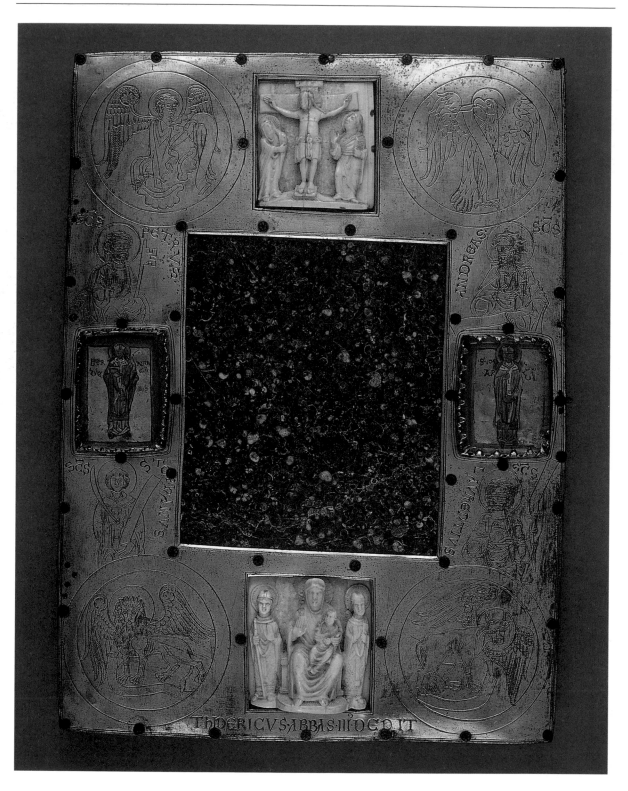

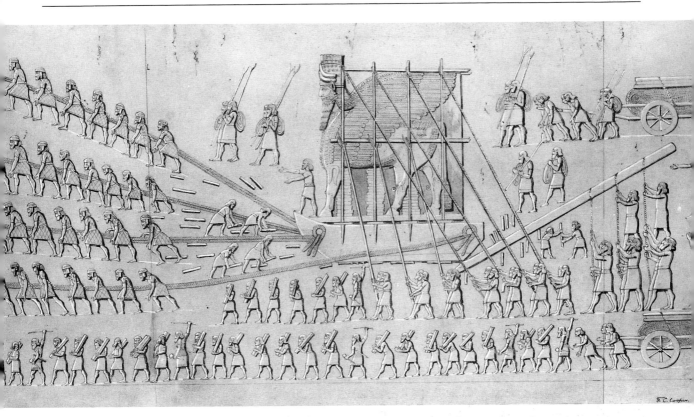

subsequently used to haul Sennacherib's winged bulls into position.

As we have seen, this semi-divine creature, known as a *lamassu*, has the body of a lion or bull, the wings of an eagle, and a human head; it thus combines the power of the strongest wild animal (the lion), or domesticated animal (the bull), with the wings of the most powerful bird in the heavens (the eagle) and human intelligence (see Fig. 51 for an early representation of the four together). Although lions had guarded gateways of palaces and temples in the Near East since before 3000 BC, the Assyrians had probably been inspired to create their huge composite *lamassu*-figures when they saw the smaller gateway figures of the Aramaeans and Neo-Hittites during their campaigns in Syria. The tradition for these figures in Syria has recently been shown to be far older than previously thought: a stele found at the site of Ebla in northern Syria, and dating to the nineteenth century BC, shows a similar human-headed, winged creature with the legs of a lion, horse (?), bull and man.

It thus becomes easier to visualise the cover of the Ark of the Covenant described in Exodus 37:7–9: '. . . two cherubim out of hammered gold at the ends of the cover, . . . made of one piece with the cover. The cherubim had their wings spread upwards, overshadowing the cover with them. The cherubim faced each other, looking towards the cover.' These would

180 Drawing by F.C. Cooper (*c.*1850) of reliefs carved *c.* 700 BC in the South-West Palace of Sennacherib at Nineveh. Prisoners, including Judaeans from Lachish (see p. 144), pull a sledge with a *lamassu* for the palace. Others, directed by Assyrians, haul on ropes attached to huge levers, lay logs as runners, collect them for re-use and move equipment.

179 OPPOSITE The Hildesheim portable altar, made of porphyry in a gilt copper frame, with the Four Evangelists engraved in circles in the corners, other engraved saints, walrus ivory carvings of the Crucifixion and Virgin and Child, and painted miniatures on vellum under crystal of two early bishops of Hildesheim in Germany. An inscription identifies the donor as Theodoric III, Abbot of St Godehard at Hildesheim between 1181 and 1204. On the back is a list of relics which were found, wrapped in small pieces of textile, inside the altar. Ht 36.5 cm.

181 A Phoenician openwork ivory plaque depicting a winged sphinx among stylised plants. The sphinx wears an Egyptian wig and apron and an extremely abbreviated version of the Egyptian double crown. 8th century BC; excavated in Room SW11–12 in Fort Shalmaneser at the Assyrian capital of Nimrud. Ht 7 cm.

probably have been three-dimensional versions of the sphinxes depicted on 181 the ivories.

In 1853, after his rediscovery of the Assyrians, Layard was granted the Freedom of the City of London and the documents were presented to him in a silver-gilt casket decorated with bull- and lion-*lamassu* figures and with 182 motifs taken from Assyrian reliefs. This is one of many objects inspired by the Assyrian reliefs displayed in the British Museum and, during the Great Exhibition of 1851, in the Crystal Palace; these included porcelain and bronze figures and an 'Assyrian Style' in nineteenth-century jewellery design.

Another descendant of the *lamassu* is probably the *senmurv*, which combined the foreparts of a dog or lion with a peacock's tail. According to tradition, the flesh of the peacock did not putrefy and it therefore came to be associated with immortality. For this reason the peacock occurs frequently in early Christian iconography as a symbol of the Resurrection. A creature resembling the *senmurv* appears in a circular frame on the Borradaile 183 Oliphant and it is probable that the motifs on this horn were taken from Byzantine or Sasanian silks.

The motif of the *senmurv* was frequently woven into Sasanian textiles, 19 which were traded all over the known world. These textiles were highly prized, and surviving pieces were used for wrapping 'relics' for gullible Crusaders, in order to give them an aura of age and authenticity. The relics of St Leu were wrapped in samite woven with *senmurvs* in roundels decorated with globes – the so-called 'pearl border' (Paris, Musée des Arts

182 ABOVE A silver-gilt casket presented to A. H. Layard in 1853 when he was awarded the Freedom of the City of London. It is decorated with bull- and lion-*lamassu* figures and panels based on sculpture of the 9th century BC from the Assyrian capital at Nimrud. Designed by the sculptor Alfred Brown and made by John S. Hunt. Ht 6.8 cm.

183 BELOW The Borradaile Oliphant, an ivory hunting horn of the 11th century AD, probably from southern Italy. The designs within circles were based on motifs on Sasanian and Byzantine silks and include this creature which resembles a *senmurv* (cf. Figs 175–6). L. 53.5 cm.

Décoratifs), and an almost identical motif decorates a silk caftan of the eighth or ninth century, lined with squirrel skin and found at Mochtchevaja Balka in the north Caucasus (St Petersburg, Hermitage Museum). When it was opened, the Hildesheim portable altar was found to contain minute 179 pieces of bone wrapped in twists of textile – some brilliantly coloured and a few in elaborate weaves – probably dating to the tenth century; the finest enclosed, respectively, the relics of St Cyprian, St Benedict, St Denis and St Tornatus. Another reliquary in the British Museum, the 'Basel Head' of the thirteenth century, contains fragments of seventh-century textiles, some of which come from Central Asia and are resist-patterned using a technique also found in China. Perhaps the most interesting example of the way patterns travelled is a copy of a Sasanian textile in the Shoso-in at Nara in Japan: pearl borders enclose four Japanese archers mounted on winged horses on either side of a fruit tree resembling William Morris's orange trees; between the roundels is a pattern which is remarkably close to the designs on Assyrian glazed wall plaques of the ninth century BC! Finally, the *senmurv* appears on wall-paintings in a number of locations including one of the rock-cut churches, probably of the eighth or ninth century, in the Ihlara

184 Roundels painted in about the 8th century AD in one of the Byzantine rock-cut churches in the Peristrema Gorge (Ihlara Valley) in central Turkey. They have been interpreted as 'cocks praising the Nativity' but are clearly based on the Sasanian *senmurv* (see Figs 175–6).

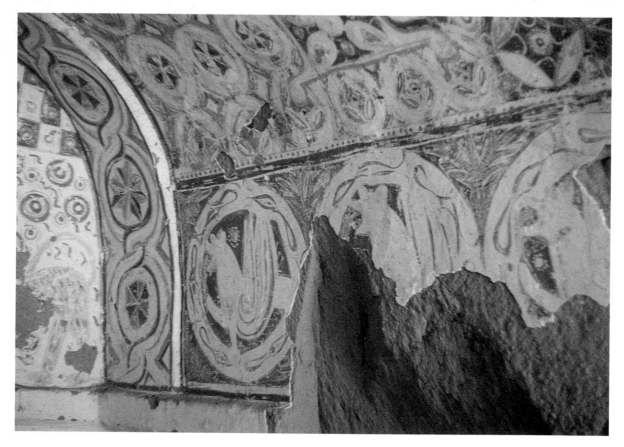

184 Valley (also known as the Peristrema Gorge) in central Turkey: three are shown in patterned roundels but are interpreted as 'cocks praising the Nativity'. While we are on the subject of the Nativity, it is perhaps worth recalling that in the course of their destructive raid into the Holy Land in 614, the Sasanians did not destroy the Church of the Nativity in Bethlehem because the mosaic on the façade depicted the Magi wearing Persian dress!

Several royal icons still in use today owe their origins to the art of the Ancient Near East. The first is the concept of the lion as a royal animal which has here been traced back to representations of the 'priest-king' killing lions in the late fourth millennium BC (see pages 50–1); a representation on a painted bowl from Arpachiyah in northern Iraq may take the motif back to around 5000 BC, but there neither the identity of the figure nor the type of felid he is shooting can be determined. The motif of heroes and their allies fighting lions, found on cylinder seals and on metalwork, survives on 185 Romanesque and Gothic capitals. In the first millennium BC, lions were the symbol of royalty in the courts of Assyria, Urartu and Israel – and probably others, including Judah, as indicated by the title 'Lion of Judah' in Revelation 5:5. Nor, nowadays, is England alone in having a lion as part of its coat of arms.

185 A hero between two lions decorating a capital in the Norman cloisters at Monreale in Sicily. Late 12th century.

219

In the third millennium BC, and probably even earlier, statues of lions were set up outside Sumerian temples, for example at al-'Ubaid. In the ninth century BC, gigantic lions stood at the entrance to the Ishtar Temple at 186 Nimrud. These lions symbolised protection, but in later times just the head was sufficient guarantee. A Sasanian disc with the head of a lion probably 189 decorated a shield. However, a similar disc of bronze, said to be from Byblos on the Lebanese coast, dating between the first and fourth century AD, had been attached to the end of a wooden coffin as a handle, judging by the remains of an iron ring surviving in its mouth (WA 48348); it recalls later door-knockers, for instance one dating from around AD 1200 from Brazen Head Farm in Essex (MLA 1909,6–5,1). Appropriately, lions' heads in roundels are carved on the wooden doors of the British Museum.

186 One of the lions which flanked the entrance to the temple of the goddess Ishtar in the Assyrian capital at Nimrud in northern Iraq. 9th century BC. Ht 2.59 m.

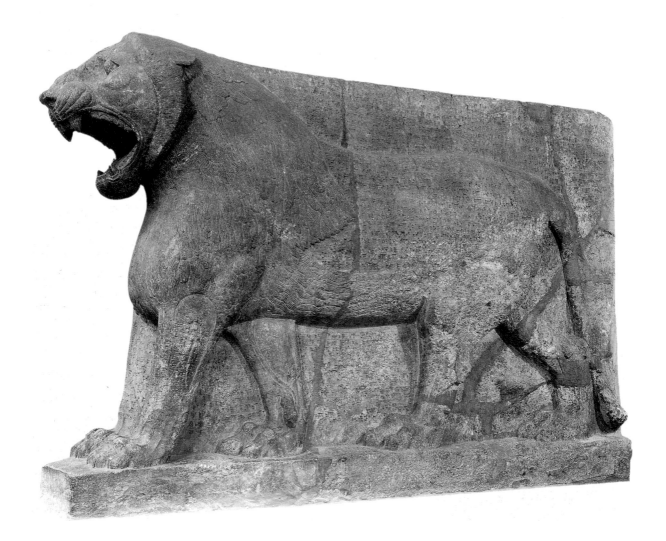

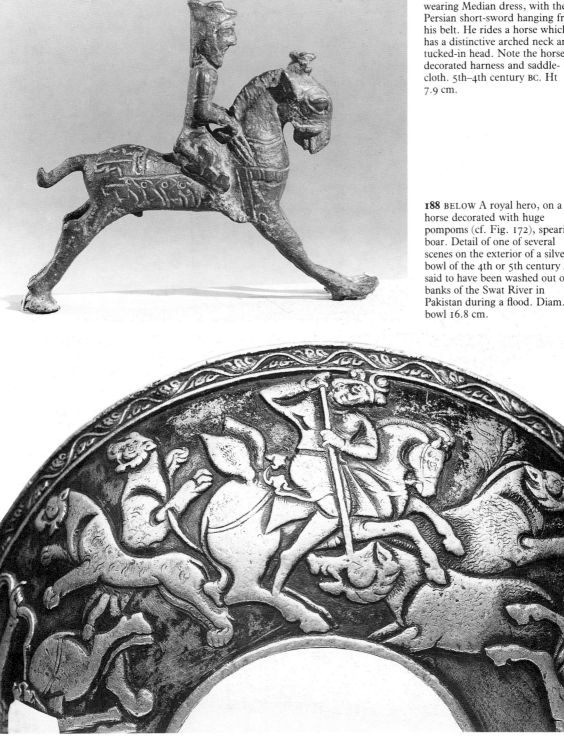

187 A bronze figure of a horseman wearing Median dress, with the Persian short-sword hanging from his belt. He rides a horse which has a distinctive arched neck and tucked-in head. Note the horse's decorated harness and saddle-cloth. 5th–4th century BC. Ht 7.9 cm.

188 BELOW A royal hero, on a horse decorated with huge pompoms (cf. Fig. 172), spearing a boar. Detail of one of several scenes on the exterior of a silver bowl of the 4th or 5th century AD said to have been washed out of the banks of the Swat River in Pakistan during a flood. Diam. of bowl 16.8 cm.

189 A decorative Sasanian disc of silver with gilded details, perhaps a shield-boss (cf. Fig. 16). It shows the frontal head of a lion with a diamond on its forehead and the tip of its tongue protruding. 4th century AD. Diam. 15.9 cm.

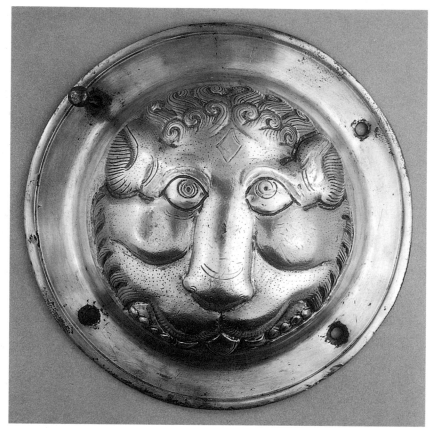

190 BELOW Detail of one of the Hittite reliefs decorating the Sphinx Gate at Alaca Hüyük in central Turkey. It shows a double-headed eagle grasping two hares and supporting a human figure, now fragmentary, who was probably a queen. 14th–13th century BC.

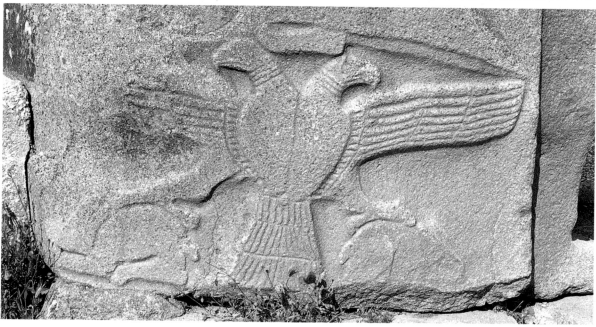

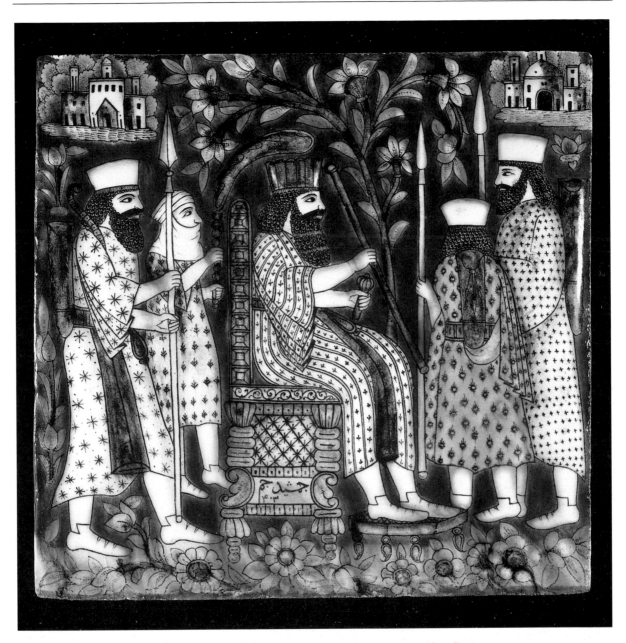

The double-headed eagle of the Austrian and Russian royal families appears on Assyrian colony seals from central Turkey of the eighteenth century BC (see Chapter 3), although it is unlikely that it was a royal symbol at that time. However, by the thirteenth century BC it supports two goddesses in the rock-cut shrine at Yazılıkaya near the Hittite capital, and 190 appears nearby at Alaca Hüyük. Many other heraldic devices, and indeed the whole art of heraldry, were brought back from the east by the Crusaders.

191 Underglaze tile showing a motif of the 5th century BC: an Achaemenid Persian king enthroned. It was part of the revival of ancient motifs under the 19th-century Qajar monarchy. Probably made in Tehran in about 1850. Ht 30 cm.

223

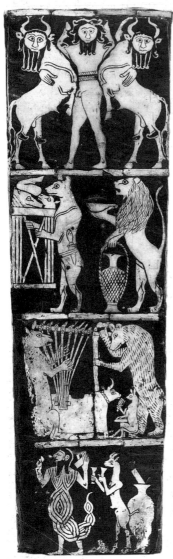

192 Panel of shell set in bitumen from the soundbox of a bull-headed lyre from Ur, *c.* 2600 BC (see Figs 50b and 53). A jackal carries a table of food, a lion holds a cup and a jar in a basket holder like that of a chianti bottle; below, a donkey plays a large bull-headed lyre, a mongoose or jerboa shakes a sistrum and a bear dances and claps, while a gazelle brings goblets filled from a jar, and a scorpion-man makes an after-dinner speech. Ht 21.5 cm (Philadelphia, University Museum).

A third royal icon which has a long pedigree in the Near East is the king on horseback. From Parthian times onwards, the king rides a special breed of horse which has a thick arched neck and tucked-in head and seems to have become popular in Achaemenid times. The horses of St Mark's in Venice, which may be Hellenistic or Roman, display the same features, as do those ridden by Renaissance kings and *condottieri*. A further adaptation of the motif of the royal rider, showing the mounted king spearing an animal, was to become the prototype for representations of St George killing the dragon. Finally, several earlier royal images were consciously revived by the Qajar monarchs of Persia in the nineteenth century; they include the enthroned Achaemenid king depicted on a glazed tile and a design based on those of Sasanian bowls.

187
188
191
193

The tradition of animals behaving like humans – exemplified by Peter Rabbit, Winnie the Pooh and others – also has a long pedigree. It goes back via La Fontaine and Aesop to representations on Assyrian cylinder seals of the ninth to eighth centuries BC, on a slab from the same ninth-century palace at Tell Halaf as Fig. 124 and on Egyptian ostraca and papyri of the thirteenth century BC. These may have been independent creations or they may have been inspired by much earlier representations of the first half of the third millennium BC from Iran and Iraq. One of these is a panel decorating a lyre from Ur and dating to around 2600 BC. The theme of animal musicians occurs on contemporary seals from Ur, and flute-playing monkeys can also be found at this and many other periods. However, in Proto-Elamite art of around 2800 BC animals replace humans entirely, and lions and bulls are shown fighting, engaged in administrative activities, or in boats. It was suggested in Chapter 2 that these animals may have represented tribal groups; they could also be the descendants of the priests or hunters shown wearing animal masks on prehistoric seals from the same area of south-western Iran which, in their turn, trace their origins back to figures such as the 'sorcerer' painted in the Trois Frères cave of the Magdalenian period (*c.* 14,000 BC) in the Ariège in France. Of more direct relevance, however, are the animal musicians on Romanesque church capitals, and the folk-tale about the animal musicians of Bremen, recorded by the brothers Grimm. It is probable that the motif was transmitted to Europe through the intermediary of monasteries and illuminated manuscripts.

192

While on the subject of music, the Near Eastern origin of many instruments should be noted. The Ur harps and lyres were discussed in Chapter 2, but it seems possible that they originated in Syria or Palestine. An instrument which is probably a lyre, but could be a harp, was incised on stone at Megiddo in Israel in a level dated to just before 3000 BC. Certainly both instruments were introduced to Egypt from the Levant around 1500 BC, together with the lute. The earliest representations of the lute are on two

50b
53

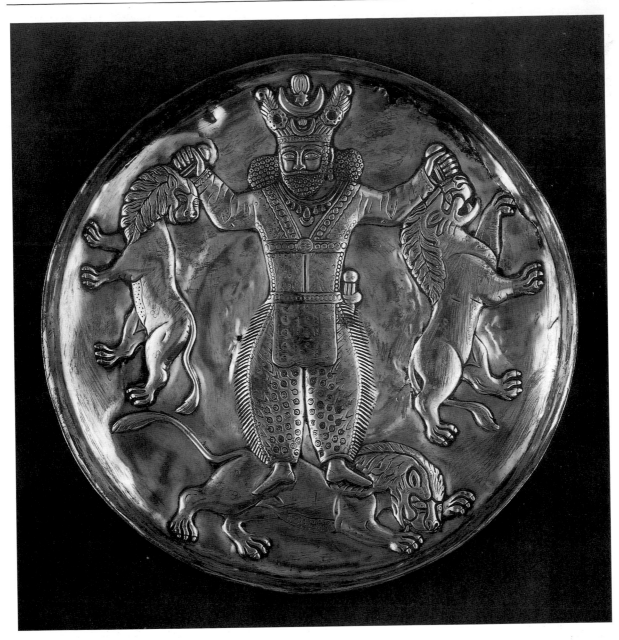

194a Akkadian cylinder seals in the British Museum dating to around 2300 BC. It has been suggested that the Sumerian word for lute, *gudi*, was eventually transmitted through Arabic *al-ud* to Spanish and Portuguese *(a)laude*, German *Laute* and English lute.

 Many Near Eastern motifs reached western Europe through Greek art. A

194b prototype for Herakles appears on an Akkadian seal of about 2250 BC. Again, textiles would certainly have been a vehicle for transferring such

193 This silver bowl, with traces of electrum gilding, was probably made in Qajar times in the 19th century, in imitation of Sasanian bowls of the 5th century AD (cf. Figs 172 and 174). It depicts a king stabbing two lions in the head and standing on a third. Diam. 24 cm.

a (enlarged)

b (enlarged)

194 Modern impressions of two Akkadian serpentinite cylinder seals of about 2300–2250 BC.

a. The seated water god Ea/Enki, patron of arts and crafts, with streams of water and fish flowing from his shoulders, sits facing his two-faced attendant, Usimu, who introduces a captive bird-man – the Zu-bird who stole the Tablet of Destinies (see Fig. 59e); his hands are bound and he is escorted by a god with stick and mace. The owner of the seal, named in the cuneiform inscription as 'Ur-Ur, the singer', plays the lute before his patron deity. This is one of the earliest depictions of the lute. Ht 3.8 cm.

b. The goddess Ishtar, with weapons rising from her shoulders (cf. Figs 59e, 82a and 136d) stands beside an altar facing a worshipper with an animal offering and a goddess with a flowing vase. A male figure wearing a lion-skin knotted around his neck, with the paws and tail hanging down, and sandals, and holding a knobbed club, a stick and a sling and sling-stones, faces a goddess; both have vegetation sprouting from their shoulders, and a small goat leaps up between them. This proto-Herakles lacks the divine horned headdress and may be a camouflaged hunter rather than a vegetation god. The seal belonged to 'Ili-Eshdar, the scribe'. Ht 3.4 cm.

motifs. Purple cloth from Tyre, made from a dye produced from the murex shellfish, was highly prized, as was embroidered cloth from Phrygia. The Assyrian reliefs show the elaborate motifs depicted on garments, and it is known that textiles were often exchanged as diplomatic gifts. The textiles have not survived, but the motifs on them were copied on pottery and metalwork and became part of the Greek iconographic and cultural repertoire. Among these motifs are lions, the lion-headed eagle, griffins, sphinxes, centaurs, stylised trees of oriental inspiration, hydras, mermaids, mermen, and monsters with heads like that of the demon Humbaba, which 148 were then conflated with the Egyptian god Bes to form further creatures such as Gorgons. Sometimes whole compositions were lifted: the killing of Humbaba by Gilgamesh and Enkidu was simplified to become Perseus killing Medusa; the hero between two lions or monsters reappears in 185 countless variations. Most then went on to be reproduced on the capitals and misereres of Romanesque and Gothic churches and in medieval manuscripts.

Henri Frankfort stated that 'while Egypt invented plant design, Mesopotamia subjected the animal kingdom to art' (*Cylinder Seals*, London 1939, p. 309). However, he also pointed out that it was the Near Eastern version of Egyptian floral patterns which was taken over by the Greeks, and it was the Near Eastern stylisation of animals to form well-balanced compositions, designs and patterns, which caused them to retain their appeal through many reinterpretations in time and space.

General Chronology

DATE (APPROXIMATE)	PERIOD	MESOPOTAMIA IRAQ	SYRIA LEBANON	PALESTINE ISRAEL JORDAN
8000 BC	NEOLITHIC			*Jericho*
7000 BC	PRE-POTTERY NEOLITHIC			*Ain Ghazal*
6000 BC	POTTERY NEOLITHIC			
5000 BC		HALAF *Arpachiyah*	*Tell Halaf*	
4000 BC		UBAID *Tell al 'Ubaid*		
3500 BC	CHALCOLITHIC	URUK *Uruk*	*Tell Brak*	
		Invention of writing and wheel-made pottery		
3000 BC	EARLY BRONZE			
		EARLY DYNASTIC		
		Diyala, Ur Royal Cemetery	*Mari*	
2500 BC				
		AKKADIAN *Akkad* Sargon (2334–2279)	*Tell Mardikh*	
		POST AKKADIAN *Lagash* Gudea (c. 2100)		
		UR III *Ur* Ur-Nammu (2112–2095)		
2000 BC	MIDDLE BRONZE	Fall of *Ur c.* 2004		CANAANITE
		Ashur, Tell el Rimah	*Mari*	*Jericho*
		OLD BABYLONIAN DYNASTY		
		Babylon Hammurabi (1792–1750)		
			Tell Atchana VII	
		Fall of *Babylon* to the Hittites c. 1595		
1500 BC	LATE BRONZE	*Nuzi* MITANNIAN	*Tell Atchana IV*	
	AMARNA PERIOD	KASSITE *Babylon, Aqar Quf*	Egyptian and Hittite control	
		MIDDLE ASSYRIAN *Ashur*		
				Israelites settle in Canaan
1200 BC	IRON AGE		Cities destroyed by the Sea People	
		Babylon destroyed c. 1157		Philistines settle in Canaan
1000 BC		NEO-ASSYRIAN *Ashur*	ARAMAEAN	David c. 1000
		Nimrud Ashurnasirpal II (883–859)	*Tell Halaf*	ISRAEL & JUDAH
		Khorsabad Sargon II (720–704)	PHOENICIAN	*Samaria, Jerusalem*
		Nineveh Sennacherib (704–681)	*Tyre, Sidon*	Fall of *Lachish* in 701
		Ashurbanipal (668–627)		
		Fall of Assyria in 612		
		NEO-BABYLONIAN/CHALDAEAN *Babylon*		
		Nebuchadnezzar II (604–562)		Fall of *Jerusalem* in 589
500 BC	ACHAEMENID EMPIRE	Capture of *Babylon* by Cyrus the Great in 539		
		Capture of *Babylon* by Alexander the Great in 331		
311 BC	SELEUCID ERA	*Seleucia-on-the-Tigris*	*Apamea*	
247 BC	PARTHIAN ERA	*Ctesiphon, Uruk, Ashur, Hatra*	Euphrates as border between Seleucids and Parthians	
AD 1	CHRISTIAN ERA		Euphrates as border between Romans and Parthians	
			Palmyra	*Petra*
AD 224	SASANIAN EMPIRE	*Ctesiphon*	Euphrates as border between Romans and Sasanians	
AD 622	ISLAMIC ERA and ARAB CONQUEST			

ANATOLIA/TURKEY	PERSIA/IRAN	PERIOD APPROXIMATE	DATE
		NEOLITHIC	8000 BC
		PRE-POTTERY NEOLITHIC	7000 BC
Çatal Hüyük		POTTERY NEOLITHIC	6000 BC
Hacılar	*Tall-i Bakun*		5000 BC
	Susa		4000 BC
		CHALCOLITHIC	3500 BC
	PROTO-ELAMITE	EARLY BRONZE	3000 BC
Troy, Yortan	*Tall-i Malyan, Susa*		
	Tepe Yahya		
			2500 BC
Troy			
	Tepe Giyan	MIDDLE BRONZE	2000 BC
Assyrian colonies	OLD ELAMITE		
Kültepe, Boğazköy	*Susa*		
HITTITE OLD KINGDOM			
Boğazköy			
HITTITE EMPIRE		LATE BRONZE	1500 BC
Boğazköy	MIDDLE ELAMITE		
Suppululiuma (1380/40–1320)	*Susa, Choga Zanbil*	AMARNA PERIOD	
Trojan War, *Yazılıkaya*			
End of Hittite Empire	*Marlik*	IRON AGE	1200 BC
	Elamites destroy *Babylon*		
NEO-HITTITE *Carchemish*	Luristan bronzes		1000 BC
URARTIAN *Van*	*Hasanlu, Baba Jan*		
Assyrian sack of Muṣaṣir	NEO-ELAMITE *Susa*		
PHRYGIAN *Gordium*	MEDIAN *Tepe Nush-i Jan, Hamadan*		
Cimmerian invasions			
Greek colonies			
Medes in east			
Persian Wars	Cyrus the Great (550–530) founds empire	ACHAEMENID EMPIRE	500 BC
	Pasargadae, Bisitun, Persepolis		
	Alexander defeats Darius III in 331		
Antioch	*Susa* renamed *Seleucia-on-the-Eulaios*	SELEUCID ERA	311 BC
	Arsaces founds Parthian empire	PARTHIAN ERA	247 BC
	Nysa, Shami, Istarkh		
Paul's missionary journeys		CHRISTIAN ERA	AD 1
Constantine the Great (306–37)	Romans defeated by Shapur I (240–272)	SASANIAN EMPIRE	AD 224
BYZANTINE EMPIRE	Yazdagird III defeated by Arabs in 651		
Constantinople	End of Sasanian Empire	ISLAMIC ERA and ARAB CONQUEST	AD 622

Mesopotamian Chronology *by C. B. F. Walker*

The following pages give an overview of the principal sources and data on which the chronology of Mesopotamia is based. They follow the scheme and chronology given in J. A. Brinkman's appendix, 'Mesopotamian chronology of the historical period', in the second edition of A. L. Oppenheim's *Ancient Mesopotamia*, Chicago 1977, pp. 335–48, which is used as a convenient point of reference by most Assyriologists and Mesopotamian archaeologists active today.

As Brinkman himself has remarked, 'Mesopotamian chronology is not a very predictable field'. Some adjustments must be expected to the apparently precise chronology presented here as new evidence becomes available and old evidence is reassessed. For instance, there is a growing consensus that the reign of 42 years attributed to Ashurbanipal by an inscription of the time of Nabonidus may be an exaggeration and that his reign may have ended as early as 631 BC.

The fundamental framework for chronology, at least back to 1430 BC, is provided by a combination of Ptolemy's Canon (*c.* AD 150), which was probably based on Babylonian eclipse records, and by the Assyrian king-lists. Surviving Babylonian astronomical records indicate the accuracy of Ptolemy's Canon, and a solar eclipse recorded in the eponymy of Bur-Saggile offers a fixed point (763 BC) in Assyrian chronology.

Estimates for the approximate dates for the First Dynasty of Babylon and all earlier dynasties, and consequently for the dates of Šamši-Adad I and his son in Assyria, can be derived from a variety of historical and archaeological considerations. But for precise dates within the parameters thus arrived at we are (or may be) crucially dependent on the astronomical and statistical interpretation of a group of tablets known collectively as the 'Venus Tablet of Ammiṣaduqa', which appear to record a sequence of first and last visibilities of Venus during the early years of the reign of Ammiṣaduqa, penultimate king of the First Dynasty of Babylon. If reliable astronomical data can be drawn from these tablets, then in principle they should allow us to establish a small number of precise possibilities for the chronology of his reign. The various possible dates are separated from each other by 56 or 64 years because of the nature of the cycles of Venus's visibility. A combination of historical and archaeological evidence led to the conclusion that only three possible dates for Ammiṣaduqa were worth consideration, 1702–1682, 1646–1626 or 1582–1562, and for a long time it has been conventional to accept 1646–1626, the so-called 'Middle Chronology', as the best compromise with the varying strands of evidence. A reassessment of the astronomical data by Peter Huber of Harvard University (*Astronomical Dating of Babylon I and Ur III*, Malibu 1982) has demonstrated that the dates 1646–1626 are no longer plausible and that the earlier dates, 1702–1682, are to be preferred. However, historical and archaeological considerations continue to suggest a cautious approach, and most writers currently prefer to retain the Middle Chronology, as presented here, as a convenient convention, although it no longer has an astronomical basis.

In the transliteration of Sumerian and Akkadian names this table retains the five letters s, ṣ, š, t and ṭ used by Assyriologists, which elsewhere in this book have been represented as s, s, sh, t and t respectively.

Assyria

Each civil year in Assyria bore the name of an official appointed for that year, the *līmu*. Copies of lists of these *līmu* officials, known to Assyriologists as 'eponym' lists (using Greek terminology), have been found at Nineveh, Ashur and Sultantepe, and such copies were evidently the source from which the various Assyrian king-lists were compiled.

In column 1 below is given the number of the king in the Assyrian king-lists: this reflects Brinkman's numbering.

In column 2 is given the king's name; this is given in *italics* if the king's reign is proven by contemporary royal inscriptions; the king's ancestry is noted (s. = son; gs. = grandson; d. = descendant; b. = brother); where this ancestry is taken from the king-lists it is given in brackets, otherwise it is taken from contemporary inscriptions. It should be noted that where a king records his ancestry over more than one genera-

tion, the term DUMU is often to be interpreted as 'descendant' rather than 'son'.

In column 3 are given the king's dates according to the current conventional chronology, as in Brinkman (1977).

In column 4 is given the number of years assigned to the king by the king-lists (note the uncertainty in the cases of kings 61, 79 and 82).

In column 5, from king 87 onwards, is noted whether the eponym (*līmu*) officials of the king's reign are attested in the eponym-lists; where complete these lists can be used to confirm the length of the king's reign, and it is assumed that such lists were the source from which the king-lists themselves were compiled (note King-List 9's comment on kings 27–32). The eponym-lists are fragmentary for the period *c.* 1100–911 BC, and can be completely reconstructed for the period 910–649 BC.

In column 6 is recorded (according to Grayson's numbering in *Reallexikon der Assyriologie* VI (1980), pp. 86–135) whether the king is listed in one or more of the king-lists (including the principal Assyrian king-list, no. 9).

In column 7 is recorded (according to Grayson's numbering, *loc. cit.*) whether the king is listed in one or more of the chronicles.

In column 8 is recorded miscellaneous information including the name of the contemporary Babylonian king; this name is either given by the Synchronistic king-list (King-List 12), which is plainly totally unreliable before 1250 BC, or by the chronicles; if taken from the chronicles it is given in *italics*.

It is now understood that the first 29 names in the list are ancestors of the Assyrian kings, and that the real list of kings begins with Puzur-Aššur I. The list of ancestors may be compared with, and is in part identical with, the list of ancestors contained in the 'Genealogy of the Hammurapi Dynasty' (J. J. Finkelstein, *Journal of Cuneiform Studies* 20 (1966), pp. 95–118).

For king 40c see A. K. Grayson, *Annual Review of the Royal Inscriptions of Mesopotamia* 3, pp. 9–14, and for king 78a and his possible relationship to king 80 see E. F. Weidner, *Die Inschriften Tukulti-Ninurta I*, no. 42.

1 no.	2 name	3 date	4 yrs	5 EpL	6 KL	7 Ch	8
1–17	(KL 9: '17 kings who lived in tents')				9		
16	Ušpija				9		Mentioned by no. 77
17	Apiašal				9		
18	Hale (s. of 17, gs. of 16)				9		
19	Samanu (s. of 18)				9		
20	Hajanu (s. of 19)				9		
21	Ilu-Mer (s. of 20)				9		
22	Jakmesi (s. of 21)				9		
23	Jakmeni (s. of 22)				9		
24	Jazkur-ilu (s. of 23)				9		
25	Ila-kabkabi (s. of 24)				9		
26	Aminu (s. of 25)				9		
	(KL 9: '10 kings whose fathers are known')						
27	Sulili (s. of 26)				9		
28	Kikkija				9		Mentioned by no. 70
29	Akija				9		
30	Puzur-Aššur I				9		
31	*Šalim-ahum* s. of 30				9		
32	*Ilušuma* s. of 31, gs. of 30				9		
	(KL 9: '6 kings whose eponyms are not known (?)')						
33	*Erišum I* s. of 32, gs. of 31, d. of 30		40		9		Kültepe 2 colony
34	*Ikunum* s. of 33		[...]		9		Kültepe 2 colony
35	*Sargon I* s. of 34		[...]		9		Kültepe 2 colony
36	Puzur-Aššur II (s. of 35)		[...]		9, 10		Kültepe 2 colony
37	Naram-Sin (s. of 36)		[...]		9, 10		
38	Erišum II (s. of 37)		[...]		9, 10		Deposed by no. 39
39	Šamši-Adad I s. of 25	1813–1781	33		9, 10		Kültepe 1b colony *Hammurabi*
40	Išme-Dagan I (s. of 39)		40		9, 10		Kültepe 1b colony
40a	Mut-Aškur				10		
40b	Rimu-x				10		
40c	Asinum						
41	Aššur-dugul		6		9		
42	Aššur-apla-idi				9		
43	Naṣir-Sin				9		
44	Sin-namir				9		
45	Ipqi-Ištar				9		
46	Adad-ṣalulu				9		
47	Adasi				9, 12		
48	Belu-bani (s. of 47)		10		9, 12		Iškibal
49	Libaja (s. of 48)		17		9, 12		Šušši
50	Šarma-Adad I (s. of 48)		12		9, 12		Gulkišar

1 no.	2 name	3 date	4 yrs	5 EpL	6 KL	7 Ch	8
51	Iʙ.ᴛᴀʀ-Sin (s. of 50)		12		9, 12		ᵐGíš-EN
52	Bazaja (s. of 48)		28		9, 12		Pešgaldaramaš
53	Lullaja		6		9, 12		Adarakalamma
54	Šu-Ninua (s. of 52)		14		9, 10, 12		Ekurduanna
55	Šarma-Adad II (s. of 54)		3		9, 10, 12		Melamkurkurra
56	Erišum III (s. of 55)		13		9, 10, 12		Ea-gamil Gandaš (?)
57	Šamši-Adad II (s. of 56)		6		9, 10, 12		Agum I and seven more Kassite kings
58	Išme-Dagan II (s. of 57)		16		9, 10, 12		Burnaburiaš
59	*Šamši-Adad III* (s. of Išme-Dagan who was b. of 55 and s. of 54)		16		9, 10, 12		
60	*Aššur-nirari I s. of 58*		26		9, [10, 12]		
61	*Puzur-Aššur III s. of 60*		24/14		9, 10, [12]	21	*Burnaburiaš (I)*
62	*Enlil-naṣir I s. of 61*		13		9, [10], 12		
63	Nur-ili (s. of 62)		12		9, 10, 12		
64	*Aššur-šaduni (s. of 63)*		1m		9, [10]		
65	*Aššur-rabi I s. of 62*		[...]		9, 10		
66	Aššur-nadin-ahhe I (s. of 65)		[...]		9, [10]		
67	Enlil-naṣir II (b. of 66)	1430–1425	6		9, 10, 15		
68	Aššur-nirari II (s. of 67)	1424–1418	7		9, [10], 15		
69	*Aššur-bel-nišešu s. of 68*	1417–1409	9		9, 10, 15	21	*Karaindaš*
70	*Aššur-rim-nišešu s. of 68, d. of 65*	1408–1401	8		9, 15		
71	*Aššur-nadin-ahhe II (s. of 70)*	1400–1391	10		9, 15		
72	*Eriba-Adad I* s. of 69, gs. of 68, d. of 65	1390–1364	27		9, 15		
73	*Aššur-uballiṭ I s. of 72, gs. of 69* d. of 68, d. of 65, d. of 62, d. of 61	1363–1328	36		9, 15	21, 22	*Kara-hardaš, Nazi-Bugaš* *Kurigalzu II*; Amarna kings
74	*Enlil-nirari s. of 73, gs. of 72*	1327–1318	10		9, 15	A1, 21?	*Kurigalzu II*
75	*Arik-den-ili s. of 74, gs. of 73*	1317–1306	12		9, 15	A2	
76	*Adad-nirari I* s. of 75, gs. of 74 (but KL 9 says b. of 75)	1305–1274	32		9	22	*Kurigalzu II*
						21	*Nazi-Maruttaš*
77	*Shalmaneser I s. of 76, gs. of 75*	1273–1244	30		9		
78	*Tukulti-Ninurta I s. of 77, gs. of 76*	1243–1207	37	E	9, 12	21	*Kaštiliašu*
						22	*Adad-šuma-uṣur*
78a	Aššurnasirpal s. of 78					22	
79	*Aššur-nadin-apli s. of 78, gs. of 77*	1206–1203	4/3		9, 12		
80	*Aššur-nirari III* (s. of 79?) (or s. of 78a?)	1202–1197	6		9, 12		*Adad-šuma-uṣur*
81	Enlil-kudurri-uṣur (s. of 78)	1196–1192	5		9, 12	21, 25	Adad-šuma-uṣur
82	*Ninurta-apil-Ekur* (s. of Ilu-ihadda, d. of 72)	1191–1179	13/3		9, 12	21	Adad-[šuma-uṣur] (?) Meli-Šipak (?) Merodach-Baladan I (?)
83	*Aššur-dan I s. of 82*	1178–1133	46		9, [12]	21	*Zababa-šuma-iddina*
84	Ninurta-tukulti-Aššur (s. of 83)		?		9, 12	22	Marduk-x-x
85	Mutakkil-Nusku (b. of 84)		?		9, 12		
86	*Aššur-reš-iši I s. of 85, gs. of 83*	1132–1115	18		9, 12	A3	*Ninurta-nadin-šumi*
						21	*Nebuchadnezzar I*
87	*Tiglath-pileser I* s. of 86, gs. of 85, d. of 83	1114–1076	39	E	9, 12	21, A4	Enlil/*Marduk-nadin-ahhe*
88	Ašarid-apil-Ekur (s. of 87)	1075–1074	2	E	9, 12		
89	*Aššur-bel-kala s. of 87, gs. of 86*	1073–1056	18		9, 12	21, 24, A4	*Marduk-šapik-zeri* Adad-apla-iddina
90	*Eriba-Adad II s. of 89, gs. of 87*	1055–1054	2		9, 12		
91	*Šamši-Adad IV s. of 87, gs. of 86*	1053–1050	4		9, 12		Ea-mukin-zeri
92	*Aššurnaṣirpal I s. of 91*	1049–1031	19	E	9, 12		Kaššu-nadin-ahhe
93	*Shalmaneser II s. of 92, gs. of 91*	1030–1019	12	E	9, 12		Eulmaš-šakin-šumi

1 no.	2 name	3 date	4 yrs	5 EpL	6 KL	7 Ch	8
94	Aššur-nirari IV (s. of 93)	1018–1013	6	E	9, 12		Ninurta-kudurri-uṣur
95	Aššur-rabi II (s. of 92)	1012–972	41	E	9, 12		Širikti-Šuqamuna
96	*Aššur-reš-iši II* (s. of 95)	971–967	5	[...]	9, 12		Marduk-biti-apla-uṣur
97	*Tiglath-pileser II* s. of 96	966–935	32	E	9, 12		Nabu-mukin-apli
							Ninurta-kudurri-uṣur
							Mar-biti-ahhe-iddina
98	*Aššur-dan II* s. of 97, gs. of 96, d. of 95	943–912	23	E	9, 12		Šamaš-mudammiq
99	*Adad-nirari II* s. of 98, gs. of 97, d. of 96	911–891	21	E	9, 12	21, [24]	Šamaš-mudammiq Nabu-šuma-iškun/ukin
100	*Tukulti-Ninurta II* s. of 99, gs. of 98	890–884	7	E	9, 12	24	Nabu-šuma-ukin
101	*Aššurnaṣirpal II* s. of 100, gs. of 99, d. of 98	883–859	25	E	9, 12	24	Nabu-apla-iddina
102	*Shalmaneser III* s. of 101, gs. of 100	858–824	35	E	9, 12	21, 24	Nabu-apla-iddina Marduk-zakir-šumi
103	*Šamši-Adad V* s. of 102, gs. of 101	823–811	13	E	9	21 21	Marduk-balassu-iqbi Baba-aha-iddina
104	*Adad-nirari III* s. of 103, gs. of 102	810–783	28	E	9	21	Ba[ba-aha-iddina?]
105	*Shalmaneser IV* (s. of 104)	782–773	10	E	9		
106	*Aššur-dan III* (b. of 105)	772–755	18	E	9		Solar eclipse in 763 BC
107	*Aššur-nirari V* (s. of 104)	754–745	10	E	9		
108	*Tiglath-pileser III* (s. of 104? or 107?)	744–727	18	E	9	1, 24	
109	*Shalmaneser V* (s. of 108)	726–722	5	E	9	1, 24	Assyrian King-List ends
110	*Sargon II*	721–705		E		1	
111	*Sennacherib*	704–681		E	12	1, 14, 16	*Bel-ibni* *Aššur-nadin-šumi* *Nergal-ušezib* *Mušezib-Marduk*
112	*Esarhaddon* s. of 111, gs. of 110	680–669		E	12	1, 14, 16	
113	*Assurbanipal* s. of 112, gs. of 111	668–627		E	12, 17	1, 14	*Šamaš-šum-ukin* Kandalanu
114	*Aššur-etel-ilani* s. of 113, gs. of 112				17		
115	Sin-šumu-lišir						
116	*Sin-šar-iškun* s. of 113, gs. of 112, d. of 111, d. of 110	–612				2, 3	
117	Aššur-uballiṭ II	611–609				3	

Babylonia

From the time of the dynasty of Akkad down to the end of the Old Babylonian dynasty each civil year bore a name based on the events of the previous year. Fragmentary copies of lists of these year-names have survived, and such lists were evidently the source from which the various Sumerian and Babylonian king-lists were compiled.

In column 1 below is given the number of the king in Brinkman's list. Note that the identity and order of the first Kassite kings remains uncertain; for a detailed discussion of the evidence see Brinkman (1976).

In column 2 is given the king's name; this is given in *italics* if the king's reign is proven by contemporary royal inscriptions; the king's ancestry is noted (s = son; gs. = grandson; d. = descendant; b. = brother); this ancestry is taken from contemporary inscriptions.

In column 3 are given the king's dates according to the current conventional chronology, as in Brinkman (1977).

In column 4 is given the number of years assigned to the king by the king-lists. Note that King-List 7 is extremely unreliable in the years it records for the Old Babylonian dynasty when tested against the lists of year-names.

In column 5 is noted the number of regnal years attested for each king either by the lists of year-names (for the Ur III, Isin, Larsa and Babylon I dynasties) or from the Kassite dynasty onwards by contemporary economic texts; in the latter case, where no contemporary economic texts are preserved the symbol □ is used, otherwise the date on the latest dated economic text is given, but in a few cases a number in brackets indicates that an inscription from a later period indicates a transaction in a particular year of the king in question (e.g. a transaction in year 11 of Adad-apla-iddina).

In column 6 is recorded (according to Grayson's numbering in *Reallexikon der Assyriologie* VI (1980), pp. 86–135, except for King-Kist S, the Sumerian King-List) whether the king is listed in one or more of the king-lists.

In column 7 is recorded (according to Grayson's numbering, *loc. cit.*) whether the king is mentioned in one or more of the chronicles. In column 8 is recorded miscellaneous information; for contemporary kings in Assyria see above.

1 no.	2 name	3 date	4 yrs	5 yrs	6 KL	7 Ch	8
AKKAD							
1	*Sargon*	2334–2279	56		S		
2	*Rimuš* (s. of 1)	2278–2270	9		S		
3	*Maništušu* (b. of 2, s. of 1)	2269–2255	15		S		
4	*Naram-Sin* (s. of 3)	2254–2218	37		S		
5	*Šar-kali-šarri* (s. of 4)	2217–2193	25		S		
6	Igigi	2192–2190	3		S		
7	Nanijum						KL S gives kings 6–9 three years altogether
8	Imi						
9	Elulu						
10	Dudu	2189–2169	21		S		
11	*Šu-Turul* (s. of 10)	2168–2154	15		S		
	KL S: '11 kings reigned its 181 years'						
UR III							
1	*Ur-Nammu*	2112–2095	18		S, 2		
2	*Šulgi* (s. of 1)	2094–2047	46		S, 2		46 to be emended to 48
3	*Amar-Suen* (s. of 2)	2046–2038	9		S, 2		
4	*Šu-Sin* (s. of 3)	2037–2029	9		S, 2		
5	*Ibbi-Sin* (s. of 4)	2028–2004	24/25		S, 2		KL 2: 24; KL S: 24/25
	KL S: '4 [emend to 5] kings reigned its 108 years'						
ISIN							
1	*Išbi-Irra*	2017–1985	33		S, 2		
2	*Šu-ilišu* (s. of 1)	1984–1975	10		S, 2		
3	*Iddin-Dagan* (s. of 2)	1974–1954	21		S, 2		
4	*Išme-dagan* (s. of 3)	1953–1935	19		S, 2		
5	*Lipit-Ištar* (s. of 4)	1934–1924	11		S, 2		
6	*Ur-Ninurta*	1923–1896	28		S, 2		
7	*Bur-Sin* (s. of 6)	1895–1874	22		S, 2		
8	Lipit-Enlil (s. of 7)	1873–1869	5		S, 2		
9	Irra-imitti	1868–1861	8		S, 2		
10	*Enlil-bani*	1860–1837	24		S, 2		
11	*Zambija*	1836–1834	3		S, 2		
12	Iter-piša	1833–1831	3		S, 2		
13	*Urdukuga*	1830–1828	3		S, 2		
14	*Sin-magir*	1827–1817	11		S, 2		
15	*Damiq-ilišu*	1816–1794	23		S, 2		Kl 2 has 4 years
LARSA							
1	Naplanum	2025–2005	21		I		
2	Emiṣum	2004–1977	28		I		
3	Samium	1976–1942	35		I		
4	*Zabaja* s. of 4	1941–1933	9		I		
5	*Gungunum*	1932–1906	27	27	I		
6	*Abisare*	1905–1895	11	11	I		
7	*Sumuel*	1894–1866	29	25+	I		
8	*Nur-Adad*	1865–1850	16?		I		
9	*Sin-iddinam* s. of 8	1849–1843	7?		I		
10	*Sin-eribam*	1842–1841	2?	2	I		
11	*Sin-iqišam* s. of 10	1840–1836	5?	5	I		
12	*Ṣilli-Adad*	1835	1?	1	I		
13	*Warad-Sin* s. of Kudur-mabuk	1834–1823	12?	11+	I		
14	*Rim-Sin I* s. of Kudur-mabuk	1822–1763	61	55+	I		
FIRST DYNASTY OF BABYLON							
1	Sumuabum	1894–1881	15	14	7		
2	Sumulael	1880–1845	35	36	7		
3	Sabium	1844–1831	14	14	7		

1 no.	2 name	3 date	4 yrs	5 yrs	6 KL	7 Ch	8
4	Apil-Sin	1830–1813	18	18	7		
5	Sin-muballiṭ	1812–1793	30	20	7		
6	*Hammurabi* s. of 5, d. of 2	1792–1750	55	43	1, 7		KL 1 has 13 years (at Larsa)
7	*Samsuiluna*	1749–1712	35	38	1, 7		KL 1 has 12 years (at Larsa)
	s. of 6, gs. of 5, d. of 2						
	KL 1 ends with a total of 289 yrs						
8	*Abi-ešuh*	1711–1684	25	[2]8	7		KL 7: 'E-bi-šum'
	s. of 7, gs. of 6, d. of 5						
9	*Ammiditana* s. of 8, d. of 2	1683–1647	25	37	7		
10	*Ammiṣaduqa* s. of 9	1646–1626	21	17+	3, 7		
11	Samsuditana	1625–1595	31	26+	[3], 7		
	KL 3: '[…] (years) 11 kings.' KL 7: '11 kings'						

First Dynasty of the Sealand

1 no.	2 name	3 date	4 yrs	5 yrs	6 KL	7 Ch	8
1	Ilumael = Ili-ma(n)	x+1/60			3, 7	20, B1	*Samsuiluna*
							Abi-ešuh
2	Itti-ili-nibi	x/[56?]			3, 7		
3	Damiq-ilišu	26?			3, 7, 12		*Ammiṣaduqa?*
4	Iškibal	15			3, 7, 12		
5	Šušši	24			3, 7, 12		
6	Gulkišar	55	2		3, 7, 12		
6a	ᵐGÍŠ-EN	(12)			12		
7	Pešgaldaramaš	50			3, 7, 12		
	KL 7: DUMU ᵐKI.MIN						
8	Adarakalamma	28			3, 7, 12		
	KL 7: DUMU ᵐKI.MIN						
9	Ekurduanna	26			3, 7, 12		
10	Melamkurkurra	7			3, 7, 12		
11	Ea-gamil	9			3, 7, 12	20	
	KL 3: '368 (years), 11 kings.' KL 7: '10 kings' (*sic*)						

Kassite Dynasty

1 no.	2 name	3 date	4 yrs	5 yrs	6 KL	7 Ch	8
1	*Gandaš*		26	☐	3, 12		
2	Agum I (s. of 1)		22	☐	3, 12		
3	Kaštiliašu I		22	☐	3, 12		
4	…		8?	☐	3		
5	Abirattaš			☐	3, 12		
5a	Kaštiliašu			☐	12		
6	Urzigurumaš			☐	3, 12		
7	Harba-x			☐	12		
8–9	(uncertain)				12		
10	Burnaburiaš I			☐	12		
11–14	(uncertain)						
15	*Karaindaš*			☐		21, 22	
16	Kadašman-Harbe I			☐		22	
17	*Kurigalzu I* s. of 16			☐			
18	*Kadašman-Enlil I*	(1374)–1360	15	15			Amarna kings
19	*Burnaburiaš II*	1359–1333	27	27		21	Amarna kings
20	Kara-hardaš	1333		☐		21	
21	Nazi-Bugaš	1333		☐		21, 22	
22	*Kurigalzu II* s. of 19	1332–1308	25?	24	3?	21, 22, A1	
23	*Nazi-Maruttaš* s. of 22	1307–1282	26	24	3?	21, 22	
24	*Kadašman-Turgu* s. of 23	1281–1264	18?	17	3		
25	*Kadašman-Enlil II* s. of 24	1263–1255	9	8	3		
26	*Kudur-Enlil* (s. of 25)	1254–1246	9	8	3		
27	*Šagarakti-Šuriaš* (s. of 26)	1245–1233	13	12	3		
28	*Kaštiliašu (IV)* (s. of 27)	1232–1225	8	8	3	21, 22	
29	Enlil-nadin-šumi	1224	1	?	3	22	

1 no.	2 name	3 date	4 yrs	5 yrs	6 KL	7 Ch	8
30	Kadašman-Harbe II	1223	1?	1	3		
31	Adad-šuma-iddina	1222–1217	6	0	3	22	
32	*Adad-šuma-uṣur* s. of 28	1216–1187	30	13	3, 12	21, 22, 25	
33	*Meli-Šipak* s. of 32	1186–1172	15	12	3, 12		
34	*Merodach-Baladan I* s. of 33	1171–1159	13	6	3, 12	23	
35	Zababa-šuma-iddina	1158	1	☐	3	21	
36	*Enlil-nadin-ahi*	1157–1155	3	☐	3, 12		

KL 3: '576 (years) 9 months, 36 kings'

SECOND DYNASTY OF ISIN

1	*Marduk-kabit-ahhešu*	1157–1140	17?	☐	3, 4, 12		
2	*Itti-Marduk-balaṭu* s. of 1	1139–1132	8?	1	3, 4		
3	*Ninurta-nadin-šumi*	1131–1126	6	☐	4, 12	A3	
4	*Nebuchadnezzar I* s. of 3	1125–1104	22	16	4, 12	21, 23	
5	*Enlil-nadin-apli* s. of 4	1103–1100	4	4	4, 12	[25]	
6	*Marduk-nadin-ahhe* s. of 5	1099–1082	18	13	4, 12	21, 25, A4	
7	*Marduk-šapik-zeri*	1081–1069	13	12	4, 12	21, 24, [25], A4	
8	*Adad-apla-iddina*	1068–1047	22	(11)	3?, 12	21, 24, [25]	
9	*Marduk-ahhe-eriba*	1046	1+6m	☐	3		
10	Marduk-zer-x	1045–1034	12	☐	3		
11	*Nabu-šuma-libur*	1033–1026	8	☐	3	17	

KL 3: '132 (years) 6 months, 11 kings'

SECOND DYNASTY OF THE SEALAND

1	*Simbar-Šipak*	1025–1008	18	12	3	17, 18, 24	
2	Ea-mukin-zeri	1008	5m	☐	3, 12	18	
3	*Kaššu-nadin-ahhe*	1007–1005	3	☐	3, 12	18	

KL 3: '21 (years) 5 months, 3 kings'

BAZI DYNASTY

1	*Eulmaš-šakin-šumi*	1004–988	17	(14)	3, 12	17, 18, 24	
2	*Ninurta-kudurri-uṣur I*	987–985	3	(2)	3, 12	15, 18	
3	*Širikti-Šuqamuna* b. of 2	985	3m	☐	3, 12, 14	15, 18	

KL 3: '20 (years) 3 months, 3 kings'

ELAMITE DYNASTY

1	*Mar-biti-apla-uṣur*	984–979	6	(4)	3, 12, 14	18, 24	

UNDETERMINED OR MIXED DYNASTIES

1	*Nabu-mukin-apli*	978–943	36	(26)	12, 14	17, 24	
2	*Ninurta-kudurri-uṣur II* s. of 1	943	8m	☐	12, 14, 17		
3	Mar-biti-ahhe-iddina s. of 1	942–		☐	12, 14, 17	24	
4	Šamaš-mudammiq			☐	12, 14, 17	21, 24	
5	Nabu-šuma-ukin I			☐	12, 14, 17	21, 24	
6	*Nabu-apla-iddina* s. of 5			33	12, 14, 17	21, 24	
7	*Marduk-zakir-šumi I* s. of 6			11	14?, 17	21, 24	
	(KL 17: 'Nabu-zakir-šumi')						
8	*Marduk-balassu-iqbi* s. of 7	–813		2	[14], 17	21, 24	
9	Baba-aha-iddina	812–		☐	[14], 17	21	
	(interregnum)			2/12+	[14]	24	
10	Ninurta-apl?-[x]			☐	14		
11	Marduk-bel-zeri			0	14		
12	Marduk-apla-uṣur			☐	14		
13	*Eriba-Marduk*			9	3, 14	18, 24	
14	*Nabu-šuma-iškun*	(760)–748		13	3, 14	15, 18, 23	
15	Nabu-naṣir	747–734	14	14	3, 8	1, 24	
16	Nabu-nadin-zeri s. of 15	733–732	2	☐	3, 8	1	
17	Nabu-šuma-ukin II s. of 16	732	1m	☐	3	1	
18	Nabu-mukin-zeri	731–729	3	4	3, 8	1	Year 4 from 36.2.1

1 no.	2 name	3 date	4 yrs	5 yrs	6 KL	7 Ch	8
19	Tiglath-pileser/Pulu	728–727	2	2	3, 8	1, 24	KL 8: 5 years for both
20	Shalmaneser/Ululaju	726–722	5	3	3, 8	1	
21	*Merodach-Baladan II*	721–710	12	12	3, 8	1	
22	Sargon II	709–705	5	4	3, 8	1	
23	Sennacherib	704–703	2	□	8		KL 8: 2 year interregnum
24	Marduk-zakir-šumi II (s. of Arad-(Enlil))	703	1m	□	3		
25	*Merodach-Baladan II*	703	9m	?	3		
26	*Bel-ibni*	702–700	3	3	3, 8	1	
27	*Aššur-nadin-šumi*	699–694	6	5	3, 8, 12	1, 15	
28	Nergal-ušezib	693	1	1	3, 8, 12	1	
29	Mušezib-Marduk	692–689	4?	3	3, 8, 12	1	
30	Sennacherib	688–681	8?	24	3, 8, 12	1, 14, 16	(24 years from 704) KL 8: 8 year interregnum
31	*Esarhaddon*	680–669	(12)	9	3, 8	1, 14, 16	KL 8: 13
31a	*Ashurbanipal*	668	(1)	38			KL 8 omits
32	*Šamaš-šum-ukin*	667–648	20	20	3, 8, 12	1, 14, 15, 16	KL 8: 20
33	Kandalanu	647–627	21	21	3, 5, 8, 12	16	KL 8: 22
	(interregnum)	626	(1)	1			(arki Kandalanu)
	Sin-šumu-lišir				3?, 5		
	Sin-šar-iškun				5		KL 5: 1 year for both

NEO-BABYLONIAN DYNASTY

1	*Nabopolassar*	625–605	21	21	5, 8	2, 16	
2	*Nebuchadnezzar II*	604–562	43	43	5, 8	4, 5	
3	*Evil-Merodach*	561–560	2	2	5, 8		
4	*Neriglissar*	559–556	4	4	5, 8	6	
5	Labaši-Marduk	556	3m	0	5		
6	*Nabonidus*	555–539	17	17	5, 8	7	

ACHAEMENID DYNASTY

1	*Cyrus II*	538–530	9	9	5, 8		(as king of Babylon)
2	Cambyses	529–522	8	8	5, 8		
3	Bardija	522	(6m)	1			
4	Nebuchadnezzar III	522	(2m)	0			
5	Nebuchadnezzar IV	521	(3m)	1			
6	Darius I	521–486	36	36	5, 8		
7	Xerxes I	485–465	21	16	8		Year 20 attested at Persepolis
8	Bel-šimanni	482		0			
9	Šamaš-eriba	482		0			
10	Artaxerxes I	464–424	41	41	8		
11	Xerxes II	424	(1½m)				
12	Darius II	423–405	19	16	8		
13	Artaxerxes II Memnon	404–359	46	46	8		
14	Artaxerxes III Ochus	358–338	21		8		
15	Arses	337–336	2		5, 8		KL 5: Ni-din-dB[el?]
16	Darius III	335–331	5		5, 8		KL 5: 5 years; KL 8: 4 years

MACEDONIAN DYNASTY

1	Alexander III	330–323	8		5, 6, 8		KL 5: 7? years; KL 8: 8 years
2	Philip Arrhidaeus	323–316	8		5, 6, 8		KL 5: 6 years; KL 8: 7 years
	Antigonus				5, 6		KL 5: 6 years
3	Alexander IV	316–307	10		6, 8		KL 8: 12 years

SELEUCID DYNASTY (SELEUCID ERA YEAR 1 = 311 BC)

1	Seleucus I Nicator	305–281	25		5, 6		KL 5: 31 years; KL 6: 25 years
2	*Antiochus I Soter*	281–261	20		5, 6		KL 5: 22 years; KL 6: 20 years
3	Antiochus II Theos	261–246	(15)		5, 6		

1 no.	2 name	3 date	4 yrs	5 yrs	6 KL	7 Ch	8
4	Seleucus II Callinicus	246–226	(20)		5, 6		
5	Seleucus III Soter	225–223	(3)		6		
6	Antiochus III	222–187	35		6		
7	Seleucus IV Philopater	187–175	12		6		
8	Antiochus IV Epiphanes	175–164	11		6		

King-lists

Listed according to Grayson's numbering in *Reallexikon der Assyriologie* VI (1980), pp. 86–135, except for King-List S, the Sumerian King-List, published by T. Jacobsen, *The Sumerian King List* (Assyriological Studies 11), Chicago 1939. Grayson gives details of the original publications. For the Assyrian King-List see also Gelb (1954).

no.	name	no.	name
1	Larsa King-List	10–11	Assyrian King-List fragments
2	Ur-Isin King-List		
3	King-List A	12	Synchronistic King-List
4	King-List C		
5	Uruk King-List	13–17	Synchronistic King-List fragments
6	Hellenistic King-List		
7	King-List B	18	Babylon I King-List fragment
8	Ptolemy's Canon		
9	The Assyrian King-List		

Chronicles

Listed according to Grayson's numbering in *Reallexikon der Assyriologie* VI (1980), pp. 86–135, and published in A. K. Grayson, *Assyrian and Babylonian Chronicles* (Texts from Cuneiform Sources 5), New York 1975, except for Chronicle 25 (C. B. F. Walker, 'Babylonian Chronicle 25: a chronicle of the Kassite and Isin II dynasties', in *Zikir Šumim* (Festschrift in honour of F. R. Kraus), Leiden 1982, pp. 398–417.

no.	name	no.	name
1–6	Neo-Babylonian Chronicle series	20	Chronicle of Early Kings
7	Nabonidus Chronicle	21	Synchronistic History
14	Esarhaddon Chronicle	22	Chronicle P
15	Šamaš-šuma-ukin Chronicle	23	Chronicle of Market Prices
16	Akitu Chronicle	24	Eclectic Chronicle
17	Religious Chronicle	25	Chronicle 25
18	Dynastic Chronicle	A1–4	Assyrian chronicle fragments
19	Weidner Chronicle	B1–2	Babylonian chronicle fragments

Some bibliographical sources for Mesopotamian chronology

J. A. Brinkman, 'Mesopotamian chronology of the historical period', in A. L. Oppenheim, *Ancient Mesopotamia*, 2nd edn, Chicago 1977, pp. 335–48

A. K. Grayson, 'Königslisten und Chroniken', in *Reallexikon der Assyriologie* VI (1980), pp. 86–135

A. K. Grayson, *Assyrian and Babylonian Chronicles* (Texts from Cuneiform Sources 5), New York 1975

M. B. Rowton, 'Chronology: Ancient Western Asia', in *Cambridge Ancient History*, 3rd edn, 1970, vol. 1, part 1, ch. VI, pp. 193–239

ASSYRIA

I. J. Gelb, 'Two Assyrian king lists', *Journal of Near Eastern Studies* 13 (1954), pp. 209–30

A. Ungnad, 'Eponymen', in *Reallexikon der Assyriologie* II (1938), pp. 412–57

A. R. Millard, *The Eponyms of the Assyrian Empire 910–612 BC* (State Archives of Assyria Studies 2), Helsinki 1994

UR III, ISIN I, LARSA, and BABYLON I DYNASTIES

A. Ungnad, 'Datenlisten', in *Reallexikon der Assyriologie* II (1938), pp. 131–96

Various studies of the year names of this period have been published or privately circulated or are still in preparation by M. de J. Ellis, M. J. A. Horsnell, and M. Sigrist.

KASSITE AND LATER DYNASTIES

J. A. Brinkman, *Materials and Studies for Kassite History*, vol. 1, Chicago 1976

J. A. Brinkman, *A Political History of Post-Kassite Babylonia*, Rome 1968

J. A. Brinkman and D. A. Kennedy, 'Documentary evidence for the economic basis of early Neo-Babylonian society', *Journal of Cuneiform Studies* 35 (1983), pp. 1–90

D. A. Kennedy, 'Documentary evidence for the economic basis of early Neo-Babylonian society', *Journal of Cuneiform Studies* 35 (1983), pp. 172–244

R. A. Parker and W. H. Dubberstein, *Babylonian Chronology, 626 BC–AD 75*, 2nd edn, Providence 1956

Further Reading

Titles marked with an asterisk are published by British Museum Press

A. H. LAYARD, *Nineveh and its Remains*, London 1849

A. H. LAYARD, *Nineveh and Babylon*, London 1853

S. LLOYD, *Foundations in the Dust: The Story of Mesopotamian Exploration*, Oxford 1947, rev. London 1980

O. R. GURNEY, *The Hittites*, Harmondsworth 1952, rev. 1981, 1990

H. FRANKFORT, *The Art and Architecture of the Ancient Orient* (Pelican History of Art), Harmondsworth 1954, rev. 1970

R. GHIRSHMAN, *Iran from the Earliest Times to the Islamic Conquest*, Harmondsworth 1954

J. B. PRITCHARD, *The Ancient Near East in Pictures Relating to the Old Testament*, Princeton 1954, 2nd edn 1969 (with supplement)

R. D. BARNETT, *A Catalogue of the Nimrud Ivories with Other Examples of Ancient Near Eastern Ivories in the British Museum*, London 1957, rev. 1975*

A. PARROT, *Sumer* (The Arts of Mankind), London 1960

E. AKURGAL, *Die Kunst Anatoliens von Homer bis Alexander*, Berlin 1961

A. PARROT, *Nineveh and Babylon* (The Arts of Mankind), London 1961

E. AKURGAL, *The Art of the Hittites*, London 1962

R. GHIRSHMAN, *Persian Art: The Parthian and Sassanian Dynasties, 249 BC–AD 651* (The Arts of Mankind), London 1962

D. HARDEN, *The Phoenicians* (Ancient Peoples and Places), London 1962, rev. 1963

S. LLOYD, *Mounds of the Near East*, Edinburgh 1963

R. GHIRSHMAN, *The Art of Ancient Iran from its Origins to the Time of Alexander the Great* (The Arts of Mankind), London 1964

G. ROUX, *Ancient Iraq*, London 1964; Harmondsworth 1966, rev. 1986

A. GODARD, *The Art of Iran*, London 1965

E. PORADA, *Ancient Iran: The Art of Pre-Islamic Times* (Arts of the World), London 1965

P. AMIET, *Elam*, Auvers-sur-Oise 1966

A. MOORTGAT, *The Art of Ancient Mesopotamia*, London 1969

B. PIOTROVSKY, *The Ancient Civilization of Urartu*, London 1969

B. DOE, *Southern Arabia* (New Aspects of Antiquity), London 1971

S. A. MATHESON, *Persia: An Archaeological Guide*, London 1972, rev. 1976

W. ORTHMANN (ed.), *Der alte Orient* (Propyläen Kunstgeschichte 14), Berlin 1975

P. R. S. MOOREY, *Biblical Lands* (The Making of the Past), Oxford 1975

R. D. BARNETT, *Sculptures from the North Palace of Ashurbanipal at Nineveh*, London 1975*

D. and J. OATES, *The Rise of Civilization* (The Making of the Past), Oxford 1976

G. HERRMANN, *The Iranian Revival* (The Making of the Past), Oxford 1977

N. POSTGATE, *The First Empires* (The Making of the Past), Oxford 1977

S. LLOYD, *The Archaeology of Mesopotamia*, London 1978, rev. 1984

P. AMIET, *Art of the Ancient Near East*, New York 1980

A. SPYCKET, *La Statuaire du Proche-Orient ancien* (Handbuch der Orientalistik 7/1/2B2), Leiden 1981

J. READE, *Assyrian Sculpture*, London 1983*

H. WEISS (ed.), *Ebla to Damascus: Art and Archaeology in Ancient Syria*, Washington DC 1983

P. AMIET, *L'Age des échanges inter-iraniens, 3500–1700 av. J.-C.* (Notes et documents des musées de France 11), Paris 1986

D. COLLON, *First Impressions: Cylinder Seals in the Ancient Near East*, London 1987, rev. 1993*

C. B. F. WALKER, *Cuneiform* (Reading the Past), London 1987 (also published in *Reading the Past: Ancient Writing from Cuneiform to the Alphabet*, London 1990, pp. 14–73)*

T. C. MITCHELL, *The Bible in the British Museum: Interpreting the Evidence*, London 1988*

J. CURTIS, *Ancient Persia*, London 1989*

S. LLOYD, *Ancient Turkey: A Traveller's History of Anatolia*, London 1989, rev. 1992*

D. COLLON, *Near Eastern Seals* (Interpreting the Past), London 1990*

J. N. TUBB and R. L. CHAPMAN, *Archaeology and the Bible*, London 1990*

J. READE, *Mesopotamia*, London 1991*

J. M. RUSSELL, *Sennacherib's Palace without Rival at Nineveh*, Chicago 1991

H. KLENGEL, *Syria 3000 to 300 BC: A Handbook of Political History*, Berlin 1992

J. N. POSTGATE, *Early Mesopotamia: Society and Economy at the Dawn of History*, London 1992

J. CURTIS (ed.), *Early Mesopotamia and Iran: Contact and Conflict c. 3500–1600 BC* (Proceedings of a seminar in memory of Vladimir G. Lukonin), London 1993*

Sources of Illustrations

Departments of the British Museum are abbreviated as follows:
GR Greek and Roman Antiquities
M&LA Medieval and Later Antiquities
OA Oriental Antiquities
WA Western Asiatic Antiquities

The maps on pp. 8–9 are by Ann Searight

1 WA 124656
2–6 Dominique Collon
7 WA Or. Dr. 1, 59
8 WA 124939
9 WA 22502 (K.1680)
10–11 WA 118885
12 WA 118801
13 WA K.3375
14 WA 124867
15 WA 92006
16 From P. E. Botta and E. Flandin, *Monument de Ninive* II, Paris 1849, pl. 141
17–18 Dominique Collon
19 British Library, Add. MS. 14758, f. 130
20 WA 127414
21 Photograph by P. Dorrell, kindly supplied by K. Tubb and reproduced courtesy of the Department of Antiquities, Jordan
22 WA 134707
23 WA 132624, 127717
24 WA 125381, 126063
25 WA 122873, 122872
26 WA 126205, 126206, 126492, 126202, 126495
27 WA 127508
28 WA 126460
29 WA 117119, 117007
30 WA 128622
31 WA 1924–9–2,2 (on permanent loan from the Musée du Louvre, Paris)
32 Dominique Collon
33 WA 120000
34 WA 86260–1
35 a. WA 131440; b. WA 102422; c. WA 120963; d. WA 108848; e. WA 132217
36 WA 118465
37 Ashmolean Museum, Oxford, 1964.744; reproduced courtesy of the Visitors of the Ashmolean. Drawing by Dominique Collon

38 a. WA 89843; b. WA 128843; c. WA 116720; d. WA 1930–12–13, 398
39 WA 123293
40 WA 1932–12–12, 25 and 38
41 WA 132405
42 WA 116666 (presented by the National Art Collections Fund, 1924)
43 Reproduced courtesy of the Oriental Institute, Chicago
44 WA 90929, 114207
45 WA 130828
46 WA 114308
47 WA 121529
48 WA 121345, 121346, 121344
49 WA 122200
50 WA 121201
51 WA 128887
52 WA 1992–10–7, 1
53 WA 121198a
54 WA 91700, 121865, 123556, 121702, 121738, 121698, 121716
55 Carnelian and chain diadem WA 122712; earrings WA 1929–10–17, 226–7; bead WA 121427; rings WA 121378, 121379; amulet WA 121404; choker WA 1929–10–17, 204; pin WA 121427; lapis and gold leaves WA 1929–10–17,180; other necklaces WA 1929–10–10,189; 1929–10–17,147, 182, 251, 275, 329; 121585
56 a. WA 89538; b. WA 120530; c. WA 121544
57 WA 118561
58 Musée du Louvre/AO, Sb 4 (photo RMN)
59 a. WA 891118; b. WA 89316; c. WA 89147; d. WA 89137; e. WA 89115; f. WA 129480; g. WA 89802
60 a. WA 89126; b. WA 102510; c. WA 102493
61 WA 113896
62 WA 122910
63 WA 135993
64 WA 115643
65 WA 91075
66 WA 132204–5
67 WA 135851

68 WA 139441, 116633, 123277; 123268 (presented by H. Oppenheimer through the National Art Collections Fund, 1913)
69 WA 120926, 120929
70 WA 132210, 134630, 120147, 113895
71 WA 139938 (presented by Dr Erik Wiget)
72 Dominique Collon
73 a. WA 89774; b. WA 113578a (drawing by Dominique Collon); c. WA 134306; d. WA 134842; e. WA 115654 (drawing by Eva Wilson)
74 WA 132963
75 a. Drawing by Dominique Collon; b. WA 129580; c. WA 138920
76 WA 135034, 105149
77 WA 91145
78 Musée du Louvre/AO, Sb 8 (photo RMN)
79 WA 22454
80 WA 103057, 124367, 123040
81 WA 115636
82 a. WA 86267; b. WA 89151; c. WA 89161
83 WA 122934 (U.16993)
84 a. WA 119162 (U.2904); b. WA 123287; c. WA 116812 (U.1232); d. WA 128891 (purchased with the assistance of the National Art Collections Fund)
85 WA 38185
86 The Metropolitan Museum of Art, New York, Gift of the Norbert Schimmel Trust, 1989 (1989.281.10). Photo © The Metropolitan Museum of Art 1983
87 WA 126389
88 WA 116232
89 WA 132116
90 WA 130738–9
91 WA 125993–5
92 WA 134901
93 a. WA 134855; b. WA 129572; c. WA 89806
94 WA 90858
95 Dominique Collon
96 WA 126155, 125986, 130764

97 **a.** WA 89128; **b.** WA 120949; **c.** WA 140793
98 WA 90858
99 WA 90840
100 WA 90841
101 WA 1853–12–19, 25, 28, 29, 24 and 26
102 WA 132960
103 WA 113886
104 WA Z87T232.1–2
105 WA 124564–6
106 WA 124567
107 WA 91681+91683
108 WA 124531
109 WA 90859
110 WA 127065
111 WA 124546
112 WA 118871
113 WA 118809
114 WA 124962
115 WA 115634
116 WA 118829
117 WA 124911
118–19 WA 124801b–c
120 WA 124920
121 WA 124867–8
122 WA 124875–6
123 WA 124875
124 WA 117101
125 Photograph from excavation archives in the British Museum
126 WA 118173. Drawing by Ann Searight
127 WA 118157
128 WA 127412
129 WA 115505
130 WA 133392
131 Dominique Collon
132 WA 91247, 118951
133 WA 91253
134 WA 91678
135 WA 91000
136 **a.** WA 134767; **b.** WA 100674; **c.** WA 89145; **d.** WA 89769; **e.** WA 103292; **f.** WA 130670

137 WA 134734. Drawing by Ann Searight
138 WA 123541
139 **a.** WA 90952; **b.** GR 60.4–4.97; **c.** GR 69.6–24.16; **d.** WA 91461; **e.** WA 98922
140 WA 132619; WA 138110–1 (presented by Mrs P. Adams on behalf of her late uncle, Captain E.G.B. Peel)
141 WA 129072
142 WA 132825
143 Dominique Collon
144 WA 129381
145 WA 132525 (on permanent loan from the Louvre, Paris)
146 **a.** WA 89132; **b.** WA 128865; **c.** WA 133322; **d.** WA 1932–10–8, 197
147 WA 123949, 123966
148 WA 135571
149 WA 124017
150 WA 123924
151 WA 134875
152 WA 126392 (presented to the Palestine Exploration Fund by Mr Hay, Acting US Consul in Jerusalem, and transferred to the British Museum in 1903)
153 WA 91593
154 Dominique Collon
155 WA 118896
156 WA 127335 (presented in 1920 by Dr M.Y. Young)
157 WA 104504
158 Dominique Collon
159 WA 1992–1–25,1 and 135126
160 WA 124097, 134628
161 WA 141529
162 WA 135977
163 WA 134963
164 Dominique Collon

165 WA 102612, 125031
166 WA 130890
167 WA 135562
168 WA L.26 (on loan from H.M. The Queen; presented to her father, King George VI, on his coronation, by the Imam Yahya of Yemen). The Royal Collection © Her Majesty Queen Elizabeth II
169 WA 125041
170 Dominique Collon
171 WA 134382
172 WA 124092 (Sir A. W. Franks bequest)
173 WA 124094 (Sir A.W. Franks bequest)
174 WA 124091
175 WA 124095 (presented by the National Art Collections Fund in 1922)
176 WA 135913
177 WA 119994
178 WA 92394
179 M&LA 1902,6–25,1
180 WA Or. Dr. II, pl. 65
181 WA 134322
182 M&LA 1976,9–3,1 (bequeathed by Phyllis Layard)
183 M&LA 1923,12–5,1
184–5 Dominique Collon
186 WA 118895
187 WA 117760
188 OA 1963.12–10.1 (presented by Mr Max Bonn in 1912)
189 WA 134358
190 Dominique Collon
191 OA 1981.6–4.2 (Woodward bequest)
192 University Museum, Philadelphia, Pa (U.10556)
193 WA 133024
194 **a.** WA 89096; **b.** WA 129479

Index

Numbers in *italics* refer to the illustrations or to discussion in a caption. Where relevant, entries to a noun include other nouns and adjectives derived from it: e.g. under Assyria, references to Assyrian and Assyrians are also included.

Abraham 33
abrasive *33b*
Abu 61
Acco *see* Acre
Achaemenes 177
Achaemenid *143–50, 187, 191*; *see also* Persian
Acre (Acco) 11, 12
Adad *see* storm god
Adam brothers 34
Adda *59e*
Aden 33
Aegean 12
Aeolian 12
Aesop 224
Afghanistan 12, 22, 68–9, 194, *68*
Africa 11, 12, 22, 161
agate 209
Ahab *11*
Aham-arshi *60b*
Ahura-Mazda *146a*
Ai 105
Ain Ghazal 42–3, *21*
Akhenaten 105
Akkad 10, 55, 72, 76–82, 85, 87, 90, 96, 99, 142, 187, 211, 225, *58–9, 82a–b, 194*
Akkadian language 24, 76, 90, 105, 212; *see also* cuneiform
alabaster 29, 117, 124, 188, *153, 166*
Alaca Hüyük 85, 223, *67, 190*
Alalakh *see* Tell Atchana
Alani 201
Aleppo (Iamhad) 10, 33, 35–6, 94, 97, 104, 109, 161, *75a–b, 90*
Alexander the Great 188
Alexandria 22
al-Mina 10, 11
alphabet 24, 37, 171, 181, 212–13; *see also* South Arabian
Altıntepe 166
Amarna (Egypt) 34, 105, 113, 119
Amarna (Syria) 36
amethyst 98
Amlash 175–6

Amman 11, 42, *21*
Amorite 94, 99
Amuq 44, *24*
Amurru *82c*
Anatolia 12, 85, 89, 92, 99, 128, 130; *see also* Turkey
Andromeda 98
Animal Style 176, 185, *142*
ankh 95–6, *75a*
Ankhesenamun 105
Anshan (Tall-i Malyan) 13
Antakya (Antioch) 10, 94, 97, *75a*
Antalya *23*
antelope *38c, 116*
Antiochus 188
Anu 98
Apamea (Qalaat el Moudiq) 16–17, 161, 188, *5*
ape *10*; *see also* monkey
Aqaba 39
Aqar Quf (Dur Kurigalzu) 199, *95*
aqueduct *8*
Arabia 7, 10, 12, 36–7, 200, 212, *166–9*
Arabic 76, 225
Arachosia 177
Aramaean 124, 130, 156, 215
Aramaic 171, 210
Ararat 12, 163
archer 136, 142, 192, 218, *7, 19, 35a, 84d, 121, 122, 124, 146a*; *see also* arrow, bow, quiver
architecture 41, 48, 51, 55, 77, 82, 140, 142, 144, 156, 177–8, 197, 212, *3, 4, 7, 16, 57, 84b, 135, 152, 154, 158, 164, 172*; *see also* column
Ardashir 201
Ardebil *137*
Ark of the Covenant 215
Armenia 12, 163
Arpachiyah 44–5, 218, *4, 23, 27*
arrow 50, 80, 117, 136, 152–3, 163, *7, 35a, 58, 59d–e, 84d, 100, 115, 117, 136d*; *see also* archer
Arsacid *see* Parthian
Arslan Tash 160

Artabanus V 201
Artemis *153*
Arvad 10, 12
Aryan 13, 118, 176–7
Ashkelon 12
Ashur (god) 150
Ashur (Qalaat Shergat) 28, 37, 84, 90–4, 112–14, 117, 155, 192, *139b*
Ashurbanipal 32, 82, 132, 146, 150, 152, 160, 167–8, 171, *8, 13–14, 114, 118–23*
Ashur-bel-kala 115, 117, *94*
Ashurnasirpal I 117
Ashurnasirpal II 63, 130–7, 140–1, 144, 152, 157, *12, 105–9, 111–12*
Ashur-uballit I 114
Asia, Western/Asia Minor 30, 198
ass *73a*; *see also* donkey, onager
Assyria 10, 21, 25–32, 38–9, 63, 67, 75–7, 82, 90, 96, 110–14, 117, 124, 128–72, 176–9, 185, 194, 205, 212–16, 227, *1, 7–14, 16, 93–4, 105–23, 134, 136, 139, 180*
Assyrian colony 36, 90–4, 96, 222, *72–4*
Assyrian language 23, 33; *see also* cuneiform
astrology 213
astronomy 213
Athar 61, 108, 200, *57, 155, 194b*
axe 80, 87, 96, 172, *68*

Baba Jan 39, *172*
Babati *60b*
Babylon 10, 22, 25, 34, 37, 68, 76, 99, 104, 112, 117, 119, 132, 144, 156, 168, 177, 188, *8, 139d*
Babylonia 10, 32, 34, 63, 76, 92, 94, 96, 99, 100, 102, 104, 114, 117, 119–20, 124, 132–3, 142, 145–6, 156, 167–8, 171–2, 175, 177, 181, 205, 212–13, *77–83, 97a–b, 98–100, 119, 134–5, 136a–b, 139d*

Babylonian language 23–4, *146a*; *see also* cuneiform
Bactria 177, *51, 52, 54, 68*
Badakhshan 12
Baghdad 10, 22, 25–6, 32, 34, 38, 48, 51, 58, 72, 79, *32, 43, 128*
Bahrain 37
Bahram V *172*
Balawat 18, 19, 34, 39, 140–1, *1*
banquet 55, 59, 69, 72, 81, 117, 151, 197, 199, *39, 50, 56c, 120, 162*
Barattarna 109
Bardiya 24
barsom 147
Bar-uli 124, *103*
basalt 48, 109, 156–7
Basel Head 218
Basra 10, 33
Battle of the Gods 80, *59g*
beehive houses *4*
Behnam 113
Beirut 11
Bekaa 11
Bel *164*
Bell, G. 38
Bell, T. S. 29
Bellino, C. 22, *9*
belt 43, 77, 80, 108, 165, 168, 172, 194, *137, 142*
Bent, Mr & Mrs 37
Berlin 40, 133, 156, 164
Bes 183, 227, *148*
Bethlehem 219
Beth-Shan 11
Beth Shemesh 20
Bible 10–11, 19–21, 33, 35, 41, 45, 77, 179, 181, 213
Bietak, M. 97
bird 43, 59, 63, 92, 94, 108, 151, 172, 176, 185, 215, *36, 39, 56a, 69, 73b–d, 86, 93a, 99–100, 103, 111, 116, 129, 136b–c, 136f, 137, 146b–c, 173*; *see also* eagle, Zu-bird
bird-man 108, *194a*
Bishapur 205
Bisitun 24–5, 77, 201
bison *56b*

bitumen 45, 62–3, 65, 72, 124, *21, 47, 50*
Black Sea 21
Blau Monuments 48, *34*
Bliss, D. 20
boar 13, 172, 204, *19, 68, 84d, 137, 188*
boat 94, 224, *19*
Boğazköy (Hattusa) 34–5, 104–5, 108, *17*
Bombay 22, 29
bone 40, 48, 94, 105, 117, 158, 218, *73c*
Borradaile oliphant 216, *183*
Borsippa 33–4, 188, *153, 178*
Bosphorus 7, 21
Botta, P. E. 25, *16*
Boutcher, W. 32
bow 80, 117, *14, 35a*, 58, *59d–e, 84, 100, 105, 109–10, 121–3, 136d, 145*; *see also* archer
brazing 48
Bremen 224
brick 15–16, 28, 37, 41, 117, 133, 156, *177–81, 4, 72, 95, 154*
British Institute of Persian Studies 39
British School of Archaeology in Iraq 34
bronze 13, 20–1, 34, 36–7, 97, 100, 108, 115, 124, 126, 132, 137, 140, 158, 161, 163–7, 172, 176–7, 192, 194, 200, 205, 208, 213, 216, 220, *68, 76, 101, 104, 129, 132, 137–8, 140, 157, 159, 162, 167–8, 171, 187*
Brown, A. *182*
buckle 194, *159, 162*
Budge, E. W. 34
buffalo 79, *59b*
bull 26–7, 30, 43, 45, 48, 50, 58, 63, 67–8, 72, 77, 80, 82, 86, 97, 108, 132–3, 136, 139, 142, 144, 156, 160, 165, 172, 176, 178–9, 200, 212, 215–16, 224, *36–7, 50b, 56a–b, 63, 66–7, 73a–b, 93a, 97b, 100, 103, 133, 136c, 136e, 137, 141, 143, 167, 192*
bull, human-headed *56b, 59a, 192*
bull-leaping 97
bull-man 72, 76, 78, 96, *56a, 59a–b, 75b, 82a*
bull, winged human-headed *see* lamassu
burial 12, 19, 21, 24, 26, 36–7, 41, 43, 45, 59, 64–5, 68, 74, 85, 87, 94, 97–9, 105, 108, 114, 125, 160–1, 166, 172, 176, 181, 194, 197, 199, 200, *165, 169*
Burney, C. 39
Burton, F. C. *183*
Bushire 29
Byblos 11–12, 213, 220, *68, 151*

Byzantine 19, 192, 208, 216, *183–4*

Cagliari 37
Cairo 156
calcite *35b*
calf 63, 160
Cameiros *139b*
camel 10, 101, 143, 187, *7, 10*
Campbell Thompson, R. 37
Canaan 11, 109, 126, 212
Canning, S. 26
capital *see* column
Cappadocian Texts 90, 92, *73b*
Capricorn 213
Cara, G. 37
Carbon 14 *18*
Carchemish 10, 25, 36, 104–5, 128, 156–60, 168, 172, *88, 100, 125, 136e*
Caria 12
Carmania 177
Carmel 13, 41
carnelian 71, 114, 163, 177, 208–9, *93, 128, 136c, 177*
Carthage 12, 37, 181
Caspian Sea 112
Çatal Hüyük 43
Caucasus 7, 12, 36, 110, 172, 218, *140*
cedar 102, 140, 177
cemetery *see* burial
centaur 114, 227
Central Asia 7, 10, 12, 22, 36, 39, 185, 191, 218, *142*
Ceylon (Sri Lanka) 25–6, 29
Chagar Bazar 38, 44, *24*
chalcedony 114, 120, 124, 209, *93a–b, 97a–b, 103, 136a, 146a*
Chaldaea 150; *see also* Babylonia
Chal Tarkhan *176*
champlevé *149*
chariot 65, 110, 114, 119, 133, 136, 143–4, 146, 150, 152, 156, 160, 164, 185, *1, 7, 39, 50, 73a, 111, 118–19, 121, 126, 146a, 182*
Chicago *43*
China 14, 192, 218
chlorite 13, 68, *51, 54, 60c*
Choga Mami 39
Choga Zanbil 124
Chorasmia 177
Chubb, M. 61
Cilicia 12, 108
clay 22, 24, 30, 32, 36, 43–4, 48, 53, 63, 89–92, 95, 105, 124, 153, 164, 168, 171–2, 181, 210, *13, 15, 22–5, 70–1, 83–4, 101, 146c*; *see also* pottery
Clayton, Capt. 164
cloisonné 71, *55, 149*
Cochin 68
cock *93c*
coffin *see* burial
Coghlan, Col. 37
coin 22, 181, 185, 192, 203

column 17, 32, 48, 63, 156, 160, 172, 178–9, 213, *8, 135, 143, 152, 158, 161, 164, 169, 185*
Constantinople (Istanbul) 19, 22, 25–6, 29, 32, 34
Cooper, F. C. 29, *180*
copper 32, 60, 63, 65, 92, 98–9, 124, 172, 181, *37, 38b, 46, 48–9, 61, 63, 66–8, 76–7, 179*
cow *16*
Crak des Chevaliers 11
Crassus 192
Crete 12, 97
crescent 13, 81, 85, 94, 168, *60, 73b, 93c, 135, 136a, 136f, 153*
crocodile 79
cross *38a–b, 97a*
Crusades 10, 17, 19, 216, 223, *5*
Crystal Palace 216
Ctesiphon 10, 191–2, *154*
Cudi Dağ (Mount Nipur) 146
Cumae *183*
cuneiform 20, 25–6, 30, 32, 34, 36, 59, 72, 77, 81–2, 90, 104–5, 108–9, 119, 130, 140, 150, 177, 212, *9–13, 16, 34, 39a, 39c–e, 39g, 60a–b, 61, 63, 65, 82b–c, 90, 94, 97–100, 103, 105, 107–8, 111–12, 115, 117, 134–5, 136c, 146a*
Cunningham, A. *183*
Curtis, J. E. 39
Curtis, V. *161*
cypress 152
Cyprus 12, 160

dagger 85, 152
Dailaman *160*
dairy 63, *59e*
Dalley, S. *8*
Damascus 11, 13
Darabgird *170*
Darius I 24–5, 77, 177, 181, 201, *145, 146a*
Davis, N. 37
Dawkins, J. 34
Dead Sea 11
deer 153, *122*
demon 55, 102, 136, 166, 171–2, 210, 227, *73e*
dendrochronology 18
Der 34
Deve Hüyük 36
Dhat-Himiyan *167*
diffusion bonding 124
Diocletian *164*
dioptase *19*
Diqdiqqeh *84a, 84c*
diorite 82, 120, *59e, 62, 64, 65, 99*
Diyala 10, 58–60, 79
dog 152–3, 172, 207, *59f, 93c, 98, 126, 140, 162*
dome 64, *4*
domestication 10, 13, 41, 50, 215

donkey 63, 90, *192*
Dor 12
dragon *155*
drinking vessels 80–1, 92, 97, 105, 108, 151, 173–4, 183, *56c, 60a–b, 73d–e, 74, 86, 93c, 120, 148, 172–5, 192*
dress 55, 63, 67, 72, 80, 82, 94–5, 99–100, 109, 130, 135, 142, 144, 151–3, 168, 175, 188, 194, 197, 199, 203, 206, 219, *38b, 39, 42, 45, 59d–e, 59g, 64, 71, 73b, 75a, 76, 87, 90, 100, 105–6, 108, 110, 112, 116, 120, 123, 136, 145, 161, 169, 171–2, 174, 177*
drum, drummer 102, 108, 151
Drummond, A. 36
Dunanu 150
Dunhuang 39
Dura Europos 192
Dur Kurigalzu *see* Aqar Quf
Dur Sharrukin *see* Khorsabad
Dutch 21

Ea *see* water god
eagle 80, 108, 136, 213, 215, 223, 227, *46, 51, 59e–f, 89, 93c, 96, 160, 190*
East India Company 21
Ebla (Tell Mardikh) 215
ebony 177
Ecbatana *see* Hamadan
Eden 10, 213
Egypt 13–14, 16, 20, 22–5, 34, 36, 50–1, 62–3, 68, 76, 95–9, 104–5, 108, 110, 112, 119, 126, 128, 142, 144, 151, 160–1, 177, 181, 188, 198, 224, 227, *129, 148, 151, 181*; *see also* ankh, winged sun disc
Egyptian Blue 172
Egyptian hieroglyphs 51, 95–6, *75c*
Elam 13, 53, 58, 77, 94, 120, 124, 146, 150–1, 153, 224, *103, 118–19*
Elamite language 24, *97c, 146a*
electrum 65, *48*
elephant 79, 95, 161, *10, 19*
Elymais 156
Emar (Meskene) 109
En-hedu-anna 79
Enki *see* water god
Enkidu 102, 227
Enlil 98
Ennanatum *45*
En priestess 79, *57*
Erbil 16, 150
Erech *see* Uruk
Eriba-Adad 114
Eridu 33, 112, *3*
Esarhaddon 136, *134*
Esdraelon 11
Eski Mosul 39
Etana 80, *59f*
Etel-pi-Shamash 77
Ethiopia 177

Euphrates 7, 10, 13–14, 22, 25, 32, 36, 38, 48, 63, 76–7, 94, 104, 109, 115, 118, 156, 188, 191–2, 197
Evangelists 213, *179*

faience 110, 112, 114–15
Fars 177, 201
figurine 13, 33, 41–6, 60, 82, 89, 94, 99–101, 105, 108, 114, 117, 124, 21–6, 61, 70–1, 101, 151, 171
fish 13, 65, 72, 80, 126, 212, 227, 50, 59e, 73b, 101, 104, 136f, 162, 194a
Flandin, E. *16*
fly *35b, 82a*
fortification 17, 24, 28, 41, 144, 163, 5, 7–8, 16, 115
foundation deposit 33, 45, 82, 167–8, 171, 26, 28, 61, 63, 135
fox *173*
flood 16
Flood, the 33, 35, 213, *13*
France 21–2, 26–7, 32–3, 37, 39–40, 63, 77, 94, 120, 156, 224
Frankfort, H. 61–2, 227
Franks, A. W. 183, *147, 149–50, 172–3*
frontality 63, 72, 74, 76, 84, 94, 96, 99, 101, 136, 172, 192, 197–8, 200, 203, 206, 57, 82a, 82c, 156, 189
furniture 67, 80, 82, 97, 119, 129, 132, 158, 160, 162, 164–5, 179, 16, 35b, 50b, 59d, 59g, 60, 73b, 93c, 102–3, 105, 117, 120, 132–3, 163, 169, 191, 192, 194a

Gadd, C. J. 109
Gailani *2*
Galilee 11
game 68, *113, 125*
Gandhara 177
garden 151, 205, *8, 120*
garnet 194, *136d, 160*
Garstang, J. 20, 36, 41
gate 34, *17, 57, 113–14*; see also Balawat
Gaudin, P. 35, 59
Gaza 20
gazelle 153, 176, *35d, 38b, 56b, 73b–d, 93c, 115, 192*
genie/minor gods 132, 136, 168, *105–6, 108, 113, 136b–c*; see also lamassu
Georgia 194, *162*
Germans 24, 28, 32, 35, 37, 225
Ghab *5*
Ghaiman *168*
Ghalilat *169*
Ghirshman, R. 124
Gibraltar 12
Gilgamesh 64, 102, 227
Gipar-ku 74
Girsu *see* Tello

glass 110, 112, 114, 119, 160, 165, 172, 181–3, 197, 206, 210, *90, 92, 139*
glaze 109, 117, 124, 132–5, 156, 172, 179, 181, 197, 218, 224, *15, 107, 109, 145*
goat 63, 65, 77, 131, 213, *47, 52, 66, 68, 136d, 137, 160, 194b*
god 28, 55, 60–2, 68, 73–4, 79, 82, 84, 94–5, 99–101, 105, 108, 110, 115, 117, 119–20, 132, 136, 140–1, 153, 157, 164, 168, 192, 210, 227, *59e, 59g, 60c, 82a, 83, 87–8, 97a, 97c, 98–100, 135, 146a, 156, 194a*; see also genie
goddess 36, 43, 51, 55, 60–3, 73, 76, 79, 81–2, 84–5, 94–6, 99–101, 108, 115–17, 120, 141, 157, 172, 223, *59e, 59g, 60, 70, 82, 84a–b, 88, 94, 153*
goddess/nude female 84–5, 115–17, 158, 172, *82a, 94, 126, 151*
Goff, C. 39
gold 39, 42, 60, 65, 71–2, 82, 85, 87, 92, 105, 108, 114, 119, 124, 136, 160–1, 163, 176–7, 183–7, 198, 205, 207, 215–16, *48–9, 80, 88–9, 128, 130, 132–3, 142, 147, 160, 173–5, 179, 182, 189*
Gordian III 201, *170*
Gorgon 227
Gothic 224, 227
Graeco-Persian 181
granulation 72, 119, 177, *96, 160*
grave *see* burial
Greece 10, 12, 20, 25, 34–5, 110, 119, 151, 162, 177, 181, 185, 188, 191–2, 197, 212–13, 225, 227, *146d, 151, 156, 168*
greenstone 79, 181, *59b, 59d, 59g, 60a, 146d*
griffin 78, 92, 114, 166, 168, 205, 227, *73e, 93a, 127, 132, 144, 149, 157*
Grotefend, G. F. 24–5
Gudea 82–4, *62–3*
guilloche *75b, 109–10, 126*
Gula 98
Gulf 7, 10, 110
Guti 80
Guzana *see* Tell Halaf
gypsum (Mosul marble) 130, 156, *33, 113*

Habhu 164
Hacılar 43, 45, *22*
haematite 92, 97, 100, 108, 209, *73a, 73e, 82, 136e*
Haftavan 39
Haft-Tepe *97c*
Hagago 165
Haid bin Aqil 166

Haifa 11
Hajji Mohammed *3*
Halaf period 44–5, *23–4, 27*
Haldi 164
Hall, H. R. 37
Hama (Hamath) 10, 17, 35, *2, 4*
Hamilton, W. 34
Hammurabi 99, 102, 112, 117, 120, *78–9*
Han 192
Hana 115, 118
Hanging Gardens 22, *8*
Hannibal 12, 37
hare 176, *190*
harp 68, 102, 133, 145, 150–2, 224
Hasan Dağ 43
Hasanlu 39, 160
Hashhamer *60a*
Hathor 96
Hatra 10, 26, 192, 194, *158*
Hatti 104
Hattusa *see* Boğazköy
Hattusili 97
headdress *see* dress
Hebrew 76
Hellenistic 224
Henderson, P. 36
Herakles/Hercules 225, *156, 194b*
Hermes 156
Hermitage *see* St Petersburg
hero, nude bearded 55, 72, 76–7, 79, 96–7, 219, *36, 56a–b, 82a, 93a, 192*
Herod *152*
Herrmann, G. 158
Herzfeld, E. 39
Hildesheim *179*
Hissarlık *see* Troy
Hittite 12, 34–5, 96–7, 104–5, 108–9, 127–8, 130, 156–7, 160, 166, 212, 215, 223, *17, 18, 85–7, 125, 190*
Hittite hieroglyphs/language 24, 35–6, 108, 157, *18, 73e, 86, 88, 125*
Hodder, C. D. 29
Hogarth, D. G. 36
Homer 35, 126
Homs (Qadesh) 10
horse 114, 133, 136, 144, 146, 152–3, 160, 164, 172, 187, 203, 215, 218, 224, *93b, 111, 118–19, 121–2, 126, 146a, 159, 170, 172, 187–8*
höyük 16
Humbaba 227, *84b*
Hunt, J. S. *182*
hunter, hunting 32, 41, 43, 50–1, 55, 82, 108, 117, 132, 142, 152–3, 167, 185, 205, 224, *14, 19, 116, 121–6, 145a, 172, 174, 182, 194b*
hunting god 79, *59e*
Hurrian 24, 108, 110
hüyük 16
hydra 227

Iamhad *see* Aleppo
Iarimlim 94–5

Iasmah-Addu 94
Ibbi-Sin *60b*
ibex 185, *35e, 38b, 138, 142, 146b–c*
Idin-Dayan 77
Idrimi 108–10, *90*
Ihlara Valley 218–19, *184*
Ili-Eshdar *194b*
incense-burner 151, 163, *120, 146b*
India 14, 21–2, 25, 29, 39, 68–9, 71, 79, 95, 161, 183, *10*
Indo-Aryan 13, 118, 176–7
Indo-European 104, 110, 124
Indus Valley 14, 39, 59, 69, 79, 177
Inanna 51, 74, 76, 79–80, *33, 35a, 37, 59e*; see also Ishtar
Ini-Ea *82c*
Ionia 12, 177–8, *135, 144*
Iran 10, 12–14, 22, 24–5, 29, 33, 37, 39–40, 45, 48, 53, 55, 58–9, 62, 68–71, 73–4, 77, 80, 85, 89, 94, 110, 112, 120, 124, 146, 160, 163, 172, 176, 191–2, 205, 224, *19, 30–1, 35c, 35e, 38c, 51–2, 54, 58, 68–9, 97c, 101–3, 137–8, 140–9, 156, 160, 170, 173, 176–7, 191*
Iraq 7, 10, 13, 16, 18–19, 22, 29, 32, 34, 37–9, 44–5, 48, 56, 63, 89, 102, 110, 112, 145, 163, 205, 218, 224, *1, 3, 7–16, 23, 25, 27, 29, 32–4, 35a–b, 36–40, 42–51, 53–65, 70, 73a, 77–84, 93–5, 97a–b, 98–100, 105–23, 126–9, 134–5, 136a–d, 139, 153–5, 158, 178, 181, 186*; see also Mesopotamia
irrigation 7, 14, 17–18, 25, 46, 56, 76, 102–4, 132, *2, 5, 8*
Ishara 98
Ishkun-Sin *60a*
Ishtar 76, 79–80, 137, 150, 220, *59e, 82a, 94, 98, 112, 136d, 186, 194b*
Isin 99, 124, 77, 98
Isis 96, *151*
Islam 6, 17, 144, 156, 208, 211–12
Israel 7, 11, 27, 41, 126, 160, 212, 219, *11*
Istakhr 201
Italy 183, *139c, 183*
Itûr-Ashdum 79
ivory 26, 37, 51, 95, 105, 115, 117, 119, 126, 130, 135, 151, 157–61, 165–6, 177, 216, *73c, 85, 104, 110, 126–8, 181, 183*
iwan 144, *19, 154, 158*

Jabul 161
jackal *192*
Jaffa (Joppa) 11–12
Japan 32, 218

jasper 124, *59c, 97c*
Jebel el-Araq 51
Jehu 27, *11*
Jemdet Nasr 55, *35b–c*
jerboa 192
Jericho (Tell es-Sultan) 20–1,
 40–1, 43, 97–9, *6, 20, 75c*
Jerwan *8*
jewellery 19, 32, 37, 41, 43, 69,
 71–2, 85, 87, 94, 101, 108,
 124, 136, 151–2, 161, 177,
 181, 183, 194, 199, 216, *14,
 55, 80, 83, 88, 89, 96,
 101–2, 105, 117, 123, 128,
 130, 132, 136d, 149–50,
 160, 165, 179*
Jezreel 11
Jezzine 99, *76*
Jones, F. 25
Joppa *see* Jaffa
Jordan 7, 11, 21, 37, 41–2,
 126, *6, 21, 104*
Judah 41, 142, 144, 212, 214,
 219, *7, 117, 180*

Kadashman-Enlil 119
Kalki 80, *59d*
Kamani *125*
Kanesh 90, *72*
Kapara 156
Karaindash 118
Karen Pahlavs *160*
Karkheh *10*
Karmir Blur 167
Kar-Tukulti-Ninurta 114–15
karum 90, 104, *72–3*
Karun *10*
Kaş 110
Kashmir *136d*
Kassite 117–20, 124, *95, 97a,
 98–100*
Kenyon, K. 20, 41
Kerman 68
Kermanshah 24, *145b*
Ker Porter, R. 37, 205, *19*
Khabur 7, 38, 110
Khafajeh 67–9, *39, 51*
Khinaman 68
Khorsabad (Dur Sharrukin)
 26–7, 142, 156, *16, 113,
 116*
Khuzistan 26
Kidmuri *107*
Kidudu 28
king 18, 21, 24–5, 27–8, 30–2,
 51, 55, 63–7, 76–7, 79–82,
 84, 94–5, 97, 99–100, 104,
 108–10, 115–17, 119–20,
 128, 130–6, 141–2, 144,
 145, 150–6, 163, 168, 171,
 175, 177–9, 188, 192,
 201–7, 224, *1, 8, 11, 14,
 45, 50, 58, 60a–b, 61–2,
 75a, 77–9, 82b–c, 84b–c,
 100, 103, 105, 108–10, 112,
 117–21, 135, 146a, 170–2,
 174, 191, 193; see also*
 priest-king
king-lists 80, 117, 128
King, L. W. *37*

Kirkuk 85, 110
Kish 80, *101*
Knossos 97
Koban 36, *140*
Konya 43, 156
kudurru 63, 120, 168, 213,
 98–100
Kültepe 36, 90–2, *70, 72–3*
Kurlil 63, *44*
Kushan 201
Kuyunjik *see* Nineveh
Kybele 36

Laban 101
Lachish 21, 110, 132, 142–6,
 150, 214, 224, *7, 117, 180*
La Fontaine 224
Lagash 63, 81–2, 99, *45*
Lama/suppliant goddess 81,
 99–100, *60a, 65, 73a, 79,
 82b–c, 135*
Lamashtu 172
lamassu/winged human-headed
 bull 26–7, 29–30, 130,
 136–40, 142, 144, 178, 183,
 215–16, *12, 113, 132,
 143–4, 180*
lamp *98*
Laodicea 188
lapis lazuli 12, 62, 65, 69,
 71–2, 108, 114, 119–20,
 161, 163, 209, *42–3, 49–50,
 52, 56c, 73d, 88, 127–8,
 139e*
Larsa 32, 82, 99
Latakiyeh 12
Lawrence, T. E. 36
Layard, A. H. 25–32, 34, 36,
 136, 139, 164, 172, 216, *7,
 10, 59d, 113, 129, 139a,
 182*
lead 115, *181*
Lebanon 7, 11, 37, 40, 99, 102,
 177, 213, 220, *151*
leopard 77, *56b*
library 30, 32, *13*
lightning fork *98, 100; see also*
 storm god
limestone 16, 55, 63, 65, 73,
 120, 145, 156, 178, *32, 49,
 50, 57, 60b, 68, 76, 100,
 112, 134, 152, 155–6, 165*
lion, lioness 27, 30, 32, 48, 50,
 58, 63, 72, 77–80, 82, 101,
 109, 129, 132–3, 136–7,
 142, 151–3, 156, 160,
 164–5, 167–8, 171–2, 176,
 178, 183–5, 204, 213–15,
 219–20, 224–7, *16, 51, 56a,
 59a–c, 59e–f, 74, 82a, 82c,
 93b–c, 105, 121–4, 126,
 128, 133–4, 136a, 136d–f,
 137–8, 139a, 140, 142,
 145a, 145c, 148, 150, 172,
 182, 185–6, 188–9, 192,
 193, 194b*
Lloyd, S. H. F. 61
Loftus, W. K. 32, 39, 124, 188,
 197, *15, 101, 126*
lost-wax process 37, *76, 139c–e*

Louvre *see* Paris
Lugal-mansi *97a*
Lullubi 76, *58*
Luristan 172, *138, 140*
lute 101, 133, 151, 224–5, *194a*
Luwian 104
Lycia 12, 162
Lydia 12, 162, 177
lyre 68, 102, 144, 151–2, 224,
 39, 50, 53, 169, 192

Macalister, R. A. S. 20
mace *35e, 59g, 75b, 105, 112,
 194b*
Mackay, E. 37
Mackenzie, D. 20
Madaktu 150
Madrid 32
Mafaddat *169*
Magi 219
magnesite 37, *90, 112*
Mahmatlar 68
Mallowan, M. E. L. 19, 38
Mamu 140
Mandaean 210
manganese 181
Marduk 104, *98*
Marduk-nadin-ahhe 131, 168,
 99–100
Mari 63, 79, 94, 99, 114
Mark Antony 192
Marlik 112, 175
Marston, C. 21
Masjid-i Soleiman *156*
mathematics 117
Matthews, R. 38
Mazandaran 173
Meander 12
Media 39, 87, 124, 146, 177,
 179, 212, *147, 187*
Mediterranean 10–12, 21, 25,
 37, 44, 126, 161, 165
Medusa 227
Megiddo 11
Meluhha 79
mermaid, merman 227
Mersin 36, 45
Meskene (Emar) 109
Mesopotamia 9–10, 13, 19, 22,
 25, 33–4, 37–9, 45, 51, 53,
 56, 59–60, 63–4, 69, 73–4,
 76–7, 82, 84–5, 89, 92, 94,
 99, 105, 108, 110, 112, 118,
 128–9, 210, 213, 227; *see
 also* Iraq
metal 14, 45, 60, 84–9, 99, 105,
 119, 129, 141, 150–1, 157,
 160–3, 165, 172, 181, 183,
 197, 206, 219, 227, *1, 16,
 37, 46, 49, 53, 55, 61–3,
 66–8, 76–7, 80, 86–9, 96,
 102, 104, 129–30, 132–3,
 137–8, 140, 142, 147–51,
 157, 159–63, 167–8, 171–5,
 179, 182, 187–9, 193; see
 also* copper, bronze,
 electrum, gold, lead, silver
Minet el-Beida 11

Mitanni 108–14, 117
Mochtchevaja Balka 218
mongoose *192*
monkey *84d, 93c; see also* ape
Monreale *185*
moon god (Sin) 74, 79, 81, 98
Moqimo *165*
Morier, J. 36
Moses 77
Mosul 25–6, 38–9, 156
Mosul marble *see* gypsum
mother-of-pearl 63
mound excavation 18–19
mound formation 15–18
mountain pattern 80, 142, *1,
 7–8, 16, 47, 58, 59e–f, 78,
 84b, 115, 117, 128, 172*
mud brick *see* brick
mudhif 3, 33, 37
Muşaşir 163, 165, 168, *16*
mushhushshu 156, 167
music 55, 64, 67–8, 101, 144,
 150, 153, 158, 175, 197,
 205, 207, 224; *see also*
 drum, harp, lute, lyre,
 pipe, singer, sistrum

Nabonidus 168
Nabu *98*
Nabu-apla-iddina 168, *128*
Nahavand 39, *160*
Nanshe 63
Nara 218
Naram-Sin 76, *58*
Nebuchadnezzar I *98*
Nebuchadnezzar II 64, *105*
Neolithic 13, 39–42, *20–1*
Nergal *82b*
Nesite 104
New York 58, 105, 108, 164,
 68, 86
Niebuhr, K. 24
Nile 14, 126, 177
Nimrud (Calah, Kalah) 25–9,
 32, 38–9, 129–38, 140,
 156–7, 160–1, 172, 220,
 *10–12, 105–12, 115, 126–9,
 139a, 181*
Nineveh (Kuyunjik) 20, 22,
 25–6, 28–9, 32–4, 37–8,
 56, 59, 94, 112, 115, 139,
 141–2, 151–2, 156, 194,
 *7–8, 14, 38a, 40, 93c, 94,
 114, 117–23, 155, 180, 186*
Ninevite 5 *56, 38a, 40*
Ninhursag 63
Ninurta 172
Niqmepa 109
Niqmepuh *75a*
Norman *185*
Nubian 143, *128*
Nusku *98*
Nuzi 110–12, 117
Nysa 191

Oates, D. 38–9
Oates, J. 39
obelisk 27, 117, 140, 152, 161,
 10, 11
obsidian 43

oil 14, 18, 166
Oman 39
Omri *10*
onager 65, 153, *50, 122*
onyx 209
Orontes 11, 17, 161, *2, 5*
Orousbekov, N. 36
oryx *59b*
ostracon 224
ostrich 68, *54*
Ottoman 12, 17, 21–2, 26, 37
Ouseley, G. & W. 36
Oxford 37
Oxus 39, 183–5, *147, 149–50*

Pahlavi 210, *173, 177*
paint 13, 43–5, 48, 59, 63, 84,
 89, 94, 97, 100–1, 112, 117,
 124, 135–6, 142, 156, 199,
 207, 218–19, 224
Pakistan 12, 14, 69, *68, 136d,
 188*
palace 15–16, 21, 26–33, 38, 42,
 55, 72, 90, 94–5, 97, 104,
 109, 114, 119, 129–30, 137,
 139, 140, 142, 144–6, 150,
 156–7, 160–1, 163, 172,
 178, 181, 213, 215–16, 224
Palermo 19
Palestine 7, 12, 19–20, 41, 45,
 74, 85, 94, 97, 99, 110,
 126–7, 224, *20, 96*
Palestine Exploration Fund
 19–20
palmette 132, 160, 164, *106–7,
 110, 114, 127, 130, 136a–b,
 146d, 181*
palm-tree, date-palm 13–14, 63,
 142, 146, 150, 152, 156, *3,
 51, 120, 135, 136d, 146a*
Palmyra (Tadmor) 10, 34, 192,
 197–8, *164–5*
paridaiza 205
Paris 41, 77, 79, 120, 164, 218,
 58, 78
Parthia 32, 188, 191–7, 200–1,
 212, 224, *15, 155–61, 163*
Pasargadae 39, 177
Peleset 127
Peristrema Gorge *see* Ihlara
 Valley
Persepolis 24, 36, 138, 171,
 177–8, 185, 201, 211, 219,
 224, *30, 143–4*
Perseus 227
Persia 12–13, 22–5, 29, 36, 39,
 124, 138, 171, 177–81, 187,
 192
Persian, Old 24, *146a*
perspective 65, 136, 140
Peter the Great 21
Petrie, W. F. 20
Philadelphia 38, *192*
Philip the Arab 201, *170*
Philistine 11, 12, 127
Phoenicia 11–12, 37, 160–1,
 181, 212, *127–30, 144, 181*
Phrygia 12, 34, 141–2, 162, 227
phyllite *34*
pindu stone 146

pipe 151
Pittman, H. 117, 133
Place, V. 32
plaster 4, 43, 146, *20–1*
Portuguese 21, 225
potter, pottery 13, 18, 20, 24,
 35–6, 43, 45, 55, 59–60, 63,
 74, 85, 89, 92, 94, 105, 111,
 142, 166–7, 173, 210, 222,
 *3, 22, 27, 29–31, 35b, 39,
 40–1, 69, 73b, 73e, 74, 86,
 91, 141, 178*
priest 14–15, 55, 64, 82, 105,
 144, 152, 192, 224, *57, 82a,
 135*; *see also* priest-king
priestess 51, 64, 74, 76, 79, 99,
 57, 153
priest-king 48, 51, 219, *34, 35a,
 51*
Proto-Elamite 58, 224, *38c*
Ptolemy 188, 212
Pu-abi 64–5, 68, 72, 74, *47–8,
 56*
Punic, 12, 37; *see also* Carthage,
 Tharros
Puralish 124, *103*
Puzur-Shullat *59c*
Puzzuoli (Puteoli) *139c*

Qadesh *see* Homs
Qajar 224, *19, 191, 193*
Qalaat el Moudiq *see* Apamea
Qalaat Shergat *see* Ashur
queen 55, 64, 105, 132, 150–2,
 157, 198, *120, 190*
quiver 80, 108, 136, 163, *35a,
 59d–e, 105, 109, 111, 121,
 123, 136d, 145*; *see also*
 archer

Rachel 101
rain *51–2*
ram 100, 105, 115, *37, 49, 81*
Rassam, C. 26
Rassam, H. 19, 29–34, 36, 164,
 139d, 153, 178
Ras Shamra (Ugarit) 10–11,
 127, 158
Rawalpindi 183, 206
Rawlinson, H. C. 24–5, 32
Raynolds, Dr 164
Reade, J. E. 28, 39
Red Sea 11, 39
reed 42, 82, 146, *3, 19, 33, 51,
 59c, 63, 95*
register 26, 51, 65–8, 74, 130,
 141–2, 145, 153, 176, *1,
 7, 10–11, 34, 39, 50, 53,
 56c, 57, 98, 111, 115,
 119–20, 122–3, 125, 169,
 178, 180, 192*
religion 19, 42–3, 48, 51, 74,
 117, 124, 171, 188, 191,
 201, 210–12, *57, 59d*
Renaissance 224
repoussé 206
Revival, Achaemenid 224, *191*;
 Assyrian 216, *182*; Sasanian
 224, *193*
rhinoceros 79

Rhmw 200
Rhodes *139b*
rhyton see drinking vessel
Rich, C. J. 22, 25, *9, 81*
Rim-Sin 82
rock crystal *38b*
Romanesque 213, 219, 224, 227
Rome 12, 16–17, 34, 37, 90,
 151, 188, 190–2, 197–201,
 224, *5, 8, 152, 158*
rosette 43, 56, 68, 72, 112, 124,
 140, 156, 161, 181, *14, 23,
 51, 54, 75b, 84a, 91, 93a,
 97a, 110, 114, 136f, 144,
 148, 152*
Ross, H. J. 26, 29
Rusa (Ursa) 163
Rusahinili *see* Toprakkale
Russia 21–2, 36–7, 104, 194,
 223

Sabaean *168–9*
Sagittarius 98
saints 218
St Mark 19, 213, 224, *179*
St Petersburg 164, 218
Sakcegözü 36
Salamis 160
Samaria 160, *11*
Samarra 10, 17, 45
Sardinia 37, 181, *130, 146d*
Sardis 177
Sargon of Akkad 76–7, 79, 90,
 142
Sargon II 25, 77, 132, 137, 142,
 163, 165, 171, *16, 113, 116,
 139c–d*
Sasanian 19, 144, 192, 201–3,
 206–8, 210–12, 216–19,
 224, *19, 154, 170–8, 183,
 188–9*
Sasson, J. 109
Sayce, A. H. 35
scarab 97–8, 181, *76c, 129,
 136e, 146d*
Scarlet Ware 59, *39*
schist *34*
Schliemann, H. 35
Scorpio 98
scorpion *51, 56b, 75b, 98–9*
scorpion-man *192*
scribe 79–80, 109, *1, 16, 59a,
 59d–e, 60b, 194b*
sculpture (in the round) 28, 36,
 41, 45, 48, 51, 55, 58, 60–3,
 82–5, 100–2, 105, 109,
 115–17, 136, 181, 188, 192,
 194, 200, 205, 220, *21, 28,
 32, 42–4, 62, 64–5, 81, 90,
 94, 112, 153, 166*; *see also*
 lamassu
sculpture (relief) 21, 24, 26–7,
 29–32, 36, 43, 48, 51, 55,
 63, 67–8, 74–7, 99, 104–5,
 117, 124, 129–36, 140–57,
 163, 166, 168, 171, 178–9,
 185, 192–4, 199, 201–5,
 227, *7, 8, 14, 16, 18, 19,
 33–4, 36, 45, 51, 57–8,
 78–9, 98–100, 105–6, 108,*

*111, 114–25, 135, 144, 152,
 155, 165, 169–70, 180, 185,
 190*; *see also* lamassu,
 obelisk, seal, stele
seal, sealing 19, 22, 32, 36–7,
 48, 50–9, 64, 69, 72, 77,
 79–82, 85–92, 95–100, 104,
 108–14, 119, 130–2, 157,
 163, 166, 168, 171, 179,
 181, 185, 207–10, 213, 219,
 223–7, *35, 37–8, 52, 56,
 59–60, 73, 76, 82, 93, 136,
 142, 146, 177, 194*
Sea Peoples 126–7
Seleucia 10, 188, 191, *153*
Seleucus I 161, 188
Seljuk 12
senmurv 207–8, 216–18, *19,
 175–6, 183–4*
Sennacherib 21, 29, 132, 139,
 142, 144–6, 151, 164, 215,
 7–9, 114, 117, 134, 180
serpent *see* snake
serpentinite 115, 168, *194*
Shah of Persia 22, 36
Shahr-i Sokhta 68, *71*
Sha-ilimma-damqa *97a*
Shalmaneser III 28, 38, 48, *1,
 10–11*
Shamash *see* sun god
Shamash-nishu *82b*
Shamash-shum-ukin 168
Shami 192
Shamshi-Adad I 94, 112
Shapur I 201, 205, *170, 174*
Shapur II *174*
Shar-kali-sharri 79
sheep 48, 63, 67, 77, *33, 50,
 59f–g*
shield 142, 165, 220, *1, 7, 16,
 115, 189*
Shilhak-Inshushinak 124
Shiptu 94
shell 62–3, 65, 94, 161, 227, *20,
 42, 47, 49–50, 56a, 192*
Shiraz 124
Shulgi 81, 84, *65*
Shumalia 98
Shutruk-Nahunte I, *120, 124*
Sicily 19, *185*
Sidon 12
silver 39, 58, 60, 65, 72, 87, 92,
 105, 108, 124, 161, 163,
 177, 182, 185, 205, 207, *48,
 67, 148, 161, 163, 173–5,
 182, 188–9*
Sin *see* moon god
Sinai 19
Sind 177
singer 67, 150, *50b, 194a*
Sin-lidish *82b*
Sippar 34, 77, 89, 94, 115,
 167–8, *79, 82, 98, 134–5*
Sirara (Zerghul) 63
sistrum *192*
slinger 142, *7*
Smith, G. 33, 35–6, 194, *13,
 155*
snake, serpent 55, 68–9, 80, *51,
 99–100*

soldiers 64–5, 133, 136, 144, 150, 156, 187, *1, 7, 15, 50, 58, 109, 115, 117, 145*
South Arabian script 37, 200, *167, 169*
Spain 12, 32, 225
spear 48, 65, 108, 142, 152, 223, *1, 16, 39, 50, 58, 111, 121, 145, 189*
sphinx 30, 109, 132, 160, 200, 216, 227, *106, 129, 136b, 181*
stag 105, 108, 176, 205, *46, 86, 93c, 142, 150, 162, 174, 178*
star, star-disc 79, 81, 94, 108, 168, *11, 58, 60b–c, 98–100, 135, 136a, 151*
Starkey, J. L. 21
steatite 97, 108, *38a*
Stein, A. 39
stele 37, 50, 76–7, 99, 117, 120, 140–1, 168, 181, 215, *1, 8, 58, 156*
Steuart, J. R. 34
stone 14–16, 19, 24, 26, 28, 35–6, 41–5, 48, 51–5, 61–3, 65, 68, 72, 76–7, 79–80, 84, 89, 94, 98, 100, 102, 110, 114–15, 119–20, 124, 135–40, 143, 146, 150–1, 156, 165, 168, 172, 177–9, 192, 199, 208–9; *see also* basalt, carnelian, chalcedony, chlorite, diorite, greenstone, gypsum, haematite, lapis lazuli, limestone, magnesite, onyx, schist, steatite
storm god (Adad, Ishkur, Teshub) 96, *17, 46, 75b, 98*
Stronach, D. 39
stucco *176*
Suez 22
Sugamuna *97b, 98*
Sumer 10, 13–14, 56, 59, 62–3, 68, 73, 76, 79, 81–2, 84, 211–13, 220, *38d, 39, 42–50, 53–7, 60–5*
Sumerian language 10, 22, 24, 56, 64–5, 212, 225, *38c, 45, 56c, 60a–b, 61, 63, 65*; *see also* cuneiform
sun god (Shamash, Sharruma, Utu) 80, 99, 108, 115, 132, 167–8, *18, 59e, 78, 82c, 88, 97a, 98–9, 134–5*; *see also* star-disc, winged sun disc
Suppululiuma I 104–5
Susa 13, 22, 32–3, 39, 48, 56, 59, 77, 94, 99, 120, 124, 177, 188, *31, 101, 145*
Swat *188*
sword 151, 168, 185, *76, 87, 100, 105, 109, 112, 121–2, 136a–b, 136d, 147, 171–2, 174, 187*
Sykes, P. 68
Syria 7, 10–16, 33, 35–41, 44–5, 48, 53–6, 59, 62–3, 73–7, 85, 89, 92, 96–7, 99,

104, 108, 110, 112, 126, 128, 130, 132, 156, 158, 161, 166, 171, 198, 215, 224, *2, 4–5, 24, 26, 35d, 71, 76, 88, 90, 96, 124–6*
Syriac 210
Syrian Desert 10, 13, 17, 34, 94, 192, 196, *164*
Syrian goddess 96, *75a–b*

Tabal *163*
Tablet of Destinies 80, *59e, 194a*
Tadmor *see* Palmyra
Takht-i Kubad *183*
Tall-i Bakun *30*
Tall-i Malyan (Anshan) 13
Tammaritu 150, *118–19*
Tammuz 65
Tartous 10
Taq-i Bustan *19*
Taurus 12
Taylor, Col. 25–6
Taylor, J. G. 33, 37
Tehran 39, *141, 191*
tell 16, 41, 142
Tell al-'Ubaid 37, 63, 220, *29, 44, 46*; *see also* Ubaid
Tell Asmar 60–3, 79, 112
Tell Atchana (Alalakh) 10, 94–7, 104, 108–12, 127, *75a, 90, 96*
Tell Brak 38, 45, 48, 55, 62, 77, 112, *26, 28*
Tell Chagar Bazar *see* Chagar Bazar
Tell Chuera 62
Tell ed-Dhibai 212
Tell el-Ajjul 20, *96*
Tell el-Daba 97
Tell el-Hesi 20
Tell el Rimah 39, 102, 114, *92*
Tell es-Sa'idiyeh 21, 126, *104*
Tell es-Sultan *see* Jericho
Tell Fara (Iraq) *56a*
Tell Fara South 20
Tell Halaf 156, 224, *124*; *see also* Halaf
Tell Harmal 212
Tell Jemmeh 20
Tell Judeideh 99
Tell Mahli *4*
Tell Muqqayar *see* Ur
Tello (Girsu) 82, *44–5*
Tell Sifr 32
Tell Taya 39
temple 16, 19, 33–7, 39, 45, 48, 51, 55–6, 60–1, 63, 73–4, 82, 101–2, 109–10, 118–19, 137, 140, 161, 163–5, 172, 185, 220, *57*
tepe 16
Tepe Giyan 39, 89, *69*
Tepe Nush-i Jan 39, 87, *177*
Tepe Sialk *141*
Tepe Yahya 13, 68
Teumman 150–1, *118–20*
textiles 19, 54, 90, 114, 119, 130, 141, 207, 216–18, 225–7, *14, 100, 106, 109–10, 169, 179, 183*

Tharros 37, 161, 181, *130, 146d*
Thebes (Egypt) *145a*
Thebes (Greece) 119
thermoluminescence 18
tiger 68
Tiglath-pileser III 132, 141, 156, *110, 115*
Tigris 7, 10, 13–14, 25–6, 32, 39, 76, 140, 182, 192, *1*
Til Barsip 156
Tillya Tepe 194
Til Tuba 150–1, *118–19*
Timna 166
tin 12, 90, 181
Tiwal esh-Sharqi 21
Tod 119
tomb *see* burial
tophet 37, 181
Toprakkale (Rusahinili) 34, 36, 167, *131–3*
tree 18, 101, 108, 142, 145–6, 151, *8, 39, 58, 84d, 100, 116, 118–19*
tree, stylised *131–2, 218, 226, 14, 75b, 93a, 108, 127, 144, 146d, 181*
Trincomalee 29
Tripoli 11
Trois Frères 224
Troy (Hissarlık) 35, 87
Tubb, J. 21
Tudhaliya IV *18*
tubular drill *38a*
tuff *38c*
Tukulti-Mer 115
Tukulti-Ninurta I 119
Tunis 12
Turco-Persian Boundary Commission 29, 36
Turkey 7, 10, 12–14, 16, 21–2, 26, 34, 36, 39, 43–5, 55, 59, 74, 76, 80, 85, 87, 89–90, 94–7, 99, 104, 108, 110–12, 126, 141, 146, 156, 162–3, 177, 198, 213, 219, 223, *1, 17, 22–4, 35d, 41, 67–8, 70, 72–4, 89–90, 96, 131–3, 136f, 184, 190*
turquoise 194, *160*
turtle *82a, 98, 100*
Tushba *see* Van
Tuthmosis III 104
Tyre 12, 227

Ubaid period 45, 63, *25, 29*
Ubil-Ishtar 80, *59d*
udjat eye *146b*
Ugarit *see* Ras Shamra
Ugaritic 24
Ulai *see* Til Tuba
Ummanigash 150
Untash-Napirisha 124
Ur (Tell Muqqayar) 33, 37, 64–5, 68–76, 79, 81–2, 84, 87, 90–2, 98–101, 181, 213, 224, *25, 38d, 47–50, 53–5, 56b–c, 57, 60, 80–1, 83, 192*
uraeus *129*
Urals 194, *136d*
Urartu 12, 34, 96, 150, 160,

162–7, 171, 212, 219, *1, 16, 131–3, 136f, 142*
Uruk (Erech, Warka) 22, 32, 45, 48, 51, 53–6, 60, 62–4, 82, 114, 118, 194, 197, 213, *15, 28, 32–4, 35a, 36, 46, 56a, 61*
Ur-Ur *194a*
Usimu 80, *59e, 73e, 194a*
Utu *see* sun god

Valerian 201, *170*
Valle, P. della 24
Van (Tushba) 12, 34, 36, 163–4, *1, 131*
vegetation deity *59g, 194b*
Venice 19, 32, 213, 224
Venus 43, 80, *59e*
vine 142, 152, 161, *117, 120, 173*

Wadi Araba 11
Warad-Amurru *82c*
Warka *see* Uruk
Warka Head 48, 62, 114, *28, 32, 34*
Warka Vase 51
Washshukani 110
water god (Ea/Enki) 74, 80, *59e, 81, 98, 194a*
weight 167
Wellcome, H. 21
West Semitic 24
Willendorf 43
Wilson, C. 19
wine 18, 166–7
winged sun disc 96, 98, 132–3, 160, *11, 14, 75b, 86, 88, 93c, 108, 136e, 146a, 182*
Winter, I. J. 158
Wood, R. 34
wool 67, 92, *50a*
Woolley, C. L. 36, 38, 64–7, 94–5, 97, 105, 109
writing 14, 20, 22–5, 48, 51–8, 64, 90–5, 105, 114, 144, 163, 171, 212; *see also* cuneiform

yaka timber 177
Yariri *125*
Yazdagird II *177*
Yazılıkaya 34, 105, 223, *18*
Yellow River 14
Yemen 37, *166–9*
Yortan 35, *59, 41*

Xerxes *143*

Zab 10
Zagros 10, 39, 76, *58, 95*
zebu 69, *51–2*
Zenobia 197
Zerghul (Sirara) *63*
ziggurat 33, 82, 119, *95*
Zimri-Lim 94, *79*
Ziwiye 176, 185, *142*
Zodiac 213
Zoroaster 210, *146a, 147*
Zu-bird 80, *59e, 194a*